D1614818

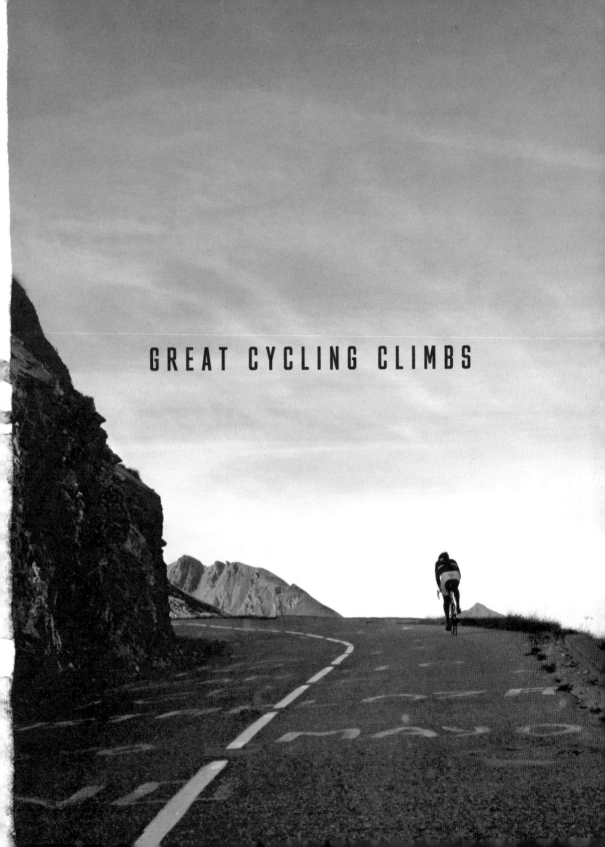

# GREAT CYCLING CLIMBS

# GREAT CYCLING CLIMBS

## THE FRENCH ALPS

### GRAEME FIFE

#### PHOTOGRAPHS BY PETER DRINKELL

#### WITH 61 ILLUSTRATIONS

 **Thames & Hudson**

# CONTENTS

# LIST OF ILLUSTRATIONS

# HOW TO GET THERE

Fly either to Grenoble or Geneva or, at a pinch, Lyon. The European Bike Express (*www.bike-express.co.uk*) operates a coach service with a trailer for bikes and will deliver you to Valence and other points quite close to the area. The French TGV system is also a convenient alternative to the car.

*Maps*
MICHELIN LOCAL, 328: Ain, Haute-Savoie
MICHELIN LOCAL, 333: Isére, Savoie
MICHELIN LOCAL, 334: Alpes-de-Haute-Provence, Hautes-Alpes

*Emergency Services In France*
Call 112

# PREFACE

For Pete, of course

There is something intrinsically perverse in writing about mountains. How to capture an iota of their grandeur? Horace put well the trivial nature of so much of our endeavour, and the vanity in which we drape it: *parturiunt montes nascetur ridiculus mus* – the mountains are in labour and will bring to birth a laughable little mouse. I once took the Circle Line trip round New York City and, as the boat rounded the southern tip of Manhattan, a yacht under full sail glided past – a beautiful sight – even as I heard the guide saying over the tannoy: 'There you see, in front of you, on page four of your guide, the Twin Towers of the World Trade Building.' All heads went down to the page to scan the virtual, ignoring the actual. There is no earthly point in just going somewhere for the sake of it. Looking isn't seeing and hearing isn't listening.

For all that my long-time collaborator, Pete, photographer, companion and friend, has supplied to this and the other books in the series, 'thank you' doesn't come close; praise wilts on its hanging syllable and appreciation is yet in its infancy. Let the dedication speak its own volumes, therefore.

*Note*: All translations in the text are by the author, unless otherwise indicated.

# INTRODUCTION

*Riding the Alps*

When I first chose to test myself on a bike in the mountains,
it seemed obvious to explore what was, and from almost the
beginning of the history of the Tour de France has been, one
of the major challenges: the High Alps. The Pyrenees came later,
but it was on some of the giant Alps described in this book that
I received my baptism of climbing, my shocking early taste of the
effects of gradient, distance and altitude on my mind and body.
That illuminating experience added rich testament to the already
compelling power of these French Alps.

*The Sectors*

Because of the overall geological and topographical uniformity
of the region covered in this book, the choice of sectors into
which to divide the description of it was problematic. True, there
are rivers and arterial roads and identifiable separate spurs off
the main chains of the massifs which parcel up the area here and
there, but there are no obviously useful natural discrete boundaries
offered. I therefore decided to centre the eventual seven areas on
prominent cities or towns. That, at least, gave the ordered whole
some cohesion, even if it is not immediately related to any distinct
difference in landscape.

## Alps: An Introduction

Alp, strictly, refers neither to any peak or ridge of the mountain chain but to an upland mountain pasture just below the snow-line which reappears each spring when the snow melts. These meadows are of great antiquity – recorded as early as the eighth century AD and subject, one assumes, to the same kind of measurement as the fertile alluvial mudfields of the Nile's banks after the annual flooding, the importance being to mark out the exact same dimensions of each allotment of ground as it became available, for planting or pasturage. (The origin of geometry: measuring areas of the Earth.) Hay is cut in lower fields but in insufficient quantity to support herds and flocks all year round. The *Alpgemeinden* (alpine communes) of the Swiss cantons are composed of those who have a right to take their cattle up to the alpine grazing every summer, the right being traditionally attached to certain plots of ground in the valley or houses in the village or to certain families. The size of the Alp is determined by how many animals it can support: one cow or two heifers, three calves or sheep, four pigs or eight goats.

The Alps are not continuous like the Pyrenees but consist of numerous ranges separated by comparatively deep valleys. The mountain mass describes a broad band, convex in form towards the north. The lie of the valleys is mostly west to east and south-west to north-east. Many of the ridges are intersected transversely by deep clefts ranging from full-scale valleys to tight passages through crowding rock. Known in French and Provençal as *clues* (or *cluses* in the Jura mountains) from the Latin *claudere*, 'to close or stop up', they have not only been used from the earliest times for the passage of man and animals, but also act as air vents which moderate the otherwise sharp differences in climate on adverse slopes.

## Composition of the Alps

The Alps were formed as part of a massive crumpling of the Earth's crust, a general upward flexure known as geanticlinal, which took place from the Rif mountains in Morocco to the Himalayas. The tegument was rucked and folded in a complex series of ridges and pleats both anticlinal (the inverted V of a ridge) and synclinal (the

cleft of a valley) on which ice, water and atmosphere worked further
to mould mountain ranges and the intervening plains between them.

The action of heat, water, ice and pressure transforms the fundamental
matter of the Earth's body into metamorphic rock. Igneous rock is
produced by volcanic combustion; crystalline rock, composed of crystals
or crystalline particles, such as mica (Latin for 'crumb'); schist, whose
component minerals are arranged in a more or less parallel manner;
gneiss, composed, like granite, of quartz and mica but distinguished
from it by its foliated or laminated structure; limestone, composed
of conglomerated fragments of shell and chalk; sandstone, from the
compressed bed of an ocean which has receded. Sedimentary rock is
dumped by the movement of a glacier, rivers or the withdrawing of
waters, while conglomerate rock consists of the debris of pre-existing
rocks, rounded or waterworn, broken down and cemented together.
(Cement comes from *caedimentum*, 'cutting', thus broken or pounded
stones, tiles etc. mixed with lime to make a hard-setting mortar.)
Amorphous rocks are those which are uncrystallized, massive, and
without stratification, cleavage or other division into similar parts.

The Alps present a geological medley of processes and types;
a blotch picture, if you will, of the immemorial time-scale of the
great lifting, shoving, grinding down, wearing away, compacting
and compounding which resulted in the mountains as we see them
today. And, during the clash and shift of their formation, a depression
sank north-east/south-west between the crystalline central massifs
and the foothills known as the Prealps which, in the course of
erosion, became a long furrow cut through marl (clay) known as
the Alpine Trench.

The Alps are lacerated by a number of great rivers which, beginning
as mountain torrents, played a crucial role in the shaping of the ranges
and the watering of the resultant valleys: the Rhône and its great
tributaries, Isère, Romanche, Drac, Durance, Verdon; the Var, the
Vésubie and the Tinée feeding the Alpes Maritimes. Those valleys
acted as conduits for people on the move, too, and along them were
built forts and fortified towns to obstruct the people whose movement
was unwelcome. Briançon, for example, whose ramparts were rebuilt
by the eminent military engineer, Sébastien Le Prestre Vauban.

## Vauban

Born in Burgundy into the minor nobility in 1633, Vauban began his military career aged seventeen, and received his first commission as *ingénieur du roi* (king's engineer) in 1655. Louis XIV personally noted Vauban's courage and ingenuity in the conduct of the sieges of Douai, Tournai and Lille (1667), and his intellectual brilliance, diversity of interests, potent energy, and above all his inventiveness in the matter of defensive masonry consolidated a career of remarkable achievement. He advised the king more broadly on the defence of France's borders and his extensive work in the Alps alone is testimony to the confidence placed in him.

Like a number of French *savants*, as scientists were called, Vauban's intellectual curiosity encompassed a range of disciplines: agriculture, the rearing of farm animals, forest and canal management, the census, colonial government… Short, thickset and stocky with a truculent air, he had little grace, being described by one commentator as somewhat churlish and vulgar. Confident, perhaps, in the king's high opinion of him, Vauban was not averse to speaking his mind with the forthright manner of a man who deals in practicality. His treatise criticizing the king's levy of taxes – printed without the necessary royal imprimatur – was condemned, albeit Louis XIV blocked prosecution of his master military builder. He died in 1707.

Vauban demonstrated his genius in both aspects of his siege-work: building forts strong enough to resist attack, and exploiting the weakness of enemy strongholds. He could read terrain – contour, dip and rise, aspect, perspective and relative lie of ground – and take the best strategic advantage of what it offered in terms of protection from, and opening to, attack, and visibility or concealment. He devised – or adapted from a Saracen model – a system of parallel trenches for the carrying of enemy citadels, and refined the 'star fort' developed in Italy during the fifteenth century to counter the destructive force delivered by 'black' (i.e. gun–) powder: his walls were built lower and made of brick, which does not shatter and fragment, unlike stone. Brickwork was strengthened with compacted earthworks. Sloping revetments deflected the full impact of cannon fire.

An effective fortress must keep the enemy out and its own garrison safe. Starting with the core curtain wall, the girdling *enceinte* (the same word means 'pregnant'), Vauban improved and elaborated it, using a complex geometry of angles and faces, walls, projecting bastions, salients and outworks to supply maximal possibilities for denying an attacker close access while not only protecting the defenders but simultaneously allowing them to direct fire against the assaulting army from the main gun positions and enfilading (flanking) fire from the angled projections – notably arrow-shaped, projecting *demi-lunes* (solid half-moons) jutting out from the *enceinte*.

Vauban was a tireless overseer of the building works – all carried out by manual labour, picks and shovels, wheelbarrows and carts, cranes and explosives, amid the dust and smoke from the lime kilns, a racket of noise, from 5 a.m. to 7 p.m. with breaks totalling three hours. 'Remember,' growled Vauban, 'Vitruvius [the Roman writer on architecture] said that the best mortar needs to be doused in sweat.' He also instituted recruitment and training of military engineers and founded an Engineers Corps.

> *The Alpine Apothecary*
> Yet mark'd I where the bolt of Cupid fell:
> It fell upon a little western flower,
> Before milk-white, now purple with love's wound
> And maidens call it 'love-in-idleness'.
> Fetch me that flower, the herb I show'd thee once.
> The juice of it, on sleeping eyelids laid,
> Will make or man or woman madly dote
> Upon the next live creature that it sees.
> Shakespeare, *A Midsummer Night's Dream*, II. i

Prompted by a jocular encounter with a man picking arnica flowers on the eastern flank of the Galibier, I include here a short discourse on what used to be called 'simples' – natural remedies from the juice or leaves of plants. The remedies came variously as pills, oils, syrups, juleps, decoctions, ointments, plasters, poultices, electuaries (a medicinal conserve or paste consisting of a powder or other

ingredient mixed with honey, preserve or syrup of some kind),
lohochs (linctus, from the Arab word for 'to lick'), and trochisks
(flat, round, medicated pastilles or lozenges).

Oberon's love philtre 'love-in-idleness', namely *Viola tricolor*,
was better known as heartsease, but more generally as the pansy
(a fanciful application of the French *pensée*, 'thought', because the
flower vaguely resembles a pensive visage, puckered in mental
effort). Its other popular names – 'kiss-me-at-the-garden-gate', 'three
faces under a hood', etc. – link the flowers, which bloom in spring,
to the traditional start of the courting season. A filter of pansies in
a baby's bottle cleared phlegm, and of heartsease, the celebrated,
if occasionally unreliable, astrologer-physician Nicholas Culpeper
(1616–1654) says that 'the syrup of the herb [i.e. leaf] and flowers
is an excellent cure for the venereal disease… convulsions in
children… a remedy for falling sickness [epilepsy], inflammations
of the lungs and breasts' and so on. By 'venereal disease' he may have
meant lustful urges or more specifically what the English called the
French pox, and the French called the English disease.

The seeking out of remedies in the plants of hedgerow, field,
woodland glade, high pasture, riverbank and meadow was, for
centuries, vital to the basic pharmacopoeia of country communities.
Physicians rarely strayed far beyond towns, and when they did their
fees were prohibitive to the rustic poor. It was left to proto-botanists
and plant experts, very often women, to supply simple remedies.
The word 'simples' refers to medicines derived from a single plant.
The women who practised simple medicine were often vilified as
witches and punished in consequence. Their secret lore, mistrusted
by church authorities quick to ascribe it to pacts with the Devil,
ranked with the most sinister interpretation that could be put on old
wives' tales: unacknowledged by medical texts, akin to black magic,
work of the Devil, heterodox. Indeed, in 1587, Thomas Erastus, a
Swiss physician, published a book *Repetitio disputationis de Lamiis
seu strigibus* (A repetition of the dispute about lamiae or screech
owls), in which he wrote: 'For the devil would not have done many
evil things had it not been for the provocation of witches.' (A lamia
was a sorceress who was reckoned to suck the blood of children, and

owls, especially the extremely shrieky screech owl, had long been associated with bad things of the night.) A doctor was revered, often misguidedly, as a learned man who had studied medicine almost as a branch of theology. An illiterate woman in a hovel, brewing potions in a cauldron, had more than a faint whiff of sulphur about her, even if her remedies worked and the approved cures did not. Nevertheless, the herbal remedy was, for a long time, all that most country dwellers could afford or look to. The cheery scrumper I talked to on the Galibier knew well how efficacious arnica is for bruises and strains.

In his informative and entertaining book, *Les Mots pour dire Savoie*, the Savoyard Jean-Marie Jeudy recalls how his grandmother steeped arnica flowers in a bottle of eau-de-vie, i.e. brandy or other ardent spirits. Jeudy speaks also of childhood recollection – the leaves of the elder used as a poultice for fractures, marigold flowers as the base of an ointment to form scars on open wounds. Bad colds and chills were treated with a tisane (infusion) of violet, poppy, pansy and coltsfoot (whose French name, *tussilage*, echoes *tusser*, 'to cough'). To soothe sore throats and coughs, children were given a root of fern, bittersweet in taste, to suck, like a stick of liquorice. His mother made a jam of eglantine berries, rich in vitamin C, to ease an upset stomach. The writer Colette, born in Burgundy, reports the same. The eglantine had the official name of dog rose or sweetbriar; the vulgar name, 'scratch-arse', from its prickles that scorch the picking hands (or bottom when leaning down). To the conserve made of sweetbriar might be added barberries and compote of apples to soften a somewhat sharp taste. Women used an infusion of mugwort (wormwood – *Artemisia vulgaris*) to alleviate period pains and, to stem diarrhoea, a decoction of wild thyme from the mountain slopes. Myrtle berries enhanced vision at night, burdock was good for skin complaints, the leaves of the box are imbued with a powerful disinfectant, effective against acne, while a suffusion in wine of herb bennet, the mountain geum or avens, was given to cows bitten by a viper. In England, herb bennet also lent a clover-like flavour to ale. Abscesses were treated with a poultice of Saint-Fiacre's herb, the great mullein or Aaron's rod. Saint Fiacre, a celebrated layer-on of healing hands, was Irish but better known in France, where he founded a hospice for travellers.

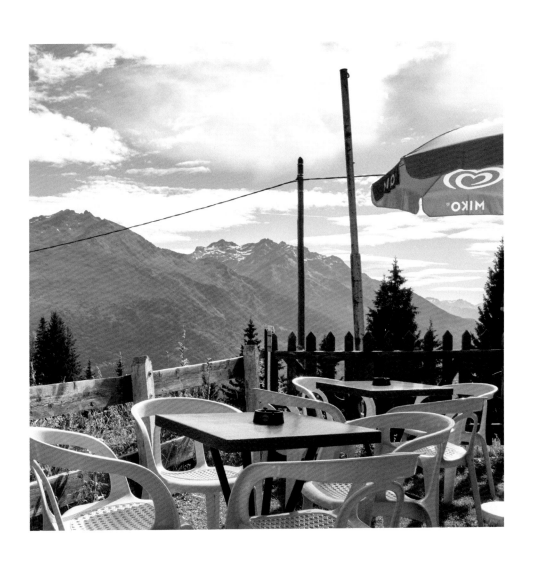

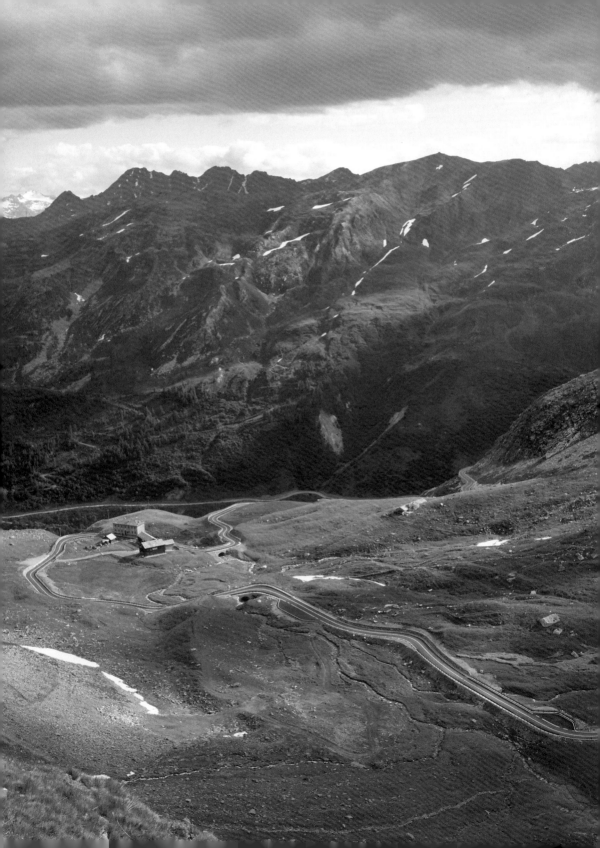

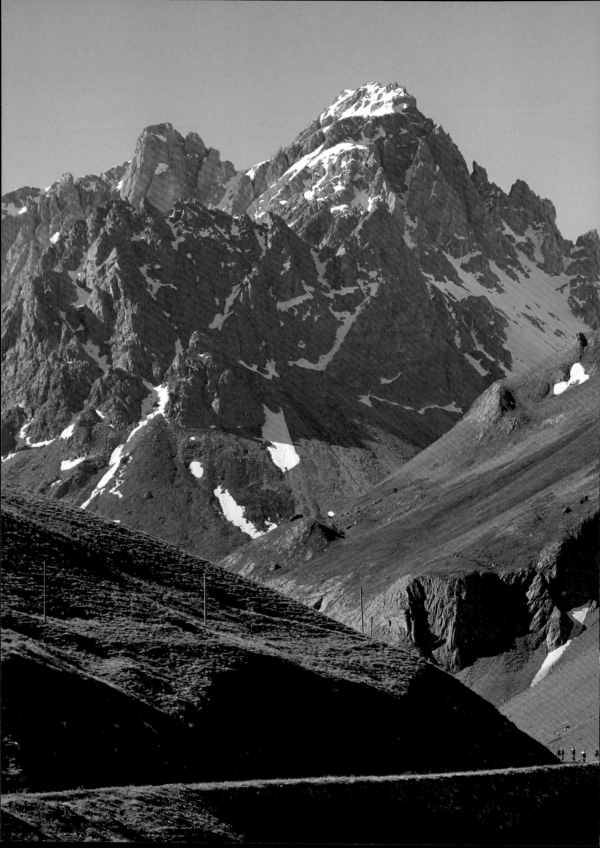

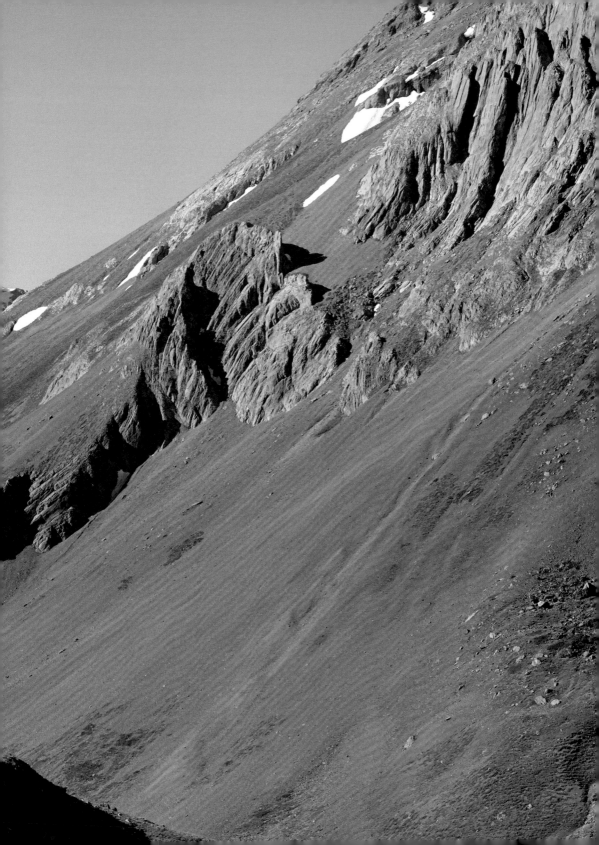

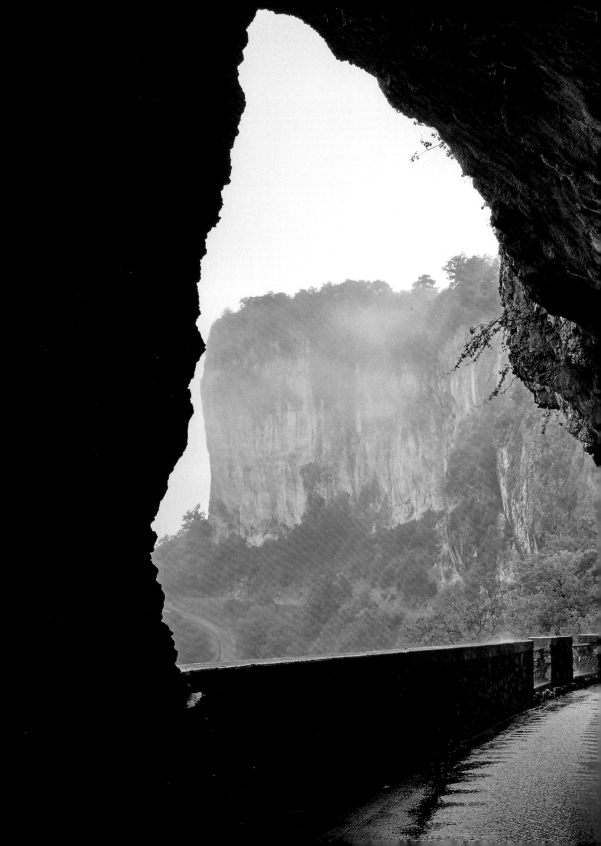

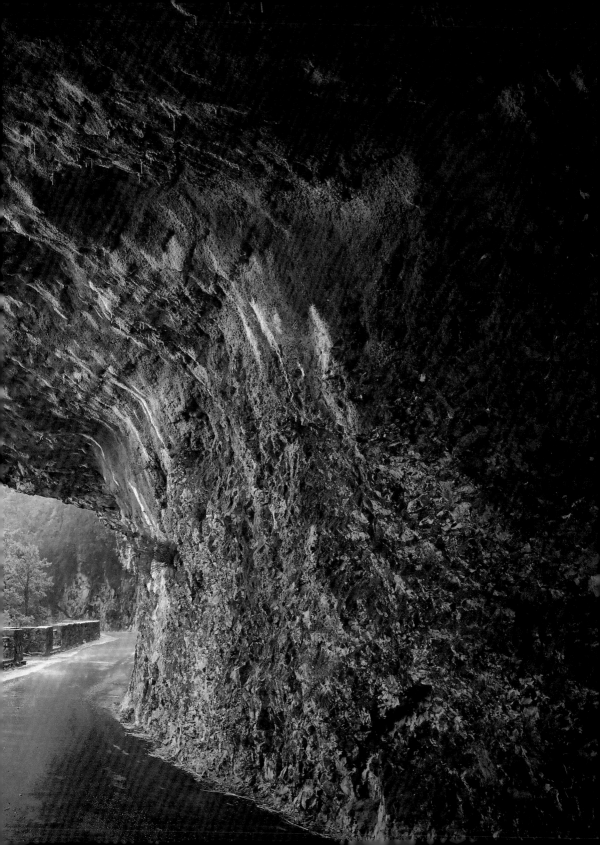

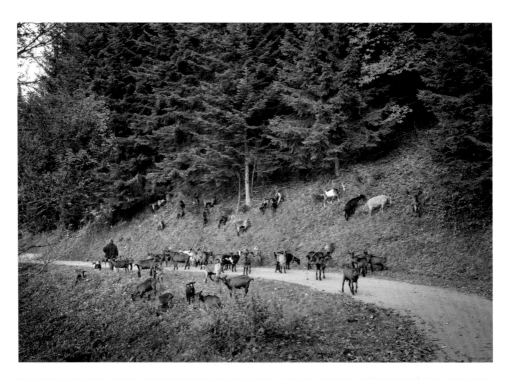

In 1897 a doctor from Chambéry, Alfred Chabert, in the course of compiling a study of plants used in medicine, made a field trip in the mountains. He begged lodging overnight in a chalet and made the mistake of telling his hosts what he was about. That evening the woman of the house produced a sheaf of plants, each endowed with particular healing virtue: *génépi*, puffball, allium (onion)… The doctor duly identified them, with Latin names, of course, but had no understanding of their remedial properties. They laughed. 'Call yourself a doctor?' The powdered spores of the puffball are used as a styptic on cuts and the *génépi* is hailed among mountain people as a panacea, a magic remedy. This is undoubtedly because the *génépi* is most commonly used as a flavouring agent for spirits, most beneficial in the assuaging of coughs, colds and sinking morale. The *génépi*, a Savoyard word for the alpine yarrow or wormwood flower, grows in fissures of rock and in the moraine between glaciers between 2300m and 3800m and has three varieties: *Artemisia spicata*, the true or black génépi, *Artemisia mutellina* the white, and *Artemisia glacialis* the yellow, also known as the 'absinthe of the glaciers'. Absinthe was originally distilled from wine mixed with wormwood, making an extremely potent intoxicant declared illegal in France during the First World War. Soldiers got drunk, and worse, on it. Browsing in an antique shop in Collioure one day, I lit on a number of rather battered flat-ended, perforated aluminium spoons. I asked the shop owner what they were. He shook his head. '*Interdit.*' (Illegal.) I pressed him. He explained, reluctantly, that they would have been heaped with sugar and placed over an empty glass to filter a stream of pure absinthe, to sweeten the bitter-as-gall, fiery alcohol.

Chabert noted the proven worth of *génépi* against typhoid and scarlet fevers, severe toothache or a difficult labour. He added a footnote on the pragmatic reaction of those in attendance: if the patient got better, no one could doubt that the remedy was sound, one had but to have faith. If the patient fared ill, the dose had not been of the right proportion or the plant had been picked too late. Gentian is another plant that can thrive at dizzy altitude and now provides the base of an aperitif, but it was prescribed by the first-century Greek doctor Dioscorides against stomach ache and liver

pain. In the sixteenth century it was employed variously as a diuretic, a febrifuge (to fight fevers) and to evacuate intestinal worms. Naturally the French claim mighty digestive powers for the aperitif and call gentian the poor man's quinine, or more colourfully *lève-toi et marche* (stand up and walk).

Not medicinal but very useful, the *linaigrette* (cotton-grass) lives in damp, or flint and sandy soil. Its flowers form soft tufts of fibre like cotton balls and were commonly used to stuff cushions. Hence the plant's nickname, 'poor man's pillow'.

To lavender, sage, pulsatilla, fennel, digitalis, lily of the valley, aconite and many other plants of the mountain slopes and valleys are attributed a range of medicinal properties. Sphagnum (bog) moss has long been known as an ideal dressing for wounds, and in the First World War, when combined with the highly antiseptic raw juice of garlic diluted in water, it saved many lives by arresting putrefaction. Deadly nightshade of the potato family is known as belladonna, 'beautiful woman', because a small dose of the juice of its berry dilates the pupils of the eye, delivering an intense, swimmy gaze, a venerean strabismus, a seductive squint, for which the goddess Hera was known. This was reckoned to indicate a woman's sexual readiness. The toxicity of belladonna is widely exaggerated, although Culpeper does warn against imbibing its juice. A poultice of its leaves and root, however, is effective against swellings, and 'an ointment made of the juice evaporated to the consistency of an extract does wonders in old sharp ulcers, even of a cancerous nature'.

The vulnerary *Hypericum nummularium*, a species of Saint John's wort which emits a strong scent of coumarin, like that of fresh-mown hay, cures lesions, as its name implies (Latin *vulnus* – a wound). It also flavours brandy and fruitous spirits, is recommended against melancholy and even madness, and possibly finds its way into the secret recipe for the famous liqueur distilled by the monks of the Chartreuse. In France, picking it is expressly forbidden, by state and church alike. I was once prescribed homeopathic pills derived from the plant, coupled with others derived from rattlesnake venom, as a cure for hay fever. This was psychologically interesting – no placebo man, I – but remedially ineffectual, alas. Chartreuse liqueur and the

various *digestif* drinks based on *génépi*, on the other hand … they may not cure but they can make you feel *so* much better.

> *Roads*
> Brook and road
> Were fellow-travellers in this gloomy Pass…
> > William Wordsworth, *The Simplon Pass*

Roads began, as do all journeys, with a step, an individual setting his or her foot on the solid ground with an intention to go somewhere, to explore, to move from start to destination, known or unknown, impelled by curiosity, need, whim or inner prompting. The faintest vestige of that first track in open country, through woodland, over hill, down dale, by riverside, up and over a hill or mountain, led those who followed along the same path, step by step. And more steps and more steps thereafter. From the trace of those leading steps, the established path of the multitudes that came, year upon year. And in the long process of confirming a route, given that no one purposely seeks to make a journey longer or more difficult than it needs to be – 'travel' was originally synonymous with 'travail' – the ability to read terrain is paramount, most especially in the crossing of mountains, where the shrewdness of eye can subdue gradient by circuit or meander. And often, where water flowed, men went, too. Generally, roads were built on existing tracks beaten long before the engineers arrived.

EARLY TECHNOLOGY

Before the Romans, who are justifiably lauded as innovative road-builders, the Persians laid a vast network of roads covering their empire, roads along which an express service of imperial couriers famously galloped from staging post to staging post for change of fresh horses, centuries before the legendary Pony Express. However, the Romans were the great pioneers of highway construction. Their legions made the roads as they marched to conquest or repression of revolt and, although not every mile of the latticework of their *viae* displayed the same high level of construction, for want of time or

materials to hand, the basic technology deployed was remarkable. (Once territory had been pacified, more roads could be built and existing routes improved by the deployment of slave labour, for the shifting of earth and the humping of materials at least.) The oldest, the Via Appia, 'queen of the long roads', eventually linking Rome with Brindisi (a distance over 500km), began with a 212km stretch between Rome and Capua, in 312 BC. It was the first of what eventually became a diffuse grid of highways linking every corner of the Imperium Romanum: north to Caledonia, west to Lusitania, south to Aegyptus, east to the shore of the Mare Caspium. For over three centuries all roads did, assuredly, lead to Rome. An anonymous medieval writer put it thus: *Mille viae ducunt homines per saecula Romam* (a thousand roads lead men to Rome through all time), and in his *Treatise on the Astrolabe* (late fourteenth century) the English poet Geoffrey Chaucer writes: 'Right as diverse pathes leden the folk the righte wey to Rome'.

Surveyors traced the course of the road and two parallel trenches were dug to mark its width, usually around 4m. Loose earth between the trenches was removed to expose a solid foundation for the body of the road that consisted of four layers to an overall thickness of about a metre: at the bottom, two or three courses of flat stones or, if they were not to hand, of other stones laid in mortar; on top of this rubble, masonry or smaller stones or coarse concrete; next a layer of finer concrete, on which was laid the pavement of polygonal blocks of hard stone neatly jointed. The base layer might be dispensed with if there was rock below the soil, and paving with dressed stones might be replaced by pebbles or flints set in mortar or else clay or marl, even hard gravel or cobbles, always depending on the availability of materials. The profile of the road formed a shallow curve to aid drainage, and the edges were lined with raised stone. Roman roads were cut straight – that being the shortest distance between points – although there's a stretch of road across the North Yorkshire moors, inland from Whitby, heading towards York in a crazy serpentine wriggle. An enigma.

A marching legion, around 5,000 men strong, could survey and lay a mile of paved road – foundations, infill of broken rock

and stone, drainage gutters and smooth top layer of broader flags –
in a single day, and then build a fortified camp.

## THE FRENCH ROYAL ROAD

Closer supervision of the French road system was initiated in the
early seventeenth century under Henri IV. The *chemins royaux* were
widened by 7.3m to fully 22m, avenues of trees were planted along
them and so on. Crosses, marker posts or pyramids were erected at
all junctions. But a report on the condition of the roads in and around
Soissons in 1686 says: 'The roads which ought to be straight, wide,
solid, usable and maintained by seigneurs exacting tolls or by the
inhabitants of neighbouring parishes… are almost all curvy, twisting,
full of holes, mud and slush, heaps of stones and, as a consequence,
extremely hazardous.' There is no reason to suppose that Soissons
was unique. Progress in the repair of the highways had to wait for
the creation of the office of Ponts et Chaussées (bridges and roads)
in the mid-eighteenth century. Since the roads were ill–constructed,
poorly maintained, subject to vicissitudes of weather, flood, frost
and sun and constantly battered by carts, carriages, heavy wagons,
horses, mules, armies and post vehicles, as well as the constant flow
of pedestrian traffic – all answering to the basic imperatives of travel,
moving merchandise and administering justice – their persistent
ruin, if not collapse, was inevitable. The more fertile and arable the
soil, the more prone were its roads to quagmire. Chalky regions had
road surfaces that were pulverized into white dust. Granite rendered
highways of hard rubble like a horizontal scree. In some areas, the
only remotely serviceable roads were the surviving Roman *viae*.

The *corvée*, 'forced labour', instituted under Louis XIV, obliged
those who lived in country villages, and only them, to work,
unpaid, for between six and thirty (sometimes even forty) days
every year on the construction or the maintenance of the principal
highways designated the 'royal roads'. The royal *corvée* ceased
during the Revolution but local *corvées* persisted, according to need.
Notwithstanding, the great roads of France might look in good repair
for a brief spell but, ill–constructed in the first place and shoddily
managed, they soon reverted to tracts of stone-littered mud.

# Traders were criss-crossing the alpine barrier long before the advent of anything like roads.

## PIERRE-MARIE-JÉRÔME TRÉSAGUET

Pierre-Marie-Jérôme Trésaguet, a civil engineer born in 1716, pioneered the use of a foundation layer overlaid with smaller stone to create a strong pavement. This more solid construction not only held up under the compressive force of the wheels of carts but was actually improved by being pounded into a tighter unity, while the upper surface carried wheeled and hoofed traffic more readily. Trésaguet refined this method further. Perhaps on the Roman model, he excavated a wide trench to a depth of around 25cm and laid large stones on edge, trimmed to present an even surface and to carry a second course of smaller, rounded stones. The top layer, convex in profile, was formed of broken stone rammed down.

In 1775 Trésaguet was appointed Inspector General of Roads and Bridges and his form of road structure was used until about 1820, when France adopted the cheaper process invented by the Scotsman John Loudun McAdam. A fellow Scot, Thomas Telford, had already improved the method, but by expensive use of pitched stones laid as in brickwork. McAdam simplified. He eschewed the heavy stone foundation, believing that native earth would serve as well. He also restricted the size of the stones to be used for two layers – stones broken by men with hammers, 75mm for the bottom, 20mm for the top. Metal carriage tyres were 100mm in width and could crunch down the stones to form an impacted, unshifting surface of a road 9.1m wide with a camber of no more than 7.5cm from edge to centre to allow for drainage.

## Transit of the Alps

Traders were criss-crossing the alpine barrier long before the advent of anything like roads. They followed tracks barely wide enough for a man and a donkey, the inveterate footpaths, the natural ledges and runs fashioned by animals roaming the upland forests and pastures. High and inhospitable as the mountain crossings were, they did, at least, have the advantage of following these ancient tracks on solid ground. These might be widened and cleared by manual labour and, although no transition of an alpine pass could ever be less than inherently perilous, custom and roads improved by use eased the journey.

In 1670, a Piedmontese architect in the employ of the Elector of Brandenburg designed a horse-drawn, four-wheeled carriage for four passengers, with a hooded compartment, separate from the front axle frame, the rear portion connected to the fore by two perches (central poles), with thorough brace suspension, i.e. a pair of strong leather bands, or braces, connecting the front and back C-springs and supporting the body of the coach. The new vehicle, named a 'Berlin' for the capital city of Brandenburg, made travel over long distances faster, marginally more comfortable and, because it was more stable and less inclined to tip over, safer. It quickly replaced what had been the most amenable form of alpine transport hitherto, the two-wheeled chair, and fostered the establishment of regular coach itineraries.

The public stage coach – the stages referred to the intermediate stopping points on the overall journey – was known in French and subsequently English as the diligence, from the secondary meaning of that word: 1. Constant and earnest effort to accomplish what is undertaken; 2. Speed, dispatch, haste.

In 1756, Thomas Nugent, writing up his Grand Tour, said: 'The Diligence is a kind of stage coach so called from its expedition [speed], and differs from the *carosse*, or ordinary stage coach, in little else but in moving with greater velocity.' The carosse, unequal-sized wheels front and rear, a single perch, originally uncovered, was principally a town coach.

A fine painting by Rudolf Koller shows the Gothard diligence in 1874 pounding along a hard-packed earthen road at full gas, four

main horses with one on a looser rein to act as leader, all blinkered, the driver high on his bench plying the traces, a full cargo of baggage under a billowing tarpaulin on the roof behind him, a startled heifer in the road ahead straining to get out of the way.

## Resistance and Liberation

On 14 June 1940, after the humiliation of a surrender signed in the carriage near Compiègne where the armistice was signed in 1918, the German army entered Paris and paraded in arrogant triumph down the Champs Elysées. Charles de Gaulle, provisionally made General during the brief spell of combat in Belgium, had escaped to London. He was keen to reassure his countrymen that they had no good cause to give up. The French had not been outnumbered. Not only were they possessed of as many tanks as the Germans, but their own light tank was superior to its German equivalent. This was wishful thinking. The speed, force and surprise of the German advance, supported by large numbers of Junkers Ju 87s, 'Stuka' dive bombers, had proved unstoppable.

In his celebrated call to the French people to take up arms, broadcast on radio by the BBC, de Gaulle, having assumed the mantle of leader of what became formalized as *France libre* and *Forces françaises libres* (Free France and Free French Forces), a government in exile opposed to the collaborationist government in Vichy, declared that hostilities were still on. He described the war as a world war, no longer confined to France, and concluded his speech: *Quoiqu'il arrive, la flamme de la résistance française ne doit pas s'éteindre et ne s'éteindra pas.* (Whatever happens, the flame of French resistance must not be extinguished and will not be extinguished.)

There is no space here to recount the evolution of the Resistance movement in France, from tentative, localized action to the fully coordinated effort of the FFI, *Forces Françaises de l'Intérieure* (French Forces of the Interior), and the smaller, civilian groups and cells based in towns, villages and the remoter countryside, but the first conspicuous, and successful, retaliatory blows against the Nazi occupiers were delivered in the Haute-Savoie *département*. The people of the Dauphiné region, which included Haute-Savoie,

had always considered themselves separate from greater France, cleaving to the spirit, if not the fact, of their ancient autonomy, nor, in common with many other areas far distant from Paris, did they take kindly to peremptory mandates issuing from the capital. In their view, the Jacobin decrees promulgated by the French revolutionary government in Paris were quite as hateful as those of the royal despotism which it professed – speciously – to have replaced with liberty and brotherhood. One tyranny succeeded another. And now came Vichy, Gestapo, Wehrmacht, Nazi, Milice (the detested military collaborationist police), another pack of odious outsiders.

In the winter of 1943–1944, the resistance set up a training school for Maquis leaders in the village of Manigod, near Thônes, not far from Lake Annecy (see Col de la Croix–Fry, *Annecy*). The Maquis were named for the scrub vegetation, often impenetrable, common in the arid uplands of Corsica, an island long notorious as a hotbed of brigandage and outlawry.

The people of Haute-Savoie were once more on the move against their oppressors. Towards the end of January, what we may call the first regiment of the AS (*une Armée Secrète*, secret army) moved into position on the Glières plateau, north of Thônes, ready to fight. Men and teenagers from surrounding villages, supplied by friends and neighbours, men and women, climbed up to the windswept, rocky table through deep snow. They set up camps in the mountain wilds and prepared for action.

GLIÈRES

In those first months of 1944, the once–scattered underground resistance across France itself was growing and becoming more coherent, even as the Free French, commanded by de Gaulle in England, were preparing for the invasion. At the beginning of May, the Chief of the Resistance in Savoie sent a dispatch to all the mayors in the region. The Germans, he said, were bent on the destruction of France, 'to erase it from the world map' by the same barbaric means that they had used in their retreat in 1918, 'having pillaged the country of its wealth to destroy it with fire and explosives'. He continued: 'The troops of the RESISTANCE have determined to

prevent the Germanic hordes from realising this Machiavellian design. Therefore, we need men capable of taking up arms in every village to form up in military groups for the defence of their homes… Time is short. The future of your village and its children, of your province, and of FRANCE is at stake.'

As the Maquis gained in strength and solidity, the *départements* of Savoie, the Ain and Dauphiné-Isère were classified by the German command in Grenoble as 'regions of great unrest', and Haute-Savoie as 'one of the most active of insecure areas in France'. The Allies corroborated this opinion by setting up airborne drops of arms, ammunition and supplies on high flat ground across the region. The men on the Glières were told that there would be such a drop to reinforce them. They waited. The drop was delayed by continuing adverse weather conditions. On 20 February, their commander, Tom Morel of the 27th Chasseurs Alpins, gathered them together round the French tricolour flag to swear the oath that became a watchword for the mobilized Forces Françaises de l'Intérieure: *Vivre libre ou mourir*, live free or die.

The local Milice commander, concerned to not lose face with the Germans, earmarked the 'nest of terrorists' on the Glières for eradication. That they were there must have been widely known. For six weeks, attempts by the Vichy police to encircle the plateau and hunt down any other maquisards in the valley proved futile. The Glières men pushed them back again and again, and both sides finally agreed a truce of mutual neutrality. The Milice reneged and took five maquisards prisoner. Morel hit back. On 9 March, he and 150 of his men surrounded the *miliciens* in the village of Entremont, on the eastern slope of the plateau, and took sixty prisoners. Morel was shot dead, in the back. The following day the drop of arms finally arrived.

The decision to maintain position on the plateau and to replace guerrilla operations with bold confrontation was made at an undercover meeting of local AS commanders in Annecy in mid-March, prompted by a need to convince London that the Resistance was doing more than talking a good fight. They needed to prove they were a force against which the Germans would be obliged to deploy large resources of men and *matériel*. In strategic terms, the decision

to hold the Glières plateau was sound: it would tie the Germans down, if temporarily. Tactically, however, it was folly – the French were vastly outnumbered and outgunned. But French forces would engage the enemy on native soil for the first time since 1940, not only confirming the FFI's courage and resolution but inspiring the wider resistance.

The German command named the campaign designed to subdue the region *Frühling* (spring). On 23 March, five infantry battalions of the 157th alpine division of the Wehrmacht moved into position at the foot of the Glières plateau held by the remaining 456 men of the FFI. The *Gebirgsjäger* were backed by detachments of the Milice and, more significantly, two battalions of the fanatical SS, and deployed a formidable array of weaponry: heavy machine guns, one battery of 75mm mountain (i.e. light) artillery, 80mm mortars, two batteries of 150mm heavy artillery, anti-aircraft guns, armoured cars; all supported, what's more, by several wings of the Luftwaffe. The full might of this ordnance pounded the plateau for ten days, and then the infantry, 12,000 strong, moved in. The fighting lasted for a further eleven days before the new FFI commander, Captain Anjot, ordered the survivors to withdraw.

Four hundred Germans had been killed and 300 wounded. The French lost 100 killed in the action and a further sixty on the precarious descent down the precipitous hillside. Those who made it down scattered. Reprisals followed. Men were hunted down, rounded up from the villages and shot. One of those executed, an eighteen-year-old lad from the village of Môle, had been gravely wounded during the fighting, captured and left untended in a cell in the Thônes school, requisitioned by the Gestapo in 1943, for interrogation. His stubborn refusal to divulge information about his fellow *résistants* was typical of the men saluted in a memorial speech to the dead of Glières by André Malraux, himself a decorated *résistant*: 'This No spoken by the obscure maquisard joined to the earth by the first night of his death is enough to make of this poor boy the companion of Joan of Arc and Antigone. The slave always says Yes.' (The speech was given on 2 September 1973 at the inauguration of the memorial to the Resistance on the plateau.)

The Gestapo based in the Thônes school interrogated, tortured, shot or deported 232 people all told – few returned from the camps – and on 19 August 1944 an ossuary was found under the courtyard of the school, the common grave of their victims.

But the men of Glières were not finished. Despite a swingeing campaign of reprisal by the Milice, the Maquis reoccupied the plateau, received a huge consignment of arms and ammunition by parachute on 1 August and, in fierce fighting between 15 and 19 August, forced the surrender of all the German garrisons in the département.

## VERCORS

The Frühling campaign continued in the Bauges massif and Mont Revard, to the east of Aix-les-Bains. On the eve of the June landings in Normandy, the Savoyard Resistance heard de Gaulle's broadcast on the BBC containing the coded message for the FFI to go into action – *Le chamois des alpes bondit* (the alpine chamois leaps forward) – and activated their *Plan Vert*, Green Plan. The young men of the secret army regrouped on Mont Revard and were attacked on the night of 10 June by three battalions of the Wehrmacht, in driving rain. Thirty *résistants* died. The 157th German division now attacked the Bauges in full force, thinking that they faced 1,200 fighters. In fact, there were only 150 but they fought gallantly and held out for an improbably long time until they were overrun.

Jean Moulin, as head of the *Mouvements Unis de la Résistance* (MUR), and de Gaulle had approved a plan drawn up by the military commanders in Savoie, *le Plan Montagnard*, to transform the Vercors plateau into a sort of Trojan horse. As soon as the Allies had landed, in Normandy and the Mediterranean littoral, the Vercors AS would cut German supply lines all along the valleys of the Isère and the Rhône. The maquisards would also act as guides and military support to the advance guard of the Allied forces from the north and the south.

But the English and Americans engaged in Normandy could spare no troops or heavy equipment, and the southern landings didn't come until mid-August. As a result, the men of the Vercors

were unsupported and woefully ill–equipped when the Wehrmacht moved in on 14 July. A month earlier, the Resistance commander François Huet had written that, despite the promise of arms, 'we have received no weapons apart from a miserable drop on 7 June from which we recovered one machine gun, eleven rifles, twenty-two submachine guns, 110 grenades, eighty pairs of shoes'. French citizen soldiers had always been short of boots. Many men in the first revolutionary armies went into battle unshod.

# The young men of the secret army regrouped on Mont Revard and were attacked on the night of 10 June by three battalions of the Wehrmacht

Since what the French called J-Jour (i.e. D-Day), 6 June, hundreds of volunteers had left their villages along the valleys to join the 500 maquisards already in position on the Vercors. At the beginning of 1942, the Maquis had established a camp in Ambel, by Lake Sautel on the eastern skirts of the Obiou peak (see Col de Mens, *Grenoble*), and from 1943 they had moved onto the Vercors. Sixty kilometres long and thirty wide with sheer cliffs on all sides, this thickly wooded limestone plateau is a remote, impoverished place, one of the least inhabited, most inaccessible regions of France; a natural fortress, but potentially a trap from which there was no escape. Huet was, understandably, nervous.

By the end of June, the *résistants* numbered some 4,000. They were living in bivouacs, foresters' cabins and huts, and were supplied with food by local Resistance groups and friendly locals. They had already encountered the Germans in a number of clashes below the plateau. On 21 June at dawn, for instance, ten volunteers of the Villard-de-Lans company guarding the tight defile of the Ecouges sector were attacked by an infantry column with artillery support. It took them eleven hours to drive the Germans back.

On 3 July, in the Hôtel Breyton, now defunct, in Saint-Martin-en-Vercors, headquarters of the Resistance in the Vercors, the FFI declared the restoration of the French Republic and abolished all decrees passed by the Vichy government. This had very little active effect. It was, though, a cogent indication of how resolved they were to fight.

On Bastille Day, Wehrmacht General Karl Pflaum ordered a first probing attack. It was summarily repulsed. A week later, Pflaum unleashed a massive assault with 15,000 German troops, the largest force any maquisard group ever faced. They came up by the narrow roads and the forest tracks, and along escarpments passable only on foot. Glider and airborne troops landed on the flat land which the Maquis had cleared for the Allies around the village of Vassieux. For nine days in late April, the Milice had ransacked Vassieux to intimidate neighbouring villagers, burning several farms and shooting or deporting a number of the inhabitants, but to no avail. Support for the Maquis in this remote mountain fastness was solid. (In recognition of the gallantry shown by the people of the village, Vassieux was later awarded the Order of Liberation, second only in standing to the *Légion d'Honneur*.)

On 22 July, the Germans advanced through the woods on a forest track south out of Villard-de-Lans towards the village of Valchevrière, a maquisard base, in a steep clearing of pastureland. The hundred men defending it, under Lieutenant Chabal, ambushed the Germans and held out all day, but were overwhelmed and annihilated the next morning. The Germans burnt the village to the ground with phosphorus grenades. Only the chapel survived, and it remains, today, the single trace of what happened there, *in memoriam*. The heroic defence had little purpose but to delay the German advance a few hours. Yet the irritant value on battle-hardened troops of these last-ditch encounters with determined freedom fighters is not to be discounted.

On the third and last day of fighting, a Luftwaffe squadron bombed and strafed Vassieux. Transport planes landed and disgorged a platoon of paratroopers and Russian and Ukrainian members of the *Ostlegionen* (eastern legions), to mop up.

In the bitter fighting on the Vercors, the Maquis were hopelessly outnumbered and outgunned. Subjected to furious assault on the ground and bombardment with high explosives from the air, they lost 630 dead, the Germans 160 and an unknown number wounded. More than 200 of the civilians who had been rounded up and thrown into gaol died in atrocious conditions. Forty-one were deported, 573 houses were burnt down. Exemplary reprisal followed: sixteen youths shot in La Chapelle-en-Vercors; in a grotto being used as a temporary hospital the Germans killed the wounded, deported seven nurses and took the doctors to Grenoble, where they were shot.

Tragic as the crushing of the Vercors was, a sizeable German force had been deployed to encircle 4,000 maquisards. Even so, 3,270 managed to escape. Perhaps it is invidious to single them out, but the Glières and the Vercors stand, today, as high points of the Resistance, symbols of a France resurgent from the misery of occupation. (For the eventual liberation of Savoy, see the introduction to *Annecy*.)

On 25 January 1944 a meeting of leaders of the Mouvement de Libération Nationale (MLN) at Méaudre in the Vercors had floated the idea of producing a newspaper for Grenoble and the alpine region to be called *Le Dauphiné Libéré*. When Grenoble was liberated on 22 August, the ranks of the MLN had been so weakened by deportations, imprisonment and execution that they could not produce such a journal. It wasn't until a year later that the paper finally appeared, billed as 'the free journal for free men'. This triumphant message it shared with the *Midi-Libre* (Free Midi) newspaper, based in Montpellier, which began publication in 1944, sounding a defiant blast against the Nazi occupation of France.

# THE FRENCH ALPS

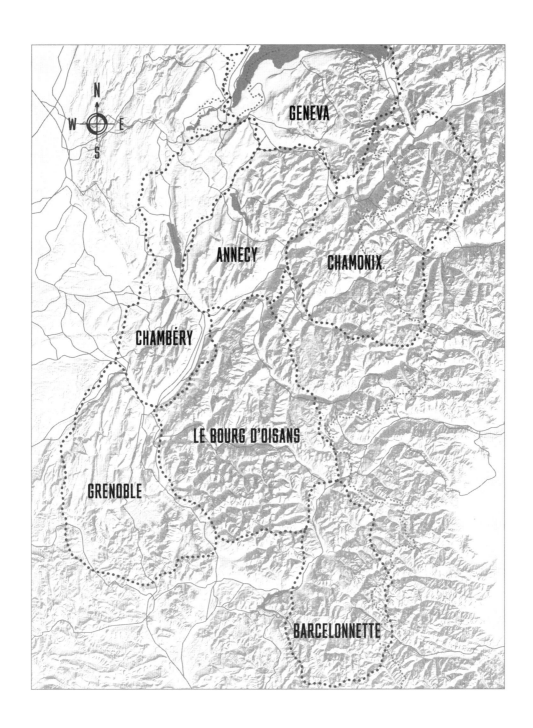

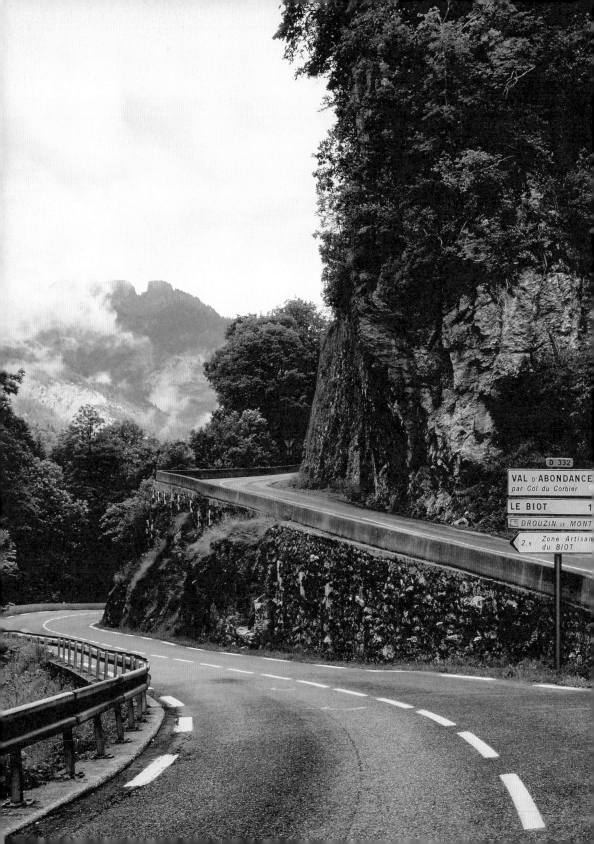

GENEVA

# GENEVA

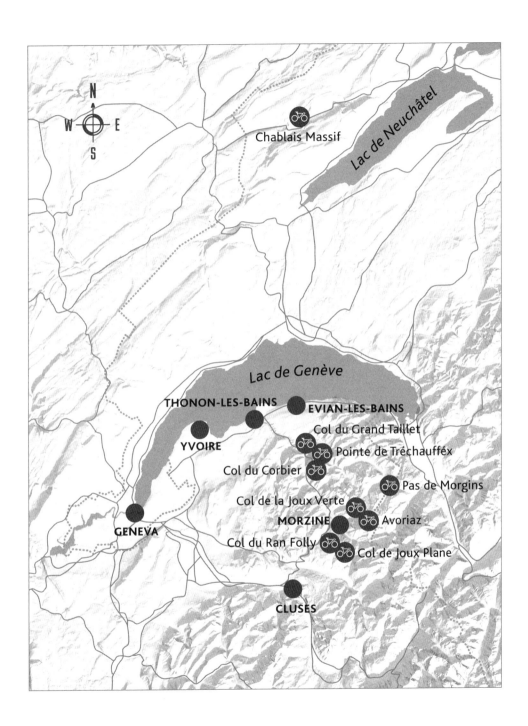

N

W ⊕ E

S

Chablais Massif

Lac de Neuchâtel

Lac de Genève

THONON-LES-BAINS • EVIAN-LES-BAINS

Col du Grand Taillet

• YVOIRE

Pointe de Tréchauffex

Col du Corbier

Pas de Morgins

Col de la Joux Verte

MORZINE • Avoriaz

• GENEVA

Col du Ran Folly

Col de Joux Plane

CLUSES

# INTRODUCTION

The lake known to the French as Lac Léman, to the Francophone Swiss citizens of Geneva as le Lac de Genève, to the Germans as Genfersee and to us as Lake Geneva, was identified by the invading Romans, Julius Caesar first of them, as Lacus Lemannus, or simply Lemannus, a primitive word meaning 'lake'. Hence we have here 'Lake Lake', just as the River Avon (Welsh *afon* is 'river') means 'River River'.

Not long after the German theologian Martin Luther posted his ninety–five theses of protest against the abuse of authority in the Roman Church in 1517 and triggered the Protestant Reformation across Europe, Geneva declared for the new theology. So affronted were a group of French Catholic noblemen that, according to Rousseau in his *Confessions*, they formed the Gentlemen of the Spoon, their professed oath 'to eat the people of Geneva with a spoon'. They wore the item of cutlery as a pendant, earnest of their intention, and made several attacks on the city, which came to nothing.

The reforming Protestant theologian Jean Calvin (1509–1564) fled Catholic persecution in France for refuge in Geneva in 1536. His extreme doctrines were not immediately congenial to the local church authorities. They booted him out, and he spent five years in Strasbourg before returning to establish an austere theocratic regime that turned Geneva into the 'Rome of the Reformation'. In diametric opposition to such ascetic self-denial, the Venetian libertine Giovanni Giacomo Casanova recounts, in his *Memoirs*, an extremely lively dinner party at the lakeside villa, Mon Repos, on his third visit to Geneva in 1762. He concludes his narrative, written, he said, to laugh at himself, so that others might laugh too: 'I can say *vixi*.' (Latin for 'I have lived'.) Casanova was, moreover, no idle, vapid fop. 'The man who seeks to educate himself,' he wrote, 'must first read and then travel in order to rectify what he has learnt.' The poet Byron, himself

not averse to sensual disport, speaks of an early visit to Geneva
during his Grand Tour:

> *Lake Leman woos me with its crystal face,*
> The mirror where the stars and mountains view
> The stillness of their aspect in each trace
> Its clear depth yields of their far height and hue
> <div align="right">(<em>Childe Harold's Pilgrimage</em>, canto III, 47)</div>

The lines refer to the majestic sweep of the view he saw from the
villa in Cologny, a north-eastern suburb about 6km from the centre
of Geneva. Close by, at the Villa Diodati in Cologny, Mary Shelley
began writing *Frankenstein* in 1816. She admits to having been
greatly influenced by the scientific reports made by the Italian Luigi
Aloisio Galvani (1737–1798) on what he called 'animal electricity' to
describe the effect of an electrical impulse on the nerves of muscles.
(Hence 'galvanism'.)

Jean-Jacques Rousseau, born in Geneva, advanced radical theories
of egalitarianism in his *Social Contract* which were direct inspiration
for the theorists of the French Revolution. 'Man is born free', he
wrote, 'and is everywhere in chains.' Such a vehement challenge to
political stability enraged the authoritarian city's councillors. On
their orders, Rousseau was first driven from the city to exile in 1762,
and then his books were burnt in front of the town hall. Two years
earlier, another tricky individual of uncomfortable ideas, Voltaire,
who had lived in Geneva since 1755, was declared persona non grata
and decamped across the border into France to set up home in the
small village of Ferney a few kilometres away, to practise what he
preached in *Candide: Il faut cultiver notre jardin* (One must cultivate
one's own garden), an admonition whose deeper implications bear
on moral responsibility. That both men lived with women to whom

Evian spring water starts as
melted snow and rain which
filters through glacial sand.
The clay surrounding the
sand protects the water
from pollution.

they were not married made them doubly unacceptable to the
strait-laced city fathers of the Calvinist, fun-free polity.

Calvin is also credited, by some, with the beginning of
watchmaking in Geneva. His outright embargo on jewellery –
mere ostentatious trumpery, baubles and trinkets – compelled the
local fine craftsmen to switch their expertise in intricate work to
the making of timepieces. The earliest mechanical clocks appeared
in Europe in around the thirteenth century but remained unreliable.
In 1602, Galileo, having observed and noted the regularity of speed
in a swinging pendulum, constructed a more accurate mechanism.
The story of Calvin's jewellers turned clock-makers may be true,
although it is just as likely that they switched to the making of
scientific instruments, a craft which also demanded the use of the
sort of precision tools with which they were adept.

The French southern shore of the lake is dotted with resorts,
some relatively small. Yvoire, a medieval walled village, now a
celebrated *ville fleurie* (town of flowers), is a good place for eating

fish. Excenevex (pronounced *Ay-tschner-vay*) consists of little more than the lakeside Hôtel de la Plage, an old establishment, somewhat faded now, but clean and nicely appointed, with a spacious and excellent terrace. Dine on the splendid terrace and take in the view of the girdling mountains in the lake applauded by Byron. The lake shelves are too shallow inshore for much of a swim here, but multiple-oared skiffs knife out from a nearby staithe. Storms break over the lake from time to time and lightning flashes across the imposing, fretted range of peaks to the east, the Rochers de Naye.

Further to the east, Thonon-les-Bains and the once-fortified Evian-les-Bains, 'the pearl of Lake Geneva', are grander and more reputed. A gentleman from the Auvergne came to Evian in 1789 and, after drinking ample draughts of the local water, found that the kidney stone that had been giving him such trouble must be dissolving, because he was no longer in pain. He concluded that this was due to the water. Evian spring water starts as melted snow and rain which filters through glacial sand. The clay surrounding the sand protects the water from pollution. The water is very pure and low in minerals. Much used in hydrotherapy, both for drinking and bathing, Evian water is generally reckoned sovereign for kidney and digestive disorders. Thonon, ancient capital of the Chablais region, also has baths offering treatment for kidney and bladder diseases.

# CHABLAIS MASSIF

Ten cols, 108km into and round the massif from the southern, French shores of Lac Léman to Morzine.

*Note: In this section as elsewhere in the book, a number of intermediate cols are listed in sequence as part of a headed entry. Distances in the text where this occurs are calculated from the last col mentioned initially in capital letters, and are not, therefore, cumulative.*

Take the D903 from Bons-en-Chablais heading south to the Col de Saxel. A very good surface through farmland, large clumps of pale pink and blue hydrangeas flourishing below mixed wooded slopes, the road's selvedge nicely prinked, trim, neat. The woodstacks hereabouts are very fine, nay elegant, lesser school of Andy Goldsworthy. From Marclay, a good long view of Lac Léman. Curves aplenty, no great gradient, a pleasant ride, and we pass a cyclist going smoothly, the well-chosen gears bestowing that generosity which comes with regular slopes. The col is undistinguished, no more than a slight rise and dip, a bare tumescence. The minor D50 off to the right weaves sinuously up through woodland to the Massif des Voirons and a viewpoint, the Grand Signal. After 14.4km there is a dead end at the very top, the site of a monastery. A café stands by the col.

The descent towards Saxel (at 0.5km) and Boëge (735m, 4.9km) is smooth, less curvy, less shaded, through cultivated farmland. In Boëge, a defunct bike and *moto* sale and repair shop, evidence of farm machinery, barns and working yards. A market on Tuesdays. Take the D22 left towards Habère-Lullin, a much-frequented road.

Villard (Savoyard for 'hamlet' and a nomenclature much used in the region) has a hotel/bar/restaurant, Les Allobroges, named for early Celtic settlers of this region. They arrived from Central Europe and their name appears to mean 'foreigners', similar to the contemptuous Welsh *saesneg* and Gaelic *sassenach* – i.e. Saxon – for the invasive English. Their territory having been annexed to Rome in 121 BC, the Allobroges prudently refused to join the general uprising of the Gauls under Vercingetorix against Caesar's occupying legions and remained, off and on, loyal to Rome.

'Les Allobroges' is the Savoy hymn, first sung at Chambéry in 1856. The refrain:

> *Allobroges vaillants! dans vos*
> *vertes campagnes*
> *Accordez-moi toujours asile et sûreté*
> *Car j'aime à respirer l'air pur de*
> *vos montagnes:*
> *Je suis la Liberté! la Liberté!*

> Valiant Allobroges, in your green fields,
> Give me shelter and safe refuge,
> For I love to breathe the pure air
> of your mountains:
> I am Liberty, Liberty.

The road becomes a long causeway with fields to either side before hitching up to climb through various small communities into the more substantial Habère-Lullin (4.5km from Boëge). Note a nineteenth-century school building with *Alt[titude] 950m* painted on its front wall. During the vicious fighting in this region in the late summer of 1944, the Germans inflicted a massacre here.

The road flattens then climbs again. Above Vernay, a café calls itself *Une Pause Ici*, 'Take a Break'. Past *Au Gai Séjour* (happy hols) a *maison d'enfants* (nursery) and a *ski du fond* (cross-country ski) centre, a view of the valley opens to the left just before the Col du Cou (1117m ) at 9 kilometres distant. (The map calls it *de* Cou.) Set back from the road, a rustic timbered restaurant offers a welcoming niche: *Arrêtons-Nous Ici*, 'Let's Stop Here'. Continue and descend through the Forêt Communale de Cervens – the small town north-west below the col. A short way down is signposted '*Mémorial de la Résistance Foges*' off to the left. Local men of the Maquis set up a headquarters in the small hamlet in the forest. They were betrayed, the French Milice besieged the place and, after a furious gun fight, set fire to the house. Some of the men inside had managed to get away, others took refuge in the cellar. They were caught and shot.

Foges comes from the Latin *fovea* (ditch), and may indicate a cave, or an animal's lair or sett. Cervens itself is from the Latin *cervinus*, 'deer-like'. In 1956 Hergé set part of the action

of his Tintin adventure, *L'Affaire Tournesol*, in the woods nearby.

From the Cou (neck) there is a good descent towards Draillant on a smooth piste and negotiable bends. A view of the lake opens out to the left. Near the bottom of this D12, at around 8km from the Cou, turn right on the D246 for the climb to the Col des Moises (1123m).

Woodland, some quite steep sections, out into the open at Sur-le-Mont. Fields and, a little way beyond, what seems to be the main cluster of the village, a Grange Neuve. This was the communal granary or barn where the harvested crops were brought for threshing on the big floor. There will have been much junketing for the erection of the new grange to replace the old.

The Col des Moises is open to the sky, unmarked, and the road leads straight down a kilometre or so back to the D12, jinking into some bends at the bottom as if it's slamming the brakes on at the last minute. Turn left towards Habère-Poche and left again onto the D22, by a slightly distressed building which heralds itself on a maroon signboard as *Coopérative Laitière* (Dairy Cooperative). The system of sharing resources for the treatment and trade of local produce still persists in many parts of rural France.

Two kilometres on, the Col des Arces (1164m, 1171m on the map) is marked by a small oblong metal sign, white on black. This is fairly wild country, the surface of the road

pitted and uneven, no barrier, nothing but an electric fence wire to restrain the cattle in the field off to the right. Farms and smallholdings, little sign of human life. A kilometre down into Monterrebout and then turn left at a fork to Vauverdanne. The climb suddenly gets very shirty, around 8–9% up through La Grangeaz – the Suisse Romande patois form of *grange* – past a junction left to Très le Mont (1365m). Take it, if you fancy another 7.3km of 8.5% to visit the oratory (for prayer), the *gîte* (for refreshment) and the magnificent viewpoint out towards the lake over the roofs of the ever-so-humble village, which can muster only Sur-le-Mont for title, no more than a few houses and agricultural sheds clinging to the side of the slope. At the junction, a large signboard announces *Domaine du Coteau* – a designated area of hillside. There follows a very steep and broken surface into la Plagne (signifying either *plaine*, flat land, or *platane*, a plane tree) which is higher than the col. Then on, down a slight drop, about half a kilometre to the Col du Feu (1117m), past holiday chalets – one very grand in dimension – just below the col. The col marks a crossroads with the D36. Opposite, a restaurant/boutique, *La Ferme de Paul et Mimi*, has carved on one of its window lintels 'Meynet Jean D. 1881', perhaps the original owner. From the FEU turn right down into Lullin, through the hamlet of Le Col and a Stade de Neige du Col du Feu (winter sports station), another hamlet, La Touvière, up the wall of one of whose houses grows a spectacular climbing

rose, tea pink of hue. The 3km of descent continues round hairpins and through woods into town, 850m.

Lullin's Hôtel de la Poste is a sort of hub for *randonneurs*. The owners welcome these cyclists and walkers, and there is a network of local help – up in the hills are refuges, and many of the hostelries in the surrounding district will field calls for help or a saving lift in a motor. The *patronne* was both very friendly and helpful. When I offered *fric* (cash) for payment, Madame supplied synonyms: *oseille* (sorrel), *picaillons* (Savoyard for 'small change', from the tinkling sound it makes), *blé* (corn)… Posters on the café walls announce local music evenings, mostly featuring accordion players. The doyenne of French accordionists, Yvette Horner, accompanied, in both senses, eleven Tours de France, 1952–1964. She was paid by Calor, a race sponsor, to travel in the publicity caravan on board an open-topped Citroën Traction Avant in floral dress, silk scarf and Mexican sombrero, pumping out a repertoire of French boulevardier tunes and light classics.

From a short way south of Lullin, the D22 leads to the Col de Terramont (1096m). It is a wideish road, good surface, long straights that gradually lean into gentle bends, no great gradient. Here's a cyclist out of the saddle as we go by – either over-geared or engaged in endurance training, because the slope doesn't call for such extreme effort. (As they say, if you have no hills to ride, hit a headwind on a big gear, excellent for conditioning even if it can

be a real morale-crusher.) The col sits on a low brow just above a café/restaurant, L'Auberge des Montagnes, and a junction with the D32 on the left heading towards the Col de Jambaz (1027m, 4km away). (Jambaz is French for *jambe,* meaning 'a long stretch of land', also 'the pastern of a horse'.)

The road traverses open rolling country, past chalets (the ski station of Hirmentaz lies above up a side road), and on down a wide road – near Les Mouilles, a hamlet off to the left, ski lifts supply the upper piste – to a junction with the D26 at a broad clearing and the Col de Jambaz. In both directions, the D26 is a broad ski road coursing north up from the valley through woodland towards Bellevaux, the village which gives its name to the area.

Turn right (south) down through Chaumety on a long, long straight, which makes it a cracking descent but a real slog of a wearying climb. In the hamlet of Mégevette (4.5km), the façade of a building has a painted note: 'Alt 884m'.

The road snakes into a stretch of gorge below La Culaz, whose name tells its nature: a tightened gap at the bottom of a valley, a ravine, a cul-de-sac, literally 'bottom of a bag'. Medieval Latin has *culata terra,* namely collapsed or sunken ground, a cave-in.

Through Pouilly, where there is a monument to local *résistants,* and on into Saint-Jeoire, home of the Château de Beauregard, an architectural jumble – curtain wall with corner towers like syringes, an oversized *pigeonnier*

(dovecote), turrets and towers clamped onto the main house but somehow disproportionate, faintly vulgar. It was rebuilt in the eighteenth century after twice being burnt down. A local man, Germain Sommeiller (1815–1871), engineered the Mont Cenis tunnel (1857–1880), once the longest tunnel in the world.

Left on the D907 on a balcony overlooking the valley of the Giffre, the river running south of the road, then down for 6.5km from the junction through a wide gorge into Mieussy (634m), mostly sited on a link road to the D308. Mieussy boasts a number of elegant chalets put subtly in their place by the gracious onion cupola of the church high above their roofs. Through Le Jourdy this D308 drops away for a distance, then resumes its gentle uphill into Messy (810m), 3.1km from the turn, a place of clean order and trim mien, some quite grand chalets, a couple of older granges with tight-packed wood stacks under the broad wings of the spreading eaves designed to shoot a fall of snow as far away from the house as possible. The gradient splutters from 6 to 7.5 to 8.5%. Into Chez Besson and a good view over the valley formed by a tributary of the Giffre springing from somewhere up near the Lac de Roy overhead, part of the ski area above the Ramaz. Suddenly, the bare cliffs, on top of which the lake heaves into view. From here, the climb kicks in for 4km of around 9.5%, as the road heads stubbornly for those cliffs, up and up, through 20m of snow tunnel and more tunnels beyond. The road hugs the

# This road has the stern purpose of going up to a mountain height, albeit not a very high altitude, via tree-fringed grassy leas, a few dwellings, and into solitude as the trees on either side close in

side wall, exposed on the cliff side, and the succession of drab functional snow cloches adds to the bleakness, a sickly grey of concrete and rock.

On a side wall a graffito, *100 Ans Vive le Tour*, and indeed it came through in 2003, Virenque first over, the only appearance ever of this Col de la Ramaz (1559m) in the race. A cyclist tells us that the climb is regular and steady, with no abrupt changes in rhythm over the 14km from Mieussy. Old French *raime* means 'branch' (Latin *ramus*), but the dialect word *ramaz* means an enclosure where the flock is gathered upon the alpine pasture – therefore made of interwoven twig and branch hurdles or else a wooded area.

A short drop past the ski station Le Praz-de-Lys (1498m, 2.5km – the name means 'field of lilies') to the Col de la Savolière (1418m, 3.8km) and all the winter-sport clutter, so drab without snow – a muddy car turnaround, bars, restaurants, chalets with rusty, ugly corrugated roofs and, away from the road, a slurry of *chalets à louer pour l'hiver* (chalets to rent for the winter). There is one enormous chalet, Les Terraces, much foraminated with windows, looking like a penitentiary, with a number of lanterns perched on its roof in the shape of Chinese bamboo hats. More ski villages follow, a litter of cabins, each one locked up, forlorn. A large, surrounding mountainscape – crags and yokes and chiselled ridges like broken

teeth. From Sommand the road drops away into a grassy bowl girdled by ridges and another clutch of chalets comprising the ski station of Sommand, probably attractive in season, but in summer it has an aspect of domestic litter with its uncollected garbage of ski gantries and unused lifts. There is no sign bragging its name, only one board indicating *Randonnées* (walking tour) and another, *Sommand Domaines Skiables* (ski areas). The grassy peak is shaped like a desiccated coconut ice cake.

Descend to the D328 round a steep hairpin and a gentler straight towards the Col de l'Encrenaz (1433m) – *encrenaz* is dialect for 'breach', a narrow cut through a rock wall. The D328 is narrow and shaded. Pass a handsome new chapel – oblong body, steep-pitched roof, a large wooden door adorned with a central panel formed by thin triangular panels in a fan shape, at the acute finial of the roof a gleaming golden cockerel weathervane. A man and a woman were gathering edible *escargots* from the ditch at the side of the road when we went through.

This road has the stern purpose of going up to a mountain height, albeit not a very high altitude, via tree-fringed grassy leas, a few dwellings, and into solitude as the trees on either side close in for a listening ear to any hint of conversation or whisper. The col has a car park and turnaround. To one side stands a sizeable wooden cabin with painted boards above opposing doors on either side, like those on a large church clock, a woman appearing out of one, a man from the other: one called Le Roc

(presumably for the Roc d'Enfer, at 2244m the peak surging out of this outcrop of stone), the other Le Plane. In the centre between them, a notice reads *Le Réfuge Privé du Dahn* (Private, keep out. Dahn family property) with a picture of a chamois. On a ledge along the porch in front, an old-style, open-frame, wooden sledge 2m long, 80cm wide. To the left of the building, crudely sculpted in wood, two bears, back to back, and a marmot. Beyond them, behind a fence, a much smaller cabin with a bargeboard, shaped like drooping eyebrows, decorated with a floral pattern. On the other side of the road, a bar/restaurant calls itself the Ancrenaz.

The descent is narrow, twisty, over some quite rough patches. La Côte d'Arbroz, 2km on, offers a Café de l'Union, chalets and a view of Morzine, into which the road swings by way of a succession of hairpins, as if reluctant to arrive, as indeed it might be. Morzine is a sorry heap, a congeries of ski junk, the sort of place where bartenders speak that obsequious, ingratiating smarmy in-between of true language best called 'tourist', expressive of nothing more subtle than an oily desire to fawn in joyless exchange for custom. *Mor-* is a Celtic word meaning 'a rock detached from a larger stone mass'.

## MASS HYSTERIA IN MORZINE

The trouble began in 1837. A nine-year-old girl fell abruptly into a comatose sleep after an (unspecified) great shock. The trance lasted only fifteen minutes but recurred every day

thereafter. A month later another girl, aged eleven, underwent a similar trauma, and others followed, girls and young women all under the age of twenty. Declaring themselves possessed by demons, they broke loose and ran wild through the countryside, climbed trees and fell into convulsions. The local priest and his assistant failed to exorcise the demons, the stricken girls taunted them and, when confronted with local magistrates, attacked them physically with considerable violence. The malady spread to older women, and reports of the disturbances reached Paris. The chief superintendent of asylums for the insane arrived in Morzine, dispersed the affected women into scattered communities so that they should have no mutual contact, and dispatched the two incompetent clergy to the Bishop of Annecy for a good dressing down. Few of the women recovered, a number died – one man also fell victim – and when others returned to Morzine, they relapsed.

There was more to come. In 1843 a similarly afflicted thirty-four-year-old woman of the Chablais was brought before Bishop Laurent of Luxemburg. From the age of fifteen, in her lucid intervals, the woman spoke in dialect but, during bouts of convulsions, she babbled in a jumble of Latin, French and German. The bishop endeavoured to drive the demon out of her without success, and instead the demon turned on him, visiting him at night and planting blasphemous doubts about the existence of God and the truth of

redemption through Christ. Having weathered and mastered the blasphemous assaults of these dangerous errors, the bishop at last managed to free the woman of her diabolic possession. Her spirit cleared, her countenance became angelic.

However, greatly perturbed by the spread of the hysteria in Morzine, the Bishop of Annecy himself arrived to perform an exorcism. Seventy affected women were brought into the church, whereupon they screamed and yelled like banshees. Eight strong men were hard put to drag one possessed child to the altar, while the rest of the women howled blasphemies and belaboured the men with their fists and feet. The bishop was caught up in the fracas, and, bruised and in fear of his life, fled.

A short way south of Morzine, the small town of Les Gets is said to have been founded in the fourteenth century by a colony of Jews exiled from Florence – *gets* means 'Jews' in local dialect – but this seems to be fanciful since Les Gets has been recorded as early as the beginning of the twelfth century. More likely it is one of a number of place names derived from Low Latin *gistum*, 'a lodging house' (French *gîte*), or more precisely, 'the area in front of a chalet where the flock can be corralled'. Les Gets now proclaims itself to be the *Capitale de la musique mécanique* and is home to a museum of mechanical instruments dating from the nineteenth century.

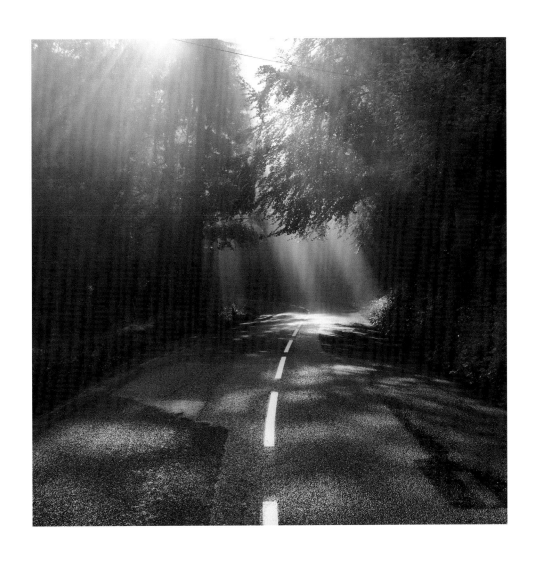

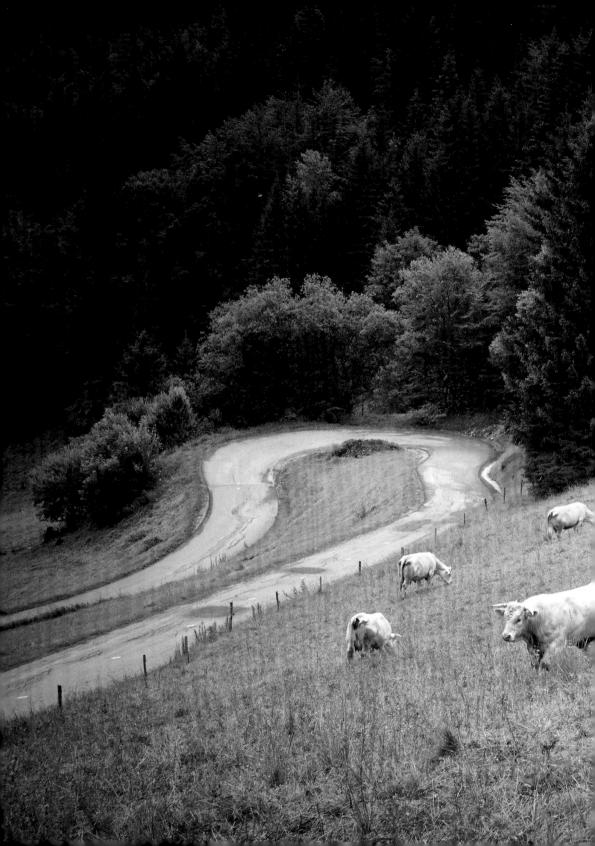

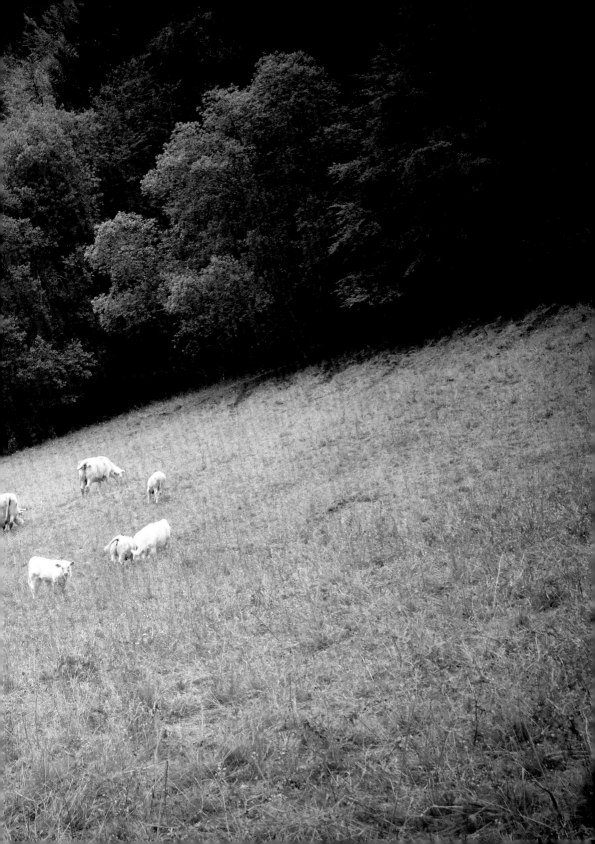

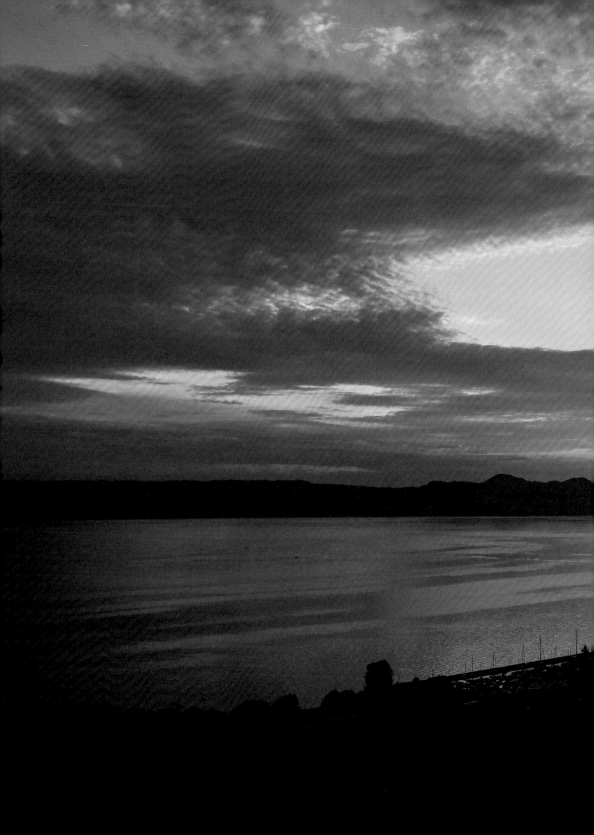

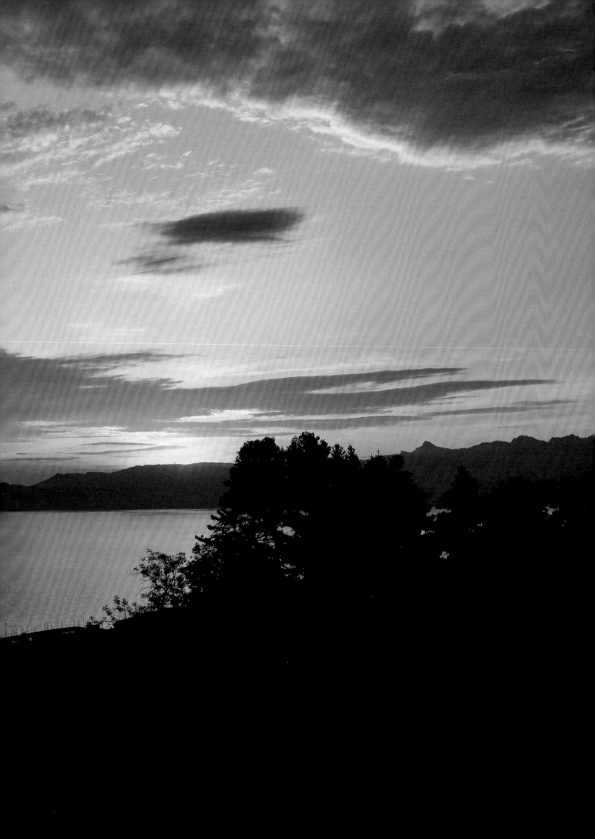

# COL DU RAN FOLLY 1656M
# COL DE JOUX PLANE 1691M

*Northern approach from Morzine 960m*

LENGTH **12.3KM**

HEIGHT GAINED **731M**

MAXIMUM GRADIENT **11%**

A *joux* is a forest of mature timber trees, up to 200 years old, on a mountain, from Gaulish *jor*, medieval Latin *juria*. *Ran* is dialect for 'a sloping mountainside' and the folly comes from Latin *folia*, therefore 'leafy'.

Take the D354 out through the Morzine overspill onto a sudden steep pitch of upwards of 10.5 to 11%… nothing like a brisk warm-up, eh? Beneath and athwart this slope run the waters of the Dranse de la Manche (literally 'the valley of the valley'.) A series of tight hairpins and, at 4km, 1234m, a short drop into a minor valley cleft and across one of the many rivulets streaming off the massif. Having flirted with dipping its toes in the stream, the road hoists itself up again along a narrow road winding up the mountainside, past a scatter of chalets, round more hairpins at a more relaxed gradient, between 7 and 8%. This change of mood lasts about 3km before the tourniquet of 10% tightens again. Suddenly, all smiles once more as the road flips over the Col du Ran Folly. Here sit a *télésiège* (chairlift), a board for Morzine Plan des Pistes and a wide view. Below the prominence, Le Gretzet bar and snacks. On down a kilometre of exposed road and another kilometre up where suddenly the Col de Joux Plane pops out, marked as

1700m. A 'Site Nordique du Col de Joux Plane' and a wooden cabin, as the sign indicates, for cross-country skiers. The southern descent of 13.4km, maximum gradient 10.5%, continues very exposed to the swirl of cold winds about these ranges, but the treeless skyline allows a long view of the valley below. Further down, the road enters trees and starts to jink round steep hairpins on a harsh gradient. Small farms with a sprinkling of houses here and there – one very large cowshed in a community (Chanternerle) above Le Tour.

Below L'Abbaye the road breaks cover again – a field shamefully planted with abandoned cars, junked clumps of rusting vehicular trash – and ducks back into trees once more as if ashamed of the desecration of these meadows. Through another hamlet and into Plan Praz (flat field).

# AVORIAZ 1829M

## From Morzine 960m

LENGTH  14KM
HEIGHT GAINED  869M
MAXIMUM GRADIENT  8%

Morzine takes a lot of getting away from. The D338 to the ski station is a doggedly featureless road at what seems a harder gradient than it really is (the effect of its functional nature and the spiritless purpose of its existence, maybe) with a view of the ski town diminishing down below, sprawled like drunken guests at a car park picnic, *déjeuner sur le béton*. The heights on the far side of the town, topped by the Pointe de Ressachaux and Les Hautforts, exaggerate a void dominated by the cables slung from side to side of a télésiège, the car dangling like a moving overhead camera. When the straggle of houses peters out, the road develops that familiar pattern of hairpins and straights, a feeble attempt at movement and some flow, but not altogether enticing. From La Mouille (1330m), a hamlet, the promontory opposite has the shape of a lion couchant with splines of trees down its flanks, as if this poor sleeping beast has alopecia on its neck, but its lower flanks are still quite bushily covered.

Avoriaz appears in stark profile, the clear horizon stippled with ski lifts and the gaunt main block of apartments looking like a prison complex, some ghastly Maison de Force (gaol), from which the only escape as an inmate would be by flinging yourself out of one of the tiny windows into the abyss. And when you get close to it, the chilling presence is quite as bad, truly awful, scarcely recompensed by the big view. Is there any reason to ride up here other than for the history of the Tour? The word itself is a dialect version of *ça ne vaut rien*, 'it's worthless' – a crop of stones and thin earth, useless for grazing or anything much.

The lumpen ziggurats constructed of wood and the exterior surface of slantwise slats resemble something out of a computerized fantasy film, hall of the demonic mountain king. At 1.5km below the ski station lies the Col de la Joux Verte. Avoriaz has appeared in only six Tours, on four of those occasions as a time-trial, twice won by the eventual overall winner: Lucien Van Impe in 1977 and Bernard Hinault in 1979.

# COL DE LA JOUX VERTE 1760M

## From Montriond 886m

LENGTH  14.6KM
HEIGHT GAINED  874M
MAXIMUM GRADIENT  10%

If the Avoriaz approach to this col is dreary, the alternative ascent on the D228 is, by sharp contrast, a choice ride: quiet, full of interest, agreeably taxing in parts. Use the other road for a swifter, less technical descent.

Very narrow and exposed at the top, the road seems to shoot you from its steep, steep fall out into the open air. Trees start some 1km down, the road, bespeaking its origins as a mountain track, indulging in bags of shiver. There is shade from cordons of tall trees, ample greenery, lovely quietude, no houses and, 3km down, a short stretch of balcony – side wall to the right and parapet to the left. The balcony is like a piece of wire stripped of its tree-girt insulating cover and then fused into woodland once more. Wild blooms bedeck the grass like those in Robert Frost's Faraway Meadow, a place that's 'finished with men' and left

> For you, O tumultuous flowers,
> To go to waste and go wild in,
> All shapes and colours of flowers
> I needn't call you by name.
> *The Last Mowing*

Almost inevitably, alas, just beyond the village of Lindaret (Les Lindarets on the map), the ski-town blight bursts out again like a pustular eruption, and Lindaret is a mess of bars and restaurants serving the winter invasion. The name comes either from a Gaulish root, *lindon*, meaning 'liquid', therefore a lake or pond, or else from the Latin adjective *limitaris*, 'of a boundary', a pale beyond which it may be unwise to stray. A shop with a balcony displays some of its wares, garishly painted tat-textile blankets: the Bengal Tiger in towelling cloth, the sloe-eyed Indonesian beauty, etc.

Gazing away below we see the road cut as a ledge, a naked ledge, breathing in the open once more, casting off these lendings of winter commerce and heading down towards the valley which wriggles its way between lines of counter-posed spurs. The gradient stirs into a fiery stretch of 8–10% into the next village. The village of Ardent, belying its name (which actually harks back to a forest fire), lies off the road, but is made up of chalets with a distinctly depressed air. Then snow tunnels and a broader road, curves, trees and a sudden beauty: Lac de Montriond in a deep crater ringed by high cliffs. This was created by a massive fall of rock, somewhere between 4500 and 3000 BC, when a portion of the mountain that loosened came away from the massif of the Pointe de Nataux to the north-west and then dammed up the torrent (there is a cascade by Ardent) to form the third largest lake in Haute-Savoie, 1320m long, 235m wide and 19m deep at its maximum.

# COL DU CORBIER 1237M

The purity of its water reflects the colour of the surrounding trees and imparts a lustrous shade of emerald green. Formerly subject to sizeable fluctuations in depth, winter to spring, it was finally sealed off and made watertight by the local municipality in 1990. Fishing, swimming, canoeing and kayaking, under supervision.

Below the lake the road forks, the D228 continuing direct into Montriond (rounded mountain), the right fork showing a more sylvan option, narrower and leafier, although both eventually stub their toes on wooden chalet suburbia with smaller enclaves sectioned off, like closes in a modern 'desirable homes' estate, with not entirely prepossessing nomenclature: Le Crêt (The Crest), La Bouverie (The Cowshed).

*Southern approach from Morzine, 720m*

LENGTH 6KM
HEIGHT GAINED 517M
MAXIMUM GRADIENT 10%

*Turn off the D902 for Thonon-les-Bains on the D332 to Biot.*

The col straddles the heights dividing theDranse de Morzine from the Dranse d'Abondance. The Gallic *druanto, druento – dru* (large), *nant* (valley) – yields *dranse* for a river or torrent in a notched valley. It is a good place for heroic defence, as a handful of peasants proved in 1536 outside Saint-Jean-d'Aulps, 4km north of Morzine, when they took on, and sent packing, a raiding war party of Bernese professionals. The ruins of an eleventh-century Cistercian abbey stand nearby.

This is a splendid, short, hard climb with no let-up. A savage first ramp with an overhang of rock to the right hauls you a kilometre into Biot (*chef-lieu du canton* – principal community of the canton) where the D32 swings off right onto another withering stretch of road. Into trees, the surface a bit chewed here and there, out of trees where the surface gets smooth, the gradient racking up to around 10% on a winding stretch with an open view of the defile valley of the Morzine. The climb is relatively unscenic. There are intermittent hairpins, but mostly a succession of long bends through the village of Le Corbier. The col, marked at 1230m,

is occupied by the Station de Drouzin le Mont, comprising a number of unattractive apartment blocks, ski lifts, bar/restaurant, a large old metal sign, blue on cream, for the col itself. General ski junk and snow tractors parked in a line on an unmetalled car turnaround distract somewhat from a fine view of the mountains overlooking the Dranse de l'Abondance across the way. As you quit the stagnant detritus scattered across the col, a perspective opens of the road twisting and turning in an exaggerated slalom into the cleft of the valley, lined with green verges and meadows, the downhill drape of conifers, the skyline ahead dominated by the rounded peak of the Pointe de Pelluaz (1916m), Le Dent d'Oche (2222m) beyond it and the Chau d'Oche (2199m) to its right. In dialect, *chau* means 'mountain pasturage' and *oche*, 'a notch', named for the gash formed by the Col de Planchamp between these two peaks. The Pelluaz (peeled) has a bald pate.

The northerly descent is marginally shorter and less steep, more gracious, slinking through hairpins, a more stylish secretarial hand of curlicues than the uncouth scrawl of the southern side. This certainly makes the ski station, tawdry and formless as it is, more appealing in prospect. 'Tawdry' is a conflation of Saint Audrey, originally Ethelrida (d. 679), daughter of Anna, king of East Anglia and patron saint of Ely. She died of a tumour in her throat, which she took as just retribution for her frivolity, when young, in wearing 'manifold splendid necklaces, in vain show'.

This is a splendid, short, hard climb with no let-up. A savage first ramp with an overhang of rock to the right hauls you a kilometre into Biot

# COL DU GRAND TAILLET 1035M
# POINTE DE TRÉCHAUFFÉX 1290M

In the sixteenth century, neck adornments made of thin and fine silk came to be called Saint Audrey's laces and, in the severe climate of Puritan denunciation of such frippery, they were associated with the cheap, godless ornament reviled by such as Calvin, hence our word.

Bonnevaux at the foot of the col, 906m, is a chalet strip, which the bright-coloured window boxes, along windowsills and porch balustrades, strive to lift out of amorphous anonymity. Below Bonnevaux, an outcrop of chalets called La Solitude sits on the valley bottom. This lower stretch idles into a mild downhill past Cent Fontaines and left on the D222 on around 8% through a hamlet of chalets – Ecotex (*es coteaux*, 'on the hillside') – into trees and leas and more chalets. Cows graze on a sweep of mountain meadow in which sprout more chalets of La Grange. The road dips into Le Fion and we see across the conduit of the valley to the other side, a built-up area, below the Oche.

*Northern approach from below Fion 725m*

LENGTH  8.8KM

HEIGHT GAINED  565M

MAXIMUM GRADIENT  8.5%

From Le Fion, another sizeable little town, the road runs flat through and then, at 3km from the col, the gradient's mild temper hardens over the space of a kilometre and kicks up into 7 and 8%, round a hairpin and onto more hairpins and a much tougher slope which does not relent. Consider this a short rustic escapade. Limousin cows graze in a small field on the sloping hillside, tails flicking at the nuisance of flies, the bull in one corner contemplates his harem, overhead a radio mast peeks over the brow announcing the col, in company with an attendant still-life of telegraph poles and wires. The pass (some claim its height should be 1041m) makes a modest entry, marked by an old sign much pitted by weather. Taillet, via French *tailler* (whence our 'tailor') and Latin *talea* (a slip or cutting), is taken to mean 'a clearing'.

There remain another 4.5km to the belvedere under the Pointe de Tréchaufféx. It's written Tréchauffé here, but that's the way the locals pronounce the suffix -ex. Since *tré* means 'pasturage', here we have 'warm pasture'. The way is passingly steep, a continuation of the approach, the ascent probing just above the tree line. On one pin near the top stands what might be an old-fashioned tea kiosk, and

from the viewpoint a grand view of Lac Léman. Press on a way and the road plunges down into a deep siding with a *fromager* (cheese shop) and *petite restauration* (snacks), for walkers, presumably, at the Alpage (upland pasture) de Tréchauffé. Opposite the belvedere, blue-purple harebells grow in the fissures and crannies of a much-wrinkled rock wall.

Descending westwards from the col through trees into Rosset hamlet, you may pass a modest potato field in flower on the bend. During the French Revolution, much public spite was levelled both at those even suspected of hoarding grain and at the authorities who so callously and incompetently failed to maintain a supply of the main staple, bread. The shortage was exacerbated by successive years of failed harvest. An attempt to encourage the populace clamouring for loaves to switch to potatoes for their starch was driven by Antoine-Augustin Parmentier. Taken prisoner during the Seven Years' War (1756–1763), he spent time in a Prussian jail where he was fed on potatoes, which were then despised by the French as food fit only for swine. The anti-potatoists persisted in their contempt, despite the enthusiastic backing of Parmentier's proselytizing efforts on behalf of the spud by Queen Marie Antoinette, who gaily sported sprays of potato flowers – they are poisonous, of the same family as deadly nightshade – in her corsage. The attribution to her of the scurrilous and dismissive '*qu'ils mangent du gâteau*' (let them eat cake) is almost certainly a canard, but her brazen espousal

of pig food cannot have gone down too well in what were unrelievedly irascible times. Incidentally, the baton shape of the traditional baguette (little stick) is said to have originated from the French revolutionary wars. Such a loaf could fit happily in a narrow pocket in a soldier's trews against his leg.

Almost at once, here is Forclaz, an oldish mountain village, once upon a time the gateway to the upper reaches of pasture, surely. Its church is capped with a bulbous onion dome (much in favour and in various forms in Savoy). Le Cruet, a short distance on, introduces a steeper slope, upwards of 9.5%.

# PAS DE MORGINS 1369M

*Western approach from the entry to the Grand Taillet on the D22 831m*

LENGTH  19KM

HEIGHT GAINED  538M

MAXIMUM GRADIENT  7%

This is included as a cross-border road into Switzerland, a pleasant enough ride but no great test of the legs.

By the side of the road, a black wooden silhouette of a man's outline (like a shooting range target) is one of a number marking road accident fatalities. This one has *J'avais 24 ans* (I was 24 years old) in a roundel.

The road goes through Abondance (920m, 4.7km), famous for its eleventh-century abbey, founded as an Augustinian priory, and noted for its cheese, similar to the Savoyard Tomme. The first canons of the priory saw the rich commercial potential in the cows of the valley and they embarked on an extensive programme of land clearance to create high pastures which they rented to the villagers. They also furnished them with cauldrons for the manufacture of cheese, on a percentage return. The commerce thrived, hence the name Abondance, and, in 1381, when dissident French cardinals, having broken with Rome, gathered in Avignon to elect their own Pope, Abondance cheese was served at table. Thus it received the grace of appointment to the papal pantry.

The whole milk of Abondance, Tarine or Montbéliarde cows is poured into a copper cauldron. (The Montbéliarde cows come originally from the Haute Saône-Doubs region of France, and were descended from the Bernoise cattle brought to the region by Mennonites, fleeing persecution in Switzerland.) Rennet, a mass of curdled milk found in the stomach of an unweaned calf or other animal, is added to make curds, which are then cut away from the liquid with a hand scoop. The curds are then heated and, by means of a linen cloth – two corners tied round the neck, the loose ends held in the hands – the cheese-maker filters the granular curds free of the whey, *petit-lait*, the watery part of the milk. (French *ça se boit comme du petit-lait* means 'it slips down nicely'.) The rescued curds are placed in a wooden circular former to produce the characteristic concave shape of the finished cheese. Once salted the cheese is placed in a cool larder on spruce planks for at least a hundred days.

*Recipe*

# LE BERTHOUD CHABLAISIEN

This emblematic dish of the Abondance cheese is named for a local family who kept an inn at Thônes and were famous for it.

Rub a large oven dish with raw garlic and lay therein fine slices of 150g of Abondance cheese. Douse with a coffee cup of Madeira and another of white Savoy wine and season with pepper. Toast under a grill for 5 minutes or brown in a hot oven for 15 minutes. Serve with boiled potatoes.

Note: Remove an Abondance cheese from the refrigerator at least an hour before consumption.

The Savoyards have always been known for their taste for the cheeses of the region, but it is generally allowed that the Tomme is so much part of the diet that in Savoy, at least, the word is synonymous with *fromage*. The writer on Savoy cooking, Marie-Thérèse Hermann, of the Chablais region, opined that one could recognize a Savoyard by their pronounced taste for Tomme.

Châtel (1200m, 16km) has a decent market where you may buy very cosy sheepskin slippers as well as *saucisson sec* (cured sausage) and dried fruit for your picnic. Another 3km of gentle pull up to the Pas, the col, a lake and on to the border and a caravan park, sprawl of apartment blocks. Morgins, ski dross, cement mixers, diggers and a large sign bidding you *Au Revoir*.

Below the Pas the road drops 10km to the junction – left to Monthey, right to the dead end in Champéry. The climb up this way is a relatively steady 7% with 2km of between 8 and 9% before easing off to the top.

CHAMONIX

# CHAMONIX

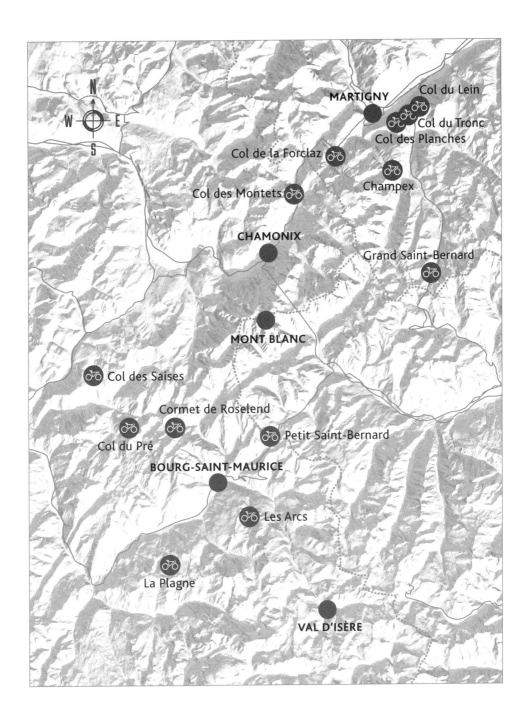

MARTIGNY

Col du Lein

Col du Tronc

Col des Planches

Col de la Forclaz

Champex

Col des Montets

CHAMONIX

Grand Saint-Bernard

MONT BLANC

Col des Saises

Cormet de Roselend

Petit Saint-Bernard

Col du Pré

BOURG-SAINT-MAURICE

Les Arcs

La Plagne

VAL D'ISÈRE

# INTRODUCTION

Chamonix sits beneath Europe's highest mountain, Mont Blanc (4810.45m), first climbed in 1786 by a doctor, Michel-Gabriel Paccard, and a local guide, Jacques Balmont, both citizens of the Kingdom of Sardinia in whose territory the mountain stood at the time. They went up and got back down, unroped and without ice axes. There's a statue in town of Paccard and another of Balmont with the naturalist Horace-Bénédict Saussure admiring Mont Blanc. Saussure, a botanist and physicist, pioneered the study of alpine geology and topography. He climbed a number of high peaks, encumbered with scientific instruments to measure the relative humidity of the atmosphere at different heights, its temperature, the strength of solar radiation, the composition of air and its transparency. The fourth ascent of the White Mountain was made in 1787 by Mark Beaufoy, a Fellow of the Royal Society who, befitting his social status as an English milord, went up with six guides and a manservant. Maria Paradis, a maidservant of Chamonix, accompanied by Balmont, was the first woman to make the ascent in July 1808. (The second woman followed in 1838.) The famous Compagnie des Guides was founded by thirty-four original members in 1821, to monitor ascents of the mountain and to oversee and improve safety precautions.

Two Englishmen, William Windham, a Norfolk landowner resident in Geneva, and Richarde Pococke, a priest and anthropologist much given to foreign expedition, on his way home from the Near East, visited Chamonix in 1741. Between the mid-seventeenth and mid-nineteenth centuries (when rail travel became more common), young European men of wealth and education were generally dispatched on a cultural Grand Tour, a sort of peripatetic finishing school course. Thus Paris for dancing, fencing, riding and courtly behaviour, Italy for Renaissance art and architecture, Greece for ancient ruins and, perhaps, Homer's strictures on the idea of

peregrination as voiced by his eponymous hero in the *Odyssey* on
his return home after twenty weary years' absence: 'There is no
worse evil for mortals than wandering the earth' (Book XV, 343)
or the Roman Seneca's pithy caution: '*Caelum mutas, non teipsum*'
(Wherever you go, you take yourself with you), which he plagiarized
and condensed from Horace: '*caelum non animum mutant qui trans
mare currunt*' (they change their skies but not their spirit who course
across the sea). Edward Gibbon had a somewhat jaundiced view of
the Tour's real purpose: more sightseeing than assiduous study and
immersion in culture, he suggests. Others at the time were more
tart. One eighteenth-century critic wrote: 'The tour of Europe is a
paltry thing, a tame, uniform, unvaried prospect.' Why? Because the
Grand Tour merely reinforced ingrained prejudice about national
characteristics. As Jean Gailhard's *Compleat Gentleman* (1678)
observes: 'French courteous. Spanish lordly. Italian amorous.
German clownish.'

The itinerary took the grand tourists via Paris, Lyon, Geneva
and the Simplon Pass into north Italy and on to southern Italy.
There was no obvious emphasis on mountains, viewed more as
obstacles than as objects of wonder in themselves, and Windham
and Pococke's precocious jaunt to Chamonix's mountain was unusual,
possibly unique.

They are certainly the first recorded travellers who explored the
region for pleasure. They climbed Le Montenvers, 'the mountain
on the cold, northern slope', to the north of town, helped by local
guides, and from its summit looked over, and later investigated, the
huge river of ice which they called the Mer de Glace. Three years
later in 1744 Windham published *An Account of the Glacieres of Ice
Alps in Savoy* and was appointed a Fellow of the Royal Society as a
result. His rapturous description of the mountains round Chamonix
brought ever more visitors and eventually spurred the great influx

In the Middle Ages Mont Blanc was generally known either as Les Glacières or La Montagne Maudite, 'the accursed mountain', presumably for the avalanches and rock slides it unleashed.

of mountaineers, pioneers of alpinism, many of them British. Enthusiasm for the high places, the majestic beauty of mountains in range or the lone towering peak in stark splendour, whether imbued with mystic aura, as Mount Olympus, or hitherto anonymous, did not grip everyone.

The French writer Chateaubriand went to Chamonix in 1805, but had little truck with what he encountered. 'There is only one circumstance in which it might be true that mountains inspire forgetfulness of earthly troubles: that is when one retires far from the world to dedicate oneself to religion. An anchorite who devotes himself to the service of humanity, a saint who wishes to meditate on God's grandeur in silence, can find joy and peace among wildernesses

of stone; but then it is not the tranquillity of those places that occupies the souls of those solitaries, on the contrary, their souls spread serenity in a region of storms.' He'd probably have hated the bicycle too. The English Romantic poets – Southey, Shelley, Wordsworth, Byron – were captivated, however:

> *Mont Blanc is the monarch of mountains;*
> They crown'd him long ago
> On a throne of rocks, in a robe of clouds,
> With a diadem of snow.
>
> <div align="right">Byron, <em>Manfred</em></div>

The earliest known charter of Chamonix refers to a *rupes quae vocatur alba* (a crag known as the white one), while in the Middle Ages Mont Blanc was generally known either as Les Glacières or La Montagne Maudite, 'the accursed mountain', presumably for the avalanches and rock slides it unleashed. The French word *glacier* was current from the early fourteenth century, almost certainly a regional word later adopted by the Swiss in their form, *Gletscher*. The variant *glacière* appears in the seventeenth century and comes into English from Windham's monograph.

# COL DES MONTETS 1461M

## Southern approach from Chamonix 1037m

LENGTH 11.8KM
HEIGHT GAINED 424M
MAXIMUM GRADIENT 6%

The Montets is an intermediate obstacle between Chamonix and the major Col de la Forclaz across the border in Switzerland. Follow the D507 main road which runs without much wobble through a succession of towns. It's fairly wide into Argentière (1240m, 8.5km) and on an easy slope, but from here bikes and cars have to share on equal terms. A clutch of big hairpins outside Argentière cranks the gradient to around 6%, like a coiled spring on whose contained bounce you dance up to the brow of the col, which is unmarked. The road slides gently down into the Défile de la Tête Noire (Defile of the Black Head), along whose bottom flows the Eau Noire, a river whose waters filter the dark stone of its bed and banks. Leaving an outcrop of communities at Le Buet, the road starts to wriggle and then opens up, broadening into Le Nant, Le Morzay and the larger strip of buildings which is Vallorcine, 1256m and 4.1km from the col, at whose far end comes the frontier post. The core of the older village is evident, bound in by its later accretion of holiday building. The road continues quite close to the river and tightens towards the customs kiosks, a narrow squeeze through and still losing height into Le Châtelard at 1120m, 2.4km on. Finally, it begins to climb again below the Tête Noire and the Gorges Mystérieuses towering over Trient (pronounced Tree-anne) with a shabby edifice marked *Restaurant Super Marché*, which looks far from alluring. Off to the right in Le Peuty on a narrow meadow sit a number of chalets. The road makes no pretensions to being anything other than a well-worn transit between France and Switzerland.

# COL DE LA FORCLAZ 1527M

*Continuation from Le Châtelard 1120m*

LENGTH  8.6KM

HEIGHT GAINED  407M

MAXIMUM GRADIENT  10%

The road dips for 2.4km to a bridge across the Trient (1066m), and then begins the ascent at a steady ratchet of gradient past a left turn towards Finhaut at 9% and past La Lechère at 9.5 and 10%. It swings wide and round to the left and runs more or less straight on that same steepness to the col, trees to the right, hotel/restaurant to the left. The descent from the col on this side is fast on a broad road, often quite busy. The slope runs at a steady 7–8.5% for 13.7km. A viewpoint at Bans du Fay (1325m) offers a vast panorama of Martigny and the flat, glacial valley of this part of the Rhône, cut through by motorway and carriage-road. A panorama board identifies, amongst others, the Col des Planches (to the east, where you may be heading), Haut de Cry, Grande Garde, Catogne and the Col du Grand Saint-Bernard.

When we passed in early July, our photographer took up position at the crown of the bend opposite this belvedere as I bought Valais apricots from a small caravan. *C'est dangereux*, opined the woman serving me, remonstrating and wagging her finger. *C'est OK – il est avec moi* (It's OK – he's with me), I replied. This excuse, of absolutely no merit at all, seemed to assuage her fears. Her concern was, however, fair warning that traffic hurtles up and down this road. The Valais is the local Swiss canton, of which Martigny is a major town.

The side road off to the right down to Le Fays, 6.7km from the col at 1000m, cuts off the belvedere corner and is a much quieter option. It's very narrow and steep, and the hairpins are tight, leading into a rustic backwater which is, nonetheless, a bus route. Some 0.6km down the chute it arrives in Le Fays (950m), which makes the gradient 11%, then Le Cergneux (880m) 1.5km from the turn, past a bus shelter and twisting on down through more hamlets at a steady 10% or so. This is the old road up

# A viewpoint at Bans du Fay offers a vast panorama of Martigny and the flat, glacial valley of this part of the Rhône

to the col. Here the gradient stiffens from 9.5 to 12% for 2km into Les Rappes (600m, 4km). Just below the hamlet, where terraces are neatly planted with vines, look across to a projection of rock like the prow of a boat on which sits a small shrine. A large farm building to the right sports a number of poker-work wooden plaques celebrating cows which have won prizes in local cow-fights at Martigny, Almyra and Les Ars, as *Reine Bovine* (Bovine Queen) named Rhea, Diamante, Bataille, Rafale, Vandale, Diablesse, Falbella... rather more punchy than Daisy. Rafale (Gust of Wind) suggests crafty methane-related stratagems. There is, too, a wood stack of some note.

The *Combat des Reines* (Combat of Queens) held every September is a sort of bovine Mongolian wrestling contest. Their horns blunted, and the cows push, shove and barge an opponent, for as long as forty minutes, till one of them gives up. This goes on, contest by contest, until one cow only is left standing and declared the winner, *la reine des reines*. Since Martigny hosts its fights in the old Roman amphitheatre, it may not come as a surprise that the more intelligent of the species, possibly picking up a somewhat sanguinary vibe from the spirit of place, tend to back off before the contest even gets going. These combative cow queens are generally sterile and poor milkers, but they are made a grand fuss of: beribboned, their horns decked with flowers, their bell of the finest make. Martigny hosts a champions' contest, playing off the top queens of the

seven districts around Mont Blanc which hold separate tourneys. Only in Switzerland, I thought, except that it isn't only in Switzerland. The cows of the Aosta valley (see SUSA) and in other alpine pockets trundle into the arena.

Below the barn, a house called 'Just Married' (the sign looks temporary), and a house with a mural – a cat leaping through a wall, cartoon style. A hamlet called Pied-du-Chateau, but its chateau not in evidence. Gradually the villages coalesce at the bottom into Martigny Croix, which feels like a recently built dormitory extension of Martigny itself.

# THE ROMANS IN MARTIGNY

In the winter of 57–56 BC, one of Caesar's officers commanding the Twelfth Legion, Servius Galba, established a camp on the site of Martigny, called Octodurum by the Romans. His mission, during the campaigning season, had been to secure the Great Saint-Bernard pass for Roman merchants who had long been prey to the levy of tolls. The Gauls of Octodurum attacked Galba's legion with huge strength before the Romans had completed their defence works and a desperate struggle ensued, culminating in gross slaughter – the highly disciplined Romans cutting down the massed hordes of the enemy with the swift stab and slash of their short Spanish sword, the *gladium*. After the battle, Galba prudently withdrew to the territory of the friendly Allobroges (see p. 50).

Over 200 years later, the locals were once more in revolt. However, the so-called *bagaudae* (which probably means 'fighters') were not a tribe but ad hoc bands of dispossessed or impoverished local free peasants, reinforced by brigands, runaway slaves and deserters from the legions, resisting the oppression of crippling taxation in the marginal areas of an empire in decline. To quell this rebellion, the Emperor in Rome, Diocletian, appointed Marcus Aurelius Valerius Maximianus, commonly known as Maximian, co-Caesar, before bestowing on him the divine title of Augustus. Maximian was uneducated and rather stupid, but a solid general. In the late summer of AD 285, his legions swept the territory north from the military stronghold of Octodurum to Agaunum (Saint-Maurice-en-Valais), hounding and slaughtering the *bagaudae*. In Agaunum, one of the legions, the Theban Legion of Christian Soldiers from Egypt, mutinied, either because Maximian ordered them to persecute Christian rebels or else insisted that they must worship heathen gods. The Thebans refused and were decimated – one in ten soldiers executed. The recusants held firm, encouraged by their commanding officer, Mauritius, were decimated once more and, finally, slaughtered to a man. That's the story, an inflated version of what must have been a limited protest of a few soldiers put to death in Agaunum. Mauritius was sanctified (in Switzerland he appears as San Moritz) and lends his name, French 'Maurice', to a number of towns in the Alps.

# COL DES PLANCHES 1411M
# COL DU LEIN 1658M
# COL DU TRONC 1606M

*Western approach from Martigny, 471m*

LENGTH 13.6KM

INITIAL HEIGHT GAINED 940M

MAXIMUM GRADIENT 11%

Let it be known: this is triple chainring country.

From Croix, scoot down to the main road, turn right towards Le Bourg, then across the railway line and take the road towards a village called Chemin de Martigny. This is much quieter, narrow, shaded. At 2.3km, the beginning of the climb, the road suddenly kicks up into 6km of between 10 and 11%. The surface is battered. There is a large view of Martigny in the flat-bottomed bowl of the two valleys converging round it. At 2.6km, 700m, the neat village of Chemin-Dessous. On through mixed woods to Les Escoteaux (On the Hillside) 3.7km, 790m, and turn right. The hairpins are very sharp. A short way on, an outpost house flies the Swiss flag.

Steep it may be but this road, twisting through placid woodland, is a treat. A fork at 8.2km, 1105m, offers entry to the village of Chemin-Dessus to the left or right, a bypass towards the col. Above the village opens a large view of the range of peaks to the north – Sex Carro (Latin *saxum*, rock, and carro from *quadrus*, square), Grand Chavalard (ultimately from Latin *cavum* – a hollow or ravine), Montagne de Fully (from *folium*, thus 'leafy'), Montagne de

Quieu (probably from the Valais dialect *kieu*, meaning 'col').

A field in which cows graze or loll contentedly, despite the heat... a small cabin called Le Petit Paradis... and at 9km, 1305m, a low wooden building which purveys refreshments. The road dips away for a stretch of around 400m still in woods, then climbs again for 2km at 7 then 10% to the Col des Planches. At a milder rack of slope another 3.4km and 247m past Le Ranch – to the left, a cabin with black walls and tomato-red shutters – to the Col (or Pas) du Lein (1658m). A wooden cross dated 2006 stands over a picnic area. We pass this day, in a lea nearby, a herd of black cattle with numbers painted in white on their flank: since cows who compete in the fights have numbers, perhaps these are contestants in preparation, their training oddly sedentary. The road narrows even more into 8%, flattens briefly then dips down into the open, wide meadows to either side as the surface metal peters out gradually into hard-packed earth top to become a quasi-forest track, not quite off-road and altogether manageable. Beware a few diagonal rain gutters – a thin slit edged with two metal strips – across the track. Some 4km down from the Lein, at 1606m, sits the Col du Tronc. Another wooden cross, dated 1986, occupies a slight rise of ground nearby. On down to Le Levron, very steep, on the same packed earth surface to around 500m below the col, from where it is metalled. A large panorama of rocks dominates the skyline

above Le Levron, and the road negotiates an open balcony before plunging away down into woods. Just above Le Levron, another cross inscribed '19 Mission 66' (i.e. Mission of 1966) and on a house nearby a Tibetan flag. From Levron the slope is milder. The crosses were planted by Catholic faithful – not for a specific event or pilgrimage, but merely to assert a spiritual presence in the high places and the sanctuary of the woods.

The road becomes a full double-width and so down into Sembrancher via a village called Cries, where it narrows, and then Vollèges.

This locale, known as the Mont Chemin, was rich in silver, lead, iron, marble and fluor, and much mined. The *Sentier des Mines du Mont Chemin* records the industry. The Mont Chemin is characterized by a great diversity of different rocks, crystalline gneiss and schists, marble, quartzite and quartz porphyry, granite; a veritable geological cornucopia in which are laced the seams of the precious and semi-precious metals and stone. Fluor was first identified in the sixteenth century by the German Georgius Agricola ('Farmer Farmer'), known as the father of mineralogy, who described it as resembling gemstones, though not so hard, but fusible and useful as a flux in smelting.

Sembrancher lies off the main road, a decrepit, dusty, neglected town of tumbledown wooden granges and poky back streets with virtually no sign of life or *restauration* (sustenance). The restaurant by the station, some way beyond the central cluster of dwellings, seems rarely to be open. The pizzeria on the main road before the turn–off into town is basic, friendly and in full swing.

# CHAMPEX 1470M

*(The road south from Sembrancher heads
towards the Grand Saint-Bernard past
a right turn leading to the Champex,
but the more agreeable approach is
from the main road between Martigny
and Sembrancher.)*

*From Martigny 471m*

LENGTH 17KM
HEIGHT GAINED 999M
MAXIMUM GRADIENT 11%

South-west out of Martigny on the main road
towards Bovernier, the Grand Saint-Bernard
and Italy, past the turning towards the Forclaz,
along the valley of the Dranse, for 5.8km to a
right turn (626m) for Champex up the Gorges
du Durnand, a steep haul – 8km of between
8 and 11% – through delightful terrain.

Les Valettes, half a kilometre on, has a
café/bar and a sharp right onto rough surface.
This marks the entrance into the Gorges du
Durnand (Gorges of the Big Valley) and a sign
gives 12km to the top. There is some shade,
if sparse. At 1.3km another eatery and a short
way on, survey the vineyards over to the left
in a strange patchwork layout of independent
plots, like a circuit board or a painting
by Mondrian in an acute angle phase of
his Neo-Plasticism.

Bémont (795m, 2.5km) where the way
gets awfully steep, a gradient accentuated by
a very harsh hairpin. Cooling air comes out

of the gorge and its torrent in spate. Hairpins
twist the slope up markedly hard through a
number of small clusters of houses: Le Lombar,
L'Assarley, Le Crettet (1040m, 5.3km), where
a sign gives times of Mass in the summer, the
riding season when poor wandering cyclists
need every scrap of scripture they can get.
This is a most attractive climb, full of variety,
but very, very hard. More named hamlets pop
up and Champex d'en Bas at 8.8km, 1350m,
signals the approach of the summit, you hope.
There remain 2km of around 7% to 10.9km,
1490m, where, suddenly and pleasingly, the
road flattens and drops 1.5km to a turn-round
for cars, *télésiège*, ski information, a restaurant.
A board indicating another set of times for
Mass makes reference to a *culte évangélique-
réformiste*, a sort of indexed–gears update on
traditional friction-shift theology.

Champex is a prefab town, put up to house
the visitors who come for the activities on
offer locally. We observe walkers preceded by
a packhorse, laden with their red canoe bags,
led by a young girl. Shops line the road skirting
the lake, whose waters are chill, but on a hot
day most bracing and refreshing for a body
sagging with heat. Pedalos and rowing boats
are moored to a jetty, restaurants overlook
the glinting waters. A bric-à-brac shop on the
way out of town is worth a rumble and, on the
corner beyond it, where the road swings right,
a forecourt leads to the bunker that is the
Fort d'Artillerie, built between 1940 and 1943 to
protect the two potential invasion routes

to the area of Grand Saint-Bernard and
Val Ferret (Switzerland).

The French were much exercised by the
potential threat from Italy and seem to have
prevailed on the Swiss, who remained neutral
throughout the war, to countenance this
intrusion upon their territory. The fortification
was used by the Swiss army until 1988 and
now functions only as a museum to belligerent
excess. It is hewn entirely out of the living
rock, and has more than 600m of corridors and
rooms – including filter room, munitions store,
operating theatre and infirmary, plus living
quarters to accommodate between 150 and
300 men. The four artillery casemates are
divided into two batteries.

The road down towards the highway
south runs smooth, serpentine and broad with
occasional tight hairpins at a steady 7%, which
makes for a lively descent. One section has
recently been refurbished. The village of
Som-la-Proz (High Pasture, 990m) 8km from
the lake, guards the foot of the climb and I
note a particularly fine wood stack there.

Bémont where the way gets awfully steep, a gradient accentuated by a very harsh hairpin. Cooling air comes out of the gorge and its torrent in spate.

# GRAND SAINT-BERNARD 2469M

The noise of cars, motorbikes and lorries thundering through the snow tunnels below the summit, amplified in the unkind reverberant acoustic of the concrete chamber, is markedly unpleasant. The road up to where the tunnels start is a heavy trunk road, a to-and-fro cross-border freighter-race, 37km from Martigny to Bourg-Saint-Bernard (1920m), where the juggernauts disappear into the Tunnel du Saint-Bernard. Here, at the Pas de Marengo, the cyclist swings off right onto the final approach, 6.3km of testing gradient. The first 17km of the ride amble along at around 3 and 4%. The climb to the tunnel is a bit harder, but only the final pitch is difficult. With a brief intermission of 6 and 8%, scaling the bleak upper reaches dishes out 9–10%. A series of water cisterns built in 1962, each emblazoned with a name as well as the altitude and distance to the col, lines the way. The rock is craggy, most of the time clothed in snow. As a transition into Italy, this celebrated pass has little to commend its long first section but repays with grandeur on the final stretch. These last 6.3km to the col, one of the highest metalled passes in Europe, are wild, rugged and challenging,

The Pas de Marengo recalls the battle at Alessandria in Piedmont (90km south-east of Turin) in June 1800, when Napoleon drove the Austrians out of Italy. Napoleon named the decisive encounter – and his favourite horse – after the small village around which much of the action pivoted. The victory consolidated Napoleon's position as First Consul in Paris, a title he had assumed after a coup the previous year, and established French power in Italy. A month earlier, mounted on a mule, he had led his army across the Grand Saint-Bernard, still deep in snow, because it was the most direct route into the valley of the Po.

# THE SAINT-BERNARD HOSPICE

Founded sometime around the end of the tenth or beginning of
the eleventh century by Saint Bernard of Menthon (see p. 95), the
hospice gave refuge and succour to travellers and pilgrims using
both this and the Petit-Saint-Bernard passes. Their principal role was
in seeing off the bandits who preyed on itinerants or else rescuing
the latter from snowdrifts. From around 1800 they began to use
the large dogs named after the saint, endowed as they were with an
exceptional intelligence and scenting powers. Their barking acted as
a sort of homing beacon, while their naturally friendly disposition
was of undoubted comfort to those stranded in mist and ravine in
biting cold. The big dogs, often first to find an injured traveller,
appeared like envoys of succour and safety. The legend of their
carrying small barrels of brandy slung from their collar is assuredly
false: alcohol lowers body temperature and will almost always prove
fatal in cases of extreme hypothermia. Moreover, brandy fumes
would surely diminish the scenting flair of the dog. It's likely that
this erroneous notion sprang from the image of dogs fitted with
a shoulder bar, from whose two ends was suspended a jug for the
routine portage of milk and butter to the hospice.

The newly surfaced and barriered descent into Italy runs on black
tarmac, fresh white-painted central dashes like an extended ellipsis.

The newly surfaced and barriered descent into Italy runs on black tarmac, fresh white–painted central dashes like an extended ellipsis.

Aosta lies 33.1km away down the valley of the Artanava, on a long descent of never more than 8% for half the distance and considerably less for a middle section of 6km before the marginally steeper run-in.

Between the southern foot of the Grand Saint-Bernard and the start of the Petit Saint-Bernard, along the Valle d'Aosta, lies Arvier, birthplace of Maurice Garin, 'the little chimney sweep', who won both the inaugural Tour and the second edition, but was stripped of that title, for alleged cheating, and suspended for two years. He never raced again. With a French father and an Italian mother he and the family left Arvier in 1885, probably in secret, to cross the mountains and make for the north of France. The local Italian authorities were concerned to prevent depopulation and to clamp down on trafficking in young children, who were taken off to be poked up chimneys as sweeps' brushes to learn the trade. Garin started work on the chimneys in Reims, but eventually settled in Lens and took out French citizenship in 1921. A brass bas-relief, erected on a roundabout in Arvier, commemorates him. Garin, then aged seventy-eight, returned to Arvier once, in 1949, to see the race go through. Fausto Coppi and Gino Bartali were riding for the Italian national team. On the stage from Briançon to Aosta, Coppi arrived five minutes ahead of Bartali, who had fallen and twisted his ankle, and ten minutes on the following bunch. That year he became the first man to win the Giro d'Italia and the Tour in the same year.

# PETIT SAINT-BERNARD 2188M

*Eastern approach from Morgex 905m*

LENGTH  27.2KM
HEIGHT GAINED  1283M
MAXIMUM GRADIENT  8%

Head west out of Morgex towards Courmayeur and turn left for Pré Saint-Didier at 4.4km. In 407, Didier, bishop of Langres, north of Dijon in the Haute-Marne, approached the king of the marauding Vandals to ask him to call his pack off: 'A touch more humility, O king: my people have had more than enough of your sack and pillage.' The king of the Vandals was brisk in reply. 'Cut his throat,' he said. A henchman obliged.

From the meadow named for the martyred saint, a set of eight numbered hairpins – called, here, *tornanti*, since you are still in Italy – leads up to a string of snow tunnels. Since this road crosses the frontier, it is well maintained, the surface is sound, the hairpins are frequent, interspersed with gentle bends, and there is shade from pines. At 3km, a *galleria* (tunnel) of 150m, lit. The road, which follows the Dora di Verney flowing out of the eponymous lake just below the col, is of moderate width, the gradient fairly mild, between 4 and 6%. There will be traffic, although Mark Neep of GPM10, who knows the area well, reports that it is generally not too oppressive, indeed that this is one of his favourite climbs. Its steady slope makes for a relatively fast ascent. The first tunnel announces others, spread over 2.5km.

Haute Elévaz (1280m, 10.2km) is a shy place that hunkers down, not much of it to be seen from the road. Until the sixth century, it was known as Cleuva, an Occitan word meaning 'closed'. Revers shrinks from notice too, no more than three houses in a huddle, while above it marches a line of pylons to either side of the V-shaped cleft of the valley ahead. A long, illuminated tunnel merges with an open galleria, which processes you into La Thuile (1435m, 14.2km), a sizeable town. Thrusting up from the range of high peaks dominating the skyline to the south-east, the Testa del Rutor clears 3486m. Two Englishmen, Matthews and Bonney, together with the alpine guide from Chamonix Michel Croz, climbed the Rutor for the first time in 1862.

Now a ski and summer resort, La Thuile's economy was originally based on mountain pasture, smallholding – cultivation of potatoes, rye and oats – and, from the beginning of the nineteenth century, open-cast mining of coal. In the 1920s, however, deep mine shafts were sunk and, for some forty years, La Thuile thrived as a mining town. The mines were closed in 1966. Above town, a few trees stand scattered about like village league footballers waiting for a match to start. The road is quite exposed now, threading across a large mountainscape. Ski lifts sit idle on the slopes, eyeing the power pylons along the slope opposite, their upper arms painted red and white. The road narrows at 11km from the col and trees crowd again,

among them the soft-fronded larch. Larch wood is valued for its tough, waterproof and durable qualities – resistant to rot when in contact with the ground, it is therefore much used for posts and fencing. The best-quality knot-free timber is in great demand for boat-building, as well as for exterior cladding of buildings and interior panelling. A quarry some distance from the road supplies building stone out of the hillside. The gradient continues at a fairly even 5 to 7%, with some intermediate jolts of steeper sections linking flattish ledges as the road approaches the upper reaches of mountain meadow.

At 17km, 1580m is La Riondet *pizzeria/birreria* (pizza and beer), whose frontage is adorned by logs hollowed out along their length into troughs for flowers, purple and yellow pansies. A row of snow tractors is parked to one side with owl faces painted on their fronts. The bar inside is festooned with badges, stuffed chamois heads, paddle-shaped wooden cheese boards, copper pans and griddles, framed aquatints and posters. There's a stove on the go, even in this mid-July. The tables are set with gaudy cloths. Across the road from the hostelry, on a swathe of grass, sits a giant carved snail by a small duckpond with house and platform, to one side a triangular rabbit hutch, as might be a model of a roof.

The road narrows tighter still. After some 1.5km, another bar/restaurant appears, an imposing, rather austere structure, not at all welcoming somehow, and a bit further

on the road rides onto a plateau where any wind will catch you, a sort of causeway belt – the road shaking itself free of the tight grip of the mountain to run free into the open, the mountain whose lower flanks cling on so stubbornly: flattish moorland to the left and, to the right, falling away as if inclining deferentially to a line of ridges some way off. Lac Verney is in view, way down to the right. These final kilometres run slowly out of gas: 6.5%... 6... 5... 3.5%.

Cold gales do blow up here across the shelterless summit. Be prepared. A ruined customs post sits just below the col, and the road runs in a long strip across into France, past a *télésiège* and a bar/restaurant towards a big view over the valley beyond.

Up to the left, a statue to the alpinist and botanist Abbé Pierre Chanoux (1828–1909), '*ami des fleurs des hommes et de l'alpe*' (lover of flowers, mankind and the alp) keeps company with a tiny chapel built to house his mortal remains. From 1859 he was rector of the hospice over the road and died there. In accordance with his dying wish, his sister Maria, his inseparable companion in life, is buried next to him.

This col is prey to a very harsh climate, year round. It is generally covered with snow for eight months out of twelve, up to 4m thick in the depths of winter, in February. The prevailing temperature is +1°C which allows ice to resist thaw for around 200 days per annum. There are between eight and eleven days of

precipitation every month. The best-known of the winds which sweep the col is the *vent du Petit Saint-Bernard*, the *oûra*, in Valdôtain, a foehn wind. Blowing over the col from the east, this warm, moist airstream releases its precipitation and cools down over the top, then sinks down the lee side of the mountain into the valley of the Reclus, warming up as it does so.

Despite the harshness of its climate, this pass offered the best crossing over what the Romans called the *Alpes Graiae*, running from the Mont Cenis to the Little Saint-Bernard between Italy and central Gaul. The emperor Augustus ordered the route to be paved during his first expansion and consolidation of the *Imperium Romanum* shortly after he came to power. In 25 BC, his general Terentius Varro Murena crushed the Salssi in the Valle d'Aosta and a large military base was established – Augusta Praetoria, later Aosta. The road followed and another depot, Ariolica (later Thuile), was built to police the route. A column made of a solid block of green serpentine stone veined with quartzite stands at the col and was known from the Middle Ages as the Columna Iovis, 'the column of Jupiter'. Jupiter, father of the gods, replaced the local Gaulish deity, Graius. The Romans took Graius for the naming of this range of the Alps and at the col built a *mansio* (way station/hostel), either used as, or replaced by, a chapel and hospice for travellers after they left. This was destroyed in the sixth

century by marauding Lombards (*Langobardi*, 'Longbeards'), a bellicose Germanic people moving south in quest of warmer climes. Perhaps their destruction of the house on this col was no more than an unsavoury reaction to the piercing chill of the summit, not at all what they had come for. The hospice was rebuilt in 777 by Pope Adrian I who had sought the protection of the Frankish king Charlemagne, later Holy Roman Emperor, from the troublesome Lombards, asking him to cast a beneficent eye on the refuges dotted about the Alps, especially those on what was then called Mont Joux (i.e. Jovis) and by the Columna Iovis. Alas, the Saracens arrived in the tenth century and destroyed the buildings once more.

Saint Bernard, a fiery Cistercian monk who fomented and blessed the Second Crusade at a big indaba of royals, nobs and ecclesiastics in Vézelay in 1146, instigated the rebuilding of the refuge, subsequently named after him, a dependency of the larger hospice on the Grand Saint-Bernard. The Cistercians maintained the refuge for four centuries. During the winter months it was manned by only the rector, two servants and the resident dogs, whose job it was to find travellers floundering in the snow. In 1572, Pope Gregory XIII entrusted its management to the lately combined Orders of Saint Maurice and Saint Lazarus. The Order of Saint Lazarus had been founded in the late eleventh century to protect pilgrims going to the Holy Land and, specifically (hence their

name, see Luke 16:20), to care for lepers. The Order of Saint Maurice, founded in 1434 by Amadeus VIII, Duke of Savoy, had declined, but in 1572 was reinstituted by Pope Pius V, who died shortly afterwards, to be succeeded by Gregory. The combined military and religious orders were charged with protection of the Holy See as well as the care of lepers. The present gaunt building is the larger edifice constructed by them in the eighteenth century, and their community lived and worked here until 1947. The former hospice now houses an excellent visitors' information centre. The view from the pass is splendid.

*Alternative approach from the east, via the Colle San Carlo 1951m, from Morgex.*

A small road leaves the centre of Morgex towards Arpi. There follow 10.5km of around 10%, slacking a trifle for the final kilometre to the Colle. Signs note gradient and distance to the col. From the summit, a descent of 6km – the opening trio at 9.5, 10 and 11.5% – into La Thuile and the main road up to the Petit Saint-Bernard. On both sides the climb is quite closely wooded, so that there is nothing much of a view.

This col is prey to a very harsh climate, year round. It is generally covered with snow for eight months out of twelve, up to 4m thick in the depths of winter

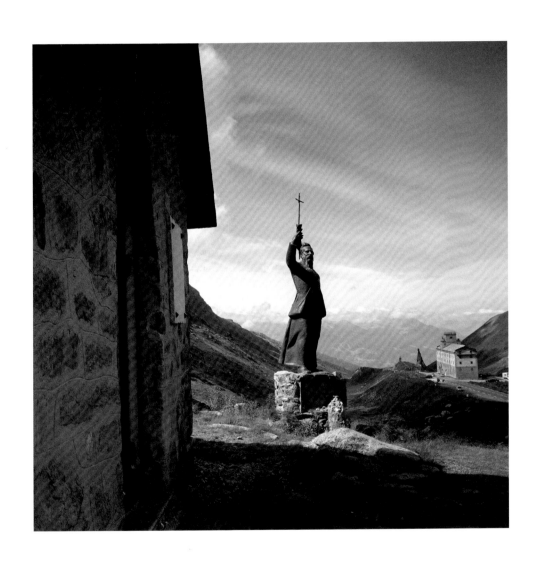

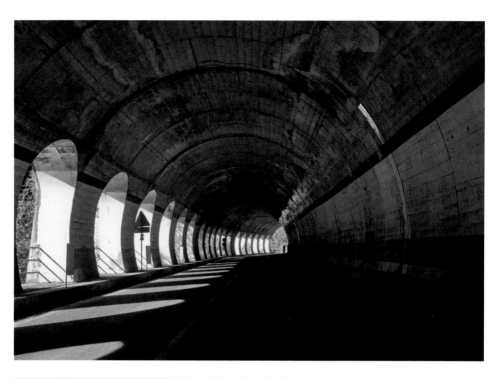

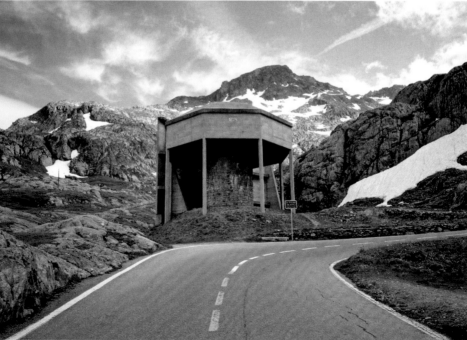

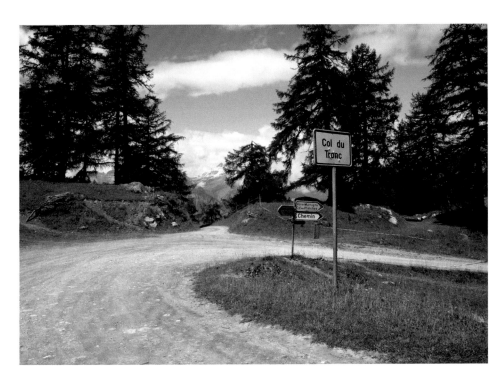

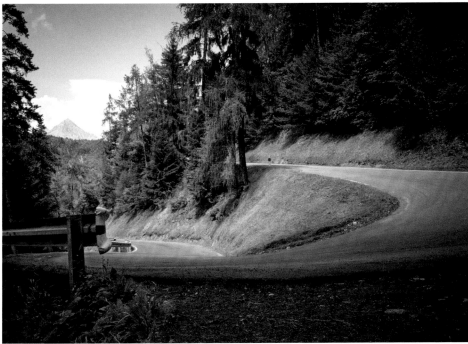

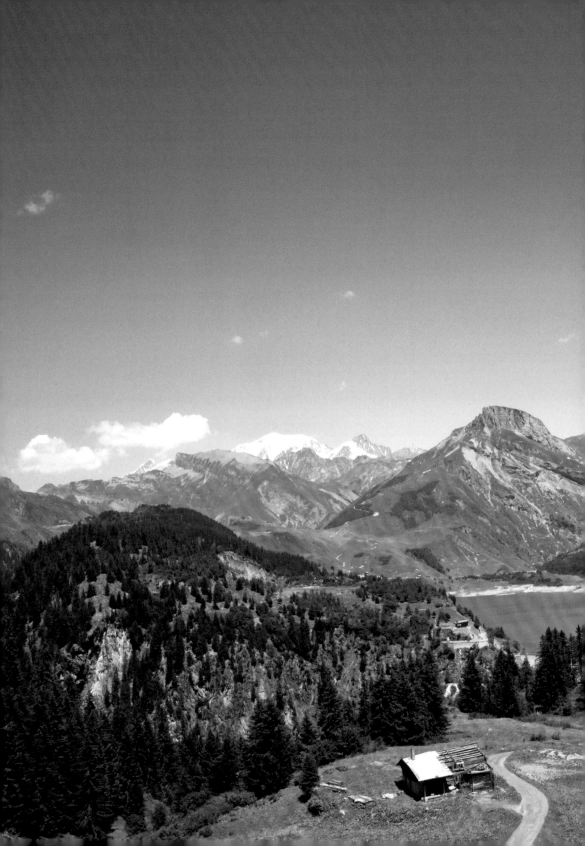

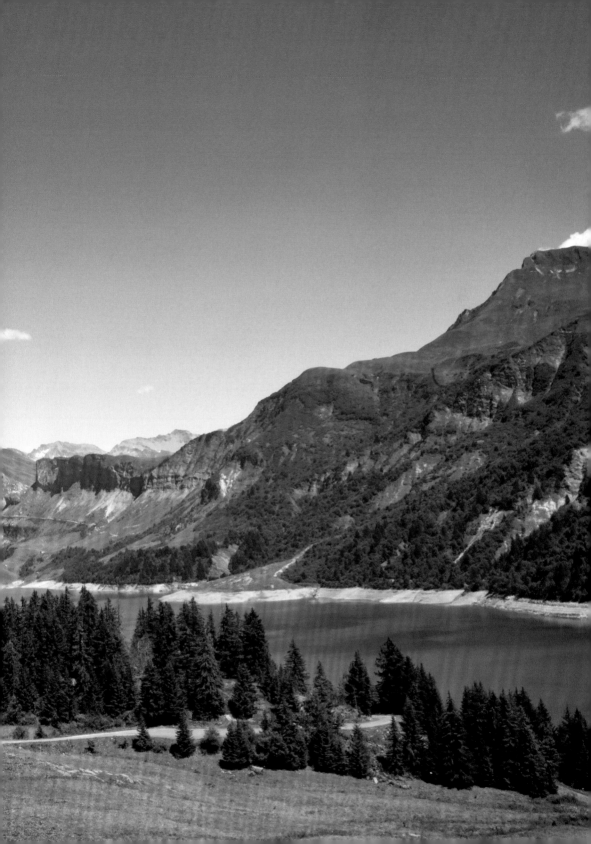

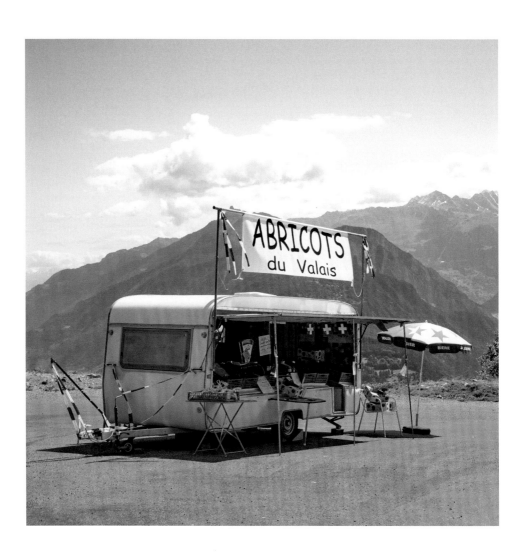

## Western approach from Bourg-Saint-Maurice 813m

LENGTH  31KM

HEIGHT GAINED  1375M

MAXIMUM GRADIENT  6%

This gently sloping road, kinked like a firecracker, was built during the reign of the Emperor Napoleon III. For much of the way you have a wide view of the upper reaches and the skyline and the frontier towers, as it were, to either side of the col, the Sommet des Rousses and Mont Valaisan, flanking the gateway into Italy. The gradient is regular.

By a hairpin just below La Rosière (1840m, 22.8km) a memorial hails the soldiers of the AS (Armée Secrète) who died for the liberation of France: *Tués Sept 1944*, that is, 'killed'.

La Rosière is twee ski fantasy-land: a giant plastic model of a Saint Bernard dog, shops aplenty purveying souvenirs, books, tat, plenty of bars and restaurants, car parks, a post office with public loo attached, street lights, a Gatling gun parked on a roof, one hopes not operational.

From La Rosière, the road straightens for most of the way to the col, but still at the same mild gradient.

As a descent into Bourg-Saint-Maurice, this direction is pretty hairy. From the top, there are no barriers, a yawning drop to the right and a long view of Bourg-Saint-Maurice in the valley way below. Some long straights with kinks, fast, fast, fast with spells of hard braking, a fair bit of new surface. Below La Rosière the bends begin to swing. Le Belvédère, a hotel/restaurant and *relais aux motos*, (motorcyclists welcome) at 1260m, 17km from the col, is also identified by a dark blue sign, as a hamlet.

Bourg doesn't look very inviting from this height, 24km from the col, an urban spread clogging the valley basin like detritus collecting against a sluice grille, a sight further vitiated by a massive electricity power installation, EDF (Electricité de France) at its least environmentally friendly, an oppressive mesh of stanchions and cables, a grim wire and rod realization of a mechanistic spider's web.

Once you are in town, however, the mood is friendlier. A pleasant little square in which to sit for coffee and cake. Remember that it is quite permissible to buy your *éclair, pain au chocolat, réligieuse* (iced bun) or *baba au rhum* at a patisserie and import it to a café.

Before the opening of the Mont Blanc tunnel in 1965, the two Saint-Bernard passes offered the only routes circumventing the Mont Blanc massif.

# LES ARCS 2130M

*The usual approach is from Bourg-Saint-Maurice but we explored a quieter, more attractive side route of around 19km through a number of small communities and woodland. The gradients are manageable all the way.*

From Landry, which lies on a side road running parallel to the N90 south out of Bourg, take the D87 to Peisey-Nancroix, a pleasant, bendy road. The surface is smooth, the gradient regular. At 1.8km a torrent gushes down to supply the small river Ponturin in the long cleft it has carved on its way from the Lac de Plagne, and from Moulins, the mountainous skyline which houses that lake hoves into view. Turn left to Vallandry. Peisey-Nancroix is in an enclave of its own up a side turning.

Its name is derived from the *épicéa commun,* or red pine, and two words signifying a river valley, thus Red Pine of the Valley. This small community is the principal base for the ascent of Mont Pourri (3799m) whose mighty bulk bestrides the heights on the west side of the Isère valley, so-called 'rotten' (*pourri*) because the quartzite of which it is largely composed is very friable. The valley was once much mined for the silver-bearing lead, first unearthed here in 1714. When Savoy briefly became French in 1802, the Consulate decreed the institution of a School of Mining in Paris. A subsidiary school established in Moûtiers had a practical work centre in Peisey. When Savoy reverted to the kingdom of Sardinia, the mining school decamped to Paris, the works at Peisey was abandoned in 1836 and the mineworks finished thirty years later.

At 1.8km a torrent gushes down to supply the small river Ponturin in the long cleft it has carved on its way from the Lac de Plagne and from Moulins

There's an excellent delicatessen in Vallandry, perfect fare for a hearty picnic. From Vallandry, stay on the D226 to Plan Peisey and then turn left to Les Arcs l'Été (on a sign with other indications for chalets, etc.) up past the Bar du Mont Blanc and on through a barrier onto a narrow road, smooth and wooded. This is the Forêt Communale de Landry. The road runs flat round the hillside in ample shade of pines, breaks clear through meadows into Les Arcs l'Été, a complex of apartment blocks, a swimming pool. We observed a class of water aerobics, an instructor on the side doing the actions for the class in the pool. On past the golf course – emphatically *past* the golf course – tennis courts and Chalets d'Alpage (Alpine huts) down into Les Arcs 1800m and a jumble of garishly coloured chalets like something out of a child's toy box. Paragliders wheel above the apartment blocks and cable cars. The D119 heads down to Bourg past a right turn which leads up to Les Arcs 2000m, 4km of around 5%, three of 1–3% and a final hoist to the ski station and the clamour of shops of four at 7%.

The descent to Bourg, 14km of an average 7%, is undistinguished. Towards the bottom a plaintive marble plaque fixed to a rock with a nosegay of flowers lying by it is dedicated:

A la mémoire de mon époux de mon père
   DO ROSARIO BREIA
*Antonio décédé accidentellement le*
   *5 10 2000 victime de l'imprudence*
   *des hommes*
(A wife and son remembering their husband/father, killed in a car crash caused by a reckless driver)

The cables of a funicular are slung across the road from its terminal in Bourg.

# LA PLAGNE 2100M

*From Aime 670m*

LENGTH  21.4KM
HEIGHT GAINED  1430
MAXIMUM GRADIENT  9%

This is one of the more picturesque ascents to the hideosity of a ski station dead-end, about which nothing favourable in the language of aesthetics can cheerfully be said.

The new tarmac of the D224 leads into Macôt (770m, 2.6km), a one-star *village fleurie* – village of flowers – whose church is crowned with an elaborate spire like an upturned wine goblet topped by the spike of a Prussian helmet with a couple of knobs on and, spreading at the bottom, an ostentatious blancmange mould.

The road is curvy, trees line the route, the surface is well maintained and, as on l'Alpe d'Huez, the hairpins are numbered, although not all give the intermediate altitude. The gradient hovers around 7–8% pretty well all the way.

21: La Grangette 867m at 1km, full-log (pit-prop) barriers. 20: La Combe swings about sweetly. 19: Les Fontanils at 2km. 18: Le Château. 17: Les Echables 1046m at 5km. 16: Côte Rouge. 15: Plan du Guy and a lovely vista to the left. 14: Le Cretet ushers in a sting of around 9% but for a short stretch only. 13: La Bise. 12: Villard du Bas (1192m). 11: Villard du Haut. 10: Le Savouï (8.3km) and a big view down over Aime and the length of the valley. 9: Les Charmettes. 8: Les Césières. 7: Les

Ouvertes/La Roche (1545m). At 11.7km the road skirts the distinctly scary Piste Olympique de Bob off to the side, built for the 1992 Winter Olympics hosted by Albertville. Here the road shrinks to what may have been the first narrow way up here. 6: Plangagnant (the name of a hamlet higher up). 5: Le Pont de l'Arc (14.2km), where the chalets begin, but only a small outcrop. 4: Les Bouclets and the high-rise apartment blocks of the ski station come into view. 3: Pra-Conduit (1816m) and a sign to La Plagne. 2: Plante-Melay. 1: La Mine and a final hike of 1km to the centre of La Plagne which occupies a bowled slope below a ring of heights. From here take in a wonderful panorama and look forward to a rapid descent, with open views for much of the way, back to the valley.

Although La Plagne is no less unsightly than any ski station, the road up to it has charm, movement, views and gradient to make it hard, if not (the 1987 Tour story apart) particularly momentous.

*Snapshot*

# TOUR DE FRANCE 1987
## STAGE 21, BOURG-D'OISANS-LA PLAGNE *185KM*

On Stage 20, Pedro Delgado had taken the yellow jersey from
Stephen Roche with a withering attack on the slopes of l'Alpe d'Huez,
which took two minutes out of the Irishman. Roche counter-attacked
next day along the valley of the Maurienne into a powerful and
blustery headwind. This seemed to be rash, a thoughtless waste of
energy. Delgado and Erik Breukink, taken by surprise and assessing
the move as foolish, made no move to follow, but the Frenchman
Jean-François Bernard chased. At the summit of the Madeleine,
Roche was caught, his attack nullified. Now Laurent Fignon, finding
himself unmarked by the others, went out on his own to chase the
early escapees, among them the Colombian climber, Fabio Parra,
and the Spaniard, Anselmo Fuerte.

When Delgado launched his own attack at the foot of the climb
to La Plagne, Fignon had a lead of three minutes on him. Halfway up,
Roche, sorely depleted from his efforts earlier in the stage, trailed the
yellow jersey by ninety seconds. But, Delgado was weakening, too. He
crossed the line and the seconds of his advantage over the Irishman
began to mount up. Nearly forty had gone by when, suddenly, round
the last corner, came Roche, driving himself to exhaustion. Phil
Liggett, commentating for Channel 4 on British television, cried
out, hoarse with excitement: 'It's ROCHE, it's Stephen Roche, I don't
believe it!' Roche, having clawed back almost a minute of his deficit,
collapsed off the bike and was immediately given oxygen. Word is

Fignon took the win, a brilliant piece of riding by an outstanding bike rider. A man apart, of lucid intelligence and straight talk, estimable in his honesty, worthy in thought and dealing

that he was cracking jokes even at that moment in extremis, to the effect that he didn't need any gas, but this may be apocryphal.

Fignon took the win, a brilliant piece of riding by an outstanding bike rider. A man apart, of lucid intelligence and straight talk, estimable in his honesty, worthy in thought and dealing, he died, at the age of only fifty, in 2010. Salute his shade.

The following day, Roche, completely recovered, easily answered two attacks by Delgado on the final climb to Joux-Plane, then attacked in his turn and took eighteen seconds back from him. Delgado was no racer against the clock, and after the final time trial in Dijon Roche was back in yellow by a margin of sixty-one seconds. Later that year, he became only the second man to win the Giro d'Italia, Tour de France and World Road Race in one season (the first was Eddy Merckx in 1974).

# CORMET DE ROSELEND 1967M

*(Cormet comes from medieval Latin culmus – a summit, peak, as in 'culmination'. Roselend, a place abundant in roseaux, a name for various plants which grow in moist ground, from a Germanic rausa, rauza – reed, flag, rush.)*

*Eastern approach from Bourg-Saint-Maurice 813m*

LENGTH 20.3KM
HEIGHT GAINED 1154M
MAXIMUM GRADIENT 9%

The D902, the Route des Grandes Alpes (which runs across the mountains from Evian-les-Bains to Nice), leaves town on a mild slope and narrows to a ledge with a friendly vista of rooftops and winds on past a bluff and a ruined tower. In La Grange, a sign indicates 18km, 905m. Here too, a climbing-practice rockface/slab about 10m high. From Le Chatelard (960m) an uninterrupted view of the piped cables from and into the EDF installation running over the mountainside like corded veins and, near the lake by the town, the lower terminus of the funicular.

A short way on, a road off to the left leads up to two forts, the Fort du Truc and de la Platte. After the annexation of Savoy by France in 1860, the new frontier ran close by Bourg-Saint-Maurice and a string of forts was built, spaced around 3km apart, to form a defensive curtain. As Franco-Italian relations deteriorated

towards the end of the century, heavier emplacements were constructed, among them these two blockhouses at 2000m, for defence against any incursion by Italian troops.

A sign, first of a series from here on, reading '17km 960m 4%', mimics the old round-topped *bornes* (kilometre stones), white with yellow cap, adorned with a Savoy flag. An intermittent log barrier lines the route into a kilometre of gradual descent, which accounts for the averaging of the 4% to 16km, 995m, 3%, where the road narrows and the surface has suffered a little from vicissitudes of weather and wear. At 15km, 1020m, 7% the road broadens again in company of trees and a river, the Torrent des Glaciers, to the left, on the approach to Bonneval (in dialect Bonnévaz) les Bains (1070m), the spa hotel that is, was, Bonneval. This massive edifice has been completely stripped out, doors and windows gone, walls, stairs, ceilings flayed and scraped back to the skeletal concrete, some floors broken and removed, a goof-faced Homer Simpson daubed on one wall, the floor of the cellar strewn with litter and assorted rubbish.

Over the road, opposite, a concrete-lined tank with a chute, clearly a former *piscine* with slide, supplied by diverted waters from the clear glacial torrent (its glacier lies under Mont Blanc). Some 30m further up the road, a large car pull-off and a smaller torrent running down. A sign on the river side carries fishing restrictions: one fish per angler per day, and

a minimum size of 23cm, only one hook without a barb (*sans ardillon*) to be used.

The Romans certainly exploited the waters for baths at Bonneval, but it was not until the nineteenth century that the water was analysed and found to contain slight traces of sulphuric acid, whence the slight odour of sulphur they emit. In 1888, a high spate imported a mass of debris to raise the bed of the torrent and to flood the springs feeding it. This encouraged a number of enterprises for full exploitation of the waters here, hence this five-storey hotel, swimming pool and diversion of the torrent, built before the First World War. Alas, as soon as the building was completed, the waters receded, although a local woman whom I asked about the place told me that her father remembers going there to swim in the 1940s. The source eventually dried out completely and was only rediscovered in the 1990s. The broken hotel stands, therefore, like the ruined and broken statue of Ozymandias in the desert.

The gradient is now in a loping stride for 5km of around 8% along this Vallée de Chapieux between trees to the right and meadows to the left which slope down to the brisk waters of the torrent flowing under the bare sides of the cliffs soaring up towards the Aigles de Prainan and du Grand Fond and La Terrasse. Majestic surroundings: the road, a widening valley, beetling ramparts of rock, a grip of that mystery attached to altitude and

the forbidding air of bulwarks of native stone shaped and battered by natural assault, ice, rain, sun.

Gradually, the road climbs away round hairpins to leave the torrent some distance below as new springs of replenishing water bubble off the hillside to the right. A sudden flatness intervenes at 9km, 1475m, 1% and the interfold of opposing pleats of the mountain appears ahead. The torrent runs on a broader, flatter bed at this upper reach of the valley and a cleft in the rock wall to the left still retains some snow, unmelted even in this July. A house, abandoned and forlorn with no roof. From 7km, 1530m, 6% the cirque of crests and high cols through which flow the first waters of the Torrent des Glaciers, one of many cascades spilling out of the Mont Blanc massif, comes into view ahead.

Travellers using this lonely road were once prey to a nest of brigands who holed up in a wooded fastness on a side track and forced ransom out of them. (The word stems from Latin *redemptio*, that is money to redeem a debt or pledge.) These bandits were, so church legend has it, eventually chased off by Saint Anthony of Padua on his way back to Italy from Provence. Saint he may have been but patently, if he planned this route home, his sense of direction was woefully short of dependable. Miles out of his way. Nevertheless, he was sanctified within a year of his death and the grateful itinerants of the Chapieux valley placed

# Majestic surroundings: the road, a widening valley, beetling ramparts of rock, a grip of that mystery attached to altitude and the forbidding air of bulwarks of native stone

a statue of him in a niche for their continued protection. It is nowhere apparent now.

Les Chapieux (1549m) lies off the main road to the east along a roughly metalled track which forms part of the eight-day, approximately 160km circular Tour du Mont Blanc, first organized in the nineteenth century. The refuge in the village serves as an overnight stop for trekkers. The village, whose name in dialect signifies a grange or storehouse for fodder, is of ancient date although its chapel was not built until the start of the seventeenth century. You'd have thought the wandering thirteenth-century holy man Anthony might have had something to say on that score – godless inhabitants plagued by robbers, get a pious grip…

As part of the general fortification of this valley, barracks were constructed in 1889 and served as living quarters for a detachment of the 22nd Battalion of the Chasseurs Alpins based in Albertville until 1944. In the fateful summer of that year, the Germans destroyed Les Chapieux in their furious response to the uprising of the Free French and Resistance.

(The barrack buildings were swept away by an avalanche in the winter of 1999–2000.)

From Les Chapieux, a *navette* (shuttle service) takes eighteen walkers at a time 4km up to the Ville des Glaciers (1781m), lying below the Glacier des Glaciers, plainly visible, with the Aigle des Glaciers poking up above it. The Refuge Les Mottets lies a short hop beyond the *ville*.

A shop in Les Chapieux sells honey, jam, soap, bunches of dried *génépi*, the yellow flower used for flavouring alcohol, and cheese. 'Welcome to the Beaufortain', chirrups a notice. The cheese is made from milk of the Tarine (also known as Tarentaise, from Savoie) and Abondance (from Haute-Savoie) breeds of cow that pasture here and up towards the col for a hundred days in the summer transhumance. From their milk comes *le prince des gruyères:* le Beaufort.

The last 6km zigzag at 6% through green slopes – a stubble of furze studded with bushes, here and there a veritable rash of stunted bushes, or a sparse bristle of dwarf pines. Ruined buildings are dotted about as well,

upland summer cabins presumably – they lend a certain doleful air to this rather bleak area. Following 3km, 1795m, 5% and 2km, 1840m, 7% the road does up its jersey, settles the Rudy Project shades on its nose and rides the Arrivée strip of a long, long exposed straight, a deadly throw for this final ride-in, the hummocks of the col enticingly ahead. Another sign comes like a jeering taunt, 1km, 1905m, 6%, and so to the col at 1967m. (The old blue and white sign reads 1968m.)

A stall purveys minerals and crystals, pollen mixture, royal jelly and pastilles of *gomme de propolis* (in various flavours composed of liquorice, eucalyptus, orange and honey blends) to soothe a sore throat and freshen the breath. Propolis is a resinous mixture gathered by honeybees from tree buds, sap flows or other botanical sources. They use it to plug small gaps in the wall of the hive. Larger spaces they seal with beeswax. As well as acting as a filler, propolis is reckoned also to act as a sort of disinfectant against disease and bacterial infection.

An information panel tells us:

1909   The (automobile) Touring Club de France initiated work on the Route des Grandes Alpes.

1913   The autocar Compagnie Paris-Lyon-Méditérrannée launched its cross-Alps service, following the grand route in five day-stages.

1914–1918   The war called a halt to everything.

1930   The journey from Nice to Chamonix now took no longer than a day and a half.

1970   Opening of the Cormet de Roselend.

A tufa and limestone chapel to Sainte-Marie-Madeleine, dating from some time before the fifteenth century, was rebuilt 1946–1948, perhaps to bless work on the new Barrage de Roselend (see below).

A short way down from the col, the Chalet de Roselend invites visitors to learn about the transhumance, an essential part of the local economy. Droves of cattle to please any discerning cowpoke's eye graze on both sides. The road shimmies on open country round a number of stabbing corners and two large bends at a steady drop of 7–8% for 8.2km to the Col de Meraillet (1605m). (The Refuge du Plan de la Lai at 1822m squats by the road 2.7km from the summit.) A torrent rushes along its channel below the col and two jutting buttresses of bare rock stand over it like barbicans. In the distance, the blue intaglio of the Lac de la Girotte, the first reservoir to be opened in the Beaufortain region, 1923. The D925 continues northwards for 12.3km into Beaufort (745m) at around 8%.

# COL DU PRÉ 1703M

From the Col de Méraillet, a narrow road plunges off to the left, a winding descent of just short of 2km, which sways round a right-hand hairpin and winds round the bowl at whose bottom sits the Lac de Roselend (1559m). When the barrage was complete (constructed 1955–1962), a village drowned beneath the waters of the new reservoir. A chapel, replica of the old church, was erected by the waterside, in memoriam.

A warning *Baignade Interdite* does not deter everyone from taking a dip in the milky jade-green waters. A former wild freshwater swimmer myself, I spotted the outlaws and approved. Not all aquatic disport is discouraged. A *Club Nautique de Roselend* resides in a wooden shack next to another such which houses a bar/restaurant/café. Further along, a hotel/bar/restaurant and, past a road leading right back to the D925, at an angle of the artificial lake, begins the short (5km) climb to the Col du Pré on a very narrow path of a road. One bout of 8%, the last 2km at nearly 10% to the high point (*c.* 1720m) from which you may look across to see the switchback of the descent off the Cormet de Roselend. This is not the col. A short drop brings you to a sign, *Bienvenue au Col du Pré 1703m*, 500m below the brow, and another sign, lower down, by a picnic table on a bank. Thus, an odd trinity of heights, vying for attention.

The col overlooks the neatly groomed valley of the Pontcellamont, etched with a curvaceous wiggle of small roads weaving round to the entrance of the houses and their laid-out plots of land, in a pattern resembling the tunnels in a termite hill whose top surface has been sliced off to reveal them.

The col overlooks the neatly groomed valley of the Pontcellamont, etched with a curvaceous wiggle of small roads

## Western approach from Beaufort 745m

LENGTH 13KM

HEIGHT GAINED 958M

MAXIMUM GRADIENT 10%

Beaufort has a striking church. The clock tower – clock attached – first develops an open, arcaded gallery on top of which sits a bulbous roof in the shape of a cloche hat whose crown extends, slightly narrower than the full bell, to another, smaller arcaded gallery, like a lookout platform. The whole is topped with a slender spire, an orbed bobble at its peak, base for a cross.

A steady haul of around 7% from Beaufort to Arèches (1032m) into the sanctum of this lovely wooded pleat of the hillside. In Arèches, a sizeable *centre de vacances* (holiday centre) with ski shops in evidence but no ski lifts; note a barn decorated with a vast number of red, blue and green metal plaques attached to the wooden wall, prizes at agricultural shows. A further 2km of similar slope into Boudin, 'Pudding?'. Sadly not; rather the name is from a Germanic word meaning 'messenger'. How dull is that?

The houses of Boudin (we read from a *panneau* – sign) were once all built of limestone, the last constructed in around 1900. The stone was quarried from the Roche Parstire which looms over the village. Its flanks are stepped in steep, bare cliff faces stacked on top of each other. The quarried limestone was baked in an oven at 600–800°C for a considerable time to dry and harden it.

The climb up from Boudin to the col, beautiful, tranquil, unspoilt, is hard, 5km of nothing less than 10% to a slight easing at the top.

# COL DES SAISIES 1650M

*This col celebrates rock, the stuff of this landscape, in* saxa, *the plural of the Latin* saxum, *which an ill-schooled, chancy ungrammared fellow took for a feminine (it's neuter) on the way to shaping Old French* sasse, *a rock. Imagine, -um as feminine.*

## Southern approach from Beaufort 745m

LENGTH  18.2KM
HEIGHT GAINED  905M
MAXIMUM GRADIENT  8%

Three kilometres north of Beaufort on the D925 turn right onto the D218m and the start of the climb, a fairly trouble-free opener. The road, part of the Route des Grandes Alpes, follows a broad valley with a spacious view, lazy bends on a very long straight bit of highway with sporadic indication of distance. Hauteluce, which lies below the road to the right at 3km, has a church whose steeple resembles that of Beaufort. Beaufort, until the twelfth century, retained its old Latin name of Lucia, and this high Lucia is the upper outreach of the main town. The fields are well cared for, and there was a sort of crop circle pattern in dun colour cut into the green of the mountain slope some distance off to the right.

## Alternative 1 via Villard-sur-Doron 705m

LENGTH  16KM
MAXIMUM GRADIENT  10%

From Villard-sur-Doron, follow the D123 towards the Signal de Bisanne. The road is quite narrow and mounts on a steady increase through 7–10% for just over 12km to the junction (1710m) with a cul-de-sac leading to the Signal (originally a semaphore post) from which a vast panorama extends across the Combe de Savoie, the Aravis mountains and the Beaufortain and Mont Blanc massifs. From the junction, the road descends for a kilometre and then climbs the final stretch at a docile 5%.

## Alternative 2 via Villard-sur-Doron 705m

LENGTH  15.8KM
MAXIMUM GRADIENT  11%

Even steeper, this route goes from Les Perrières on the D925 by way of Le Mont to the same junction with the Signal road. The col is a wide plateau – car parks, shops and eateries and a monument to the FFI and a parachute drop of arms made here in daylight.

## Northern approach from Flumet 910m

LENGTH 15KM

HEIGHT GAINED 740M

MAXIMUM GRADIENT 8%

Flumet is a summer and winter resort and this road up to the col is lined with small communities more or less serving the same commerce. Notre Dame de Bellecombe (1110m, 3.2km) has its own outcrop of ski lifts. The slope flows between 6 and 8% for 9km, falls away and mounts the final 4km at no more than 6.5%.

## Southern approach via Villard-sur-Doron 705m

LENGTH 16KM

HEIGHT GAINED 945M

MAXIMUM GRADIENT 10%

The extremely narrow D123 heads through the village and out onto that familiar pattern of steep hairpins linking longish straights. As Villard sinks below the line of sporadic new chalets, a view of its cemetery and the valley road. Shade is intermittent, the trees mostly obedient to a routine spacing though they occasionally get conspiratorial and crowd more densely, hugger-mugger. There are kilometre signs all the way save, perhaps from superstition, at 'lucky for some' number 13. The gradient lower down feels steeper than the 6.7–8.5% of official reckoning and the string of settlements, all separately named, make claim, of title, somewhat beyond their obvious standing: Le Cray d'en Bas; La Place; Le Cray-en-Haut; Les Charonnes; La Nuaz; Les Pallières (where the barn to store the straw – *paille* – originally stood).

After the upper Cray, the slope gradually tightens and the last kilometre (2km from the Saisies), leading to the turn-off to the Signal de Bisanne, is at 10.9%. From the turn, the road drops down through the extended Saisies ski suburb to the col. At 10.2km, a turn left brings up the road from another approach, via Mont. It's narrow, steep – up to 11% – through open farmland, 15.8km long.

## Alternative northern approach via Crest-Voland from Flumet 910m

LENGTH 14.7KM

HEIGHT GAINED 740M

MAXIMUM GRADIENT 9%

The D71$^B$ passes a concrete parapet near Flumet on which is daubed 'SAVOIE LIBRE' (A free Savoy). This would seem to be a forlorn hope. Another narrow steep climb, through farmland and the occasional tree thickets of the upper slope, for 6.5km into Crest-Volland (1218m) where the D71$^B$ becomes the D71$^A$. In one of the acreages of woodland, a site for ESCALADVENTURE, high jinks involving wooden slat bridges, rope walkways, overhead cables for sliding down on pulleys and rope seats.

# 'EBONITE', *August 1944*

(Ebonite: a hard compound of India rubber and sulphur formed by the action of heat. Used as an insulating material before the invention of bakelite, ebonite, or vulcanite, also goes into the manufacture of lawn bowling balls, fountain pens, and saxophone and clarinet mouthpieces.)

The code name of the col, Ebonite, was included in a BBC radio broadcast message on 31 July 1944 prefaced by '*Dans le potager le jardinier arrose ses laitues*' – the gardener is watering his lettuces in the vegetable plot. (Two months earlier, the Allied invasion on D-Day had been signalled by '*Jean a la longue moustache*' – John has a long moustache.) This alerted sections of the FFI, already partially armed, to block access to the Beaufortain area, namely the high mountain paths over the cols de la Bathie, Forclaz, Cormet d'Arèches and Roselend (not yet a road) as well as the important through-route along the Val d'Arly which follows the line of the D1212 from Albertville north-east to Flumet (at the northern foot of the Saisies) and Megève, into which the Arly flows from the heights above town. This area was to be held by *résistants* whilst other sections of the FFI made for the Saisies itself.

On 1 August 1944, towards 3pm, seventy-eight B17 bombers from the 388th Group USAAF which had taken off from Knettishall in Norfolk flew over the col. Eight US Marines jumped, one parachute didn't open and Sgt Charles Perry crashed fatally to the ground. The men were followed by 864 supply cylinders containing thousands of weapons, which were gathered in and stored in the nearby chalet-hotel Eckl for distribution in lorries, carts, mules or on men's backs. The massive consignment included Sten automatic machine guns, Bren light machine guns, Lee Enfield .33 rifles, Mills bombs, Gammon grenades, automatic pistols, PIST anti-gun guns, 2.5 million rounds of ammunition, several tons of explosives, medical supplies, rations, chewing gum and bicycle tyres.

The American Major Peter Ortiz, of the Office of Strategic Services (their intelligence operation set up during the war), in command of the drop, jumped with a suitcase containing a million French francs for the *résistants* on the Vercors plateau. The drop party also carried a silver hip flask of cognac each and several packs of Lucky Strike cigarettes without markings.

The French officer commanding the FFI regiment, codename Alberto, was one Capitaine Jean Bulle (John Bull: surely another codename). He liaised for the drop and subsequently, as the hard-pressed Germans were being pushed back, he approached their HQ command under truce to sue for the surrender of Albertville. He was arrested and executed – '*lachement*' (in cowardly fashion) – by the Germans on 21 August.

ANNECY

# ANNECY

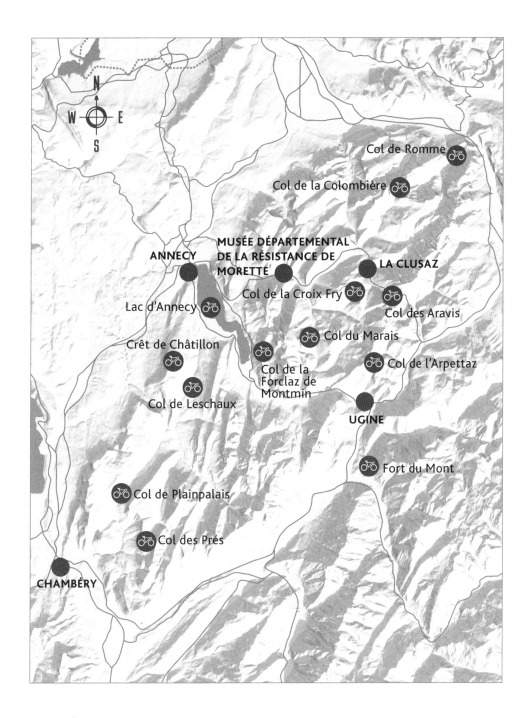

Col de Romme

Col de la Colombière

MUSÉE DÉPARTEMENTAL
DE LA RÉSISTANCE DE
MORETTE

ANNECY

LA CLUSAZ

Col de la Croix Fry

Col des Aravis

Lac d'Annecy

Col du Marais

Crêt de Châtillon

Col de l'Arpettaz

Col de la
Forclaz de
Montmin

Col de Leschaux

UGINE

Fort du Mont

Col de Plainpalais

Col des Prés

CHAMBÉRY

# INTRODUCTION

The old centre of Annecy, situated at the north-west end of the eponymous lake, is laced with small canals whose sidewalks abound with flowers in pots and hanging baskets. Cafés and restaurants, shops, a gentle breathing of contentment. A short step away from the waterways, umbrageous arcades house more shops. The lake itself opens out eastwards from the promenade, a fine vista, boats moored, the pleasure cruiser, full-bodied as a barge, ready to go, the far horizon crenellated with mountains. Annecy is a most attractive place. Away from town, the lake offers good freshwater swimming, shoreline orchards, hotels and restaurants, small marinas for the boats, sail and motor, which ply the broad expanse of the water, 3.5km across its widest point. In short, Annecy makes an ideal base for wider exploration.

In the early years of the Reformation, Annecy welcomed a number of monastic institutions and individuals driven out of Calvinist Geneva. François de Sales (later Saint), born in a château in Thorens-de-Glières to the north-east in 1567, became bishop of Geneva in 1602 but, in the face of hostile puritanical sentiment in that bigoted society, made his base in Annecy. A spellbinding preacher and a man of simple and passionate faith, he had a particular affinity with the poor and no truck with the notion that sanctity was a gift of the Church alone, choosing, rather, to address himself directly to lay people with a message of individual faith.

Jean-Jacques Rousseau, expelled from Geneva in 1728 aged sixteen for thrice failing to return to the city before the gates were shut for the night, was directed by a sympathetic priest to go to Annecy and seek out a pious woman, a recent convert to Catholicism, the twenty-eight-year-old Madame de Warens. 'I had expected her to be a peevish, sanctimonious old woman... but [at their first meeting] I saw a face full of charm, lovely round blue eyes radiating kindness, a fair skin and a gracious neck... I was, on the instant, hers. I knew

that the faith preached by such a missionary could not but lead me to paradise' (*Confessions* Book Two). Her influence on him was profound and the paradise to which she led him was earthly – they became lovers when he was twenty years old – as well as spiritual. But he was muddled. She was also sharing her bed with her steward. Rousseau called her Mamma and he eventually declared that he loved her too much to desire her.

## The Liberation of Haute-Savoie, 1944

The German army, SS and Gestapo moved into Annecy in late 1943 together with a garrison of the Milice. Arrests, executions and deportation of suspects followed in a wide sweep of *rafles* (round-ups) across the region.

On 31 January 1944, in response to the increasing activity of the local Resistance, the Vichy government declared martial law in Haute-Savoie, effectively placing it under a state of siege. Anyone caught in possession of or storing arms or explosives was to be taken immediately before a Court Martial, to face summary judgement and execution. This had precedent in the brutal jurisdiction of the French revolutionary Terror, when the public prosecutor had insisted that 'the ideal time between arrest and execution was twenty-four hours'. This prompted a judge, a friend of mine, to remark: 'Not a very sophisticated system of appeal, then?'

The edict, disseminated on posters throughout the region, concluded: '*Toute attitude hostile, le recel d'individus "hors-la-loi", SERONT REPRIMÉS SEVÈREMENT tant dans les personnes que dans les biens.*' (Any hostile behaviour, including the hiding of outlaws, WILL BE SEVERELY REPRESSED, both persons and property.) A curfew was imposed. (Originally *couvre-feu*, this was a regulation in medieval Europe by which the tolling of a bell at a fixed time each evening indicated when fires had to be extinguished. The purpose was, it

On 31 January 1944, in response to the increasing activity of the local Resistance, the Vichy government declared martial law in Haute-Savoie, effectively placing it under a state of siege.

seems, to prevent the risk of conflagration if fires in grates were left untended overnight.)

On 13 March, ninety-eight people were arrested in Annecy and held prisoner in one of the lake's pleasure steamboats. The manhunt intensified after the fighting on the Glières plateau (See *Introduction*) and continued until the end of May, the eve of the Allied invasion. Maquisard sabotage grew bolder and, on 10 May, Allied aircraft bombed Annecy for a third time. The target, a factory in German control producing bearings, was flattened. Unhappily, despite attempts to keep civilian casualties to a minimum, forty died and twenty-six were wounded. Reprisals ensued.

The sabotage continued and, within a short while, most lines of communication in the *département* had been cut. Some railway tracks and roads were repaired, but by the end of June the Maquis controlled all the high crossings, all the valleys and the mountain zone of the Haute-Savoie, and the Germans were bottled up in Annecy and a number of other scattered garrisons.

*14 July*. Bastille Day, the national festival, armed *résistants* parade through the streets of Thorens-Glières at the foot of the plateau and in other villages and towns in an audacious open show of force.

*1 August*. One hundred and sixty tons of arms and ammunition dropped, in broad daylight, by seventy-two American B17 Flying Fortresses to 3,000 men and women waiting on the Glières plateau and distributed to other resistance groups within forty-eight hours.

*2 August*. A column of German troops and Milice overcomes resistance on the Col de Bluffy outside Annecy to the east and moves on to batter Thônes with artillery fire before entering the town and killing twelve civilians, wounding thirty. They return next day and shoot dead a woman and her child out of hand.

*8 August*. The German command in Grenoble instigates the *Hochsommer* (High Summer) campaign to crush Haute-Savoie.

*11 August*. A broadcast message: Allied landings in Provence imminent. The FFI put on high alert. Phase one: to isolate and pick off German reinforcements heading from their base in Grenoble, using the natural barrier of the Chéran river in the marshy area west of Annecy. Phase two: to attack German garrisons across the region. Phase three: to converge on Annecy.

*14 August.* News: Allies landing in Provence. *Résistants* launch assaults on all German garrisons except Annecy. In the early hours of 16 August, Evian becomes the first town to be liberated when the Germans there surrender. Other towns soon follow.

*17 August.* Fourteen lorries packed with German troops sets off from Annecy to reinforce the beleaguered garrison in Cluses holed up in the Ecole Nationale d'Horlogerie (National School of Horology – see *Col de Romme*. Ambushed by the FFI near Thorens. Discovering that four of the trucks are transporting hostages, the FFI back off and the convoy proceeds to Cluses.

*18 August.* Cluses. At dawn, under cover of early morning mist, a small convoy of Germans leaves with the hostages. Halted at Vougy, the Germans run. 9am, Cluses taken. 10.30am, Annemasse taken. The Gestapo chief and a number of senior officers escape across the border into Switzerland. Later, Swiss radio announces: 'The *département* of Haute-Savoie has been liberated, with the exception of Annecy which is encircled by 13,000 men of the FFI.' At 10pm, Colonel Meyer, the German commander in Annecy, with only 1,000 Wehrmacht and SS at his disposal, entered negotiations with the FFI commander in Le Grand-Bornand. At 7am next morning, his delegation arrived at a villa in Chavoire on the northern shore of the lake under a white flag of truce. The Germans agreed to unconditional surrender and the delegation returned to the Wehrmacht HQ in the Hotel Splendide, by the lake in Annecy. (Our photographer and I, ever eager to research the slightest detail, stayed two nights there, without untoward incident.) Meyer was given until 10am to reply. (The Milice, in their requisitioned HQ, Les Marquisats, to the south of town, surrendered at dawn.)

In the meantime a Maquis group, augmented by a group of Spanish fighters, moved into the north-west quarter of town, surrounded the main garrison in the centre and, at 8.30 a.m., the 600-strong cadre of German troops caved in. Half an hour later, the SS counter-attacked but were soundly beaten. Two maquisards died, the only fatalities that day, and several were wounded. At 10am, Meyer signed the act of capitulation.

20 *August*. The victorious FFI paraded through the streets of Annecy, hailed by massive cheering crowds. Haute-Savoie, the first – and only – *département* to be liberated by French forces, unaided on the ground.

23 *August*. Seventy-six former *gendarmes* from the Milice were subjected to a parody of a trial and condemned to death by a Court Martial of the FFI. The following day, they were shot, close to the Peseretaz wood in the Bouchet valley. Forty-four were buried in a cemetery created on the spot. Report has it that several were younger than eighteen and at least one had never been part of the detested militia but was caught up in the excuse for a vendetta.

# COL DE LA COLOMBIÈRE 1613M

*Northern approach out of Cluses 485m*

LENGTH 19.5KM

HEIGHT GAINED 1128M

MAXIMUM GRADIENT 10%

The D4 turns off the main D1205 (left for Chamonix, right for Annemasse and Genève), heading west, bypassing Scionzier and Blanzy, a jostle of shops, industrial estate, supermarket, petrol station, into quieter marches beyond the urban sludge. A sign indicates Le Reposoir, 'resting place', and although this must not allow false comfort – there is still a long way to go and hard climbing – it is a nod at the more peaceable acres up ahead. You proceed in company with trees. You do not need to hug a tree to know its solidity nor lie in its shade to register its balm. A tree is a thing of splendour, of long and steady growth, one of the few artefacts of nature which is all the better for an ever-spreading girth. Its seeming death at winter in leafless stark nudity, like a shivering beggar on a blasted heath, is the image of our own vulnerability, stripped to the core, bare of pretension, our spirit shorn of all the gaudy carapace that cunning thought and avoidance can garb it in. Think it possible always that you be mistaken, cast off the sureties of conviction which are, so often, no more than a refusal to be found out, to acknowledge error and fault. Be open. And once open, as the tree takes on a new crown of leaf in springtime, the miracle of renewal, come fresh to the experience laid

A sign tells you that this is part of the Route des Grandes Alpes. The way is wide and smooth and straightens into Neyrolles.

before you. So too, in the hard miles of any mountain, learn from yourself, explore the mental and psychological landscapes that extreme effort spreads out in front of you, the secrets of the heart unlocked. All this from a tree? As a tree lives and breathes, inhaling, absorbing and rendering harmless the noxious carbon dioxide of petrol fumes and expelling a fresher air, so we imbibe the nastier toxins of error and misunderstanding to transmute the rough knowledge into a better insight.

> Two roads diverged in a wood and I
> I took the one less travelled by
> And that has made all the difference.
> Robert Frost, *The Road Not Taken*

A sign (6km, 690m) tells you that this is part of the Route des Grandes Alpes. The way is wide and smooth and straightens into Neyrolles, 6.7km. An Italian fan has daubed *Forza! Forza!* (On! On!) for his men on a concrete barrier, whited out but just legible. A fragrance of pine resin from the woods beyond. An elegant stone well of fairly recent construction shores up the bank to the right (8.1km), trees above it, and a short way on, a large advertising hoarding – *Bienvenue au Pays Fermier du Reblochon* (welcome to the farming country of Reblochon) – and a cow on whose muzzle someone has painted red whiskers. (Reblochon is a Savoyard soft cheese, to which I will return.)

## Southern approach from Le Grand Bornand 940m

LENGTH 11.5KM
HEIGHT GAINED 673M
MAXIMUM GRADIENT 8%

In Le Grand Bornand, which puffs itself as the home of Reblochon – there's a Wednesday market for the purchase thereof – go to the Hotel/Restaurant de la Croix Saint-Maurice. The patron is a cyclist, friendly and informative, there's a free sauna for guests, a lift, and the restaurant is excellent. In the centre of town opposite the hotel entrance, a children's play park, plus novice climbing wall, both supervised.

The ascent to the col from this direction is largely a ride through an extended town, mild of slope and happiest in the final stretch of open country beyond the encroachment of buildings.

Le Grand Bornand occupies a hollow at the junction of the Chinaillon valley, cut by the stream flowing off the mountainside and the Bouchet valley to the east. The Plateau de Glières lies a short distance to the north-west.

# LE REPOSOIR

Le Reposoir (966m, 11.7km) emerges from open country, a sizeable village with cheese shop, tobacco/newspapers, fruit and vegetables. The D119 to the left leads to the Col de Romme. Le Reposoir, originally called Béol, is named for the valley at whose head it sits, the Vallée de Béol. It was christened Repausatorium in 1151, as a plaque on the church records, by 'le B [i.e. Bienheureux, 'Blessed'] Jean d'Espagne', a monk of Chartreux (mother house of the Carthusian order) sent from Grenoble. One obviously romanticized version of the story has him pitching up in this village, walking a short way up the course of the river, lighting on a tranquil spot, a resting place, plentifully supplied with the essentials for survival – fresh water, good farmland, a hidden domain – where he founds the priory of Le Reposoir, from which the village takes its new name.

At a time when seigneurs owned the land, seigneurial protection and funding was vital to any religious foundation. Enter one Aymon I of Faucigny, a nobleman with large demesne in the area, domiciled in a château in Châtillon-sur-Cluses. Home from the disastrous Second Crusade (1147–1149), as an act of penance, Aymon offered a group of monks some of his land in the Vallée du Béol for a religious house. They seem to have been ill-suited to such an enterprise. They lost animals to the depredations of wolves and, after a bad run of weather, they were flooded out. They abandoned the project. Jean d'Espagne was made of sterner mettle. With Aymon's blessing and backing, as articled in an act of property transfer on 22 January 1151, the priory of Le Reposoir had its foundation and its first prior, this same Jean.

Jean died on 25 June 1160, was beatified by Pope Pius IX on 14 July 1864 and will, it is said, intercede in the matter of a cure for eye diseases.

An inscription over the portal – *Ianua Coeli* (doorway to Heaven) – of the religious house:

AYMO DE FULCINIACO FUNDAVIT ANNO 1151
RESTAURATUR ANNO 1671
(Founded in 1151 by Aymon of Faucigny, restored in 1671)

The priory was subsequently looted and desecrated during the Revolution and the Carthusians were booted out – this is referred to in a Latin inscription by the interior door into the church from the colonnaded cloister as *in perturbatione derelicta* (abandoned during the troubles). The Carthusians returned in 1816, were evicted again in 1855, returned in 1866 but were driven out for good in 1901. A powerful anti-clerical faction, consisting of all republican groups in the Chamber of Deputies, had voiced their determination to oust royalists, militarists and clerics from public life. They forced through various anti-clerical measures, including the Law of Associations (1901), which suppressed nearly all the religious orders in France and confiscated their property. Le Reposoir was bought by a speculator and opened as a luxury hotel in 1907. The First World War killed its trade and it went bankrupt. It was bought by the Chartreuse house in 1922 and since October 1932 has been home to Carmelite nuns.

There were seventeen in residence when we visited. Quite chatty, as it happens, given the right approach. I am an old monastery hand.

La Pointe Percée (2752m), the highest peak of the Aravis chain, to the south of Le Reposoir, was the site chosen for reintroduction of the bearded vulture (*Gypaète barbu*) in 1987. May the Resting Place be their resting place. The climb out of the village is narrow and sharp, a mounting tension of gradient which instils a cogent sense of heading up for the pass, enhanced by the presence across the gorge to the south of a steep grass and pine-clad ridge, that of the Aravis and the Chaîne du Reposoir. The pines are densely planted with a texture like chunky knitting.

Some 3km from the top, a view of the pass on the skyline. The road is open, exposed to the weather that drove those first monks away, hugging the overhanging side wall. There's no barrier and the tarmac loafs towards the col like the hesitant step of a sheepish youth crossing the dance floor to ask a minx to dance. The final 2km are like her haughty rebuff, crushing, intransigent, hurtful, 9–10%. Then, like her, the col plays coquette, peeking, smiling but hanging back, dodging behind the side wall as it shoves the road round the bends and obscures the view ahead.

At the col, a restaurant and *cadeaux/souvenirs* (gifts/souvenirs) shop and a sumptuous view, north, of gaunt massifs, spiny ridges, whipped peaks, sharp-edged facets as of napped flint, the stone coated with a film of green and, this day, set off by a diaphanous flue of white clouds.

The road skips down into a wide, open valley and a great sprawl of grassland and trees. The first outpost of the omnipresent ski station, 5km below the col, Le Chinaillon, an old village swamped by resort appendages, has chalets broadcast here, there and everywhere as if delivered willy-nilly in prefab from pantechnicons, by the road, off the road, up the hillside, anywhere there was room. On one concrete parapet barrier some disgruntled paint-wallah has written 'BRIGAND'. The frayed ribbon of dwellings continues more or less unbroken into Le Grand Bornand, where some of the grander chalets sport smart new copper guttering, still unoxidized, gleaming trout-flesh pink.

# COL DE ROMME 1291M

*Note: Before the Tour de France came through (for the first time) in 2009, this col, named for the village in which it is to be found, was not separately identified as such.*

*Western approach from Le Reposoir 966m*

LENGTH  6.2KM

HEIGHT GAINED  325M

MAXIMUM GRADIENT  9%

Through dense woodland out of the village on the D119, 4km of stiff riding. High on the bank by a left-hand hairpin, 2.9km, a small slab of stone. Into its surface the shape of a cross chiselled out, painted red, white ground, and a square painted white, red border containing a red number 93. My curiosity was pricked, but, alas, enquiries as to its significance proved vain. It may be some marker for a limit of wood-cutting in the forest.

The slope eases and tilts down into Romme, so that the high point is not in the village at all but in unmarked land. Romme is a tidy little community, to every house a log stack and to most a line of flower troughs – the geranium is king – along the balcony balustrade or the edge of the platform or else the steps leading up to it and round the footings, complemented by hanging baskets from the eaves. There are stretches of new tarmac (thanks to the Tour).

Ornamenting the balcony balustrades was, traditionally, a task for the long winter months when snow overlaid the land and people were idle, cooped up in their houses, kept warm by log fires and the heat emanating from the animals which shared their living space. The balustrade supports were generally made of larch wood – which is rot-resistant – cut with a handsaw and assembled with mortise and tenon joints held tight by pegs. The oldest surviving balconies date from the seventeenth and early eighteenth centuries. Later, *épicéa* (spruce – see below) replaced larch. Modern balustrades mimic the old decorative pattern – roundels and lozenges – but generally not the more practical purpose to which the south-facing balcony was put, that of drying sodden hay. They were, accordingly, called *solarets*, Latin *solarium*, 'sunny terrace'.

## Northern approach from Cluses 485m

LENGTH 10.7KM

HEIGHT GAINED 806M

MAXIMUM GRADIENT 11%

Cluses comes from a regional French *cluse*, ultimately from Latin *clausa* (*claudere* – to close) and describes a valley enclosed by steep cliffs, a narrow defile, a tight gorge. The town was, from the eighteenth century, famous for its watchmakers. At the beginning of the century, one Claude-Joseph Ballaloud, son of a family of watchmakers from the village of Saint-Sigismund on the hills to the north-east of Cluses, went off to perfect his skills among the master-craftsmen of Nuremberg. He returned to Cluses in 1720, took on apprentices and started to fashion parts, cog wheels and pinions, for timepieces which he sold to large watchmaking enterprises in Geneva. The revenue supplemented the small profit they made from the land. Gradually, watchmakers proliferated along the valley of the Arve. From some thirty in 1758, by the early 1800s, over half the population was engaged in the precision trade, working from home. One important technical development in watchmaking is rooted in the Arve valley, that of *décolletage*. The word, used of 'the wearing of low-necked dresses', i.e. in the imperial style, refers here to the watchmakers' process of manufacturing screws by turning on a lathe metal bars with the same diameter as the head.

They then removed the *collet* (collar) to leave a shank, thinner than the head, into which they could cut the thread.

Larger workshops succeeded domestic industry and, in 1848, Cluses became home to an Ecole Royale d'Horlogerie by royal decree of Charles-Albert, duke of Piedmont-Sardinia, in whose domain it lay. When the territory was ceded to France under Napoleon III in 1860, the school became Imperial and later National. The school is gone but the Espace Carpano et Pons, Place du 11 Novembre 1945 (once a factory built on a bridge over the river, hence Pons, by a former pupil of the Ecole, Louis Carpano), houses a splendid museum of watches and escapements. At the eleventh hour on the eleventh day of the eleventh month in 1918, the Armistice was signed, ending the First World War. The date is commemorated in the name of this square by reference to a year in which the Second World War ended.

When watchmaking died out, the precision engineers of Cluses turned their skills to micromechanics.

Out of Cluses, head for the Colombière and, almost immediately on the D4, short of Scionzier, turn left on the D119 for Le Reposoir and Nancy-sur-Cluses.

Away from the main road, the road picks its way between a concrete barrier, left, and rough rock and vegetation, right. A steep right-hand hairpin leads onto a balcony, the grey rock of the side wall to the left netted with oversize wire mesh for bloated poultry, and over the

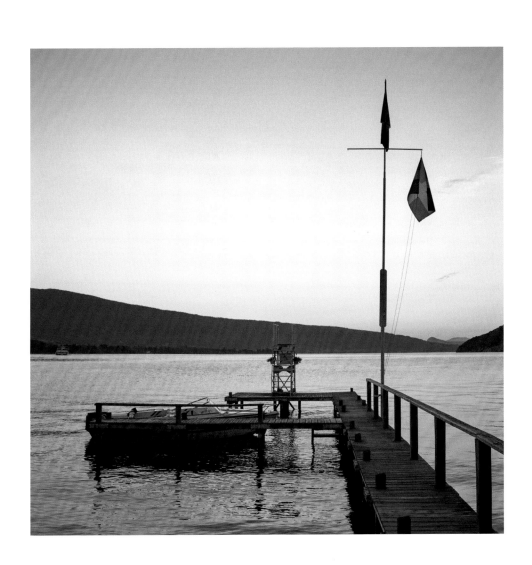

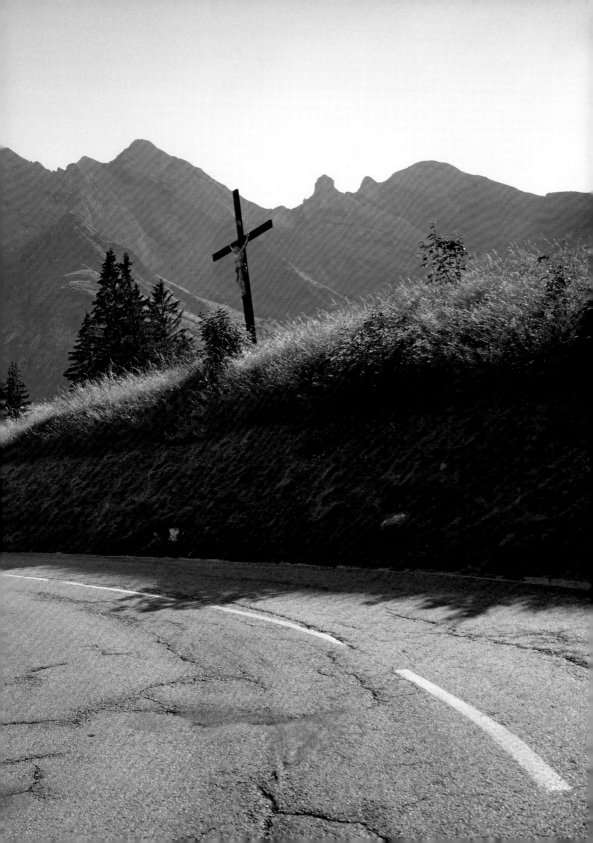

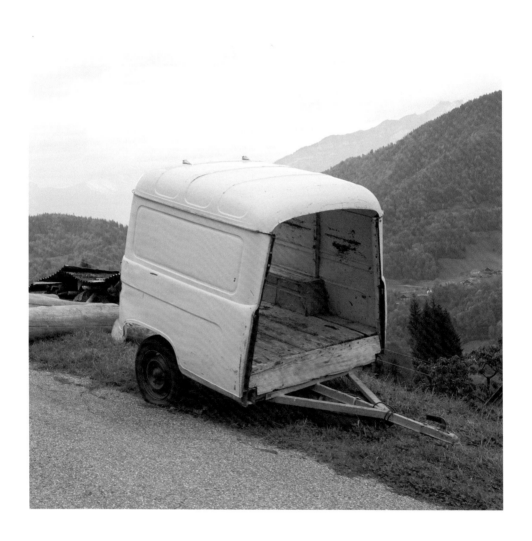

parapet to the right, a grand view of Cluses. Drink it in, as these first 2km of climbing are evil, up to 11%.

In the full surge of that steepness, Les Cruz (2.3km) sports a spanking new wooden bus shelter, dandy as a garden summerhouse, positively a lovers' arbour. The gradient eases steadily onto a flatter ledge by a grassy bank and a line of trees and another balcony enclosed by side wall and barrier. At 4.2km (the start of more staggers, if only 9%), inset into the face of the side wall to the right is a niche with covering grille for Her statuette; *ND du B Secours PPN 1878: Notre Dame du Bon Secours. Priez pour nous* (Pray for us) is standard and *Secours* is 'help'. You may need both.

Still blasting away at 9–9.5%, the D119 pants into Nancy-sur-Cluses past a house called *Au Bon Accueil* – 'Nice Welcome'. There's a bar/ restaurant of the same name in Romme. Out through grassland and into woods.

In Romme, a week before the Tour arrived in 2009, someone had decorated their garden with a wood and cardboard mock-up of a Col de Romme: sloping road, central white markings, col sign, there being no other posting for the col but the village itself.

The road dips away for some 200m out of Romme, past a radio mast to the left and, after another 1.1km out of the village, a television antenna by the road opposite an *aire* (pull-off) with an information board about the trees in the vicinity. The *épicéas* (picea, spruce-fir) do not need much soil and can colonize the scree

together with deciduous cousins such as *érables* (maples), *chênes* (oaks) and *roseaux* (reeds). These are the only plants that can grow in gullies and slopes cut and swept by avalanches, because their curved and pliant roots continue to fold and seek grip under the weight of the snow, springing back when the weighty, frozen slurry of the avalanche has subsided.

Resinous trees, mostly spruce and *sapin* (fir), pretty well dominate between 1500m and 2000m of altitude. Not having to compete with rivals is to their great advantage, and although their superficial root system can cope with most mediocre soil, they remain vulnerable to strong wind. Their drooping branches let slip the snow and thus relieve them of the weight.

And so, according to the sign: *Bienvenue dans le Pays Borne et Bargy* (Welcome to Borne and Bargy country). The Borne river flows off the Aravis chain from below La Pointe Percée into the Grande Borne, while the Chaîne de Bargy (with a 2299m peak called Le Bargy) runs parallel to the road up to the Colombière to the north.

# COL DES ARAVIS 1486M

## Northern approach from La Clusaz 1050m

LENGTH 7.5KM

HEIGHT GAINED 436M

MAXIMUM GRADIENT 8%

Aravis is possibly from an Indo-European root *ar* (high) and *riv* (river). It lay on the fearsome route that took the 1911 Tour riders 366km from Chamonix to Grenoble via the Télégraphe and Galibier; a foretaste, no more, of the horror to come. It was included in most Tours until 1937 but, after 1948 when Gino Bartali topped it during the first of two crushing stage victories in the Alps on his way to a second overall win, it has appeared only intermittently. It has, alas, become a road with little distinction, a throughway to and from the extensive winter resort of Aravis, including La Clusaz and Le Grand Bornand. As if to emphasize this leaning towards function, Christmas lights are (or were) still fixed to lampposts in and out of town. The surface of the road is quite smooth, however, fairly uncluttered with extraneous buildings most of the way, swinging round grassy slopes bedecked with trees, on a nicely moderated gradient.

A signboard indicates a *Via Ferrata*, a development in the climbing of vertical pitches and cliffs with cables and metal ladders; not for the purist, maybe, but an extreme diversion for the intrepid.

The steep-sided Gorges de l'Arondine on the south side of the col were once a plentiful source of slate. To the west, the beetling cliffs of the Etale. A little over 7km in rugged surroundings through a series of cranky bends onto a good long straight for a sweet and rapid descent.

At the col, a restaurant/*crêperie/salon de thé*, a restaurant/brasserie, and capacious basins in which swim trout, destined for the kitchens. They were built to hold water in case of fire because there was, for a long time, no ready supply up here. A stone building, Le Four, announces its former status, baking bread and meats for the community at large.

The surface is a bit cracked, but once through a snow tunnel there is better tarmac. A snappish lash of bends and a spacious view down. La Giettaz (1080m, 5.7km) is a friendly little town not overrun by ski schlock, and Les Glières (990m), where the climb begins, has a sawmill. Its name refers to the gritty terrain, the sediment of the riverbed deposited after a flood, from dialect *glire* (Latin *glarea, glaria* – gravel, lumpish sand; Old French *glaire, glayre*).

The road straightens out into the trough of the valley and the Gorges de l'Arondine, the river running just below. Over a bridge in Manant and a short climb – on a parapet, *Allez Hailey* (Go Hailey) – then descend through a snow tunnel (a hole cut through the rock of the side wall to the left), and into Flumet, whose Office de Tourisme flaunts a line of national flags. Beyond it, a concrete wall bears the fading legend *Savoie Libre*, 'A free Savoy'.

# MUSÉE DÉPARTEMENTAL DE LA RÉSISTANCE DE MORETTE

This museum, some 4km along the D909 to the west of Thônes, occupies a site next to the Cîmetière de Glières where the dead from the fighting in March 1944 are buried. The extensive exhibition includes an annexe devoted to the fate of the deportees. I urge you to visit.

A poem written by a woman captured and handed over to the Gestapo:

*Je trahirai demain, pas aujourd-hui.*
*Aujourd'hui, arrachez-moi les ongles,*
*Je ne trahirai pas.*
*Vous ne savez pas le bout de mon courage.*
*Moi je sais.*
*Vous êtes cinq mains dures avec des*
  *bagues.*
*Vous avez aux pieds des chaussures*
*Avec des clous.*
*Je trahirai demain, pas aujourd-hui.*
*Demain.*
*Il me faut la nuit pour me résoudre,*
*Il ne faut pas moins d'une nuit*
*Pour renier, pour abjurer, pour trahir.*
*Pour renier mes amis,*
*Pour abjurer le pain et le vin,*
*Pour trahir la vie,*
*Pour mourir.*
*Je trahirai demain, pas aujourd-hui.*
*La lime est sous le carreau,*
*La lime n'est pour le barreau,*
*La lime n'est pour le bourreau,*
*La lime est pour mon poignet.*
*Aujourd'hui je n'ai rien à dire.*
*Je trahirai demain.*

I'll betray tomorrow, not today.
Today, rip off my nails,
I will not betray.
You do not know the limits of my courage.
I know them.
You are five hard hands with rings.
You have hobnailed shoes
On your feet.
I'll betray tomorrow, not today.
Tomorrow.
I need the night to resolve myself,
I need one night at least,
To deny, to abjure, to betray.
To deny my friends,
To forswear bread and wine,
To betray life,
To die.
I'll betray tomorrow, not today.
The file is under the floor tiles,
The file is not for the bars,
The file is not for the executioner,
The file is for my wrists.
Today I have nothing to say.
Tomorrow I will betray.

> Marianne Cohn, nickname
> Colin, codename Le Pax, in a Gestapo
> cell in Annemasse.

# COL DE L'ARPETTAZ 1581M

*Western approach from Ugine 412m*

LENGTH 16.5KM

HEIGHT GAINED 1169M

MAXIMUM GRADIENT 10%

*Arpettaz* in the Suisse-Romande dialect means *alpage*, an upland pasture, *arp* being its form of 'alp'.

Take the D109 out of town and turn off towards Mont-Dessous and Mont-Dessus (Lower and Upper Mont, 695m) for 5.3km of mounting steepness past farmland, old *greniers* (granaries) and barns, chickens in the yards, sheep and cattle, a wayside cross, a small unkempt orchard of ancient, gnarled cherry and apple trees, one house whose wall supports an abundant growth of climbing rose, beehives in a shelter of trees and then into woodland.

The form of the landscape this way up to the col is of tracts of pasture interspersed with woodland. For 3km out of Mont-Dessus the gradient hits 9–9.5% and then slackens to a more manageable 7.5–8.5% all the way to the top although, in truth, these variations hardly impinge once you are settled into the graft of riding them. And on this ascent they worry even less, maybe, for it is a ride of great character, charm and serene beauty. Its variety, its sense of purpose – not all roads have that, some look and feel lost – and the quiet grandeur of the heights to the north lend this route huge interest all the way.

An information board gives a detailed catalogue of the local fauna. The *martre* – marten, a small nocturnal musteline, i.e. of the weasel family (Latin *mustela*), feeds on eggs and unwary nesting birds. The *chevreuil* – mountain goat – reappeared in the 1970s and is increasing in numbers because of controlled hunting and the agreeable habitat. The *sanglier*, wild boar; *pic noir*, black woodpecker, with a plaintive, shrill call; *la gelinotte des bois*, hazel hen or hazel grouse, a very discreet fowl, that lives in the deep-pile leaf carpet of pine woods. *La chouette de Tengmalm* (*Aegolius funereus*), largest of the five smaller owls of the region, and easy to confuse with the little owl, is day-blind and makes its nest in holes left by the *pic noir* in mountain woodland. Its only predator is the marten. Peter Gustaf Tengmalm (1754–1803), the Swedish physician and naturalist, was particularly interested in owls. He improved on Linnaeus's classification of the species and was mistakenly believed by a German naturalist to have first identified the owl that he most generously named for him.

At Lachat (1420m, 16km) the road broaches a plateau across moorland, the upper reach of a col road below the looming high escarpment up the long grassy slope, a growth of smooth vegetation across its face like a five o'clock shadow. A short way on, to the right near the road, sits a monolith such as might have been hurled by an irate cyclops, and on it an intaglio engraved with the face of a moustachioed cove, grim and forbidding of aspect. This, as the

inscription tells us – and you will have to climb up the short pitch of the stone to read it – was set up by the Chasseurs du Mont-Charvin, the local hunters, to honour a respected veteran of their society.

Open moorland studded with rocks and stones leads to a final lift to the open summit of the col, 3km off. At the col a large wooden shack with a tin roof, low in profile, exactly like an Australian homestead, our photographer tells me. This is the bar/café L'Arpettaz and the only marking with which this fine col has been graced. Across from the twining descent stand the striated, mille-feuille black rock flanks of Mont Charvin (2407m on the map, elsewhere 2409m). A bristly stubble of sparse pines lines its edges, a growth of low bushes and scrub grass marks its sides. From the bleak stand of the Arpettaz, Mont Charvin (Latin *calvus* – bald) has a brooding air and is one of a number of other massifs of the Chaîne des Aravis visible roundabout. This is a destination which speaks mountains to you with primary emphasis. You are in the heart of a stark encirclement of them, an inquisition of solemn, stone-bound altitude. The pattern of woodland and lea, though open land is more preponderant, repeats after the initial fall from the bare slopes of the upper level, a gentle drop on an easy descent, 3km of 5.5% to a couple of flat kilometres and away from Lachat. A short way on, La Lierre (a rustic branch of The Ivy?) is a Swiss chalet, decorated with leaf and floral motifs in the bright colours of peasant-girl skirts, a restaurant from whose windows, on a clear day, can be seen the distant peak of Mont Blanc. By the wayside, a number of open-air pizza ovens, or so it appears – stone structures with a large wooden paddle slung beneath the oven aperture. At Les Banzins, near a cluster of trees resembling a sculpture by Giacometti, a board spells out information. On down through a relay of small communities, some of which are patently most inhabited by holidaymakers. Indeed, in Hauteville, at 9km, 1160m, that misty day in November, we encountered a group of young men and women hailing from Paris, Vienne and Lyon, weekending at the roomy, rickety chalet belonging to the parents of one of them. They had cropped tiny apples from the orchard and were pressing them into an antiquated, cast-iron mincing machine before squeezing out the pulp in a spanking new cider press – a wooden barrel into which goes the pulp, then a lid, and on top of the lid a series of sizing blocks to reach to the top under the screwplate itself. All wooden parts are made of sycamore which imparts neither odour nor taste. The handle turns and turns, the lid clamps down, the juice trickles out and, absorbed as we are in this novelty – to us and to them – we're offered the first tasting and delicious it is, a full appley aroma and a hit on the tongue imbued with a natural sweetness, scarcely acid at all.

At a T-junction, left to Héry, turn right to Bange through denser woodland for a short distance and into farmland again. The drop

# FORT DU MONT 1330M

from Lachat to this junction is a fairly constant 8–9.5%. From here onwards, the final 6km relax to around 6%. A fine view across the Gorges d'Arly. L'Arpettaz is a joy, from start to finish.

The eastern ascent charges dearer in gradient, a stretch between the turn to Héry and Hauteville of 9–10%.

The 11km steep climb from Albertville to the Fort du Mont goes past the medieval walled town of Conflans. Albertville was founded by Albert of Sardinia in 1835 and Conflans was an ancient fortified settlement – its fourteenth-century fortifications (built by the Savoyards) were dismantled by order of François I in 1536. From the start of the ascent to the old town ramparts, half a kilometre of 8–9% and another kilometre of sharp hairpins with a steady brace of gradient past houses and gardens as the road masters the peak of rock on which Conflans sits. Chalets here and there. At 5km, a flat run through woodlands and out into the open. At 5.7km a curious pink concrete blockhouse, possibly a water cistern, the pink of old foundation make-up. Plenty of sweet chestnut, intermittent big views across the valley, in and out of woods, mature beech, ash, pine and, on one bend, a lone, grand larch, gaunt in its solitude, an oracular tree, maybe. The Fort, built between 1877 and 1881, arrives at 10.3km, but is not the col which lies 2.3km further on, namely the Col des Cyclotouristes (1330m), in a narrow alleyway hemmed in by walls of trees. A marble stele on a little prominence to the left, the Roche Poncet, 1333m, records a sweet tribute: *Jean en inventant ce col, tu as gravé dans nos mémoires une trace indélébile, tes amis cyclotouristes.* (John, in discovering this col, you have engraved in our memory an indelible trace, your cyclotourist friends.) To the side of the tablet, a freewheel cog, set like a sun with rays painted in.

# Plenty of sweet chestnut, intermittent big views across the valley, in and out of woods

A sort of bus shelter houses a map of welcome with panels telling you that the woods give home to squirrels (red), badgers, foxes, wild boar, chevreuil, chamois, and the strikingly handsome *tétras-lyre* (black grouse), with black sheeny plumage, white wing bar and rump, frilly as a tutu, lyre-shaped tail and a tiny pillbox bonnet of brilliant scarlet feathers. A short homily commends: 'In exchange for the secrets of the forest, the only currency… silence.' To protect nature is also to preserve human equilibrium and happiness. Here begins freedom's land, the freedom to behave well.

This *pays de liberté* (free parkland) comprises the Forêt Communale de Venthon and that of Queige. The road down is rough, tight, bendy and at 14km a large crater, wide but shallow – the *nid* (nest) of a singularly overweight *poule* (hen), *nid de poule* meaning 'pothole' – may still spread across the middle of a road. A short way on, a fine view of the Dent de Cons (2064m – Cons, from low Latin

*cumba*, English 'coomb', a small valley, came to mean, simply, the hamlet occupying the tiny depression). Beware, too, transverse rain gutters whose metal sides sometimes project just above the surface of the road. At 16.7km Mollies-Soulaz, one of whose wood-clad houses is extremely handsome, a large picture window wrapped partway down the roof at the chimney end and one down the side wall, the far gable perforated with no fewer than eight windows, as if it were the openings in a columbarium. Advertising their gîte and bar, the owners have suspended a bike from a small projecting beam over the road and in a tiny shed, someone from Queige, in the valley below, is broadcasting, this autumn of our visit, a sale of chrysanthemums and cyclamens at the entrance to the cemetery. Chrysanthemums are the French flower of choice for funerals and graves. A board shows various walks – or routes in winter for snowshoes – to the heights above the village, times, altitude gains and routes given.

A number of al fresco stone-built ovens dot the roadside banks, outside houses, and in one of the hamlets, of which there is a string down this open hillside, a white Samoyed dog comes out to say hello or else to remind us that he is not from these parts but originally from Siberia. A man walks by swinging a basket, in which I observe a goodly cull of tasty chanterelle mushrooms.

At the foot of the climb (620m) 25km from Albertville, in Queige, the D21 flips over the Col de la Forclaz (871m, 7.5km) into Ugine at 412m. (Forclaz means 'cleft', and there are a number of other cols so named, including that above Lac d'Annecy described elsewhere.) From Ugine take the Route des Montagnes on the western approach to the Col de Tamié (907m). From Faverges (550m), a brisk 9.7km loosener, much favoured by local cyclists. A smooth wide road climbs away from town, overlooked by the Dent de Cons to the east and the Massif des Bauges to the west towards the cleft between the Plateau des Teppes and the 2217m peak of L'Arcalod. At 4.3km it squeezes through a gorge for a kilometre and out into pasture at whose far end stands a line of poplars at the roadside, like dendrified members of a bilious anti-cycling league, tried for inhumanity, found guilty and condemned for ever after in their bark-covered coffins to witness the joyous passage of cyclists to and fro, and to shed tears as leaves each autumn, in lament for the diminution of two-wheel traffic as winter approaches.

At 9km a road to the right goes to the Abbaye de Tamié, a Cistercian house founded in 1132 and still home to a small community of Trappist monks who make the famous Abbaye de Tamié cheese, similar in style to Reblochon. *Reblocher*, a repetitive form of *blocher* (dialect *blossi*) meaning 'to pinch', alludes to the practice of leaving some milk in the cow's udder to make it creamier for a second tug of the teats. The milk of this second tugging was used to make the famous soft Savoyard cheese, Reblochon. The given explanation for this holding back – that it was a way of evading the toll, half their produce, paid by *métayers* (tenant farmers) to their landowner – is fanciful. The landowners, more pertinently their bailiffs, were quite as cunning as any peasant and the idea that they would have missed the residual swelling in a tenant's cow's udder is silly. What almost certainly happened is that a young milkmaid new to her task left some milk in the cow, was reproved by her mother who finished the job and discovered, lo, how rich and creamy was the second helping. (Our word 'daughter', of Teutonic root via Greek from a Sanskrit word, *duh*, is the young child detailed to tug the udders.)

*Recipe*
# TARTIFLETTE

Boil potatoes, peel and dice. Fry *lardons* (miniature squares of bacon) with half an onion, add the potatoes and cook for a short while. Pour into a gratin dish. Cut a Reblochon in two and lay on top of the mixture. Cover with foil and bake at 180°C/350°F for twenty minutes, remove the foil and brown the top. Eat. Remember, the melted cheese packs a biting scald of latent heat.

The country opens up again. A restaurant/bar Auberge du Col de Tamié sits back to the right and further up that track, a Chalet les Trappeurs restaurant. The col lies 100m further on.

Left towards Mercury and into deciduous woods past the Fort de Tamié. This road was built to supply the fort with ammunition by mule train from the arsenal in Albertville. The fort itself, strongest and most dominant of a line of forts built along and above the Arly valley which runs south-west from below Mont Blanc towards Grenoble, was constructed between 1876 and 1881, after the old kingdom of Savoy was absorbed into France in 1860. The forts were munitioned with heavy artillery to defend the new frontier against incursion. Miserable places in which to serve, the barrack rooms no better than windowless caves deep in the rock.

A kilometre on, the Collet de Tamié (960m) and a sudden gaping prospect of Albertville and the broad floor of the valley, that range of fire enjoyed by the fort's gunners. The 7km descent is tricky, cricked and twisted, but that makes for a good climb up and the gradient, 6–7%, is fairly kind. Mercury has a large church on the pinnacle of which perches an outsized statue of Saint Bernard. The 3.5km drop to the river (380m) is sharp.

## LAC D'ANNECY

## COL DE LESCHAUX 897M

The circuit of the lake, around 40km, makes
a fine ride, flat along the southern shore and
much of the way on a broad cycle path; to the
north the road is lumpier, a couple of lengthy,
health-giving lung-busters towards Talloires
and down to the water again. Locate a good
place to swim and you will find the lake water
both wonderfully fresh and soothing of battered
muscles; there is ample opportunity from a
staithe belonging to the unpretentious Hotel
Port et Lac in Bredannaz on the western shore.
An excellent restaurant with picture windows
overlooking the lake, too.

*(Included as an approach to the
Châtillon, hereunder.)*

*From the lake 455m*

LENGTH  12KM
HEIGHT GAINED  442M
MAXIMUM GRADIENT  5.5KM

The lakeside road out of Annecy is a busy
thoroughfare. Turn right on the D912 from
Sévrier 455m. Near the turn, a cheerful
individual has painted 'HELLO' on the road.

The vista over the lake on this approach
to the col is superb: straight across the water
sits the Château de Menthon with the heights
of Veyrier to its left. Here was born, they say
– it is, like his date of birth, disputed – Saint
Bernard, who founded the Grand-Saint-Bernard
hospice in 962 and, a few years later, its sister
house the Petit-Saint-Bernard. Son of a noble
family, he spurned the marriage his father
proposed for him to the daughter of another
seigneur in favour of the priesthood. The story
goes that he removed a bar from his window,
jumped out and absquatulated.

Above Talloires rise the Dents de Lanton
and the Tournette peak to the right. On a small
promontory on the near shore, which clips off a
narrow strait dividing the *grand lac*, north, from
the *petit lac*, south, is Duingt, whose château,
linked to the bank by a drawbridge, is prominent,
possibly of Burgundian origin. The Roc de Chère,
on the far shore, occupies a larger excrescence.

# COL DE PLAINPALAIS 1173M

Fresh tarmac, trees, a gentle ramble and, by the road, a monument to the memory of Pierre Lamy, *Inspecteur du Travail lieutenant au 179ème BAF (Bataillon alpin de forteresse) Chef de Mouvement de Résistance, torturé et lachement assassiné par les allemands 18 juillet 1944.*

*'Passant découvre-toi devant ce monument, il symbolise l'héroisme pur.'*

This individual, a factory inspector, served as lieutenant in the 179th Battalion of the forces who manned the string of defensive strongholds along the Rhône valley and the border with Switzerland, was made a Resistance commander and was tortured and shot by the Germans on 18 July 1944. A despicable act. 'Passer-by, find yourself as you stand before this monument – it symbolizes pure heroism.'

Leschaux, the village at the col, is a mixture of old and new buildings. The church with spire has a Madonna in a metal bodice and bra. The 6.7km of descent southwards into La Charniaz, on the D911 near the Pont du Diable, barely lifts above 3.5%. From the col turn right onto the D110 for Montagne de Semnoz and the Crêt de Châtillon.

*Southern approach from Chambéry 270m*

LENGTH  17.2KM
HEIGHT GAINED  903M
MAXIMUM GRADIENT  9%

Take the D912 away from town to Saint-Alban-Leysse. Clearing the spreading outspill of the place is never much more than an ordeal of traffic but, once past the skid-row of intersections and ring-road, the way is pleasant, the hairpins steep and the girding view of the Bauges ridges a singular draw. Many of the houses in Saint-Jean d-Arvey (581m, 7.9km), where a road to the right leads to the Col des Prés, show signs of long wear, but there was new building work in train and repairs on the go.

The valley below is markedly built up, part of the dormitory town. On a bend, a small building with a mural: a man standing by a table draped with a cloth on which sits a vase of flowers. He leans on a walking stick and has a log saw bending over one shoulder. He seems bored, disaffected, no welcome in his mien or attitude.

The screen of trees closes in. Two hamlets, Les Déserts and Le Mas, come and go, and of Plainpalais-Dessous, one is hard put to say what and where it is. A largely empty road proceeds by slow turns to its barely perceptible high point from which there is a short slow glide to the col marker. What is it round here with these cols that hide below the skyline? An open

# COL DES PRÉS 1142M

tract of long grass stretches to right and left, and opposite the col stands a square stone hut with boarded-up windows and an excessively tall and steep corrugated iron cap. This road, it appears, now enters the Terroir de la Tome [*sic*, usually Tomme, a noted cheese, see p. 73] des Bauges and makes a descent down a long, long straight of around 2km – deadly to ride up – to a sudden twist of bends past the side road to a village named for Saint François de Sales and an empty information hut – roof, supports, open-sided.

A string of hamlets succeeds, and in Le Perrier one house has a slanting line of geranium pots ingeniously ranged below the deep hood of its eave. Opposite the church, on a patch of lawn outside a sculptor's workshop, stands an array of carvings, faintly cabbalistic, not at all figurative in style: a violinist in a swoon of concentration, a multi-coloured totem pole with what may be carved Mayan decorations, a harlequin fantastical in sketch form, impressionistic, holding what may represent a skeletal cello.

The road is smoother now, winding at shallow gradient along the hillside before dropping more steeply through Le Crozet on a fluent line through pastureland into Lescheraines (another dairy cooperative) at 645m, 11.7km from the col.

*Northern approach from Lescheraines 645m*

LENGTH 17.3KM
HEIGHT GAINED 497M
MAXIMUM GRADIENT 8%

The D59 follows the course of the Aillon River which springs from the side of the Mont de la Buffa, by the col. The valley floor is flat, meadows bordered with trees, the road on a shelf above, a bare cut across the sloping rock at whose foot runs the water. It continues flat, winding lazily through Le Cimeteret and past the turn-off to Aillon-le-Vieux and the Margériaz ski station (900m, 9km) before descending into Rocquerand and Aillon-le-Jeune (895m, 11.2km) which does, indeed, look quite new. Here begin 4km of climbing. The col is a barely noticeable uppermost, no more than a hummock marking where the road leans over to the other side. The view is of a valley basin below a crooked line of heights and a long, slow afforested slope drifting downwards. A mere 5.5km from the col, turn left on the D21 towards Curienne. A sudden drop to the bottom of a bowl in the cleft of a torrent and a steep haul out, an open view of meadows to the right and a bluff towering overhead to the left. At a junction – D21^A left to Puygros, D21 right to Curienne – an old farm building, the bridge from its hayloft extending over the road to the 6m-high bank opposite for the trundling across of laden wheelbarrows and small carts.

A drop through Le Bois and a steep kick up round hairpins into Le Boyat (660m), a clutch of old houses at a junction. From here the D11 heads for La Thuile and the Col de Marocaz (958m). Looming overhead to the left is Mont-Saint-Michel, on which is centred a Route for the exploration of the Bauges. The col is marked by a lone picnic table on an outsize tuffet, which also houses the blue and white col sign. The southern climb to the Marocaz from the Isère valley, through Cruet, is much tougher: 7.3km of upwards of 9.5 and 10% and never slacker than 8% on a road which writhes as if in pain from the bite of those contour fetters. Lone houses, a straitened road, a bridge over the stream that has cut this steep fissure. This is one of the more interesting routes up to the massif – animated, hard, quiet.

In Cruet, left on the D201 flanked by vineyards to Saint-Pierre d'Albigny and the foot of the Col de Frêne (950m).

This col, named for the ash tree (French *frêne* from Latin *fraxinus*, the wood of choice for a hero's spear shaft) sits on the other side of Mont de la Buffa to the Prés. The mountain is 'exposed to the wind' from a dialect word *bufer*, Old French *bofer*, 'to blow'.

## Southern approach from Saint-Pierre d'Albigny 365m

LENGTH 7.8KM

HEIGHT GAINED 585M

MAXIMUM GRADIENT 8.5%

A short but taxing climb into the armpit of the massif and its shaggy sprouting of the trees of the Arclusaz forest, once an 'enclosed pasture'. The road is quite wiggly. A cement-rendered hut belongs – or belonged, the paint of its label is fading – to the *Ponts et Chaussées* commission, responsible for the maintenance of bridges and roads (originally 'carriageways') across France. The road gradually spreads its width and then, as if ashamed of the surplus of unwanted weight, slims rapidly to be graciously received, in its new trimness, by a cheerful open lea on which have been built two houses set back from the road. At the col a cross, set up by a mission in 1945 to mark the advent of peace, which bears the legend STAT CRUX DUM VOLVITUR ORBS (The cross stays motionless while the earth turns).

There is a handsome vista just below the col, a wide valley overlooked by a number of peaks, various teeth (*dents*), Arclusaz, Rossanaz, Pleuven, and a junior Grand Colombier. Below the Arclusaz to the east of Saint-Pierre d'Albigny, the château of Miolans, once the property of a powerful Savoyard family, was bought by Duke Charles III of Savoy in 1523 and used as a state prison. The

Marquis de Sade was banged up there in 1772, but he escaped four months later. The castle's dungeons were known as Hell, Purgatory, Treasury, Little Hope, Great Hope, Great Paradise and Little Paradise. Some inscriptions on the gaol walls survive: *En Dieu me fie à non autre* – I trust in God, and in none other… *Quid fui? Quid sum? Quid ero? Semper captivus* – What was I, am I, will I be? A prisoner, always… *Les corbeaux passent au-dessus de nous* – the crows fly over us. (The necrophagous carrion crow is symbolic of death.)

The descent begins with a kilometre of 7%, then flattens and straightens into a fast romp all the way down past a string of hamlets to a sizeable village, Ecole, to which all the schoolkids in the area, near and far, once came for lessons, hence the name. On the way down, you will almost certainly pass donkeys in fields. The creatures are hired out as pack animals to walkers exploring the massif and stopping in refuges, or else making a day's circuit.

The ride down continues in frolicsome ease, the scenery spacious and open like a sunbather taking in the full benison of solar rays. The D911 swings past Lescheraines and another of the many Ponts du Diable scattered across France – relic of that ancient uncertainty about crossing water, the menace of trolls, or the Adversary himself, lurking beneath the bridge to prey on unwary travellers, when merely to travel enjoined constant wariness.

From Cusy, at the junction with the D3, turn left on the D103 for Saint-Offenge-

Dessous and Dessus (750m) towards the Col de Revard (1538m), 12km distant at an average of 8%. This is a cul-de-sac but the ride over the Mont Revard rounds off the loop of the Bauges admirably.

Just beyond the start of the climb, at a bend in the road lightly shaded by overhanging trees, a miniature obelisk commemorates one Pierre Prosorof who died on this climb, 22 June 1947, an act of respect by his cyclotourist friends.

This is another leaf-curtained road, the gradient oscillating between 6 and 8% past the intermediate Col de la Cluse (1184m) at around halfway, which goes unnoticed. Around 10.6km from the start of the ride, a right turn at 1448m leads to the Col du Revard, 1.4km distant.

# THE MARTYRS OF ECOLE

On 6 July 1944, a German firing squad dispatched twelve local men outside the church opposite the *mairie* in Ecole, including the mayor, seventy years old, and three sixteen-year-old lads. The square is called Place des Fusillés, for the men who died in the vengeful fusillade.

Between January and April of that year, the Allies made three parachute drops of weapons and munitions in the area and, on 1 May, the Gestapo chief in Chambéry, Captain Heinson, brought in troops of the SS. The hamlet of Chapelle was put to the torch and thirty-two houses in Ecole were burnt to the ground. In Sainte-Reine, up the road, five absconders from the STO (*Service du travail obligatoire* – forced labour) and two Italian casual workers were executed. Lieutenant Butin, chief of the Second Command of the FFI, on mission in the Bauges from Savoy, was arrested, tortured and, on 8 June, shot in Cruet. On 4 July, a huge force of the Wehrmacht, thousands strong, invaded the massif and a company was sent into Ecole to hunt out arms caches. The mayor, Jean-Benoît Ballaz, was ordered to draw up a list of all the young men in the area, but he and his fellow municipal councillors refused, in a body. Meanwhile, twenty-five *résistants*, Alsatian Jews and fugitives from the STO, were rounded up in the neighbouring communes, tortured and put to death, 4–5 July. The Wehrmacht then left, the Gestapo stayed on.

On the morning of 6 July, in Ecole, the Gestapo hunted down and shot a *père de famille* who was trying to escape. He'd been supplying the Maquis with food. That same morning, a stockpile of ammunition uncovered in the nearby hamlet of Jarsins was detonated and eleven men rounded up and tortured. On Heinson's orders, the entire population of Ecole assembled outside the church at 3 p.m. The mayor, arrested for 'failing in his duty', was the first to be shot down with a machine gun, and the others followed. Having refused the priest's request to administer absolution to the victims, Heinson ordered them to be buried without funerary rites.

# CRÊT DE CHÂTILLON 1655M

## Southern approach from Col de Leschaux 897m

LENGTH 14KM

HEIGHT GAINED 758M

MAXIMUM GRADIENT 7.5%

Trees line the road most of the way. The Relais Campagnard chalet (990m, 2km) has 'Relax 100m' on its bargeboard. There is an appealing, leaf-mottled peek at a segment of the lake to the right. From 7km, 1320m, the gradient slackens for a while in readiness for the final blast of 7.5% across a wide, hummocky, grassy plateau, 12km, 1590m. The Hôtel Semnoz Alpes (13km) and its very dilapidated mini-golf course overgrown with grass mark the real high point of the climb at 1660m. It calls itself Le Courant d'Ere with a play here on *aire*, 'breath of fresh air', but which actually means the passage of time (*ère* – era, epoch). The Crêt de Chatillon hotel at the official col offers a children's play area and restaurant/bar.

## NORTHERN SIDE FROM ANNECY

The first 9km of the descent have been newly resurfaced – beware the cattle grid – to accommodate the holiday traffic, whether for winter or the heated, all-year luge circuit, VTT (*vélo tout terrain* – mountain bikes) and the Deval'kart and other activities in Semnoz Eté-Hiver a short way down, by a huge car park. A *téléski* (ski-tow) hauls the Deval'kart up to the start of a specially constructed piste, like a toboggan run, for the helter-skelter down. For younger kids the Rollerbe is a sort of scooter with inflated wheels, also using the *téléski* as a tug, for a slalom at will. There's also an electric minicart 'for children of three to ten years who have never driven a meteor before'. (The word is *bolide* and used, here, to give a frisson of fast, fast, fast.) The less hectic pursuit of upland walking is also on offer, as if Semnoz had a monopoly on that.

The route is, self-evidently, popular with cyclists, part of another circuit out of and back to Annecy. Mostly straightish with easy bends, it makes a great descent as well. This side of the Semnoz chine has a number of leisure parks. Les Puisots (820m, 11.1km) hosts a *Centre Maternel* (chalets for children's holidays), a *Centre d'accueil maternelle* (nursery), *Centre de vacances de loisirs* (holiday camp), *Accueil de classes de découvertes* (centre for instruction in exploring the countryside), *hiver, printemps et automne* (winter, spring and autumn). Lower down, in a close attendance of woodland, the Parc Animalier de la Grande Jeanne is an open-

air zoo. The Grande Jeanne is a 30m-high cliff behind the Parc, in shade until noon, so quite cool in summer. A walkway leads up past the zoo to a number of sectors – Daims (Bucks), Sept Nains (Seven Dwarfs), Gaulois (Dogmatix et al.) in one area, and Renards (Foxes), Lascaux (presumably referring to the caves in the Dordogne famous for their prehistoric wall paintings) and Marmottes in another, all fitted with ladders for scrambling up the cliff face, varying in difficulty of pitch. At the foot of the climb, Camping le Belvédère.

# COL DE LA FORCLAZ DE MONTMIN 1150M

*Southern approach from D1508 480m*

LENGTH  9.5KM

HEIGHT GAINED  670M

MAXIMUM GRADIENT  11.5%

Turn right off the main road onto the D42 for Vesonne (495m, 1km) across a bridge over a stream into 6km of around 9% and periodic jags of 11 and 11.5%. (The map shows 13%. Who knows?) Trees and meadows, graffiti of dubious, grassy hillside and into Montmin (1040m, 7.2km), where the road tumbles away for a kilometre of carefree *dolce far niente*. A mighty torrent to the right churns over a loose *pavé* of irregular-sized boulders. A final kilometre of up to 10% and the col, home to a restaurant/hotel, *chalet d'accueil* (visitor centre), *souvenirs*. The opening 3km of the descent dish out more steepness, up to 11.5% (marked 'risky' on the map for no discernible reason), and in Rovagny (845m, 3km), Lake Annecy comes into full view. From an outcrop of rock to the left of a tunnel stares out a carved face, with full beard and a cross round his neck, representative not figurative, smooth of lineament and characterless. A monk guarding the way? (Puzzlingly, a NO ENTRY sign for a cul-de-sac points up to the roof of the tunnel.) The Ermitage Saint-Germain is close by – religious tourism, pray-ins, events and processions – and this may well be the path up to it. Near the bottom, the D169 right leads to the Col de Bluffy and Thônes. Continue into Talloires by the lake (470m, 10km).

# COL DU MARAIS 843M

# COL DE LA CROIX-FRY 1467M

This climb is much favoured by local riders extending the round-the-lake loop. Take the D12 south from Thônes, a wide, quiet road, timber stacks off to the right, plainly a store dump for the wood yard further on to the left. Just short of Les Nantes, chalets sprout as if to announce the arrival of Le Cropt. An escarpment overlooks, to the west, the steep walls of La Tournette. The gradient is mild, an amiable ride through meadows and placid countryside. From the col, a mere bump, the Dent des Cons rears up straight ahead, a classic backdrop of mountain scenery as the road dips and glides into the slight bowl of the Chaise valley, narrows briefly as if drawing breath, continues on through Serraval and then exhales more largely into Saint-Ferréol, a trimmed and plucked town in a shallow basin girded by mountain walls. From here, the road heads into a cleft of folded and wooded mountains.

In Serraval, there is a Maison de la Pomme et du Biscantin (apple and cider shop – le Biscantin is a local term for Savoyard cider in general, but in particular, the cider of the Aravis).

From Serraval, an alternative loop crosses the Col de l'Épine (947m) on the D162 to the right and down to the main D1508, 7.5km to the pass and a further 8km of descent.

*(This was originally called the Col de Manigod, from the village 7km below the summit to the west, an important maquisard HQ in 1944. See Introduction.)*

*Eastern approach from La Clusaz 1050m*

LENGTH 7.2KM
HEIGHT GAINED 417M
MAXIMUM GRADIENT 7%

Out of La Clusaz and up towards the Aravis, then turn right on the D16 (1219m, 3km) into a ski yard, an argyle pattern of ski-lift cables slung across the road, and a Hotel Alpage and Les Laquais ski cabin. *Laquais* was formerly a military term for a valet, later extended to mean 'lackey, footman'. Woods guard a fairly broad, well-surfaced road and at the col there are a restaurant, bars, ski school and hire, very unlovely.

A sweeping descent on what is a longer and tougher climb: the first 3km run at around 7% into 10.5… 9.5… 8%. An expansive view to the left over the valley and wooden houses and chalets nicely placed for sundowners on their balcony and breakfast and lunch on the veranda. The toughness of the slope is mitigated by the distraction of the settlements en route and the view of a particularly attractive valley, the Vallée de Manigod. Manigod itself has a fine church with impressive bell tower and was, up to the

summer of 1944, an important maquisard base and training centre.

Intermittent shade, a good surface. The Sentier du Pont Romain goes off to the right, 10km from the col.

The four bridges of the Thônes valley are not Roman – they date from the fifteenth century – but were built on the site of original Roman or even older constructions. The Clefs bridge lies above the village of Chamossière just south of Thônes, the Saint-Clair on the D909 towards Annecy, the Cour north-east, some 2–3km from Thônes and the Pont des Romains out of Bornand along the Bouchet valley.

Note: While both the Col de la Colombière and the Cormet de Roselend are prone to avalanche and closed in winter, the Aravis is reliably cleared of snow and kept open.

# CHAMBÉRY

# CHAMBÉRY

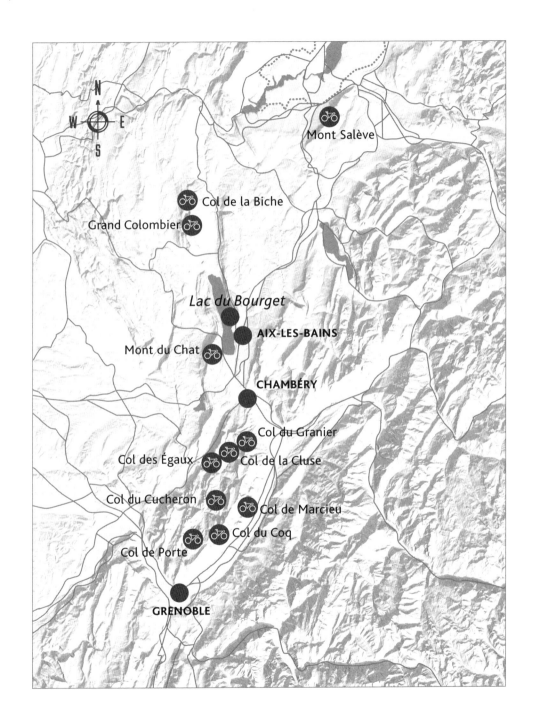

Mont Salève

Col de la Biche

Grand Colombier

*Lac du Bourget*

AIX-LES-BAINS

Mont du Chat

CHAMBÉRY

Col du Granier

Col des Égaux

Col de la Cluse

Col du Cucheron

Col de Marcieu

Col du Coq

Col de Porte

GRENOBLE

# INTRODUCTION

Jean-Jacques Rousseau came to Chambéry in late 1732 with his lover Françoise-Louise de Warens to begin work as a surveyor in the service of the king, and lived there, off and on, until his departure for Paris in 1741. The couple moved into an ill-lit, ugly and gloomy town house. Being cooped up in this dungeon of a dwelling finally got too much and, in the summer of 1736, they moved to a country residence with a garden and summerhouse in Les Charmettes, to the south-east. Rousseau quotes Horace's *Satires* (II, vi, 1) in his summation of what constitutes perfect happiness and repose:

> *hoc erat in votis: modus agri non ita magnus*
> *hortus ubi et tecto vicinus iugis aquae fons*
> *et paulum silvae super his foret.*

> This I longed for: my ideal would be a modest amount of land  containing a garden, nearby, a freshwater spring that never dries up and a small patch of woodland.

Adding a watercolour wash to the cadastre plans (public registers of land and property) which he worked on gave Rousseau a taste for drawing, while Mamma's (de Warens') interest in the picking of simples for herbal remedy further stimulated his new hobby: botany.

# Situated on the river Leysse, which flows into the lake and traverses Chambéry in part underground, the town commands the basin where the valleys of the Arc and Isère rivers conjoin

As he relates in Book Five of his *Confessions*, when France and Austria declared war in 1740 – the start of the War of the Austrian Succession – the Kingdom of Sardinia sided with Austria and regiments of the French army marched through Chambéry on their way to attack the Milanese in Piedmont. This points up Chambéry's strategic position. Situated on the river Leysse, which flows into the lake and traverses Chambéry in part underground, the town commands the basin where the valleys of the Arc and Isère rivers conjoin, dividing the Bauges mountains to the north and the Grande Chartreuse to the south. The route had long been a major arterial through the Dauphiné from Burgundy into Italy over the Mont Cenis pass.

The name of the town probably derives from the Gallic *camboritos*, a ford in the bend of a river, although a Gallo-Roman *Cambariacum* has some claim, from the vulgar Latin *cambarus,* a crayfish, or else from *cambarius,* a brewer, from Gallic *camba,* a brewing cauldron. Rousseau described the denizens of Chambéry as the best and most sociable people he had ever encountered and the town itself

# Rousseau described the denizens of Chambéry as the best and most sociable people he had ever encountered

as 'the one place in the world where life is agreeable, friendly and altogether contented', thanks to the amiable temperament of its citizens. This opinion was, no doubt, tinted by the success he had in dalliance with the 'charming young girls' to whom he gave music lessons, often (according to his narrative) with the open complaisance of their parents.

His sunny take on the neighbourhood was not an opinion shared by all. Horace Walpole came to Chambéry during his Grand Tour in the early 1740s and described it as 'a little nasty old hole... the antique capital of a dismal duchy'. A man of acerbic wit and decided opinion, his proclivity was to acid humour. 'The world', he remarked, 'is a tragedy to those who feel and a comedy to those who think.' Xavier de Maistre was born here in 1763 and, confined in a Turin prison after fighting a duel in 1790, he wrote his spoof *Voyage autour de ma chambre* poking fun at the glut of travel-writing, fanciful or overblown or both, of the time. 'When I travel through my room I rarely follow a straight line: I go from the table towards a picture hanging in a corner; from there, I set out obliquely towards the door;

but even though, when I begin, it really is my intention to go there, if I happen to meet my armchair en route, I don't think twice about it, and settle down in it without further ado.'

On the eastern shore of Lac du Bourget, to the north of Chambéry, Aix-les-Bains has been known as a spa since before the arrival of the Romans. The Allobroges, the Gaulish tribe in possession, were already taking its waters when the Romans built a thermal station here, either *Aquae Domitianae* (after the Roman emperor Domitian, born AD 51, notorious for his persecution of Christians) or *Aquae Gratianae* for Gratian, born 367, an earnest Christian much influenced by Saint Ambrose. In 1784, records show that 260 foreign visitors came to Aix. A hundred years later, the annual influx was put at nearly ten thousand, of which three thousand were British and two thousand Americans, enticed not so much by the healing waters of the spa as by the peripheral entertainments, principally the casino – the French were permitted to work but not play there – and the louche attractions afforded by the town.

# MONT DU CHAT 1504M

There are several approaches up this mountain, all singularly tough: from Chambéry to the south-east on the D916 and, at the end of this same road, from Novalaise to the south-west. The D42 leads away from Bourget-du-Lac to the east and from the north, in Yenne, the D41 goes up to Trouet to join the final steep southerly ascent.

1. From Chambéry (275m, 14km) to the intermediate Col de l'Épine (987m) and a further 5km of up and down to Vacheresse (912m) and 8.3km to the col
2. From Yenne (235m, 8.8km) to Trouet and a further 9.1km to the Mont du Chat
3. From Bourget (235m, 13.5km)
4. From Novalaise (425m, 7.8km) to the Col de l'Épine

The approaches from Chambéry and Yenne follow a similar pattern of gradient to the start of the final climb; that from Novalaise is more taxing, albeit the ascent from the lakeside is unremittingly severe.

Out of Chambéry to Cognin and the D916 or Le Motte-Servolex and the D3 to join that same road. Once clear of the outworks of the former capital of the Duchy of Savoy, the road from Le Motte is a quiet rural backwater running through dense woodland, the sort of road you need to know is going somewhere: there is no sign of people, activity, clear direction or obvious purpose for this road's existence, unless to get to the dark, secret,

mulch-rich groves where the fungi treasured by aficionados sprout – cep, chanterelle, boletus, parasol… The D916 is more sure of itself and the climb to the Col de l'Épine runs at a comfortable 5–7%. The Belvédère du Col de l'Épine (some 600m below the col itself) looks out over a stunning panorama of the encircling mountains to the east, the nearer range of the Bauges Massif south to the Granier and the distant peaks round Annecy in hazy silhouette. Look down on Chambéry and see how it has seeped in every direction into the neck of flatland at the southern extremity of the Lac du Bourget. Vast tracts of woodland were lopped down, first for building and firewood, later to make way for the ever-expanding town and its airport. Agricultural land and the flood plain were lost, built up and covered over with roads and houses. Reclamation work is in progress in all the woodland covering the Mont du Chat, beginning in *la forêt motteraine*, i.e. of Le Motte-Servolex. (The *motte* or earthen mound was the original hummock on which the suburb was sited, and *servolex* comes from the very rare Latin *silvula*, a small wood or copse.) The woodland area around Le Motte is carefully tended in order to regenerate the soil and the growth of trees as well as to promote what those in charge of the project are calling 'an exemplary biodiversity'. The vast industrial estate clogging the land beyond the motorway to the north scowls like an opponent to any such form of ecological beneficence.

The newly generated forest is 'ecocertified', conforming to the criteria laid down in Helsinki in 1974 and ratified at the Earth Summit in Rio in 1992. The Col de l'Épine (987m) arrives in a broad forest clearing with a stone and gravel car turn-round for walkers setting off down the tracks, either to explore the natural woodland or on a quest for mushrooms and sweet chestnuts. Loggers make the trek one last time before the snows to garner firewood, but the roads up here are closed during the winter.

Sixteen hundred metres down from the col, a turn to the right is signposted to the Etoile des Neiges. This is the D42ᴬ leading on past the *auberge* some 5km to Vacheresse, a woodland road that has the feel in places of a forest track. Alternatively, continue down the D912 for another 4.4km to the right turn (*c.* 590m) on the D41 for Marcieux, up through La Rosière below an impressive view of the long bulk of the Mont du Chat – which might well be a sleeping cat of primordial giant origin – and, across open farmland, up into Verthemex, the *chef-lieu* (principal community) and home of the commune's *mairie*. Right on what calls itself the C2 into woodland; a short way on, a Parc du Lama Bleu offers *randonnées* and *accrobranche* (tree-climbing activities for children) as well as a *buvette* (refreshment stand).

In Vacheresse, the more direct road from below the Col de l'Épine past the Etoile des Neiges, a homely-looking chalet with a terrace overlooking the upper Rhône valley,

*menus* at 16, 18, 20 and 22 euros. On a barn in Vacheresse, two stickers speak of the *Rallye Nationale Épine Mont du Chat*. I enquire of a neighbourly householder and he explains that this is a friendly get-together of owners of old cars – Jaguar, Ferrari, Rolls-Royce – in May. They drive round the circuit of the mountain road and gather for lunch in the Etoile des Neiges. 'Noisy?' I ask. My informant smiles. 'Not like motorbikes.'

There is much evidence of road repair and improvement round here, not, surely, anything to do with the Rallye, more likely part of the general rehabilitation of the woodland. At the junction with the D42 (780m), turn right for the Belvédère du Mont du Chat, 7km distant. New yellow-capped white bornes reel off the kilometres, the altitude and the gradient. Prepare to be intimidated. The first kilometre, 9% average, a momentary distraction past a broad gouge in the hillside, a mini quarry of caramel-red earth and stone. The road twists and swerves for 6km, 865m, 11%. A large hairpin spells trouble: 5km, 970m, 12%. The surface is good. It needs to be. Curves are a comfort and the next borne would seem to be part of the *relaxez-vous* interim: 4km, 1090m, 8%. However, the slight dips in this stretch are what reduces the average, because there is no discernible mitigation of steepness. 3km, 1170m, 12% to 2km, 1290m, 12%. Shortly before the last kilometre, in a clearing, is what must be a loggers' cement-rendered cabin, log stacks next to it. At 800m from the summit,

you may be tempted to stop at a viewing point with a panoramic vista of yawning vacancy and distance, but if you are not, swing round a tight, nastily sharp right hairpin to 1km, 1409m, 8% and allow your mind the possibly false sense that it's turned into a really quite easy ride, this one.

The Belvédère du Mont Chat, below the radio and television mast sprouting from a concrete building studded with satellite dishes, gives onto another glorious vista – a long ragged line of snow-capped mountains veiled in a sort of ectoplasmic haze far, far away. There's a café with toilets on the other side of the road, La Tare du Coureur des Bois. The coureurs des bois (literally 'runners of the woods') were freelancers who went to Canada and, without permission from the French Crown, engaged in the fur trade with native trappers in the seventeenth century. (Their activities were legitimized by permits issued by the French authorities from 1681 on.) They learnt native skills – canoeing, tracking, snowshoeing – for forays into the wooded wilderness riven with fast-flowing streams, and set up a highly lucrative commerce, trading muskets, powder, lead shot, blankets, linen shirts and stockings for beaver pelts. Further south, the natives bartered buckskins, a dollar per hide, whence the slang 'buck'. As for this Tare, I am puzzled. So, too, a French friend. In French tare is a deficiency, depreciation, loss in value, physical or moral defect, stemming from an Arab word ĐarĐah, 'that which is thrown

away'. The English sense refers specifically to the wrapping of a parcel or a container whose weight is discounted from that of the goods they enclose, also the unloaded weight of a lorry. Perhaps, then, this makes some reference to the trade practices of the coureurs.

Two walkers sat on a ledge below the belvedere eating sandwiches, staring out across the great ocean of air, on the day we were there, and I noted the signs for sentiers et balisés (marked walks) which take them along the lattice-work of tracks and paths criss-crossing this forested mountain. Do they confront the same gradients as the cyclists who ride up what Le Cycle magazine called the hardest ride in France, a loop up, over and down the Mont du Chat?

*From Le Bourget du Lac 235m*

LENGTH 13.5KM
HEIGHT GAINED 1269M
MAXIMUM GRADIENT 11%

The maximum of 11% is pretty well the average, too. Turn off the main lakeside road on the D42. It's narrow, twisting, cruelly steep, if entirely charming – trees, the fragrance of resin and bark, sunlight dappled through the leaf cover. Bends and hairpins act as brief emollients for an exceedingly tough long haul through Le Grand Caton and Le Petit Caton where vines grow along one fence as a grape-laden hedge. There is no way of dressing up the statistics to reduce the savagery of this headlong helter-skelter: 9%… 10… 10… 10… 10… 10… 11… 10… 10… 10%.

There are certain experiences which, for a while at any rate, till you recover and nature's anaesthetic amnesia kicks in, you have no desire to repeat but which you are glad to have done. I felt that way about Ventoux, the first time I rode it, for the course of such exploration can reveal places inside you that you know it's better to have seen and explored than leave forever unvisited.

Just north of Le Bourget, the D914 swings west off the lakeside road on a short steep jink over the Col du Chat (638m). The feline nomenclature is strong hereabouts, though without obvious reason: *caton* is *chaton* – a kitten, and as well as the Mont there is a Dent du Chat and a Chat Perché (literally 'Cat's Tooth' and 'Perched Cat') along with black cats painted on flowerpots here and there. In fact, the name may come, rather, from an old Gaulish word *calmis* meaning 'open country', 'a high rocky plateau', 'arid' and from pre-Celtic *calma*, 'wasteland'. The mountain's earlier name was Mons Munni – perhaps an obscure local deity – or Mons Muniti, 'mountain of the fortified place'. However, none of these explanations is wholly convincing, and we may be left with the resemblance of the Mont to a cat hunkered down, hunting a mouse or a bird.

*Snapshot*

# TOUR DE FRANCE 1974
## STAGE 10, ASPRO GAILLARD TO AIX-LES-BAINS *131.5KM*

The Mont du Chat was included in the Tour for the first time but, quite inexplicably, classed as a second category climb. (It was included a second time in 2017, as *hors catégorie*.)

At the foot of the northern slope, Eddy Merckx and his close lieutenant Jos Bruyère set off in pursuit of a lone escapee, the Spaniard Gonzalo Aja, taking other riders with them. As they neared the summit, Louis Caput jumped clear. The veteran Raymond Poulidor (then thirty-eight years old), responded to the attack. Merckx didn't budge. Poulidor was already 100m clear, out of the saddle, dancing with lively energy, his cap askew, as behind him down the slope, the yellow jersey, hunched over his bike, clung on, labouring, losing ground. At the col, Merckx had lost 1m 45s on Aja, first over, and 1m 7s on Poulidor, but he was a consummate taker of risks and, on the descent, he caught the leaders and took a second successive stage win. It gives some insight into the chemistry of his aggressive spirit, the fiery response when it seemed he was beaten, that after his harum-scarum plummet down the narrow, tight-kinked, precipitous road into Le Bourget he admitted: 'I have never descended so fast.' His wife, Claudine, said of him: 'Eddy has always retained a sort of spontaneity that sidelines common sense. He doesn't weigh up the problem first or think about the consequences.' Decide what you're going to do, then how to do it, not the other way round.

Merckx started that Tour after an operation on a chronic hardening of the tissue of the perineum and the scar had not healed. As a result, he rode the race in constant pain. He frequently got *out* of the saddle to ease the discomfort and expended more energy than he would normally, staying *in* the saddle. This was the reason for his unwonted weakness on the Mont du Chat, where he said, 'Poulidor was superb. I admit he worried me and that's why I launched that insane descent. Above all, I couldn't let him believe I was vulnerable.' (Poulidor had beaten him into third place in that year's Paris–Nice.)

Aja crossed the Tourmalet and Ventoux as well as the Mont du Chat in the lead and finished fifth overall in Paris. Poulidor, for the third time in twelve Tours, came second.

Aspro Gaillard, used as a finish for the first time in 1973, refers to the Aspro factory in Gaillard, just outside Geneva. Aspro is a conflation of 'Aspirines du Rhône'.

# COL DE PORTE 1326M

*Southern approach from Grenoble 215m*

LENGTH 17.4KM
HEIGHT GAINED 1111M
MAXIMUM GRADIENT 9%

The main route to the col from Grenoble follows the D512 out of La Tronche, on the northern edge of the city. This climbs to the Col de Vence (782m) after around 7km of tough gradient, 7–9%, and continues at an only marginally slacker rate to the big pass. A quieter route goes out of Saint-Égrève, a bit further to the west on the D105[A], about 220m away from the urban racetrack, into open country and the lie of the surrounding hills, the lower prominences of the Chartreuse. At 3km, 500m, a smoothly rounded hill topped with a small pinnacle, like a *Pickelhaube*. A short descent into woods on new tarmac into Quaix-en-Chartreuse and, climbing once more to a junction with the D57, right to the Col de Clemencière, an alternative route up from the Drac valley, then left to Sarcenas and a short haul up to join the main D512. Although the road to this point is quite narrow and twisty, in and out of woodland, the string of bus stops along its length, village to village, emphasizes the proximity of the larger conurbation: school run for children from the rural outposts.

Just outside Sarcenas, note a curious structure made of interwoven twigs (Andy Goldsworthy is the master of this form of natural manufacture) in the shape of a bird's nest. The junction with the D512 is called the Col de Palaquit (1154m), the road is wide, smooth and fast, 2.5km to the col, a narrow pass, ski-lift gantries to the left, a paintball park to the right.

The northward descent is fast on a good surface. Two kilometres down on this first 7.5–8% slope, a *colonie de vacances* (summer camp) sits back off the road behind a tall open fence, housed in cream buildings. In Martinière about 4.5km down at 1000m, at a right turn-off on the D57[B] to the Col de Coq, a restaurant and a breaker's yard. From La Diat, slightly larger at 800m and 8km down, at the commencement of the Gorges du Guiers Mort, the road climbs a short way into Saint-Pierre-de-Chartreuse, a *station d'hiver* (winter sports centre) well supplied with customer support – a bakery called, fittingly for its function, Charly Pain, a restaurant named L'Hibou Gourmand (the Greedy Owl), a cinema – as well as the retail excrescences that come with skiing.

Saint-Pierre occupies a depression at the convergence of several valleys carved out of the cretaceous limestone of the Chartreuse massif. The hollow in which it sits is ringed by three grand peaks, like bailey towers: the Chamechaude (2082m) above the Col de Porte, to the south; Le Grand Som (2026m) to the north; and the Dents de Crolles (2062m), highest of the Chartreuse massif, to the southeast. A great many torrents, cascades and rivers sprung from the core of the Chartreuse have sliced into the bulk of the original mass

to delineate huge cliffs in which thin layers of marl (a soil which consists principally of clay mixed with carbonate of lime) give purchase on the beetling rock face to outcrops of vegetation, known as *sangles*, another word for 'ledge'. The waters have also hollowed out an extensive labyrinth of subterranean galleries and caves in the rock, and the honeycomb inside the Dent de Crolles, in particular, is much visited by potholers. The monastery of La Grande Chartreuse that lies beneath the crags of Le Grand Som (summit) takes its name from the mountain range. Saint-Pierre was, according to some accounts, originally called Cartusia and the mountains round it the Cartusiani Montes. On its upper western slope, Saint Bruno built the first cells of his monastic foundation in 1084 and, on a nearby prominence, a chapel. The original cells were swept away by an avalanche in 1132, but the chapel survived.

Saint-Pierre occupies a depression at the convergence of several valleys carved out of the cretaceous limestone of the Chartreuse massif.

# COUVENT DE
# LA GRANDE CHARTREUSE

Bruno was born in Cologne in about 1030 and became a highly
regarded professor of grammar and theology in the cathedral school
of Reims, where he had studied. Appointed chancellor of Reims by
the archbishop, a man of moral decrepitude and venal habits, Bruno
was caught up in the denunciation of him by two episcopal canons
in an ecclesiastical council. They accused him of simony, the selling
of church offices. The prelate was suspended but managed to regain
the see by deceiving the usually hard-nosed Vicar of Christ, Pope
Gregory VII. He immediately ordered the houses of the clerics who
had exposed him to be ransacked. They fled and Bruno, long sickened
by, and weary of, the vice and hypocrisy of the world in which he had
achieved such distinction, applied for help to the bishop of Grenoble,
one Hugh (later sanctified). Hugh suggested that if he was looking for
solitude and peace for prayer and contemplation, he might withdraw
to the uninhabited woods and inhospitable rock of the Chartreuse
massif. Accordingly, Bruno set off with six companions in 1084 and
built the cells below Le Grand Som, where they lived, at first in pairs,
then alone. They took but one meal per day, except on the great
festivals when they ate together in a refectory. For the most part
they lived as hermits, meeting at Matins and Vespers only, and this
extreme asceticism has more or less persisted in the Carthusian order
that grew from Saint Bruno's founding house.

The first monks earned their living by copying books and, the soil
of the Chartreuse being too poor to sustain crops, breeding cattle.
Bruno died on 6 October (his festal day) 1101 and, though he was

never formally canonized as a saint, the Carthusians, eschewing such ostentation, sought and obtained permission from Pope Leo X in 1514 to keep his feast, a leave extended in 1674 by Pope Clement X to the whole Church. The first house on the site of the present monastery was built by Prior Guigues in the twelfth century after the destruction of Bruno's original cells. The present house was built in 1676 after a series of fires had destroyed the earlier foundation.

In 1605, the French king's marshal of artillery gave the Carthusian monks of Vauvert, near Paris, a document containing alchemical formulae, among them that chimera of the quest for the philosopher's stone which could turn base metal into gold, the *elixir vitae*, elixir of life. Using this as a basis for a recipe which, in its finished form, used 130 plants, flowers, herbs and secret ingredients in an alcoholic base, the monks produced a spirituous medicine, the prototype of the famous Chartreuse liqueur, both green and yellow. This is now distilled in Voiron, a large town some 25km to the west of the monastery, which is not open to visitors. Chartreuse is identifiable by its pale, apple-green colour. In 1611, a wealthy London merchant founded a chapel, school and hospital on the site of the London Carthusian monastery, which had been closed in the great Dissolution of the 1530s. The school survives as Charterhouse, a corrupt form of the French word. There is, today, a Carthusian monastery in Pinerolo, home of another fine example of human ingenuity and technical expertise, the celebrated maker of fine racing bicycle frames. Happy chance.

# COL DU CUCHERON 1139M

*Southern approach from Saint-Pierre-de-Chartreuse 885m*

LENGTH 3.1KM

The climb starts at 7.5%, slackens for a kilometre and then hits back hard with 8–9% to the top. Note, in the small hamlet La Coche, fish-scale earthenware roof tiles.

Beside the col (*cucheron* means a 'rounded summit' or 'hill') stands an *auberge*, the Hôtel de Cucheron; opposite it a teetering gantry for a decrepit ski cable on which even the emergency stop button looks thoroughly worn out, and below it ski chalets, ever hopeful.

The descent is bendy, partly tree-shaded, on new tarmac, a breezy brace of kilometres at 8–9%, and a short up-and-over onto gentler slopes through a string of villages with 8.3km to Saint-Pierre d'Entremont (640m), a sizeable place with a lot of eateries, and, a short way on, by a bridge over Le Cozon stream, a restaurant with its own stew, a pond in which to keep fish fresh for the pan.

From the col, look north-east to the 400m-high walls of the Cirque de Saint-Même, a horseshoe of what might be slab-built rock which seems to heave itself out of the forest. From the deep centre of the cliff spring the Guiers Vif, the Living Guiers. These headwaters of the river which eventually flows into the Rhône gush down through a succession of spectacular, lofty, tumbling cascades – Cascade de Source, Grande Cascade, Cascade Isolée,

Pisse du Guiers – into the last grotto from which they spill down to the beginning of the eponymous Gorges, 12km long. One very tight, perilous section of it is called the Pas du Frou (the dialect means 'of fearful step'), beneath a dizzying overhang (the Pas). Built high above the boisterous waters of the torrent, a tiny Roman bridge, still known by its medieval name, the Pont Saint-Martin, spans the deep and confined gorge.

# LA VOIE SARDE

The old cut made by the fast-flowing torrent through the living rock is very steep and, in time of excessive rainfall, not infrequently turned once more into a rapid force of water. In order to facilitate negotiation of the precipitous track, the Romans built in a succession of broad steps, hence the original name, the Défile des Echelles (*échelles*, 'ladders'). In 1649, Marie-Christine de France, daughter of King Henri IV and Catherine de Medici, wife of Victor Amadeus I, Duke of Savoy, after consultation with engineers and surveyors, instigated the reconstitution of this old, stepped Roman road to make it passable for wheeled vehicles. This eventually became known as the Voie Sarde (Sardinian Way), linking the important trading entrepôts of Turin and Lyon. (The Savoy dukes also reigned over the Kingdom of Sardinia. The duke died in 1637 and Christine ruled as regent for her infant son until 1663.)

The house of Sardinia bore the enormous cost of the vast project. Consider the proliferation of immense public works carried out by the Romans, all paid for by booty and tax revenues from the vast Empire and with much of the labour carried out by slaves, at no cost bar food and lodging.

Construction work was put in the charge of one Balland. His scheme involved first widening the natural gorge with pickaxe, hammer and chisel. He then canalized the torrent by building a revetment along the right-side verge of the descending path so that the water might be contained, flowing in a deep, narrow conduit between revetment and existing rock wall. Sturdy and prominent as the parapet is, there was, and still is, intermittent risk of flooding, but far less than previously. There followed the task of levelling the

stepped way to create a single, flat-surfaced ramp, still inevitably at a steep incline, but of a manageable gradient for wheeled carriages. Some 13000m³ of masonry had to be quarried and carted in for both revetment and paving. Work continued under the auspices of Christine's son, Duc Charles-Emmanuel II, between 1667 and 1670.

The Roman bridge over the Guiers had marked a natural frontier which was then formalized as the border between Savoy and the Dauphiné and later between France and Savoy. Ruins of the guards' sentry boxes remain, and coats of arms mark the sovereignty on either side. At the lower end of the ramp stands a grandiose monument to the duke, recalling that this road *aeternis populorum commerciis patefecit* (opened up a route for trade between people for all time). It rather sniffily dismisses the Roman effort to pioneer the transit.

Rousseau walked the Voie Sarde in 1767, on his wanderings in the Dauphiné, and the infamous smuggler Louis Mandrin (1724–1755) used the lowest of the grottoes as a hideout. A fugitive from French law, he trafficked in cloth, hides, tobacco, canvas and spices, bought in Switzerland and resold in French towns free of royal taxes. Betrayed by one of his men, he was broken on the wheel in Valence in front of a huge crowd.

Impatient of the necessary slow passage afforded by the old Voie Sarde, Napoleon ordered the piercing of a tunnel, begun in 1804 and not finished until 1813. (Through this the D1006 passes.) The ailing pope, Pius VII, summoned by Napoleon to crown him Emperor in December 1804, travelled this way. French military engineers mined the Voie Sarde in 1940, to impede the advance of German troops between Echelles and Chambéry. A later force of army engineers restored it in 1984.

# COL DU GRANIER 1134M

From Saint-Pierre d'Entremont to Épernay
(850m, 5.2km) the ascent, in the company of
a number of small communities, is relatively
unchallenging. The last 4.4km are stiffer to the
col and an open viewpoint, where a restaurant
puffs its *tarte aux myrtilles maison* (home-made
blueberry tart).

The descent – gradients of around 7%
average – on the continuation of the D912
north gives a splendid view over Chambéry.
Mont Granier, whose cliffs tower above the col,
stands stark against the sky in the form of
an anvil.

## Eastern approach from Chapareillan 280m

LENGTH 10.4KM
HEIGHT GAINED 854M
MAXIMUM GRADIENT 10.5%

*Note: There is an alternative northern approach
from Saint-Badolph (311m, 11.6km), height gained
823m, maximum gradient 10%, not described here
in full. A fairly relaxed opener of 2km gives onto a
quite severe 4km of up to 10% but then levels into
no more than 4.5% before a final run of 4km at
6–6.5% to the col.*

The D285 heaves itself up from the Isère
valley past grazing meadows and fields lined
with vines into open country at Palud (451m,
2.7km). The citadel of Mont Granier looms
overhead. The road curls into woodland and

after a blast of around 9.5%, the gradient
slackens for a way, the hairpins flatten out,
views of the bulk of the rock bluffs appear from
time to time and the fluent swing of the road
makes this a delight. At around 4km from the
top, the gradient worsens again, 9–10.5%, and
the hairpins impart more of a jolt, accordingly.

This woodland forms part of the *Réserve
Naturelle des Hauts de Chartreuse*. One hundred
million years ago, the chalk of the cliffs
overhead formed the bed of a warm sea. As the
alpine chain thrust up from the sea floor, the
layers of rock were folded and raised above the
water, which later receded. During the course
of erosion, the long gutter, the bottom of a
great fold stretching from Mont Granier to the
Dent de Crolles, was left in place.

# THE LEGEND OF THE CHASMS

One night in 1248, part of the Granier's cliff wall came down and initiated a massive earth slide and, in a few minutes, hundreds of cubic metres of mud and rock engulfed an area of 30km$^2$ to a depth of 40m. Five parishes were buried and some thousand people with them. In tune with the nervous disposition of the God-fearing time, the catastrophe was attributed to divine vengeance for miscreance. The story went that one of the Comte de Savoie's councillors had expropriated a priory in Saint-André on the eastern side of the Granier and evicted the religious who lived there. They prayed to the Virgin of the Convent of Notre-Dame de Myans, a little way to the north, for her to intervene on their behalf. Hail and tempests, earth tremors and upheaval ensued, invoked by 'the agency of demons' and with such prodigious effect that the top of the mountain fell and crushed Saint-André but, lo, the Virgin of Myans stepped in, most timely, drove back the demons and the convent was spared.

Taken as a chain of cols, the Porte, Cucheron and Granier in whichever direction offer a terrific blast of riding, and it was on the north–south trajectory that the Spaniard Luis Ocaña took a serious chunk of time out of a hitherto dominant Eddy Merckx.

# COL DE LA CLUSE 1169M
# COL DES EGAUX 958M

*A detour through to the Gorges du Guiers Vif and the Voie Sarde. Turn off the D912 onto the D45 in Entremont-le-Vieux (850m), which lies to the south of the Granier.*

Four and a half kilometres to Le Désert where the road swings left through pasture and pine woods, and, as the woodland closes in, there's the col sign, but on the descent from the actual brow. A steep climb under the cliffs of the spine of Mont Outheran and on into another valley, through a tiny community, Corbel, where the climb resumes up to the Col des Égaux. Trees hem in close, the road is barriered and rock walls appear free of vegetation periodically. The road dips down, and suddenly here is a large stone wall, like a gate to a further spell of climbing up to a marked bend from which opens a large view of a jutting mountain bluff to the left and the spread of the valley below. On through working farmland, the hamlet of Égaux and the col itself. A comfortable drop to the D1006, horses in fields yet no obvious sign of agronomy, and so into Saint-Jean-de-Couz, a substantial farm village with the usual augmentation of modern dwellings.

# COL DU COQ 1434M

*Western approach from La Diat 795m*

LENGTH  12.3KM
HEIGHT GAINED  730M (ACCOUNTING FOR A SIGNIFICANT TROUGH NEARING THE TOP)
MAXIMUM GRADIENT  10%

Turn onto the D57[B] from the D512 between the southern end of the Cucheron and the northern foot of the Porte. A little over 2km along, in Saint-Hugues-de-Chartreuse, take in the encirclement of the mighty peaks of the Chartreuse: Grand Som, Charmant Som, Chamechaude. (Gaulish *calmis*, 'open pasture', and French *chaude*, 'warm', indicate a sunny upland meadow.)

The first 5km are relatively easy, the road sidling along in company with a chattering brook to the right through the outspill of farm buildings into trees, then across a bridge without parapet, which puts the water to the left, and on into a lovely glade of mixed woodland. Here you may converse in silence with the calming elements of nature on hand, water, leaf and timber, mulch and dappling sunlight on a path which, though now metalled, surely has existed for centuries. The road bids adieu to the trees and opens itself to grassland, albeit of a narrow width but, missing the pleasing effect of light through foliage, calls the trees back. You may not notice that, here, the gradient is severe. There is much to allay the abrasion. The surface is somewhat broken,

The road bids
adieu to the trees
and opens itself
to grassland,
albeit of a narrow
width but,
missing the
pleasing effect
of light through
foliage, calls the
trees back.

but this is, all in all, a cheery by-way, placid of temper and reposeful, albeit quite small for its age.

Now, at 8.5km, after a slackening in slope the heralded drop down a long incline, some 1.7km, to climb again in trees which may thin out from time to time but are enjoying the parley too much quite to quit until they bow to the clamour of open meadows. Sheepfolds dot the heath below the col, which is marked by a diminutive yellow square, alongside similar postings for walking paths. (The sign confirms 1434m, the map says 1738m. Nitpickers, take note.)

The tricky descent speaks to the toughness of the climb from this direction, 12.7km of near-constant 8.5–9%. It is broader of width, unshaded, crimped by hairpins, a rock wall ledge of a road, exposed on its open side to a yawning panorama across the profound chasm beneath the soaring pinnacle of the Dent de Crolles.

A short way below Le Baure, left to Saint-Pancrasse, past a statue of Her and a graffito on a sidewall: 'New World Order?! *Fermer les Yieux* [sic] *c'e$t mieux'*, which needs no explanatory gloss. Another: *NON A LA DELOCALISATION*… local businesses and communities for local people.

# COL DE MARCIEU 1065M

*Included as a way through to the Col du Granier. Alternative approaches to the D30^C which passes over the col, south from La Terrasse, north from La Buissière, are both stern in the lift from the valley road. The latter, 12.5km, dishes out a couple of kilometres at 12% lower down; the former, 11.2km, barely drops below 10% into Saint-Bernard.*

Leave Coq, into Saint-Bernard – a Monastère des Petites Roches, inhabited by nuns – on through Le Guillot, Miel (honey) de Chartreuse on sale, by a left-hand bend a house with one side of its roof composed of solar panels, thence to Le Rajon and Saint-Michel, firmly distinct by name but scarcely 100m apart, a regular little suburb of hamlets, and the col.

The col is host to an *Espace Ludique* – Games Area – with much on offer in the way of outdoor activity and disport all year round. The usual medley for snow and, in summer, a variety of methods of hurtling down the forest tracks to the bottom of the slope down open tubes, on luge, mountain board (like a snowboard but with casters), and VTT, plus less hectic expeditions on foot or hired pony.

The descent north is a mix of flowing curves and clutched bends. A 10% stretch shoots you onto a slight rise, just above and on beyond Belle Chambre, where the descent eases into 4 and 6% through trees. Turn right for La Flachère, further into the chine and onto an open ledge, through a short rock tunnel and

from there on, hugging the wall to the left, a metal barrier to the right and an expansive view across the valley towards the long series of lesser cols leading into Allevard. The road peels away from the wall and gives onto a long ramp of 12%, deadly to climb but a hurtling descent.

At the foot of the drop, left into the village of Saint-Vincent-le-Mercure, where a grandiose monument, in the form of a Buddhist pagoda, celebrates the life of Ernest Marc Louis de Gonzague Doudart de Lagrée, born here on 31 March 1823, the first European to explore the Mei-Kong (Mekong) river. On one side of the monument a bas-relief shows him discovering the marvels of Khmer architecture and sculptural ornament in the ruins of Angkor Wat. In another he presents the idea of a French protectorate to the Cambodian prince, Norodom, to save the country from being swallowed up by Vietnam and Siam (modern Thailand). Norodom I ruled as king of Cambodia from 1860 to 1904. Doudart de Lagrée's attitude to proposals of advancement in rank and office from foreigners was uncompromising: 'I'd prefer to hold no position at all than to serve a foreigner.' He died of an abscess on the liver and was buried in Dongchuan in China. A doctor took his heart back to France.

# GRAND COLOMBIER 1501M

This mighty lump of rock actually forms the southern extremity of the Jura mountains to the west of the river Rhône, but, since the Jura are unlikely to provide enough material for a book of their own, I decided that such a gargantuan treat of geography, gradient and cycling adventure could be accommodated without protest in a book about the High Alps.

There are five ways up to the col.

1. *From Artemare 250m, length 15.9km, height gained 1251, maximum 22%*
2. *From Culoz 250m, length 18.3km, height gained 1251m, maximum 14%*
3. *From Anglefort 250m, length 15.7km, height gained 1251m, maximum 11.2%*
4. *From Champagne-en-Valromey 557m, length 19.2km, height gained 944m, maximum 11%*
5. *From Talissieu 236m, length 14.05km, height gained 1265m, maximum 22%*

The Grand Colombier is the domain claimed for their own garden of amusement by a bunch calling themselves the Confrèrie des Fêlés du Grand Colombier – the Daft Brotherhood of the Grand Colombier – for which you qualify, (the thought!), by doing the four main routes in a single day.

## ROUTE 1 FROM ARTEMARE

Follow the D69 to Don, Munet on a gradient of an average of 5% to Virieu-le-Petit (635m, 8km), where the trouble starts. I mean *trouble*. The first 4km out of Virieu on the D120$^C$ do not drop much below 12% and hover around 14%. The fourth of those kilometres, some 400m at 18% also incorporates a shocking punch of 22%. A brief respite of 5% again before a final withering 3km that mete out up to 11%.

## ROUTE 2 FROM CULOZ

This route – on a largely open road facing south, so try to avoid the heat of the day – offers the most spectacular views all the way to the top. Given what inspiration painters and photographers have found in the Alps – from Turner to our own man behind the camera, the eminent Pete Drinkell – it is a pity that our word 'picturesque' is fastened to a sort of paint-by-numbers twee vista deemed most suitable for jigsaw puzzles, chocolate boxes and that nadir of infra dig, the coaster. The jocular rendering of it as 'picture-skew' underlines the mundanity. Walter Bagehot noted this in his *Literary Studies* (1879): 'Susceptible observers… say of a scene "How picturesque" meaning by this a quality distinct from that of beauty, or sublimity, or grandeur: meaning to speak… of its fitness for imitation by art.' The word derives from the Latin *pingo – pingere – pictum* (to paint or embroider).

The word's French original, *pittoresque*, has a broader range and can be applied to places which charm, amuse or strike by some special characteristic. It can, more broadly, be used of persons and personality, of literary style, of language, expressive of colour, piquancy, vigour, striking force. The Grand Colombier,

This route – on a largely open road facing south, so try to avoid the heat of the day – offers the most spectacular views all the way to the top.

as viewing platform, deserves the full Gallic richness of the word.

A sign indicates the route in Culoz ('at the bottom') on the D120 towards the summit. The road climbs briskly away on 5% from the marshland beside the river Rhône and up a kilometre or so of 10% onto an open shelf curling round the lower slopes of the great mound of the Colombier, barrier to the open side, cliff wall to the other. Spread out below, the Lac du Bourget, joined at its northern end to the river by the Canal de Savière, a delightful stretch of peaceable water with leafy banks, a crucial valve for the superfluities of the river which it feeds into the lake – it has no other source of water – through a lock at Chanaz. From a viewpoint at 3.8km, 604m, the silvery courses of the waterways spread out below, the broad channel of the river, the crinkum-crankum course of the canal, the widening expanse of the lake fusing, at the far end, with the distant heights which line the horizon.

The irregularity of the gradient may add some stress – changes of rhythm do punish the legs, although the relaxing of the steeper pitches gives temporary respite and a grateful spirit buoys the mood. Some of the lesser slopes on this approach do mask passages of up to 14%, however.

From the belvedere (Italian: 'fine viewing'), 2km at around 10% with a couple of bursts of 11 and 12%. The large view persists all round. Suddenly, the shackles loosen into a relatively flat stretch past the junction with the road

to Bezonne and on down through the Forêt Communale d'Anglefort. The climb starts once more on a varied 9 to 11% with a short episode of 14% after which the final 6km, on the sloping brow of the mountain, are almost mild by comparison. A *canadienne* (cattle grid) at 14.4km and an open heathland, grass studded with stones and boulders, a short way on, the turn-off to the Auberge du Grand Colombier and another *canadienne* where the road narrows markedly, bordered with dwarf trees, a conical peak ahead with a pylon on top casting overhead cables down its slopes.

On the broad wind-scraped bare pate of the summit a signboard speaks of the wild mountain flowers to be seen here: the cream *Narcissus poeticus*; the mauveish pink *Traunsteinera globosa* (*Orchidée globuleuse*), an extremely rare flower which grows in parched upland grass in the Franche-Comté; the white *Narcisse à fleurs radiantes*; the yellow wild tulip; the pink *Erythronium dens canis* – dogtooth violet – with white, pink or pale mauve petals tinted yellow at the base and not of the viola family despite the name; the *Orchis sureau*, emitting an agreeable faint perfume of elderflower (*sureau*), in red, yellow or lilac; an alpine buttercup; the Trolle d'Europe; jonquils; and the red vanilla orchid. An admonition at the foot of the sign reminds that you can paint them or take a picture of them and thus bear away a souvenir that will never fade, but please do not pick them. That goes for all nature: leave nothing behind but the faint dint of your feet.

Gratuitous to say, perhaps, the panorama is superb. A large open metalwork cross of box construction stands on a height above the col, its significance, other than in a general way of religion reaching out as close to the ether as possible, otherwise unexplained. (For the ancient Greeks *Aither* – shining bright air, the celestial region, our ether – was the highest realm of the cosmos.)

The D120 skirts the top end of the Directissime route (1175m), the D120$^C$, at whose entry, like that into the *gouffre éternelle* (eternal abyss, Hell), stands a sinister sign reading 19%. On through woodland and some 4km from the col, open farmland. Past Brénaz to the left and a sign directing you towards the Colet de la Biche to the right on the D123. Clumps of trees and the pastured plateau of the Corniche de Valromey, a causeway across the meadows.

From this causeway, a right turn leads up to the Biche. Thirty-seven members of the aforesaid Confraternity have also completed the Bugiste Challenge (*Défi Bugiste*), which consists of the four ascensions of the Grand Colombier *and* the two sides of the Biche – 1325m, 12.9km up from Gignez, the first 7km hovering round 11% and not much better from the west – in a single day, 7043m of climbing over 208km. I assume this challenge is named after the pioneer of the lunacy.

From Bénaz, the D30 runs 5.5km to a junction, the Porte de Valromey, and right to the Col de Richemond (1060m – on the map,

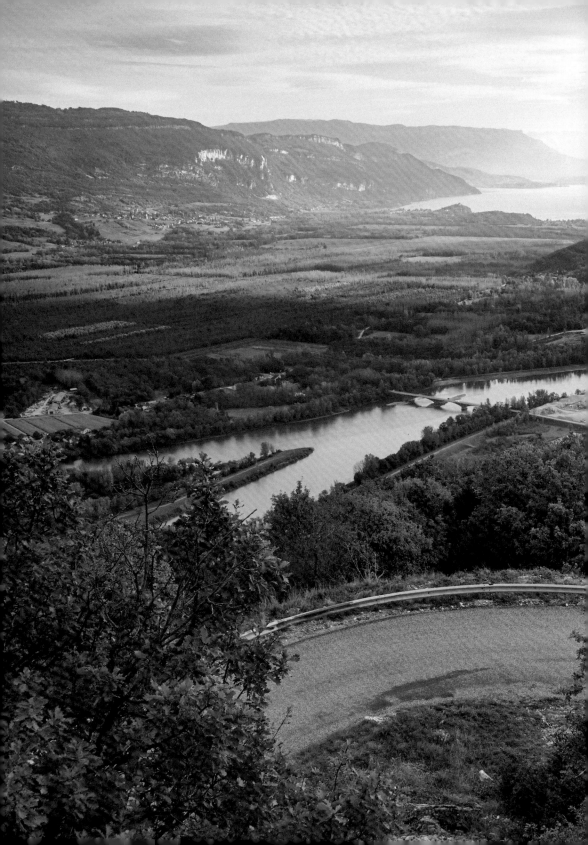

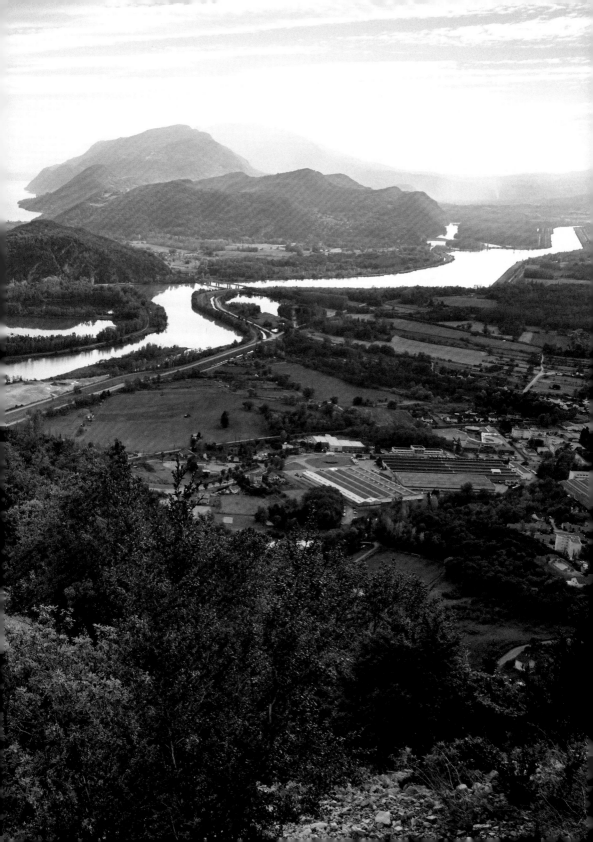

Richemont) 2km on. A memorial records the sacrifice of seventeen men of the local Maquis, eighteen to forty-four years of age. This unassuming col in a quiet small glade, sunlight glinting on the sheen of the leaves, makes an apt spot for their commemoration.

## ROUTE 3

Considered by some aficionados the hardest of the four main approaches. A gentle start on the D120$^A$ for a kilometre of near flat, followed by 9km of non-stop 10% interspersed with a hammer of 11% and, on the tenth kilometre, an excruciating spasm of 14%. Through Bezonne (685m, 5.5km) past a left turn to Culoz (850m, 7km). A gasper for a 3km stretch dwindling from 5.6 to 2.8% and a final 3km oscillating between 8 and 4.4 and 9%.

## ROUTE 4

This they call the easiest ascent, shaded as it is for some of the way by pine trees. But, in the prevailing context of how and why the epithet is applied, beware: these assessments are delivered by strictly certifiable nutters.

Ups and downs for 4km from Champagne-en-Valromey (537m) on the D69$^F$ through Charron (537m) and Pont-sur-l'Arvière (482m) to where the D69$^F$ swings right for Virieu. Here the slope steepens and teeters between 5 and 9% for 7km, with one passage of 11% in the ninth kilometre. From that turn to Virieu continue along the D69$^G$ into Lochieu (604m, 6km). Right on the D120 to Les Bordèzes

(724m, 8km) and a steady 6–8% to Abbaye d'Arvière with that passage of 11%. Flattish to the start of kilometre 14 and 9% followed by 1.6km of 14%. A lull for 2km, 5–7% and the final 2km an almost apologetic 10–10.5%

## ROUTE 5

The Confrèrie christened this one 'Le Directissime', and it is not recommended as a descent because it's too bloody sharp. For the uninitiated, *directissime* is a mountaineering term meaning 'straight up', no shilly-shallying with traverse or slantwise or (on the road) zigzag over the camber. The Fêlés (not quite right in the head) rate this one of the severest climbs in Europe. Feel free to dispute that.

From Talissieu follow the D105 a kilometre of 10% through Paradis (consider) to the hamlet of Ouche where a side road goes off to the right into Chavornay (464m), bypassing the cemetery lying in wait on the D105. Some 750m on, take another side road (483m) via Vovray and Dasin into Munet and rejoin the other road, which, meanwhile, has become the D69 towards Virieu-le-Petit, 5.7km in total. Take the right fork in the centre of the village and turn right on another side road by a communal washing basin for 400m of 19% with a dollop of 20+%. Back to the D120$^C$ and the onward route to the summit as from Artemare.

# COL DE LA BICHE 1325M

*Eastern approach from Gignez c. 430m*

LENGTH  12.9KM
HEIGHT GAINED  895M
MAXIMUM GRADIENT  10%

The arduous approach to the start of the Forête Communale de Corbonod, just past the Bifurcation de la Cabane à Pélégrini – the old wayfarers' refuge – is like a corridor with tree walls, dwarf, shrub-like trees, moreover of diminished character and with seemingly no purpose but to blot out any view. The shuttered feeling adds to the severity of the slope. At around 6.8km, there comes more open terrain, and the trees recede to leave an apron of grass to either side of the road for about 300m before the arboreal lock-down takes over again. Some half a kilometre on a view does, at last, open out to the left for a short distance, and 2km further on, a prospect of the far-off ranges lifts the eyes above the cracked and battered road and the featureless vegetation. The plateau persists for a way, its far rim tips over into a kilometre drop and then retrieves the shed metres up to the col, in a small logging clearing. The descent to Brénaz has a similar closed-in feel, but the undulating road south – a *coup du cul,* 'kick-up-the-arse' – from there below the main bulk of the Grand Colombier is a joy to ride.

# MONT SALÈVE 1380M

To the south-east of Geneva, but still in France, the massive protrusion of Mont Salève, a bulk of striated limestone, the scored open rock of its cliffs lined with vegetation, part of its slopes thick with trees, lies on the earth like a great beached whale turned to stone.

From the centre of Cruseilles (800m) turn right on the D15 towards La Roche. The outskirts of town fall away, the road is spacious, winding through fields and its verges dotted with trees, through l'Abergement, a village named not for some sort of hostelry no longer in evidence, but for an ancient feudal practice. It refers to land allotted to a peasant, over an extended period, for clearing or grubbing, on payment of a sum in cash and a pre-determined annual rent. Not what you'd call much of a deal. Slavery by another name.

As the trees begin to establish a stronger presence, the road shrinks but keeps its cheerful mood, swinging about like a country dancer threading partners in an eightsome reel. Les Lirons at 3.3km shows 930m and the slope is generally even-tempered. Mature woodland invests the way above the settlements, some mighty pines of venerable age standing proud that might be shoots from the Norse world tree, Yggdrasil, tower up from the loose floor of mulch and needle. At 8.9km the road emerges from the forest and spins to a viewpoint, 1270m, from which to gaze upon the full range of mountains – the Dents du Midi and company – across the eastern horizon on the Swiss border. A kilometre on and the trees

resume command, log stacks everywhere,
fuel for local stoves. At 11.3km a restaurant,
La Grotte au Diable. (The Devil has umpteen
sites named after him across France, forty-
nine bridges alone.) A short way on, another
stunning panorama and, if for nothing else,
this climb merits attention. You may stand
on a natural rooftop and stare across a hint of
eternity.

Upland cabins dot the open landscape and
the road veers off down towards the valley
of the Arve. Some 5km below the summit, a
restaurant, La Croisette, *gîte, crêpes, chambre
d'hôte* (guesthouse), always busy – the Génévois
come to the Salève in droves for excursions
and the walking. Up past a turn to the left
where a café Au Cret (i.e. *crêt* – ridge) sits on
a crag. Across moorland and onto the descent
where, at around 9km from the top, a radio
mast stands neighbour to a restaurant and
bar, L'Observatoire. Two kilometres on, the
*téléphérique* (cable car) arrives from Veyrier
down in the valley.

This is a pretty fast descent with an
occasional vexation of hairpins and a nervous,
intermittent nag of bends. At 13km from the
top, a restaurant advises motorists to leave
nothing in their car. The Swiss? Petty thieves?
Next thing you know, they'll be turning up late,
watchless. A road marker warns of 8% and the
road runs on into the suburban outcrop which
is Monnetier-Mornex (720m).

GRENOBLE

# GRENOBLE

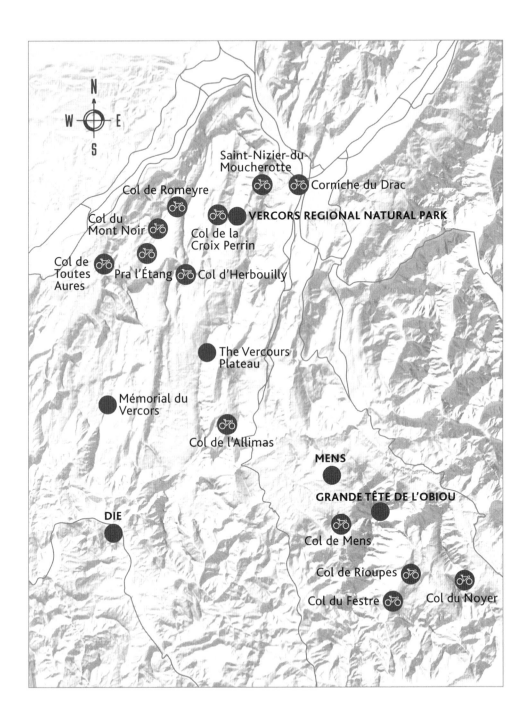

Saint-Nizier-du-Moucherotte

Corniche du Drac

Col de Romeyre

VERCORS REGIONAL NATURAL PARK

Col du Mont Noir

Col de la Croix Perrin

Col de Toutes Aures

Pra l'Étang

Col d'Herbouilly

The Vercours Plateau

Mémorial du Vercors

Col de l'Allimas

MENS

GRANDE TÊTE DE L'OBIOU

DIE

Col de Mens

Col de Rioupes

Col du Festre

Col du Noyer

# INTRODUCTION

The name of the ancient Gaulish settlement on the site, Cularo, mentioned for the first time by Cicero in 43 BC, signifies 'field of gourds'. Towards the end of the fourth century AD, the Roman emperor Gratian elevated the town to the status of city as Gratianopolis. It was almost immediately referred to as Civitas [city] Gratianopolitana and, subsequently, Gratianopoli, then finally as Grannopolis, the origin of Grenoble. Absorbed into the kingdom of Burgundy in the ninth century, it was taken over in the twelfth by the counts of Vienne, known as Dauphins, who made it their capital. Dauphin was the proper name of one of the early counts and a later successor to the title adopted the *dauphin* (dolphin) as a heraldic device. Dauphin and count became interchangeable and the seigneury, or province, over which the counts ruled came to be known as the Dauphiné. When, in 1349, the incumbent Dauphin, Humbert II, sold the seigneury to the king of France, Philippe VI, it was on condition that from henceforth, heirs apparent to the throne of the kingdom should be known as Dauphin.

In 1787, King Louis XVI's Controller-General of Finance, Cardinal Étienne-Charles de Loménie de Brienne, the Archbishop of Toulouse, in an effort to put down unrest in the city, tried to abolish the Grenoble Parlement, an assembly which had evinced an altogether too independent temper. France was bankrupt, new taxes were being called in, a series of disastrous harvests had inflated the cost of bread – the staple food – and the aristocracy and church refused to give up their privileged exemption from taxes. They insisted on retention of their right to feudal and seigneurial dues exacted from their tenants. Brienne failed to bring the Parlement to heel, troops were sent in and, on 7 June, the citizens of Grenoble took to the rooftops round the Jesuit College, pelted the troops with tiles and drove them off. The fracas is remembered as the 'day of the tiles' – famous or disgraceful, depending on one's political bias. Some commentators

reckon that this event ignited the violent protest triggering full-scale revolution a year later.

On 7 March 1815, Napoleon arrived outside the city at the head of a small force of men, on his way from Antibes to Paris. As he said later, he had only to 'knock at the gates with my snuff-box' to gain entry. 'From Cannes to Grenoble, I was still an adventurer; in that last city, I came back a sovereign.'

Occupied by Italian troops in 1942 and used as a military base of the Wehrmacht from 1943, it was eventually liberated on 22 August 1944.

## Cement

Grenoble is celebrated for bringing the manufacture of cement to its first perfection. The basic constituents of cement, a mixture of lime, clay, sand or gravel and water, have been known since antiquity, but the resulting coagulum did not always set, especially in humid climates. The Romans perfected an early process of making so-called hydrated cement by adding pozzolana (Italian *pozzuolana*), a volcanic ash containing silica, alumina, lime, etc. found near Pozzuoli (Latin Puteoli, 'little springs', near Naples) and in the vicinity of various volcanoes. Their word *caementum*, from the verb *caedo* (to cut), described a rough-hewn, undressed stone from a quarry, used for walls and the manufacture of cement, the *opus caementicium*. The building of massive public edifices, defensive walls and civic amenities associated with the Roman Empire depended much on their invention of a manageable cement. The technique was rediscovered during the Renaissance thanks to the translation of the ten books of *De architectura* by the first-century BC architect and military engineer Vitruvius, particularly Books II and VII on methods and materials. Bernard Forest de Bélidor, in his *Traité des fortifications* (1735), endeavoured to fathom the secret

# Grenoble is celebrated for bringing the manufacture of cement to its first perfection.

of the Roman builders, the properties of pozzolana, as contained in mortar and lime cement.

In 1756, John Smeaton, the civil engineer, after a protracted study of the canals and harbour systems of Holland, constructed the third Eddystone lighthouse, off Cornwall, to replace the previous structure, itself a replacement for the wooden original. He modelled his cylindrical design on an oak tree, broad at the base, tapering to the crown, built of blocks of granite secured by dovetail joints and marble dowel pegs. For the footings, he pioneered the use of hydrated cement, which will set hard underwater. In the course of construction, he experimented with various baked limes and concluded that the most useful were those which contained most clay. The clergyman James Parker published two treatises on the manufacture of cement and lime-burning – 'Method of Burning Bricks, Tiles, Chalk' (1791) and 'A Certain Cement or Terra to be Used in Aquatic and other Buildings and Stucco Work' (1796) – for which he was granted patents. In a pamphlet of 1798 he actually referred to Roman cement, which he manufactured at a plant on Northfleet

Creek in Kent, using natural nodules of chalk and clay (*septaria*) from the Isle of Sheppey. This went into the construction of the Bell Rock Lighthouse in the North Sea, 12 miles off the Firth of Tay in Scotland. Refining changes to the proportions of clay to chalk continued on both sides of the Channel.

Hippolyte-Victor Collet-Descotils, professor of chemistry and director of the École des mines in Paris, discovered in 1813 that a certain amount of silica contained in clay combined with the lime during burning to enhance its hydraulic properties, namely how it hardens under water to render it impervious. The engineer Louis Vicat, charged with the building of a bridge across the river Dordogne at Souillac, made further refinements and proceeded to burn the chalk, then mix it with clay to produce a plaster which he burned a second time to make a perfect hydraulic cement. He also analysed chalk quarries to identify the quantity of clays contained in their stone. He published his researches but took out no copyright, and his valuable pioneering work enabled the Englishman Joseph Aspdin to poach Vicat's ideas and patent Portland cement, named after the stone quarried at Portland, Dorset, in 1824.

Nevertheless, factories producing the new hydraulic cement began to open in France – some sixty by the 1840s, of which thirty had been set up in and around Grenoble. Vicat, a native of Grenoble, uncovered a massive lode of hydraulic lime in the city by the Porte de France, below the natural bastion of Mont Rachais on the north bank of the Isère, in 1827, and brought in a captain of engineers, Félix Breton, to exploit the bounty of the extensive workings for the construction of an encircling wall round the Bastille fortress, recently built on the rock. The quarry galleries cut into the bowels of the mountain outcrop, 1045m in altitude, extended for some 180km. Vicat advised the Minister of War in Paris to use the same highly plastic cement on the fortifications of the capital. The military

tacticians, however, dismissed his claims for the extreme solidity of the ramparts, considering that to be of minimal importance.

Vicat's great contribution centred on the principle of manufacturing highly resistant cements baked to 1450°C. From this 'burnt' or 'overcooked' cement resulted clinker, a very hard artificial rock, which could then be ground and pulverized to yield that fine powder known as Portland cement. Vicat *père* never manufactured the stuff commercially himself, but his son, Joseph, founded the cement plant with their name at Le Genevrey-de-Vif, just south of the city, in 1853, employing this very clay-rich limestone in his father's process. The fact that the Alps are very rich in calcareous rock added nature's happy abundance to Vicat's singular expertise.

Industry in the Isère was already thriving: paper manufacture, wooden construction, mining of metal for the foundries and coal for the furnaces, leather tanning, the waterways for transport of goods and hydraulic power (promoted as *houille blanche*, white coal), limestone from the quarries for masonry rock and cement.

When in 1885 France was hit by a major economic recession, Maurice Merceron-Vicat (husband of Vicat *père*'s granddaughter and now director of the firm) said, in a speech to the Chamber of Commerce, 'Vicat didn't make his first discovery in Grenoble, but it was here that he spent most of his life working and where he brought together, in the form of research, all his experiments and findings. Grenoble is, as a result, the homeland of cement.'

The refining of cement manufacture led to the fabrication of moulded cement building blocks and stones. One of the first edifices to be constructed entirely of cement was the church of Saint-Bruno in Voiron, on the west side of the Chartreuse massif, in 1857. (For Saint Bruno, see *Chambéry*.)

After Savoy was ceded to France in 1860, Grenoble was extended from the small core ringed by ramparts, which were by

then considered redundant, westwards to join the quarter named for the church dedicated to Saint Bruno, and generously rebuilt, largely with local cement and building blocks. Civic buildings, apartment blocks, hotels, the railway station, streets and boulevards, pavements, schools, post offices, hospitals, waterways, were all built in the fabricated ochre-coloured stone and linked by electrification. (Note: 'Brutalist architecture' refers to buildings constructed in raw concrete, béton brut.)

# CORNICHE DU DRAC

The D529 off the N85 just south of Grenoble makes an interesting approach to the transitional Col Accarias (892m). The latter part of the ride negotiates some extreme gradients and, as an alternative to the main roads, it is a commended route, ups and downs on a charmingly obscure, narrow, rustic thoroughfare. The village of Monteynard arrives at around 15.5km. Turn right on the minor D116$^B$ towards La Motte-Saint-Martin. It is a steep drop into the bottom and some hard pulls up to the corniche road above the Drac, leafy much of the way with fine views across the valley, the waters of the river jade green, edged with low beaches or cliffs. Through Le Vivier, an old village which wears its years candidly, untouched by any attempt at rejuvenation, no tarting up or plastering over, and on towards Marcieu. From La Motte, a twisty, tree-lined, narrow road, through Les Côtes. A pleasant remote byway overlooking the gorge, birch, beech, acer, dwarf oak, hazel, some pine and a granular granite chip surface. Marcieu, at 10.6km, looks as if it rarely – if ever – opens. Beyond it, a long flat open road leads through fields past Mignanne, a forlorn huddle of barns and the like in empty farmland, and on down into Mayres-Savel, curling round a steeper hillside. Turn right, some 19km into the ride, for Saint-Arey on a very steep drop towards the river. From here on, the descents and ascents are severe. Right on the C2 to La Beaume on a wickedly sharp, tight hairpinned climb which affords no relief, to Saint-Jean

d'Héran. Descend to a T-junction (24.5km) and right on the D168 towards Les Rives. A beetling drop to a narrow bridge over the Drac, pinched hairpins, the trunks of pines bristling with a stubble of old branches broken off. These mercifully short lifts and drops are all between 10 and 15%.

From the EDF (Electricité de France) plant by the bridge, turn right through La Loubière – meadows succeeded by tranquil woodland – to the D168 and on to a junction with the D526, 29.2km and 780m. Right to Mens, left to the N85 and on down to Corps, the start of the climb of the Col de l'Holme, of which more later.

The D526 is a smooth main road, perhaps conscious of its status in comparison with its bucolic cousins, a real highway, albeit of no great size, but ready to accommodate grown-up traffic, scooting down into the valley with frank energy and then up, in a single bound, a flourish, to the Col Accarias, 35.1km from the start of this detour. It's of no great height, this pass, but a surfeit of the epic is not good for anyone. 'Be great in little things', was Saint Francis Xavier's take on the contemplation of glory through the apparently mundane. And Gerard Manley Hopkins, another Jesuit from a later time, wrote:

> The world is charged with the grandeur
> of God.
> It will flame out, like shining from
> shook foil…

# SAINT-NIZIER-DU-MOUCHEROTTE 1052M

*Eastern approach from Grenoble 215m*

LENGTH  14.6KM
HEIGHT GAINED  837M
MAXIMUM GRADIENT  9%

Le Moucherotte (1901m) is the most easterly of the chain of peaks which constitute the long north–south ridge of the Montagne de Lans, standing at its northern end, overlooking Grenoble. A hotel, L'Ermitage, was built on the summit after the war, connected to Saint-Nizier by a *télécabine* (cable car). Financial difficulties and vandalism forced its closure and demolition in the 1970s, and nothing remains of it. Part of the film *La Bride sur le cou* (1961) starring Brigitte Bardot was shot there. (The film was marketed in English as *Please Not Now*, but the French name literally means 'the bridle on the neck', slang for 'getting your own way', because the bridle should be in the mouth.)

The D106$^B$ heaves away from the suburbs of Grenoble on the west bank of the Drac through Sessinet-Pariset (345m). Above the town, the eighteenth-century château of Beauregard, close by an eleventh-century church and, to the west, a wooded hollow below the limestone crags of the Vercors known as *le Désert de Jean-Jacques*, referring to Rousseau, who is said to have botanized here during his wanderings through the Dauphiné. To dawdle through woods and fields, he wrote in his *Confessions*, observing the same flowers and plants thousands and thousands of times, was to brush with eternity. The constant similarity and the prodigious variety in the bounty of nature evoke, to the trained eye, boundless admiration and wonder, whereas to the ignorant the repetition might signal only boredom. And, I should add, none of us has any excuse for boredom, ever. Rousseau wrote:

> *Mais vivifiée par la nature et revêtue de sa robe de noces au milieu du cours des eaux et du chant des oiseaux, la terre offre à l'homme dans l'harmonie des trois règnes un spectacle plein de vie, d'intérêt et de charmes, le seul spectacle au monde dont ses yeux et son coeur ne se lassent jamais.*
> Rêveries d'un promeneur solitaire
> (*Reveries of a Lone Walker*)

(But quickened by nature and clad again in her wedding gown amid the streams of water and the song of the birds, the earth provides man, in the harmony of the three kingdoms [i.e. human, animal, vegetable] with a vision full of life, interest and charm, the one vision in the world of which his eyes and his heart never tire.)

# THE VERCORS PLATEAU

As the road shucks off the vestiges of the city and its periphery, a stunning view opens out, of Grenoble, the valley of the Drac, the girdling mountains. It is a wide road, much used by local riders. You will encounter cars, but the surface is good and the gradient a steady run of between 6 and 7.5% round smooth, graceful bends.

A mighty buttress of rock appears fleetingly far overhead – three craggy vertical pillars sprouting from a single base, a shorter vertical projection to one side. These are Les Trois Pucelles, the three (though in fact there are four) virgins, much explored, caressed, fumbled at, pawed and clambered up by alpinists. Off to the right stands a tower, La Tour sans Venin, ruined since the thirteenth century and now the site of a tiny hamlet. This 'tower without malice' was, I presume, built solely as a vantage point, a gazebo, forsooth, from which to drink in the amazing perspective rather than with any bellicose intention, the usual stimulus for constructing high points of vantage. (Local informants hadn't a clue. Other explanations, that it's a snake-free zone, *venin* meaning 'poison', or that the name is a corruption of Saint Vérin, possibly a chummier incarnation of Séverin, do not dissuade me from my interpretation.) The Trois Pucelles come into more prominent view near the Mémorial du Vercors.

The foursome of rocks perversely known as the three maidens are individually called Couteau (Knife), Dent Gérard (Gerard's Tooth), Grande Pucelle (Big Girl) and Pucelle de Saint-Nizier (Maid of Saint-Nizier). No explanation attaches to the sobriquet Gerard.

The legend has it that three flirtatious young girls pushed the teasing too far and, playing wearisomely hard to get, were pursued by a trio of tumescent youths, object of their caprice, into the woods. At night? Probably. They got lost, and, fearful of the bears which

once roamed freely hereabouts, of hobgoblins and all manner of threatening peril, hesitant moreover of calling on the aid of the importunate youth whom they had so shamelessly taunted, they prayed to Saint Nizier for help and succour. Saint Nizier is one of those French holy men unacknowledged by the Vatican yet quite as subtle, if not slippery, in his dealings as most who won the ultimate pious accolade. He responded. But larding censure on mercy, both to save them from rape and to punish them for a heartless come-on, the po-faced killjoy turned them to stone. Did he ponder, at all, the comparative share of culpability in this scenario, the aggressive behaviour of the young men, even provoked, the violence inherent in assault? Apparently not. The lotharios walked away, scot-free.

How the four maidens became three may be explained simply: in legend and folklore, things and people come in threes, a prime number, not divisible fours – bears, Furies, Fates, Graces, Harpies, difficult tasks, wishes, choices, chances… The Trois Pucelles were, in earlier times, known as Gargantua's Teeth, after one of the giants in Rabelais's sixteenth-century novels, *La vie de Gargantua et de Pantagruel*.

Many French saints, like Nizier, have no place in the official hagiography. In the course of converting a rural, pagan community to Christianity, the Church in remoter districts sensibly, if reluctantly, accommodated the transfer of local divinities of the old religion into the new. Theological nicety held little sway in a rural setting. Local saints tended to be so much more helpful and dependable than any imported patron, however grand of reputation, who knew neither the area nor its people. The Celtic gods of old Gaul had been doing redemptive duty for aeons, and belief in them went far deeper in the hamlets and villages of *la France profonde* (rural France) than could be extirpated by the promise of universal salvation through a god with credentials from Paris – who cared? – or Rome – where and what is Rome? A village priest might compare the efficacy and potency of the established saint, former rustic deity, to that of even Jesus himself, Salvator Mundi, and conclude that salvation was best rooted at home, in the familiar rather than some universal abstraction.

# MÉMORIAL DU VERCORS

The cemetery, enclosed by low walls and iron gates, has the towering rock formation of Les Trois Pucelles for a backdrop, like a huge altar screen or organ loft in living stone. Simple crosses and four headstones (for the Jews among the ninety-six resistants buried here) mark oblongs for the graves laid out in rows and separated by gravel-strewn pathways. The dead include the writer Jean Prévost (fighting under the codename Captain Goderville) who, with his friend the architect Pierre Dalloz, developed the Plan Montagnard in 1944 to make the massif of Vercors a sort of Trojan horse, behind the main lines of the German army. Prévost died in Sassenage during the battle round Saint-Nizier on 1 August. Commemorated, too, are Chavant and Huet who both survived the fighting. Chavant, born in 1894, died in Grenoble in 1969; Huet, a career officer, military chief of Vercors, disappeared in 1968 and was never seen again.

The youngest man buried here was eighteen, the oldest forty-seven. One grave, in which more than one man is buried, bears the inscription *Inconnus*, and there are no fewer than sixteen dedicated to a single *Inconnu* (Unknown). The French Tomb to the Unknown Warrior, *La tombe du soldat inconnu*, was laid under the Arc de Triomphe in 1920 on Armistice Day; so too a similar memorial in Westminster Abbey and the Cenotaph ('empty tomb') in London.

The search for ten corpses of French soldiers who could not be positively identified after the carnage of the First World War was long, complicated and exhausting. When ten corpses of the many

thousands examined had been confirmed unknown and placed in coffins, a French soldier was asked to pick out one at random and the anonymous dead man was buried with full pomp in the Tomb of the Unknown Warrior beneath the Arc de Triomphe. The ascription *Inconnu* here may seem to be troubling. However, the Vercors was always a remote, impoverished place, thickly wooded, difficult of access, a natural labyrinth, and France a country whose myriad country tracks and lanes were continually tramped by strangers. Add the confusions and dangers of a country beset by an embattled, occupying army, a population infiltrated by informers of the hated Milice, and the chances of unknown men on the run joining up with the maquisards were strong.

Saint-Nizier-du-Moucherotte (1168m, 14.6km) on a final run-in of around 6% is an unremarkable little town, the road through its northern fringe widened to accommodate parking for ski traffic. The 9km descent into Lans-en-Vercors (1004m) is fast and delightful, through woodland, at a steady romping gradient of no more than 3%, big-ring joy. The centre of the old village is attractive, the outskirts more like a spreading encampment of arriviste interlopers – bungalows, chalets, houses, cabins are scattered across the flatlands below the high ridge, somehow disconnected from each other. (For an alternative downhill route back into Grenoble from Lans, take the D531 along the Gorges des Engins, cut through the lush valley of the Furon to Sassenage.)

# COL D'HERBOUILLY 1370M

*Eastern approach from Villard-de-Lans*
*1000m*

LENGTH 19KM
HEIGHT GAINED 370M
MAXIMUM GRADIENT 8%

The D531 drops south 8km to Villard-de-Lans. The *maison du patrimoine* here is a small museum of local life and a tribute to the local Villard de Lans breed, the cow of all trades, a particularly strong, versatile and hardy beast, perfectly adapted to the harsh conditions in the Vercors. Fitted with metal shoes similar to horseshoes, it can pull a cart or a plough and supplies creamy milk and beef.

From Villard take the D215$^B$ and then the D215$^C$ right towards Bois-Barbu, a hamlet 3km along on the approach to the Crête de Valchevrière. Here begins the climb, an opening hit of 5–6% up to the densely forested middle section of the bandit country of the Vercors. By a big right sweeping bend, below Bois-Barbu, stands the first of a series of memorials to the men who died here in 1944, fashioned as stations of the Cross (sometimes referred to as the Via Dolorosa, where dolorosa means 'full of sorrow'), the fourteen salient moments of Christ's last journey to his death on Calvary, in French *le calvaire*, a word often applied metaphorically to the sufferings of a professional cyclist on a bad day, *un jour sans*.

This first memorial to seven casualties of the bitter fighting is a mini-tower, some seven feet tall, inset with a niche whose wall is painted in crude gouache with a primitive image of Jesus stumbling for the first time. (The traditional fourteen stations have him falling three times.) Three hundred metres on, another ten men are named and Jesus meets his mother. In Bois-Barbu (1130m), a broad apron of road for cars and coaches coming to the Nordic (i.e. cross-country) ski centre here. The Refuge de la Glisse, a modern, steep-roofed, low-eaved, sizeable glass and wood chalet, offers a restaurant, sauna and *gîte*. Almost immediately, the road shrinks into a rustic by-way, skipping into the woods like a willing *pucelle* bent on greenwood marriage (outdoor sex under the trees, mossy roots). Another memorial to the left, this time on a bronze plaque: Jesus falls a second time.

The road wiggles on through dense woods at a bare 1% for 5.2km to a clearing called Galmiche (1185m). Suspended from a tree, the black silhouette of a witch in witch's hat, on a somewhat overweight body: '*Faim ou Soif Suivez Moi 2.5km Auberge De Malaterre*'. This points you – hungry or thirsty – towards food and drink at the Auberge de Malaterre (1280m), 2.5km down the track. It looks great: a Barraque Forestière built by woodcutters in 1904, one of whom was the grandfather of Bernard who runs the place with his wife Lydia. Winter – by ski or snow-shoe – and summer, visitors come for extremely good food in an old-style wooden lodge of gracious proportion.

A short way along, in a clearing named La Grande Allée (and near another sign for the Auberge), another memorial – Jesus falls for a third time – and a white sign on a tree showing two mushrooms, white and black, with the warning: *Ramassage limitée – un panier per personne par jour.* (Culling limited: one basket of mushrooms per person per day.) There is no indication as to how large the basket may be. Perhaps there's a standard mushroom-picker's pannier.

Another memorial, Jesus stripped of his raiment, set into a stone niche. The road dips away through a natural gateway of opposing stone crags, where the path was hewn out in the nineteenth century. The first roads across the Vercors were opened between 1827 and 1870.

The CRÊTE DE VALCHEVRIÈRE (*c.* 1250m), 8km from Bois-Barbu, marks the end of the Vercors *calvaire* (road to the Cross – *via crucis*) to the men of the Resistance. On a small balcony overlooking the valley of the Venaison stands a large plain cross and the text 'Jesus dies on the cross'. Next to it, an information board recounting the events of the final battle here. (The substance of its text is incorporated in the Introduction.) Opposite, on the far side of the road, a memorial to Les Chasseurs du 6ème BCA (Bataillon des Chasseurs Alpins) killed on 23 July 1944.

On past the Chalets de Chalimont and a restaurant to the left, the Goutanou, housed in a small shack, open only in summer. This section is a stiffer climb of around 5–6% to the Col d'Herbouilly (1370m) on a flat stretch, some 13km from Bois-Barbu in a forest glade, also known as Fontaine Froide.

There is a dip of 3.5 and 2% to a slight up and over at 3km from the summit as the road opens onto a fine prospect over the landscape across to the Grands Goulets of the Vercors National Park. Further on, in a clearing called the Pas du Loup, is evidence of substantial logging, a track off to the left leading to the Refuge de Roybon, and then a large building, probably a garage for snow-ploughs. Just below this, down a markedly steeper incline and twisty bends and sharper hairpins, that day of our passing, stood a mighty stack of logs, fully 30m long and 4–5m high. Standing on the road before it, we saw the tree-thicketed upper slopes of the plateau in the background, the still-growing forest of future logs, cousins to these trees already shorn.

The last 8km of the descent to the junction with the D103 (829m) dole out a steady 7–8%, thus completing a truly fine traverse of this rude plateau.

Turn left into Saint-Martin-en-Vercors, headquarters of the Resistance in the Vercors where on 3 July 1944 the Free French forces declared the French Republic restored. The gesture was short-lived, but its symbolism remained potent.

A ride down the valley of the Vernaison is a pleasant excursion, but the Col de Rousset is of no real interest, merely a sullen ski post

# COL DE LA CROIX PERRIN 1218M

straddling the drop into the valley of the Drôme and the town of Die, in the Roman era a centre for the cult of Cybele, the great mother-goddess, mistress of wild nature and focus of ecstatic rites, prophetic rapture, insensibility to pain. For this last attribute alone, votive offering of a gel bar or bidon is in order, perhaps.

Nevertheless, the Col de Rousset (1254m) makes a useful passage into the southern Alps, and whereas its northern approach is no more than a mild ascent, its southern flank, no steeper in gradient, is more imposing, a frontal assault on the mountain, 21.5km long, but much infested with traffic.

The famous Clairette de Die, a sweet white wine from a blend of Clairette (the origin of claret) and Muscat grapes, makes a delicious aperitif. The previous year's vintage is generally broached at the time of the transhumance in June when the flocks and herds are driven up to the high summer pasture – much festivity before and after. The Rousset also marks the boundary between the northern and southern Alps: the dense vegetation of the Vercors from the more arid terrain characteristic of Provence.

The Gorges d'Engins spin along in company with chunks of cliff known as Les Lopins, which means 'bits'. From Lans-en-Vercors (1004m), the broad D106 pulls away for Méaudre – some 3.4km of long straights with occasional bends, over no more than a slight hump which is the col (unmarked). A forest path to the right leads to a source on the peak of La Molière and a peak of the same name, nothing to do with the playwright but referring to a quarry for millstones, old French from Latin *mola*, as in a molar tooth. And 'Perrin' may derive from *pierre* (a stone) or else might be a diminutive of the name Pierre, as in Christ's statement: 'Thou art Peter, and upon this rock I will build my church; and the gates of hell shall not prevail against it' (Matthew 16:18).

Just such a quarry appears on the descent, what might be a troll's sandpit for gouging with outsize bony fingers. This col is much ridden locally and, although no great challenge as a climb, it does offer an avenue into breezy riding away from traffic.

From the col, a causeway of a road across open pasture follows the course of the Méaudret river for just over 6km to Méaudre (which means 'better') at 986m, and runs on for some 5km, through two hamlets of no markedly different identity, into a gorge, the road a few metres only above the water to the left. Where some such defiles are pinched and confining, this gorge has a relaxed feel, a flowing descent, shaded much

## COL DE TOUTES AURES 560M
## PRA L'ÉTANG 1267M

of the way. At the T-junction with the D531 in Les Jarrands (931m), turn right into the Gorges de la Bourne, a much tighter rocky throat. It might be one of the tunnels in the labyrinth in Knossos into which Theseus went, paying out Ariadne's clew of thread as his guide for return from that deadly darkness, lair of the Minotaur, whence none had ever yet returned. I exaggerate, for does it not broaden a little then narrow again at the fork with the D103 over the Pont de Valchevrière? Liking the idea, it widens into a swooping highway on its release from the gorge past La Balme de Rencurel.

But the gorge police close in, jostling it once more into a lit tunnel, beyond which the gorge is profound, a veritable abyss, its sheer sides tree-lined up to the bare skirt of the bluff. The road is crammed against the side wall; a parapet guards its left side. At last it shakes itself clear of restraint into a sinuous descent past a side road leading to the Grotte de Choranche, where you are invited to enter a fairy universe – the *son et lumière* in the enormous Cathedral Cavern, the emerald-green waters of the underground lakes and rivers, the icing sugar crystal whiteness of the walls and ceilings of the seven caves, the wedding cake stalactites and stalagmites, the whorled and fretted patterning of the rock formations…

A short way on, the D292 (right) leads to Presle and a series of cols on tiny roads by traverse of ledge and forest.

*Western approach from D531 230m*

LENGTH  16.1KM
HEIGHT GAINED  1037M
MAXIMUM GRADIENT  8.5%

A nifty track of a road sneaks round the rock wall above the valley, like a merry truant bunking off school for adventure in the woods. It darts into trees and says hello to Les Nugues, a 30m stretch of houses close by the road masked with greenery and a parasol of foliage that is virtually the only shade at this lower part of the journey up into the interior. The col (3.3km), whose sign reads 'Croix de Toutes Aures', does not halt the climbing, and the steepness of the slope – seeming higher than altitude would allow it – does not slacken. Les Champs, a farming outpost, aptly whispers in the road's ear that a slackening of steepness would be welcome, so the fugitive acquiesces a kilometre on and, after two extravagant jinks, ducks through two tunnels hewn out of the living rock of this western end of an escarpment, Les Rochers de Presles, which overlook the Bourne valley and gorge. Minuscule stalactites are forming on the moist roof of one tunnel; a group of them, milky white, clusters on a slight swelling of the rock like teats on an udder. (From far below, the tunnels appear in the rock wall like portals for gun emplacements.)

Less than a kilometre further on, at a crossroads (829m – left to Terrot), turn right

for Le Charmeil and Rencurel. Downhill through woods and rough meadow for a couple of kilometres into Le Charmeil (907m), where the climb sets in once more. This is the Forêt Domaniale des Coulmes. An *abri forestier* (foresters' hut) and picnic table stand in a clearing 3.5km further on (1125m) where the paved Route forestière des Croisettes leads off to the left for the Mont Noir – it's perfectly rideable. A brief thinning of trees offers a peephole view to the right, but the woods close in again round another clearing, which a sign calls the Pra l'Étang (Lake Meadow), 1238m. The col itself comes some 250m on at 1267m.

The vast chalk slab of this Coulmes massif is pitted with numerous cavities, worn away by the action of ice and water. The bigger caves have supplied refuge both to the larger mammals and Neanderthal and Cro-Magnon hunters. A substantial population of bears inhabited the Pra l'Étang grotto for more than a thousand years.

The descent into Rencurel passes a number of small hamlets and, at La Goulandière, 2.4km down, stands a dilapidated old schoolhouse, its upper window embrasures gaping, the lower floor openings barred. However, the roof, guttering and drainpipes are new, so it is being renovated for some purpose. The road for a couple of kilometres from here on is in poor shape – the result, certainly, of bearing the weight of traffic, logging lorries for the most part, before it is fully thawed out after winter.

In Les Glenats, note an old house to the left at the entry to the hamlet. I knocked at the door and we were given a short, guided tour by the amiable present owners. Built in 1704 under the auspices of the Abbaye de Chartreuse, it served as a relay house for travellers as well as a chapel, with an attendant priest in residence. The carved pediment of the doorway has a raised arch, signifying the abbey, two fleurs-de-lys to either side – a device on the old French coat of arms, and ever since closely associated with their monarchy. A name at the bottom of the carved relief is that of the mason who built the house, but it is indecipherable, as is the inscription – possibly Latin – over the top. The large bread oven is still in place inside.

A short drop to the D35 and left for the Col de Romeyre and the northern approach to the Mont Noir.

# COL DE ROMEYRE 1074M

## Southern approach from La Balme-en-Recurel 670m

LENGTH  8.3KM
HEIGHT GAINED  404M
MAXIMUM GRADIENT  7%

Turn off the D103 at Les Clotz (Clots on the map), a tight steep drop to La Balme-en-Recurel partway down the Gorges de la Bourne. This gorge, lined with thick layers of coloured limestone, gives onto a number of grottoes, voluminous caves in the gaunt cliffs: du Bournillon, de Choranche and the spectacular Grotte de Coufin ('narrow neck'), where in one vast cave there hang thousands of salt-white stalactites which are reflected in the waters of the lake below. The cliffs also form two magnificent *cirques*, like porches over the cave entrances, above the Bournillon and the Choranche.

La Balme-en-Recurel (670m) is a pretty alpine village on what is called the Route des Ecouges, lined with pine, larch and poplar trees, essential sources of firewood. In every community round here you will see new plantations of poplar, a quick-growing staple of French rural wood-burning stoves. The trunk of the *Populus tremula* grows tall and straight and, when logged, is ideal for neat stacking.

The road links a number of small villages, all of similar cast. The Clapiers forest lies off to the east, that of Coulmes to the west, a brisk climb on a steady slope.

## Northern approach from Saint-Gervais 189m

LENGTH  13.4KM
HEIGHT GAINED  885M
MAXIMUM GRADIENT  10%

The climb from this direction packs a much heavier punch. Out of Saint-Gervais, the slope up to the cascade of the Drevenne, where it plunges over a suicide leap into the Ecouges canyon, is a relentless 8–9.5%, with very occasional relaxation into 7 or 7.5%. As the D35 lifts away from the village, it hugs the walls of the flanking mountains ever closer, across one torrent at around 2.8km, another some 3km on, and here the gradient really bites hard: 4.5km of around 10% to the tunnels which house the narrow stretch of tarmac, bypassing the more perilous old way round the rock face. A sign (echoing another such, back down the ascent) warns you to switch on your lights, it's obligatory – *Piétons et Cyclistes Eclairage Obligatoire* – for the 600m of curving, pitch-dark tunnels.

Here, unless you are prone to vertigo, you can peer over a low wall into the canyon. Ahead of you, a cleft made by two opposed buttresses. The stone of that to the right is composed of slanting layers of natural ashlar blocks, that to the left a slope clad in trees with some bare patches, arboreal alopecia, showing through. In the V of the cleft, a long view of Grenoble.

# COL DU MONT NOIR 1421M

On the north side of the tunnels a miniature memorial – stone and photograph – commemorates a young man who died in 2009. There is no explanation. The road up to the col continues straight up the incline for a short way at around 6%, then no worse than 4%, although the lack of bends adds to the tax on what has been a hard ride earlier. Count this climb, all in all, a tough proposition.

## As the D35 lifts away from the village, it hugs the walls of the flanking mountains ever closer, across one torrent at around 2.8km, another some 3km on

*From the Col de Romeyre 1069m*

LENGTH  4.8KM
HEIGHT GAINED  352M
MAXIMUM GRADIENT  8%

The road has little life in it, there are but five bends to poke interest, and portions of the surface have been renewed. The 2.5km forestry route from the Pra l'Étang road is infinitely more interesting.

From the col, a placid ramble of 6.9km through the forest to Le Faz (994m) whence the D292 leads back to Presle and the D31 continues into the GORGES DU NAN – narrow, steep and very beautiful. The view down into the pit of the gorge is dramatic indeed.

A derelict house, locked and spent, and an empty barn stand opposite a dead tree. Its skeletal shape and peeling bark suggest ritual flaying. A warning sign, perhaps, a caveat, *Lasci ogni speranza voi ch'entrate*: abandon all hope ye who enter here. The gradient answers. A threshold of 6% and the vertiginous rush begins, 10.5 and 9% on a precipice road carved out of the mountain wall and through a number of tunnels, 6km into Saint-Pierre-de-Cherennes. On the way, a statue of Her, crowned, her arms outspread, palms open, as if to say 'What did you expect?'

The D518, off the main valley road, to Pont-en-Royans, is lined with groves of mature walnut trees. The walnut is a noble tree –

# COL DE MENS 1111M

*Southern approach from Mens 755m*

LENGTH *C.* 9KM
HEIGHT GAINED 356M
MAXIMUM GRADIENT 5%

I have one growing which I planted as a sapling in my garden – and its shade a benediction. Its wood is handsome, much used for the best gunstocks. My cutlery box, made for me by a friend to store eighteenth-century silver spoons and forks, is of walnut. The word *walnote* – from Old English *wealh*, 'foreign', as in 'Welsh' – referred to the nut of the Roman lands, i.e. Gaul and Italy, as opposed to the native hazelnut. In those countries Latin *nux*, unqualified, always denotes walnut, as does French *noix*, the fruit of the *Juglans* (from a phrase meaning 'Jove's acorn') *regia*. A pickled walnut – if the harvest can be got in before the damned squirrels strip the branches – is a fine item, too. I was introduced to it by my grandparents and developed a taste for the toothsome condiment in my early years. And there is pleasure to be had with an unpickled variety in 'After dinner talk / Across the walnuts and the wine' as Tennyson puts it (*The Miller's Daughter*).

The D66 leads south from Mens, a busy little town with a covered market, a stopping point on the Roman road. When, in 1685, Louis XIV revoked the Edict of Nantes, a decree passed by Henri IV in 1598 giving freedom of worship to the French Calvinist Protestants, many Huguenots, as these non-Catholics were called, fled France. (The Huguenots took their name from Besançon Hugues, a Protestant leader in Geneva, who died in 1532.) Others elected to stay, and Mens became a town of refuge for Huguenots in the Vercors and Trièves regions. (For another such enclave and an account of the fate of the French Huguenots, see the Col de Sarennes, *Bourg d'Oisans*.) L'Auberge de Mens in the centre of town serves a *menu des ouvriers* (workers' lunch) – which may include a salad including small chunks of Peruvian purple potato, reputedly rich in antioxidants and difficult, at first sight, to consider edible. But tasty enough.

The amphitheatre of encircling mountains to the east and south out of Mens is striking. The massive chine of the Dévoluy runs from the celebrated L'Aiguille, 'the needle', to the north in an arc round La Grande Tête de l'Obiou (2790m, highest peak in the Dauphiné Prealps and seventh-highest in all France) and

the Crête des Aiguilles. The name probably comes from the Franco-Provençal *testo de biou*, French *tête de boeuf*, 'oxhead', from its profile. (Incidentally, also the name of Alexander the Great's horse, Bucephalus.)

The chalets and houses which dot the outskirts of town stand like tired sheep in a field waiting for the shepherd's collie to round them up. Turn left (839m) on a smooth, untroubled downhill slide to Saint-Baudille-et-Pipet, through grassy leas and cultivated fields. In the small town, overlooked by the tree-covered conical dome of the Mont de Ménis, a church, grange, houses, large walled cemetery, the pale yellow painted *mairie*, and an obelisk to the eight men of the commune killed in the First World War, their names repeated on both sides.

The novelist Jean Giono set his *Un roi sans divertissement* in this immediate locale. Giono, born in 1895 to an Italian father and a Savoyard mother, was called up to serve in the 159th regiment of Alpine infantry in Briançon in December 1914. He said, later: 'In 1915, I set out to the Front not believing in my country. I was mistaken. Not in not believing, but in going.' He fought at Verdun and, in the last two years of the War, on the Flanders front. At the outbreak of the Second World War, he was arrested for declared pacifism and spent two months in the Saint Nicholas prison in Marseille. After the Liberation of France, he was arrested for alleged collaboration and, once more, sent to prison, from September 1944

to January 1945. In 1946 he wrote of a new realization that 'human nature is malign'. The war, and in particular the crimes committed by the Nazis, demonstrated that even the most ordinary individual was capable of cruelty and murder and that 'absolute evil' was not the monopoly of monsters.

Giono took his title for the novel written at the end of the war from a line in Pascal's *Pensées*: 'un roi sans divertissement est un homme plein de misères' (a king without diversion is a man full of woes). To extend this into broader human experience, a man seeking to extricate himself from existential boredom by calculated diversion may become fascinated by evil. (Victor Hugo touched on a similar theme in his story of cynical disport, *Le roi s'amuse* (The king has fun), the story of Verdi's *Rigoletto*. Albert Camus's *L'Étranger* treads the same psychological landscape as Giono's novel.) Giono sets the novel in six successive winters, when the landscape is overlain with snow, the great white silent blankness of the dark months. In such a place at such a time, boredom becomes excruciating to the point of paroxysm and may end in murder or suicide.

A captain of gendarmerie, Langlois, comes to live in an isolated mountain village terrorized by a serial killer, who buries the corpses in a tree. (It is possible that the story was prompted by the trial of the notorious Dr Pétiot in 1946. He went to the guillotine in May of that year for the murder of twenty-six

victims, whose remains had been found in his house in Paris. He claimed that they were all Germans and that he was a patriot working for the Resistance.) Langlois eventually discovers the identity of the killer, a family man whom no one suspects. Langlois hunts him down, shoots him and then resigns. Drawn by some unshakeable lure to the village and the spell it cast over him, he returns three years later, as master of the wolf-hunt. He wants to marry, settle down, participate in the village festivities. He organizes a hunt for a killer wolf. The party tracks it down and corners it, standing immobile over the body of a hound it has killed. 'The wolf stared at the blood of the dog in the snow. He seemed to be in as much of a trance as we were. Langlois shot him twice in the belly with his pistol.' But Langlois is haunted by these two deaths, which he begins to see as cold-blooded murder, and is transfixed one day by the beauty of the crimson blood of a decapitated goose staining the pristine white of the snow, and suddenly gripped with profound dismay at the hold this beauty out of death exercises over him, he commits suicide, placing a lighted stick of dynamite in his mouth, as if it were a cigar.

(During the Revolution, between 1790 and 1794, the two discrete communities of Saint-Baudille and Pipet were combined to form the larger village.)

A flat valley road leads out, across La Vanne (890m, 6.3km), meandering towards the Drac and the portal of the col, the walls of the channel cut by the eroding waters pressing in from either side. Here is the wooded quiet of solitude, and the col itself offers a partial view into the valley of the Ebron and the Montagne d'Avers beyond. A fast descent, visible curves and hairpins, into Tréminis beneath the mighty limestone cliffs of the Dévoluy.

The Col de la Croix Haute (1179m) lies on the D1075 by a railway bridge. On one arch 'ANARCHIE VAINCRA' (Anarchy will conquer), and on the other side of the road, a memorial to one Jean Gayvallet, '*Victime de la barbarie allemande 10 July 1944*' and '*Louis Picard tombé au combat 10 July 1944*' – the latter was killed while fighting, the former captured and shot.

A café/bar L'Etape du Col offers *p'tit déj/boissons/repas* so, whether you get there early enough for breakfast or later in the day, you can eat and drink. And welcome to the Drôme *département*.

Turn right on the D539 at 1068m for the Col de Grimone (1318m), 4km of steady 5–6% on a pleasant winding road. A graffito on the road just below the col snarls: 'TOURIST YOU ARE THE TERRORIST' in neat block capitals. At the col, what looks like an old customs post, boarded up, a log stack and a garage opposite, by a sign welcoming you to the Parc Naturel et Régional de Vercors. A long view down into the Gorges des Gats.

Two and a half kilometres below the col, a pink graffito reads: '*OUI AU LOUP NON AUX CONS*' – Yes to wolves, No to idiots (first

meaning of the slang *con* is 'vagina, cunt'), presumably a variation of the jibe on the other side, further down, in red: '*LES CONS NI ICI NI AILLEURS*' (idiots not welcome here or anywhere else) and then '*ETAT DE MERDE*' (The State is shite).

In Grimone a sign advertises *Pain de Grimone. Pur levain farine bio sel de guérande eau de source* (Grimone bread. Pure yeast, organic flour, sea salt [from the celebrated Salines de Guérande in Loire-Atlantique] and mineral water). This enterprise is part of a regenerating influx of young people that has brought back to life the once-abandoned villages of Grimone and Glandage, 5km further down. (Glandage, the gathering of acorns – *glands* – for feeding pigs, was an ancient right, although snooty urban folk, or else the landowning nobility, mocking the self-evident stupidity of country bumpkins, used the verb *glander* for mooning about, frittering away time. There is an expression, *tu nous crois assez glands pour tomber dans le panneaux?* – you think we're stupid [acorn] enough to fall for that? Perhaps the more perfervid of the local eco-warriors are responsible for the graffiti.)

Out of Grimone, the gradient snorts at a kilometre of some 7.5% and another at 9.5% as if supporting the general interdiction on fools before relaxing into a more moderate average of between 3 and 6% down into a torrent gully as the sides begin to hem in the road. The houses of Glandage crowd in. A war memorial carries thirty-one names, with several of the same

name two and three times recorded. Over the doorway of one house, a sign reads *ECOLE*.

About a kilometre below Glandage, the road, already squeezed tight into the constricting defile of the Gorges des Gats, wriggles through four narrow tunnels, unlit but fairly short. On the rough wall of the last tunnel, someone has daubed '*OUF*', French for 'Phew', in red paint. And a blue plaque marks the inauguration, on 25 September 1910, of this stretch of road as the Route Joseph Reynard, a Conseiller d'Etat and Conseiller Général du Canton (state councillor and local political bigwig) at the time. Various other dignitaries are named, among them four who, together with Reynard, must surely have lost their sons to the war, from the evidence of the memorial in the village.

The road slips into a gentle slope, swings past an ancient hydro-electricity plant Force Motrice des Gats, and gradually into a slightly wider funnel of the gorge, past a series of neatly clipped square and rectangular small clumps of box. There is probably someone local whose job, subvented by community funds, it is to keep them in trim. Just after a left turn towards Boulc, another tunnel (670m), now 14km from the Col de Grimone on around 2%.

Before the construction of the original road in 1865, travellers wishing to cross from the Drôme valley (west) to that of the Drac (east) or vice versa had to pick their way up the floor of the gorge itself, at water level across a number of fords or by inching along the precarious banks of the Bez.

Three kilometres on, turn right into Mensac (615m) on the D120. The Col de Menée (1457m) lies 18.4km on, the gradient nowhere exceeding 5.5% on a steady incline through woodland much of the way up the course of the Archiane to Menée and, from their confluence in the village, that of the Sareymond. The first 5.5km or so are relatively straight to a sudden whiplash of hairpins at 690m, after which entirely unwarranted excitement it relaxes once more. A citadel of rock overhangs the view ahead. The route is quiet and gentle, utterly charming. Coming into Les Nonières (840m, 8km) on a grassy knoll at a right-hand hairpin is set a blue, slatted wooden bench for anyone who chooses to sit and survey the agreeable prospect of the valley opening out south. Through the village and on past some more box hedge verge ornaments.

A high open balcony of road at 1000m affords a splendid view of the gorge before the trees step in again. *Bornes* give height and distance. The col has no sign but a panel bids goodbye to this département – 'A bientôt dans la Drôme' – and the road plunges straight into a rather nasty wide straight tunnel leading to the *département* of the Isère. To the north-west, the majestic Mont Aiguille (2086m).

The blunt form of the Mont's bluff, in the shape of an old flat-iron, the hull of a tea clipper, a heavyweight wedge, bears no resemblance to any needle (*aiguille*) that I've seen, whether sewing, packing, netting, knitting or even butcher's larding needle,

save, perhaps, from end-on of the latter's bulk. *Aiguille* is used as a general term for 'peak', but even that seems inappropriate here. The lower slopes, tree- and grass-covered, spread like a skirt stiffened by a multi-layered chiffon petticoat. The bare rock of the upper mass, gnarled, scored, wrinkled, pitted, seems, from a distance, to rise up sheer from its canted base.

On this strange extrusion of the Earth's surface, mountaineering may be said to have been born. This is, perhaps, to discount the audacious exploit of an elite party of Alexander the Great's anti-gravity Macedonians, who scaled the sheer flanks of the hitherto impregnable fortress known as the Rock of Aornos (modern Pir Sar; the Greek means 'birdless' rock), during his extended conquest of Asia. However, on 26 June 1492, in the same year that Columbus discovered America and the armies of the Christian monarchs of Spain, Ferdinand and Isabella, completed the conquest of Moorish Granada, Antoine de Ville and a team of ten intrepid individuals made the first ascent of the Mont Aiguille at the behest of the French monarch, Charles VIII. History does not record what de Ville, one of the king's servants, thought of the idea but he led the expedition to the summit plateau – still a destination for rock climbers – using ladders, ropes and, one imagines, metal stakes driven into fissures of the rock. One of the party told stories of the fabulous creatures they had seen up there in the thin air of the rocky wilderness never before visited, of leaping goat-like

# COL DE L'ALLIMAS 1352M

antelopes (chamois), exotic birds, fantastic plants and other flora, even human footprints. It is to be hoped that de Ville, rightly jealous of their own claim to be the first men ever to set foot on the rock, took the hyperbolizing enthusiast to one side and told him to drop the tale of human footprints sharpish. Getting up there second would significantly reduce the size of the king's purse offered to the blokes who got up there first.

From the north, the 14.1km climb of the Col de Menée starts with a brief spurt of 6%, but eases for another 5km to a double hit of 7% leading to the intermediate Col du Prayet (1197m, 8.6km), where it slumps back to a more moderate slope. Woodland or roadside meadows, bare rock or trees standing like spectators waiting for a race to come through: the terrain is similar to that of many of the climbs in the region.

The D7 north off the Col de Menée joins the D1075 at La Gare. Head northwards and turn left on the D8^A at Saint-Michel-les-Portes (890m). The huge presence of Le Grand Veymont, at 2341m the highest peak in the long chain of the Montagne de Lans, towers directly ahead. Farmland, chalets, a church, in a small square a large mature lime tree – more commonly French villages have big plane trees for shade in summer, many of them planted as Trees of Liberty during the Revolution. The road dips and wiggles through a narrow street out of town and down into the throat of a valley losing 20m, and here it starts to climb at a gathering gradient: 5%… 5.5… 6.5… 7.5% for 6.6km, where it drops from 1164m into La Bâtie-en-Vercors. At 3km a fairly new water-treatment and hydro-electric cabin, but this is virtually the only permanent sign of human intrusion hereabouts on a lonely road.

The huge presence of Le Grand Veymont, at 2341m the highest peak in the long chain of the Montagne de Lans, towers directly ahead.

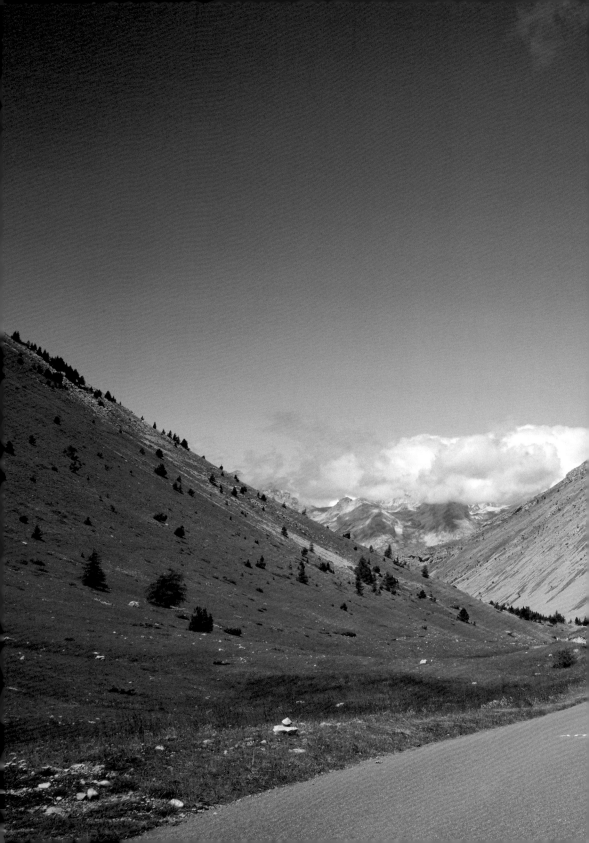

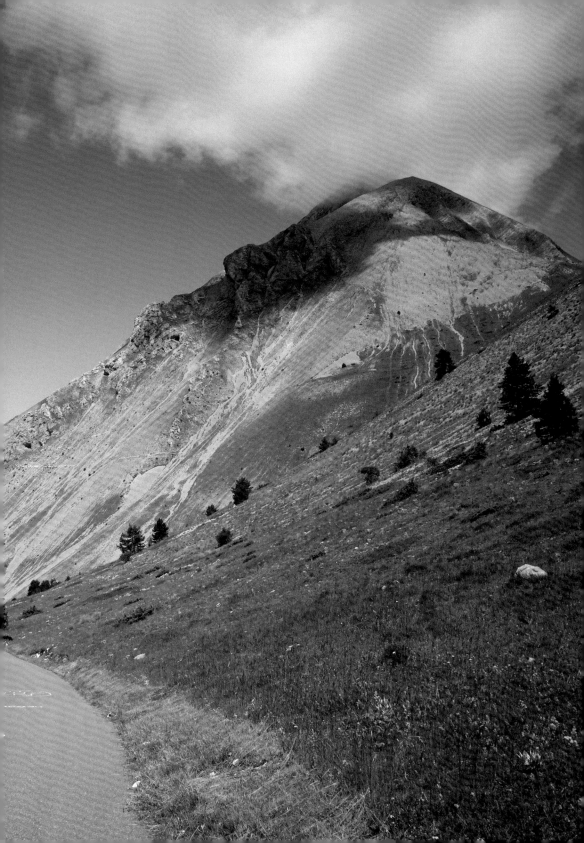

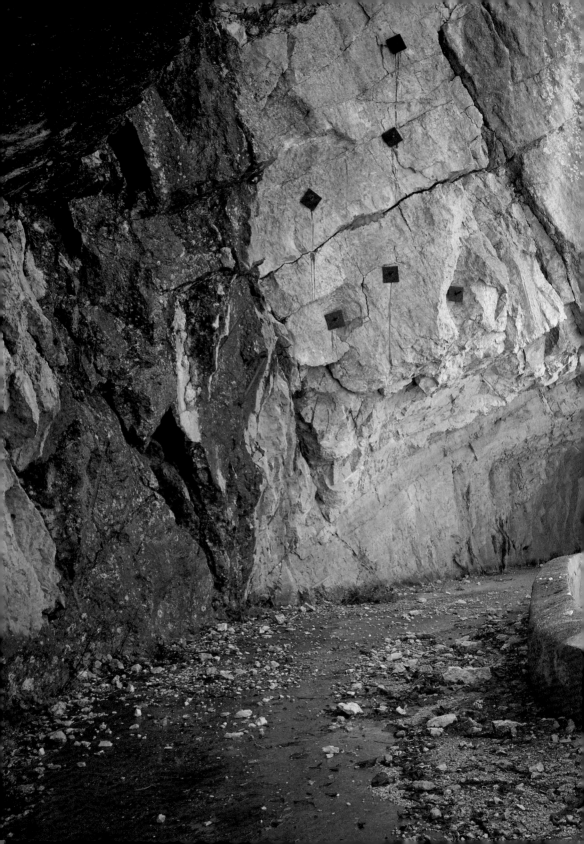

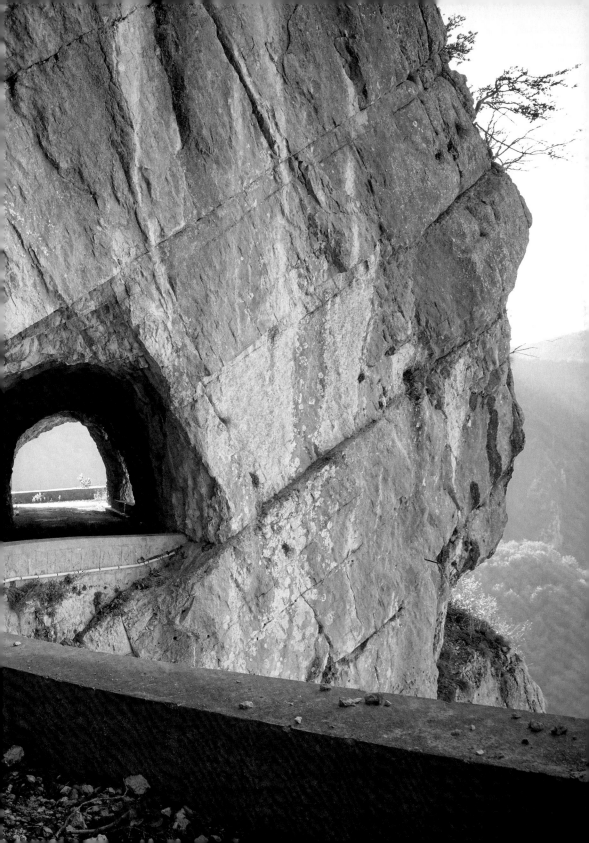

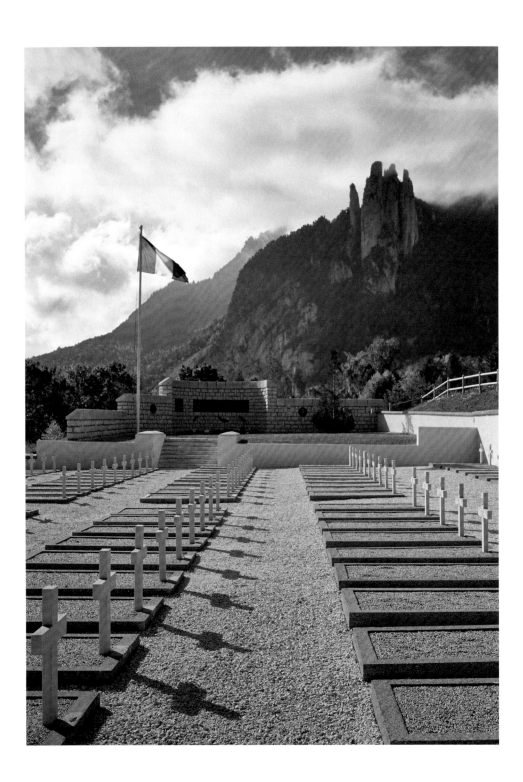

Hairpins, trees, the river down to the right in a bosky ravine and, suddenly, a view of the northern face of Mont Aiguille. At 6km, 1115m, a tiny hamlet, the big mountain presiding, and, a short way up, the 1164m intermediate height and drop down into the village – church, *auberge*, a sprawl of houses. The final heave to the col is hard, 10 and 9% and, just before the top, a grand prospect of the two major peaks of the Vercors range, Aiguille and Veymond.

The descent runs free on mild slopes – 6 and 6.5% lessening gradually – partly on an open, unprotected road, a sparse tree cordon and scrub grass slopes off to the right, then a denser attendance of woodland. A hamlet, 2km down, is actually the upper portion of Gresse-en-Vercors (1210m, 2.5km) and its thirteenth-century church. Another 1.5km down turn left on the D242 across the Gresse stream, which rises just below Mont Aiguille, towards Les Deux and the Col des Deux (1222m). Les Deux, one farm building with a fine wood stack against its outside wall, gives way to Les Petits Deux and, at 1.5km, a very shy-looking novice of a col on an open narrow road and tenderfoot gradient. But it's a snake in the grass, this one. Over its minimal hump, the road tilts abruptly into a full-blooded 10.5%, galvanizing a fast run down into Saint-Andéol. The Sommet de Malaval and Rochers de la Peyrouse, junior titans of the Vercors plateau, lie off to the left. Spindly pines, birch, beech and poplar, then at 5.2km a farmhouse to the right, at the head of whose track two junior cypresses, side by

side, as it might be twins or ill-starred lovers of some forgotten mythic metamorphosis. Through Saint-Andéol (1020m, 9.1km), Le Combe and into Château-Bernard (920m), a prim hamlet of clipped pasture, lightly terraced slopes evenly rumpled like rucks in velvet, mini ha-has, and an enclosure containing a plastic brown and white cow. There is no café or bar but a memorial cites the names of three senior figures of the resistance: Charles Delestraint, code-name Vidal, who created the Armée Secrète on 11 November 1942, was later captured and interned. He died in Dachau in 1945. Eugène Chavant, code-name Clément, Chef Civil (Civilian Commander) du Vercors from 1943. He sealed a pact of friendship and mutual help with the third man in the trio, Lieutenant Colonel François Huet, code-name Hervieux.

Uniting disparate resistance groups under agreed leadership was often problematic, men of one village being inveterately suspicious of men from other villages. The deeply ingrained unwillingness to countenance 'foreigners' from settlements no more than a few kilometres distant was a characteristic of rural communities until even quite recently. As Karl Marx remarked of French rural society, in his *The Eighteenth Brumaire of Louis Napoleon*: 'Each family is almost self-sufficient, producing on its own plot of land the greater part of its requirements and thus providing itself with the necessaries of life through an interchange with nature rather than by means of intercourse

with society.' (Eighteenth Brumaire, in the French revolutionary calendar, refers to 9 November 1799 when the Emperor Louis Bonaparte's uncle, Napoleon Bonaparte, became dictator by a coup d'état. In the pamphlet, Marx makes one of his most quoted statements, that history repeats itself, 'first as tragedy [Napoleon I], then as farce [Napoleon III]'.)

There was, too, the inveterate mistrust of strangers, particularly of those itinerant tradesmen who tramped the roads and tracks. They had no home, no roots and, useful as they might be for specific ephemeral purpose, they had to be kept an eye on. Contemporary society labels them as *marginaux* – living on the margins. The military recognized in them a vital resource: 'Deserters, strangers passing through, homeless people arrested by the police… hunters, poachers, shepherds, charcoal-burners, woodcutters… It is best to take several and to question them separately… Smugglers and pedlars make particularly good spies.' (This is from an army handbook of 1884, quoted by Graham Robb in his *The Discovery of France*.)

Another 3.7km at 6–7.5%, a rash of holiday apartment blocks surging brashly out of the dense trees and onto the flat table of the Col de l'Arzelier (1145m), an entirely charmless minor ski station dumped either side of the road. But do not be deterred: this ride of cols pays off amply in charm and pleasure – the company of the Vercors giants, the quiet roads and mixed woodland, the general absence of people, noise and cars…

Down through woods, some logging and into a quite twisty descent through L'Arzelier itself and on into Prélenfrey, nondescript but quite a lot of it, an old community engorged with new housing. As we go through, a sullen youth of indeterminate sex, lank hair veiling a downcast face, slouches by, heavy-legged, shoulders hunched, brooding on life's grotesque inequalities. Grenoble lies not far away up the road, and whatever fleshpots Prélenfrey and adjacent towns and villages of limited resource can offer must be tame indeed by comparison with those of the metropolis. Reluctant occupants of the rustic idyll may peer with envious eyes into the window of the internet.

In Saint-Barthélemy (621m) 4km on, a memorial salutes fifteen men of the Vercors who died in July 1944, including *un patriote inconnu*. The unnamed patriot, when patriot meant anyone who had declared war on France's foe. Who was he? A stranger from the east in flight from Nazi oppression? Someone from another village? A refugee on the run?

## COL DU FESTRE 1442M

*Northern approach from Barrage du Sautet 794m*

LENGTH  22KM
HEIGHT GAINED  648M
MAXIMUM GRADIENT  6.5%

From the barrage, the road runs arrow-straight, flight and shaft, towards a mighty buttress through which the waters of the Souloise have carved a defile. Fields to either side, abundant crops of maize, wheat and barley, cows graze, a line of beehives. The hamlet of La Posterle (958m, 5.7km; the name means 'back gate') waits by the entrance to the narrows below the cliffs like a toll collector. Now the road winds towards the gorge as if reluctant to broach the tree cover, where shadows lurk and who knows what is hidden in their screening? As the gorge becomes more pronounced, a thicket of pines moves in. At the bottom of the cleft a large belt of drifting scree to the right, like a

shingle bank, and a long horizontal fissure in the striated stone above, like a gallery. In the distance the Obiou's long slim crest, frilled and indented like an iguana's back.

The climb away from the gorge is smooth, bags of swish, an easy gradient, pine-layered slopes to the left. Saint-Disdier (1033m, 11.9km) has an eleventh-century Romanesque chapel, La Mère Eglise, containing various devices associated with the Templars – solar and lunar discs and the Templars' Maltese cross.

The road runs flat through Agnières-de-Dévoluy, after which an extensive straight, recently metalled. This clean blackboard has provoked graffiti:

> NON AUX LOUPS SAUVEZ NOS
>   MOUTONS (Wolves out, save
>   our sheep)
> LES LOUPS A PARIS (Wolves to Paris).

The climb away from the gorge is smooth, bags of swish, an easy gradient, pine-layered slopes to the left.

# COL DE RIOUPES 1430M

The col is signalled by an altitude plaque – 1441m, in fact – on a building on the outskirts of Festre and, by a curve in the road, a statue of Madonna and child mounted on a stone plinth stands next to a video surveillance camera, as if the eyes of the Virgin have grown dim and are failing in their tutelage.

The Maison du Col du Festre (bar, café, ski hire, etc.) names the pass, while the village is, evidently, a busy centre for *randonnées* on foot, VTT (mountain bikes), *ski du fond*.

The coast down south to La Madeleine and Montmaur, just west of Gap, is fast and pretty well clear of bends, 14.4km of mild slope. Not far from the top, more anti-lupine slogans:

*UN LOUP – UNE BALLE* (One wolf, one bullet) *MORT: LOUPS + ECOLOS* (Death to wolves and greens) *PLUS DE BLA BLA* (No more blah blah) *LOUP Y ES TU? M'ENTENDS TU? JE VAIS TE TUER* (Wolf, are you there? Can you hear me? I'm going to kill you).

Off up the hillside appear rocks whose shape plainly evokes the same process of erosion as produced the Demoiselles Coiffées, not far to the south.

Leave the road leading to the Festre from the north on the D17 into La Joue du Loup (Wolf's Cheek) and a couple of kilometres to the col and on down towards the short but very deep – between 40 and 60m – Défile des Etroits (Defile of the Straits, i.e. 'narrows' – 1238m, *c*. 3km), and Saint-Etienne-en-Dévoluy. Until 1851, there was no road into this village. The inhabitants had to rely on what they could produce.

The Dévoluy massif is part of the southern Prealps, a desolate landscape of limestone heights and empty moorland. The area is noted for a multiplicity of sinkholes formed by the karst process, mildly acidic water gradually dissolving faults in the bedrock to form a depression or cavity. These are known, locally, as *chourums*, either from an Arab word for 'creek' or else from the regional dialect, *champ roun*, designating a low-mounded meadow. In the Isère they are called *scialets*. One of the most famous, the Chourum Martin, just south of Saint-Disdier, is 360m deep and 1200m long.

# COL DU NOYER 1664M

*And so back to the walnut tree, for that is what noyer means.*

*Western approach from Saint-Etienne-en-Dévoluy 1275m*

LENGTH  8.1KM

HEIGHT GAINED  389M

MAXIMUM GRADIENT  8.5%

A sign outside the village informs us that between 9 a.m. and noon on Wednesday 21 July 2010, this road was closed to all traffic except bikes. I assumed this was for a *sportive* and determined to ask.

A level beginning as far as Le Fourniel, where the slope begins to move up. A sign gives 1355m and graffiti on the road encourage Wiggins, Pineau and Chavanel – the Tour crossed, for the fourth time, in 2010 on 14 July, tenth stage, Chambéry–Gap. Signs read off distance and altitude all the way. At 1km, 1400m, the road narrows markedly as a shelf across the arid moorland. More graffiti hail a posse of French riders, the men of the B-Box team… *Allez!* At 2km, 1475m, the names are unfamiliar, surely for the *sportive* riders? And then 'Andy Andy Andy' next to a cartoon of a snail.

This is a forceful exemplar of just how barren the Dévoluy is, enclosing the isolated, more verdant glens such as that occupied by Saint-Etienne. On a low parapet over a torrent, as the road snakes through the wilderness,

'*Ocana Presente*', referring to that day in 1971 when the Spanish ace made his long solo break to Orcières-Merlette delivering an *estocada* to the whole field (as Merckx put it), the killing thrust of the matador. More against the wolves: *NON AU LOUP ET CEUX QUI LES VEULENT* (No to the wolf and those who want them).

From 5km, 1600m, there is but a short ride across the heath to the col, where a refuge has been turned into a café/bar. Inside its roomy interior, I conducted a Pinteresque conversation with the owner.

'Can you tell me, please, why the road
 was closed on 21 July last year?'
'It wasn't.'
'An enamel sign down in Saint-Etienne
 says it was.'
'No, no.'
'I wonder, is there a cyclo-sportive ride
 that goes over the col?'
'No. There *is* a night ride.'
'But this was from 9 in the morning
 until noon.'
'No, a night ride, only a night ride.'
Silence. Quizzical look from me. The
 man resumes.
'The road does get closed… once a year.'
'Ah. For a sportive?'
'No. Just for cyclists…'

Seeing no future in this exchange I turned my attention to a couple of picture frames hanging on the wall, containing screeds detailing

the history of the road to Saint-Etienne and the remarkable story, with photographs, of Zéphirin Bonthoux (see opposite).

A law of 27 April 1847 enjoined the construction of a road, a *chemin vicinal* [country road] *de grande communication no.* 17 from Saint-Bonnet-en-Champsaur (on the eastern side of the Noyer) to Saint-Etienne. The decree was occasioned by the rapid growth of commerce, fairs and markets and, as ever, the need for military manoeuvre. In 1854, the Col du Noyer was chosen, with five other alpine cols, as a site for a Refuge Napoléon, one of many built across the Alps to accommodate travellers, by order of Napoleon III. Until 1945, this refuge was manned all year round to give food and shelter to the large number of travellers crossing the col, on foot or by mule. The building burnt down in 1947 and was rebuilt.

*Descent to Saint-Bonnet 960m*

LENGTH 12.2KM

HEIGHT LOST 704M

MAXIMUM GRADIENT 11.5%

The road is tight, steep, twisting and precarious, but the panoramic view is spectacular, of the Grand Bois de Poligny and the girdling ring of heights, the towering cliffsides ribbed vertically and corrugated across with wrinkles lined with skeins of vegetation, with sprout of dwarf pine and layers of mossy verdure. Signs check off distance and altitude and the upper 3km are severe of pitch. Trees come and go away from the bleak upper reach. Gradually the slope eases a fraction, but this is both a very tough climb and a singularly technical descent, mightily pleasing in every aspect, a ride of undoubted distinction.

# ZÉPHIRIN BONTHOUX (1858–1935)

From 1884 until 1904, this exotically named man lived in the little village of Le Noyer, halfway down the eastern flank of the col, and acted as postman. He set off every morning at 1am for Saint-Bonnet 8km distant, a walk of five hours. Having collected the mail, he marched on to deliver it in Saint-Etienne and gather up the mail there. Back to Saint-Bonnet, clearing the mail boxes in Le Noyer and Poligny (just outside Saint-Bonnet) on the way, after which he returned home to work on his smallholding. Thus, four journeys of 8km – Noyer–Saint-Bonnet – and two of 11km – Noyer–Saint-Etienne – making a daily total of 54 kilometres. There were shortcuts and, in summer, these might be feasible, but, as they say in the building trade, there are two ways of doing something – the right way and the shortcut: cutting corners in mountains always carries risk. During the three winter months Bonthoux rented a room in Saint-Bonnet, where he could stay if extreme deterioration in the weather forced him to take shelter.

LE BOURG D'OISANS

# LE BOURG D'OISANS

Col de Champ Laurent

Col du Grand Cucheron

Col de la Madeleine

Col du Barioz

Col des Ayes

SAINT-JEAN-DE-MAURIENNE

Col du Glandon

Col des
Mouilles

Prapoutel-
les-Sept-Laux

Col du Mollard

Col de la
Croix de Fer

Col du Télégraphe

GRENOBLE

L'Alpe d'Huez

Col de Sarenne

Col du Galibier

Col de la Morte

LE BOURG-D'OISANS

Col d'Ornon

Col Luitel

Col du Granon

Col de Malissol

# INTRODUCTION

Le Bourg, as it is generally known, is the capital of the Oisans region, that part of the Romanche valley as far east as the Col du Lautaret, lands once occupied by the Ucenni Gauls, from whose name Oisans derives. The Ucenni were one of forty-five Gallic tribes that submitted to Roman rule under the first Emperor, Augustus, after his military campaigns of suppression in the alpine area between 16 and 7 BC. A triumphal trophy naming them stands outside La Turbie (originally Tropaeum Augusti), west of Monaco.

Some local place names – Le Freney, for example – record evidence of a later period of occupation by the Saracens. In the early tenth century, raiding parties from al-Andalus, the Arabic name for that part of Spain ruled by the Moorish Caliphate, had established a strong presence along the Côte d'Azur. These Saracens first landed at Saint-Tropez, and the name of the Corniche des Maures, to the west of the promontory, almost certainly hints at this. They established their primary stronghold in an inland village, now La Garde-Freinet, known to the Romans as Fraxinetum, from the abundant ash trees (Latin *fraxinus*, French *frêne*) in the woodland thereabouts. Having secured Marseilles and Aix-en-Provence, they headed north up the Rhône valley and east into the Alps and Piedmont in order to poach on the trade routes. Berbers, mountain men from the Atlas ranges of Morocco, were of crucial help in seizing the alpine territories. By 906, their forces had taken the high passes of the Dauphiné, crossed Mont Cenis and occupied the valley of the Suse on the Piedmontese frontier. The Saracens erected stone garrison fortresses as they went, often naming them Fraxinet after their home base. Variations on this root spelling, including Le Freney, proliferate.

The name of another local village, Le Chazalet, points to feudal control after the expulsion of the Moors. The Old French word *chesal* (of which Chazalet is one of a number of variants) designated a habitation for slaves during the Frankish period (sixth to ninth

centuries). After the liberation of the serfs, the feudal landowners or seigneurs, whose land was worked by dependent tenants, reserved rights over these dwellings. Thus in medieval Savoy, as hamlets and villages expanded into towns, the *chesal* described a rectangular plot of cultivable land at right angles to the road with a building where it met the road. This building generally adjoined buildings on either side. Alternatively, the word was applied to a terrain that allowed for the construction of such a dwelling, similar to the Spanish *finca*.

## Huguenots

Above Clavans-en-Haut-Oisans, on the descent of the Col de Sarenne (see below), a sign indicates a Huguenot cemetery down a side track. Drawing a bow at a venture, I found a website for a bed and breakfast in Clavans-le-Bas and made enquiry. In reply, I received a letter from Xavier and Marie Odile Gonord, in handsome calligraphy, explaining that Clavans had been a secret Huguenot village. They also included a fine, hand-drawn sketch-map of the Romanche valley, the ridge of mountains and passes above it and the big torrent of the Ferrand and Valette which gave a route up to the high line. This is the text of their letter:

> Protestants moved into the Dauphiné from 1530 onwards. The high clergy were too far distant, the common clergy too ill-educated to react to the spiritual apostasy of former Catholics. The spread of Protestant doctrine was aided by the movement of pedlars and travelling merchants throughout the winter. Very soon, the villages of Clavans, Besse, Mizoën, La Grave, Le Freney, Le Mont de Lent [surely Le Mont-de-Lans?] became Protestant, either partially or entirely. Churches were built in Besse, Mizoën, La Grave. The whole region was caught up in the Wars of Religion [initiated by the Massacre of Vassy in 1562, when Catholics murdered local Huguenots in Vassy in Burgundy]. Relations between members of the same family but of different religion were amiable in these villages and pretty much so, too, in the Dauphiné where the governor, De Gordes, a Catholic, refused to execute the order of the king,

# Le Bourg, as it is generally known, is the capital of the Oisans region, that part of the Romanche valley as far east as the Col du Lautaret

Charles IX, to eradicate the Protestants [the infamous Saint Bartholomew's Day Massacres of 1572].

Clavans created its Protestant cemetery, therefore, and it has been preserved by the descendants of the people buried there. Many Protestants were, before the creation of the cemetery, buried by the roadside, in their houses, in their fields. The region was restored to peace by the Edict of Nantes in 1598, when the king, Henri IV, granted freedom of worship to the French Protestants. (Henri, king of Navarre, was himself a Huguenot but converted to Catholicism before ascending the French throne in 1589. Famously he said, '*Paris vaut bien une messe*': Paris is well worth a Mass. He was assassinated by a Catholic fanatic in 1610.)

Louis XIV, led to believe that there were no longer any Protestants in France, revoked the Edict of Nantes by an edict issued from Fontainebleau in October 1685 and provoked a huge exodus of Protestants to Prussia, the Netherlands, England... All the Protestants of the villages of the Oisans

elected to go into exile in the region of Halle (in Saxony). The greater number of them left everything they owned behind and, heading for Geneva, crossed by the Col Prés Nouveaux (a summer pasture, 'new fields', overlooking the Col de la Croix de Fer) and the Col de Martignare, otherwise Col Noir, by Les Aiguilles d'Arves, the peaks above Le Goléon, generally under snow from mid-October. The repression of these fugitives was bloody and cruel, but the majority managed to cross Savoy. Clavans and Besse lost 50% of their population, Mizoën 90%. The imposts or taxes (calculated per capita) were not reduced, the people lived in harsh poverty and the persecution continued. In restoring the houses which we now use, we discovered 1,000 documents from this era which give a detailed account of daily life in the late seventeenth century.

# COL D'ORNON 1367M

*Northern approach from Bourg d'Oisans
719m*

LENGTH  13.6KM
HEIGHT GAINED  648M
MAXIMUM GRADIENT  8%

Follow the RN1091 up the Gorges de Romanche from Bourg and turn left on the D526 into a shallow gorge on a good surface. It is a relief to be off the main road, exploring a modest climb (around 7–7.5%) on ample bends, perhaps as a training run for the fiercer beasts in the vicinity. Cross a bridge at 4.3km, the torrent coming in from the right. The road narrows against a side wall pressing in from the right and, at 6.1km, falls away to a flat stretch. The D221 shoots off right and 6.6km of around 11% to the ski station at Oulles (1440m) if you are as hell-bent inclined on punishment as that road is. The continuing road mounts quite gently again at 4.2km past another invitation to extreme gradient: the D210 to the left for Palud towards the Col de Saulude (1680m). It's a dead end, and the col itself lies some 4km beyond the hamlet of Villard-Notre-Dame, but should you wish to extend the ride, there are 9km of around 9% on offer.

At the Pont des Oulles (1032m, 8.4km), another small road branches off right towards Ornon itself, where once lived a Roman called Ornus, whose name means 'wild mountain ash'. Through two hamlets, Le Pouthuire and Le Rivier-d'Ornon, into a long straight which,

with a slight shimmy, leads up to a seeming col and a restaurant/bar. The broad road continues south on a near flat, almost a plateau, the open ground quite stony and barren, to a second hump, the actual col with its own bar/restaurant.

From here a swift ride down on a cheery straight, annoyingly kinked by some interfering tighter bends which brake the satisfying whirl of the big ring, but negotiate those with slalom nonchalance, and this is for the most part a flowing descent along the course of the Malsanne, the fast-flowing stream which bisects this narrow valley. The first 4km ask between 6.5 and 8% of you, after which the price drops to 4, 3.5 and 2%. An easy climb back, therefore.

In Le Périer (902m) 10km from the col, on the dark sandy façade of an old building set back from the road to the right, a stencil in fading maroon letters, 'Hôtel du Commerce Confort Moderne'. What modernity they speak of and to what comforts they attest, I cannot say for certain, surely not much in the way of plumbing. Ah, but what en suite sophisticates we are to chortle in bemusement at our forebears' artless, bucolic delight in toasty warming pans on the linen sheets – scented with lavender from the press – pulled tight over a goose feather mattress at moth time, small bundles of dried hops under the duck-down pillows to aid sleep, a draught rattling the loose window panes in the sash, the village rooster crowing the break of day, a tentative

toe-tip trip over bare floorboards to the ewer of hot water brought early to the room for matutinal ablution, and down a creaking flight of elm-wood stairs to a hearty breakfast of eggs brought in fresh from a nearby farm, butter from its churns and bread newly baked to eat with preserve of *myrtilles* (blueberries) culled from the mountainside the summer before.

A side road left leads to the village of Confolens 2.5km away, where strands of lesser streams meet to form a larger flow (hence the hamlet's name, from the Latin *confluens*, i.e. confluence), the Tourot, and the Cascade de Confolens. This waterfall is 70m high in a lovely setting.

A fine perspective ahead of the Mont Aiguille to the south-west as the road trips through Entraigues, and about 2km on, just before the Pont des Fayettes, across the river La Bonne, joined near this point by the Malsanne, turn left in Saint-Michel-en-Beaumont on the D212$^F$ to the Col de Parquetout (1398m). The climb begins around 800m from the turn and is a corker, a real gem: hard, beautiful, worthy of note.

A cursory greeting of 6.5% ushers you through what is Les Angelas on the map into some extremely hard questioning of 10 to 13%. There are no markings on this very attractive backwater road. The small village actually calls itself Les Engelas. The road loops through and, cowed by the stern glare of a disproportionately large church, huddles into itself. Strait, indeed, is the gate and narrow is the way which leadeth

unto life and few there be that find it. Amen. Houses give way to fields of *maïs* (maize), vegetable plots, orchards of fruit trees and woodland, which come and go on these next 6.6km of close investigation of your legs and lungs. At 3km a sign gives 1010m. An agreeable quietude, tiny oaks are sprouting, the scions of acorns which have dropped passim. A small metal post topped with a white square with a yellow band across the top (showing D212$^F$) gives the kilometres – 4km, 112m – and a 'this way' arrowhead. Passing 5km, 1213m, a white graffito on the road warns of 12%, perhaps for competitors in the running race which comes up here. A sign speaks of it. The road soon opens onto a balcony from which pop out glimpses of a large view through the trees and then the col, unnamed, its altitude here 1388m (other sources have our 1398m) marked on a wooden post dedicated to pointers for walks leading off the road around the slopes of Mont Gargas, the dominating prominence.

The descent feels steep, but perhaps this is an impression induced by the acute slope of the ascent, for it is no more than 9%, in fact. The surface is rougher, but here is a puzzle: some 400m down, there is a named Col de Parquetout (1382m). Hay fields, a skinny road looking over a prospect of meadows and, above the meadows, the mighty bosse of L'Obiou (2789m) on the skyline.

The Obiou, a layer cake of sedimentary rock at the bottom under a cretaceous cap, is a significant landmark hereabouts, a huge

mass of rock which survived the general erosion of the plateau all around, of which it was once a part. This erosion was due to the action of primeval glaciers and the karstic process. The Krâs, a plateau in Slovenia stretching into north-eastern Italy, was studied by a Serbian geographer, Jovan CvijiÐ, who named the geological process which formed it 'Das Karstphänomen' (1893), employing the German word for the plateau, *Karst*. Water acts on porous limestone to open galleries, sink holes and caverns, and in some cases this, the karst phenomenon, breaks down the rock completely. A plug of harder, denser rock like the Obiou, impervious to seepage, is left behind.

The road, with no cover now, slides through hay meadows. Rosebay willow herb (fire weed) abounds in the verges, here, joined by a clump of wild strawberries in the shade of beech trees. A right turn on the D212 goes to Saint-Michel-en-Beaumont.

Some 3.9km from the Col de Parquetout comes another, the Col de l'Holme 1207m, after a long section of road lined with a sturdy wooden barrier fence made of logs set horizontal between uprights, the customary form round here. To the right an umbrageous avenue of beech, larch and poplar. Is there an elm (Latin *ulmus*, French *orme*) too? Probably, though I did not spot it. This Col de l'Holme comes in open farmland producing hay and yet more hay, and near the col is a wooden shelter with '*Col et Bienvenue à Sainte Luce*' painted

on it. (Sainte Luce, to which we are being welcomed, is the next village 1km down the hill.) It may well be a bus shelter, but there is no timetable affixed. The village, sporting a gay profusion of vegetable plots and flower gardens, affords a view across to the right fork wending its way to Saint-Michel-en-Beaumont through similar countryside as the valley begins to spread like a melting ice cream.

Another fork out of the village, left, passes through Le Villard, a hamlet (Villars on the map) at 1097m. An imposing horizon of peaks and their shoulders. The drop into Corps (937m) comprises open-handed straights with slight bends, a fine challenge as an ascent and entrée to the treat up at the top.

# COL DE MALISSOL 1153M
# COL DE LA MORTE 1370M

*Southern approach from La Mur, 880m*

*To Malissol, 7km, a flattish dawdle to a shock of 2km 8–10%*

*From Col de Malissol, 14.7km, descent, flat and another brace of sizzlers around 9%*

Northwards out of La Mure, a long avenue of limes hugs a straight road (D26) from which the D114 branches left to Nantes-en-Ratier and La Morte, and on, still straight, down by way of Villaret and Rynaud through trees and farmland into the valley of La Bonne, a tributary of the Drac. From Nantes-en-Ratier (947m, 4.6km) it climbs sharply round gentle bends in leafy surroundings to the col (1153m, 7km) and a pleasing prospect of low heights overlooking the course of the Roizonne, another feeder for the Drac. A wooded, smooth descent on mostly new tarmac continues straight and fast into the Roizonne valley and through a number of tiny villages at no great stress of climbing. The road crosses the stream just beyond Le Fontagneu, the Roizonne's banks to the left lined with aspens, their silver-backed foliage catching the light like facets on beaten pewter. A flat causeway road leads through Lavaldens (1070m, 15.3km), the valley bottom made into pastureland across the Torrent du Vaunoire, whose waters rush in from a waterfall off to the right. A short way beyond Le Villard (1130m, 18.7km) by a right-hand hairpin, a circular sign – white centre bordered in red – guards

a side track and warns: '*Des premières neiges à 15 mai*', that is prohibiting all traffic between the appearance of the first snows and 15 May, though how it is that they can be so precise about the disappearance of the snow is odd.

The last 2km out of Le Villard are steep. The Alpe du Grand Serre ski area lies off to the left and generally gives its name to the col rather than the slightly sinister Col de la Morte (1370m) (Dead Woman's Pass). Indeed, a little way on past hay fields, scattered chalets, cabins, a *télécabine* and shops at Serre, by a small pond by a road to the left for Le Désert, a house bears a sign, faded brown with white letters, which reads 'L'Alpe du Grand Serre 1348m'. The descent swishes round a big tangle-knot scrunched coil of compacted twists at a steady 6.5–8%. The ascent by this direction – 14.6km from Saint-Barthélemy with no easing of gradient – is demanding and very pretty in an amiable tranquillity of leaf and silent tree onlookers. Suddenly, a glimpse of Grenoble opens to the left. In Séchilienne (364m), 15.1km from the col and the start of the climbing, a bridge spans La Romanche, heading out of its long gorge for the Drac, itself a tributary of the region's major flood, the Isère.

# COL LUITEL 1262M

*Southern approach from Séchilienne 364m*

LENGTH 10.5KM

HEIGHT GAINED 898M

MAXIMUM GRADIENT 11%

A gentle opener out of Séchilienne kicks into the hard stuff just before Les Aillouds, where the cyclist, pricked with foreboding, may dwell in transit on a fine echinacea, a splendiferous hydrangea with ample globed sprays of vanilla cream and pale blue florets, and a potato patch, also home to tomatoes, aubergines and onions, whose plump fullness may prompt tonic thoughts of lunch or supper. The road from here is narrow, its surface gritty and the gradient nigh on relentless, 10% or not much less all the way. A wooded stretch opens out, the trees thinning, and on a right-hand bend there is a seat planted for locals to pass the time in quiet contemplation looking out over the hills. Very bosky and remote this road, if bloodily steep and quite pinched of width, but it has joy in it too, a lovely sylvan escape. Think, perhaps, of that winsome song *Linden Lea* which the Dorset poet William Barnes translated into Dorset dialect. Its last verse runs thus:

> Let other vo'k meake money vaster
> In the air o' dark-room'd towns,
> I don't dread a peevish measter;
> Though noo man do heed my frowns,
> I be free to goo abrode,

> Or teake agean my hwomeward road
> To where, vor me, the apple tree
> Do lean down low in Linden Lea.
> I recommend Barnes, heartily.

And this 14 July as we came through, a goodly number of cyclists were out, profiting from a national holiday ablaze with sunshine. Les Blancs (700m, 4km), a hamlet… and will those same birds which carolled in the glade nearby that day serenade you? A wood stack on one corner is housed in a very tidy frame adjoining a garage with 'December 2000' picked out in brass studs, the packed triangular split logs neatly interspersed with round branches as fillers, thoroughly seasoned timber for the stove or hearth. A fine sight.

Fairly long flats alternate with sudden bursts of steepness, testing jolts of rhythm. There is shade all the way so far. Some distance beyond Les Blancs, the grittiness gives onto smooth tarmac, to return in Les Clots (1065m, 8km – on the map Clos de la Charmette). The panorama is full here and the gradient is gone, like the air from a deflated balloon, the tension from a wound-down watch, the stiffness from a wilted stalk. A welcome drop leads down to a visitor centre, the Accueil Lac Luitel, set in a *pique-nique* area in the shade of trees, just below the col sign reading 1262m.

In 1961, Lac Luitel, formed in a glacial depression, became the first nature reserve created by the French state, an expanse of 17 hectares, home to a rich diversity of peat

bogs, rare at this altitude. The fibrous earth is composed of different mosses, supporting a great number of plants and animals adapted to the essential poverty of the habitat, including the European common brown frog (*Rana temporaria*), the common toad (*Bufo bufo*), the alpine newt (*Triturus alpestris*), crested tit (*Lophophanes cristatus*), the boreal owl (*Aegolius funereus*), black woodpecker (*Dryocopius martius*), common lizard (*Zootoca vivipara*), wild boar (*sanglier*), roe deer (*chevreuil*), hare (*lièvre*), ermine (*hermine*) and dragonfly (*libellule*). (Both Latin and French names are given on the information board. For simplicity of recognition, I've used the Latin for the less obvious French names.) The mosses grow like lawns on the surface of the lake, and a number of carnivorous plants are abundant here – sundew, bladderwort and butterwort – as well as a variety of orchids.

Sadly, like youthful enthusiasm souring into age-ridden Weltschmerz and cynicism, this delightful, sequestered by-way soon merges with the ski highway up and over Chamrousse, the exuberant steepness of the one yielding to the coach-friendly 7.5% of the other, broad in the beam and devoid of charm. At the T-junction, therefore, turn right on the D111 to CHAMROUSSE (1735m).

The big resort road runs smooth round generous bends with plenty of movement and, in summer, a firm presence of cyclists. At 5.1km from the junction, a side road goes to Chamrousse (1600m) past a car pull-off and a refreshment kiosk. Further on, a track to a Centre Equestre and on to where Chamrousse at 1650m, another sector of the ski station on the hillside, appears bang in front and smacks you in the eye. This, infelicitously for the purpose to which the old mountain village has been put, is called Le Recoin (the nook, cranny). At 6.1km, Chamrousse (proper) at 1750m – a venue for the 1968 Winter Olympics – whence a *télécabine* up to the Croix de Chamrousse. On a wide plateau, chalets sprout amid the trees. The climb up here is uneventful but, taken as a complement to the Luitel, it makes for a splendid descent thence in either direction, which the drop back down the Luitel would not be. The northern descent, towards Uriage-les-Bains, flips over an intermediate col, the SEIGLIÈRES (1065m) (a village en route), some 12km on from which opens a wide view of Grenoble.

Uriage-les-Bains (414m, 20.7km) is a small spa, set in a verdant basin (once a lake, perhaps), from whose sources the briny (from sodium chloride) and sulphuretted isotonic waters have been used as remedy for skin diseases, chronic rheumatism and ear, nose and throat complaints since 1820. Like many thermal resorts, Uriage also has a casino.

# COL DES MOUILLES 1201M
# COL DES AYES 994M
# COL DU BARIOZ 1041M

A 65km roller-coaster – what the French call *route accidentée* – through villages and green fields fringed by trees, one of those crooked side roads which proliferate in France, the old country roads linking communities, the quieter ways shadowing what became the major arterials of *routes nationales*. The climbing is neither extended nor extreme but, as a very welcome alternative to the main road along the Isère valley north-east from Grenoble, this track along the flank of the Chaîne de Belledonne is a beauty. It sets off from Saint-Martin-d'Uriage (595m) outside the spa town, on the D280. Three kilometres beyond Pinet (5.5km), a side loop down to Corps negotiates a 17% drop if you're so inclined, and on to Revel – apt name for this ride entire, but Revel will arrive just off the main route, too.

On through a trio of docile hamlets, Le Mas-Julien, Le Villard, Le Petit Mont, and down to a flat stretch past an abandoned house sitting forlorn by the road, like a hungry, thirsty, fagged-out refugee whose boots have finally worn out as the last spark of will flickered. (From Le Mas-Julien, 730m, a circuit right for the Col du Pré Long, 9km at upwards of 10% most of the way, some 15% on the far side, but most of the way unpaved, alas.)

A leafy passage into Saint-Mury-Monteymond (710m) and on over the ups and downs in view of a high mountain wall dead ahead, a rampart of the Chaîne de Belledonne, a long fissure slicing down it through the trees on its flank, sluice for a torrent. Perhaps La

Gorge takes its name from that deep cleft. A kilometre past Sainte-Agnès (730m) is a large house on a right-hand bend called La Colline Riante, 'Smiling Hill', with wooden half gates in a mossy square rock archway, above each gatepost this Bastille Day, a tricolour. In Mollard (868m) a short dawdle on, an ancient wooden shed to the left sports a rusted metal advertising plaque for Mazda batteries – the road marker gives 868m.

Also affixed to the wooden wall is an advertisement for Belledonne Villes 2009. This association of some forty communities of the Belledonne – encompassing villages, *alpages* (upland pastures), forests and meadows – was set up in 1998 to stimulate interest in the area among local people who live and work here as well as visitors, for purposes of development and conservation.

In La Perrière, by the house and atelier of a sculptor, espy a row of carved and painted crude wooden heads, reminiscent of those discovered on Easter Island, together with chiselled stone and driftwood *objets trouvés*. After a short spasm of around 10% arrives the Col des Mouilles (1021m, 26km) athwart a broad road girded by trees. Here, too, a Taverne de l'Ecureuil (the Squirrel Tavern) open Friday to Sunday, evenings only, specializes in *cuisses de grenouilles* (frogs' legs) and *cassoulet de la taverne*, as well as Savoyard cheese-based dishes like *raclette, reblochonnade* (a variant on *raclette* and *tartiflette*), Vacherin (strictly from the Jura or Switzerland, an

# A kilometre past Sainte-Agnès is a large house on a right-hand bend called *La Colline Riante*, Smiling Hill

alternative to Reblochon, for melting, but also the name for a pudding of meringue crust filled with chantilly cream and fruit) and fondues. Booking recommended. They also put on weekend parties – country dancing and festive riot, lamb and piglet barbecue feasts, celebration of the transhumance, autumn cassoulet feasts… In this tranquil wooded spot appear two backmarkers of the Rumilly *vélo* club whom we saw on the Luitel. They look tired, sweated, ready for sustenance. One of their pals is already there, sitting against a tree, waiting in the shade of the pines. He calls out: '*C'est fermé.*' (It's shut.) The man replies, in as expressive a form of disappointment as you could ask for: '*Ô putain!*' (Oh fuck… originally Midi slang, now general.)

Some 3km on from the col, near Prabert, a monument to the dead of the Maquis de Grésivaudan. Its design is unprepossessing, recalling the lumpen heroic worker of Soviet statuary (or Picasso's Blue Period women), a muscle-bound stalwart in an odd leg-raised posture plonked on the obelisk out of which he's been hewn. The inscription reads: *Passant ici tu es dans une haute place de la Résistance* (Here, passer-by, you are in a place of great importance in the Resistance).

Down, down to a bridge over a torrent and gently up through Villard-Château to a junction and a further 700m to the Col des Ayes (944m), whose sign nestles below a rising brow on the far side towards the village of Les Ayes. A side road, right, leads up 5km of mild

gradient to the PRAPOUTEL-LES-SEPT-LAUX (1355m). Provençal *laux* comes from the Latin *lacus* (lake).

The Belgian Ludo Loos marked an otherwise fairly unexceptional career with a win at this ski station, the eighteenth stage of the Tour de France in 1980 (the race's only visit), a year in which he came second in the Mountains competition.

From the Col des Ayes into Theys (670m, 3.9km) on a tributary of the Isère, and a wasp-waisted road past a château (now a *postes télécommunications*). Over a bridge and on through farmland into Gré (5.6km) – some topiary of the ornamental French style, cut in the shape of a Grecian urn or wineglass. A drift downhill to La Coche (890m, 8km), then up and away from pasture through woods to the Col du Barioz (1038m). Down through woods along the course of the River Bréda into open pasture with trees dotted around and, fringing the grassland, a view over Saint-Pierre-d'Allevard (510m) by a lake, and woodland all the way into the town.

Here by the road stands a giant brick oven, the rising courses of bricks gradually stepped in to form a taper over the ledges thus formed. Belt-like steel bands reinforce the body. Minerals from the Pays d'Allevard were mined from the thirteenth century on. Before the ancient but crude process of smelting had become commonplace in large furnaces, minerals were taken direct from the mine to be baked in ovens similar to these, called *rafours*

(a form of *chaufour*, lime kiln; *chaux* is chalk), to separate the metal from its ore. The baking eliminated carbonic acid and, thus enriched, the minerals were carted on mules to the forges for working. The exceptional pure quality of the Allevard minerals brought Schneider et Cie of le Creusot here. In 1874, the company bought concessions to all the iron mines belonging to the Forges d'Allevard and set up a plant in Saint-Pierre with workshops and *fours à griller* (ovens with grilling racks). By 1893, the site had four such ovens, 14m high, heated by oil. This, the only survivor, was built in 1905 and is one of the rare examples of similar structures conserved in France, the last vestige of thirty years' industrial activity in this area.

The medieval epic poem, *Chanson de Roland*, speaks of the forging of the Frankish hero Roland's miraculous sword Durendal and its gift, by Charlemagne, to Roland. The metal is said to have come from these very mines:

> Ah Durendal, how beautiful you are,
>    how shiny, how white.
> How you glitter and shimmer in the sun.
> Charlemagne was in the valleys of
>    Maurienne when God in heaven
> Commanded the king, through the voice
>    of an angel,
> To bestow you on one of your counts,
>    a captain in your army.

In 1791 an earthquake destroyed Allevard and, in the upheaval, the River Bréda threw

# COL DE CHAMP LAURENT 1000M

up a source of black water containing natural traces of carbon and sulphur compounds. The disaster turned into a treasure trove: the waters supplied a spa for the treatment of respiratory complaints and the thermal spa buildings are gracious and elegant, of marble and tile, with particoloured brick arches, long internal corridors over-lit by a pitched glass roof, the treatment rooms lined with *fin-de-siècle* decorated tiling.

Nearby, outside Pontcharra, stands the Château Bayard, birthplace of Pierre de Terrail (*c.* 1473–1524), champion of various French kings, a cavalry commander of flair and audacity, epitome of the chivalric ideal, known as *le chevalier sans peur et sans reproche* (fearless, blameless knight) or, simply, *bon chevalier* (good knight) for his politesse and love of gaiety.

*From Allevard turn right off the main D525 onto the D209 into Arvillard and, from there, the D207 to Presle, again over ups and downs which are the pattern of this delectable extended ride.*

In Presle (570m), where this section begins, is a Salle Joie de Vivre (Good-time hall). From Le Verneil (698m) this sweet-natured road enters the Vallée des Huiles. What (I hear you say) and where are the oils which lend their name to this valley inserted between the anticlines of Savoy and the Belledonne massif? But they are not oils, you see, they are needles or peaks. A dialect *ulyi* gives *aiguille* from the vulgar Latin *acucula*, diminutive of classical Latin *acus* – a sharp point. Very well, but what (I hear you add plaintively) is *vulgar* Latin?

The classical-Latin-speaking Romans referred to hoi polloi, riff-raff, as *vulgus*, 'the people', forever loitering about purposelessly in the street and bleating for bread and circuses to keep them happy. Dangerous, though. Add *mobile*, 'fickle', i.e. venal, gullible, capricious, to the *vulgus*, and you have the origin of our 'mob'. Nastiness in crowds. The Romans later also applied *vulgus* to anyone who did not, as they the conquering class did, speak classical Latin, namely the poor, benighted barbarians whom they subjugated. Except that those same foreigners might just have the luck to be Romanized, i.e. civilized, by having heaped upon them not only taxes, laws and sundry

other benefits – e.g. plumbing – but also grammar and syntax. Even so, condemned by their own barbarity to a less than polished form of Latin, these ill-educated foreigner parties tended to speak an odd, knockdown version of it, with slipshod declension, imported native words, an idiomatic slur, you know the kind of thing – low at best, insufferable at worst – which, since they were now lumped in with the generic *vulgus*, became attributive 'vulgar' Latin. And, whilst I'm on the subject, the Latin word for a slave born to another slave in a Roman household was *verna* (either gender – they were slaves, for the gods' sake, so who'd notice or be bothered, so long as they did the work?) and the Latin they spoke with their master and mistress came to be known as a handily reduced form of Latin (to accommodate the obviously diminutive intellectual powers and limited vocabulary of a non-Roman), the 'vernacular': an early form of pidgin.

More on this Vallée des Huiles: its route offers an alternative way through to Maurienne over the Grand Cucheron. The valleys of the Arc and the Isère were, formerly, extremely marshy and often flooded, thereby hampering passage through. Indeed, some historians have advanced the theory that Hannibal led his army and elephants by way of this secondary, dry, Vallée des Huiles route.

Le Verneil announces itself with a ruined barn and bids farewell with a corridor of tree-cover all the way into Villard-de-la-Table

(760m, 13.9km). The road continues to Bourget-en-Huile, but a better option is to turn left towards La Table climbing up from Villard-de-la-Table through woods. La Table abuts more or less immediately onto La Provenchère, another lovely little village. By the church in La Table turn right on the D23 to Champlaurent. Note, *en passant*, a number of *barrières de dégel* hereabouts. This refers to restrictions placed on the circulation of traffic during the thaw after winter snow and ice, largely through temporary limitation on the tonnage of vehicles, with a view to protecting the road foundations. When the temperature drops below 0°C, road structures tend to swell from the effect of frost and moisture without any immediate damage. However, when the ice melts, the road's upper surface is the first to thaw out, while the substratum, still frozen, has not recovered its full capacity to support weight and is therefore prone to radical breakage. Restrictions may be lifted in case of emergency or vital service.

Down through woods and occasional open glades hydrangeas abound, blue in acid soil, pink in more neutral tilth. The rolling country road continues through Glapigny (970m) and a shudder of around 10% – a nasty intrusion of steep in what is, by and large, gentle and considerate of gradient. The hamlet of Champlaurent has a splendid laundry trough, and some pasture beyond leads to the Col de Champ Laurent (1116m, 14km) beside a clump of meadowsweet, whose frothy cream heads

## COL DU GRAND CUCHERON

1188M

emit a delicious fragrance of honey and are much attended by bees.

An alternative, northern approach comes up from Chamoux-sur-Gelon (295m) on the D25, 10.1km of hard climbing, a relentless 9% and not much less, all the way.

From the col, down through meadows, a log clearing and swishing bends to Le Désertet (998m), and suddenly very steep (9.5%) round one vicious left-hand hairpin and Les Granges (874m). Turn left to the Col du Grand Cucheron.

*Eastern approach from Saint-Alban-des-Hurtières 518m*

LENGTH  9.4KM

HEIGHT GAINED  670M

MAXIMUM GRADIENT  10%

Three kilometres of steadily increasing steepness to the main agenda, 4km of nothing less than 9%, easing off at the top where, on the tarmac in red paint, 'BRAVO' and an arrowhead with a squiggly tail, as it might be a kite with a tail. The road is shady most of the way, part of the Forêt Communale de Saint-Alban-d'Hurtières. In the village of Saint-Alban-d'Hurtières there is, somewhere not immediately visible, a Petite Boutique d'Horreurs (Little Shop of Horrors). This side of the mountain was once pitted with mines. Extraction of the minerals was difficult and the ore had to be heaved up to the surface, sack by sack, then hauled on crude sledges made of

Le Verneil announces itself with a ruined barn and bids farewell with a corridor of tree-cover all the way into Villard-de-la-Table

# COL DE LA MADELEINE 1993M

pine branches down the hillside and on to the Carthusian monastery of Saint-Hugon, founded in 1183 near La Rochette, at the southern end of the Vallée des Huiles, where the monks worked a large forge.

There are a number of cols called Cucheron in this region, the name evoking a pre-Celtic word meaning 'height' or 'summit'. *Hurtières* (Latin *urtica*, stinging nettle) is named for urticaria (nettle-rash), though why any community would wish to advertise the proliferation of stinging nettles in its vicinity, I do not know, unless it has something to do with this local Alban, a saint whom monks hereabouts venerated. Perhaps they were wont to flog themselves with *urticae* to emphasize their piety. It has been known.

*Southern approach from La Chambre 470m, 19.3km*

LENGTH 19.3KM
HEIGHT GAINED 1523M
MAXIMUM GRADIENT 10%

The first gradient lifts out of town into a dark mountain interior, a bold confrontation of two mighty buttresses flanking a deeply slashed defile. There seems to be no room for any road between the crush of those immense bastions of rock, but road there is and it is bruited as part of the Chemins du Baroque (Roads of the Baroque), centred on Val Thorens and the village of Saint-Martin-de-Belleville (see *Chamonix*). These Chemins du Baroque take visitors on a discovery of Savoy's Baroque heritage and the life of the mountain communities with guided visits, every Wednesday, to the Notre Dame de la Vie Sanctuary and the Saint Martin village church.

The Baroque style (from Portugese *barroco*, a rough or imperfect pearl), dominated European art from the early seventeenth to the eighteenth century – florid, sensual, heavily ornamented, grandiose in theme, voluptuous in execution, gaudy in decor. The epithet reflects an early response to the exaggerated nature of Baroque's decorative ostentation.

Hairpins and straights alternate on a smooth road and, after a gentle enough opener, there ensue five rather more testing kilometres up to the ascent's maximum through La Côte

(760m, 3.8km) and an invocation, *Allez Jérôme*, on the road. This steep battering slackens periodically thereafter, but keeps up a steady high demand of around 8.5% all the way to the col.

The way of the Bugeon valley is thickly hemmed with woodland, and there are some quite long stretches with little to look at except a hedge of tree trunks, dark foliage, tarmac and the staple of the mushroom hunters' protest: *NON A LOUP* (No to wolves). Mushroom pickers who roam the woods in early autumn fear the chancy trigger fingers of hunters out after wolves or other targets. For some of that crew, the watchword appears to be, 'if it moves, shoot it'.

After a very short snow tunnel (1095m, 7.9km) the road narrows. Saint-François-Longchamp (1490m, 11.5km) announces the first intrusion of winter sports and the barren, grass-covered yoke on which the col sits makes its entrance. The ski clutter begins to proliferate. Past Les Longes (13.1km), chalets scattered across the mountainside hove into view. This is Longchamp ski station at 1650m, a formless sprawl. The road creeps through and onto bare hillside, sparse of tree and bush. The greater presence is of posts leaning drunkenly, supporting the button lifts, the concrete stanchions of electricity cables, telegraph poles and overhead cables and wires, like strands of rope hanging out to dry. The higher up, the freer of these intrusions, but here looms a *télésiège* into view. There is no

getting away from wintry technology up here. The last kilometres spool round the grassy slope and the col arrives without ceremony on a wind-scarped straight of no grandeur. A restaurant, La Banquise, on one side of the road, and, opposite, a bar with stepped gables, Les Mazols, set back. The col sign gives 2000m, other sources insist on 1993m. Le Cheval Noir is the bristling crag up to the right. From the col, the throat of the northern valley seems to be sucking at the road as it were a string of spaghetti.

This northern side of the mountain named for Mary Magdalene is far more attractive, more generously au fait with nature, more rugged and unsullied, its original frank rustic terrain left unspoilt, principally thanks to a less intrusive presence of ski works than on its southern flank, whose huddling lower slope might well evoke the anguish and tears of the woman who lingered at the foot of the Cross when all the disciples, save John, had fled. Described in early teachings as the apostles' apostle, Mary of Magdala (probably a town by Galilee) was the first person to encounter the risen Christ (Mark 16:9) and her identification with a repentant prostitute is almost certainly an error of translation. That she did give her name to 'maudlin' – a word which declined from the simple sense of lachrymose to the more pejorative tearful sentimentality – is unfortunate. It calls into question her sincerity and blackens her name and character, altogether unfairly.

The road runs open on long straights with coquettish flicks of bend and without a barrier. At 4.8km a torrent gushes off the cliffs, and not until around 7km from the col do trees begin to multiply as the valley of the Eau Rousse gradually closes in to a V shape.

Le Logis des Fées (1845m, 8.4km – literally 'fairy dwellings') and Celliers-Dessus are each no more than a handful of houses, and whence those fairies hail I do not know. Celliers-Chapelle is much larger, and in maroon letters on the pale yellow (old gold) of the back wall of its church is written: *ND de Celliers Priez Pour Nous.*

The walls of the valley tighten and a concrete parapet acts as barrier for a resurfaced road forced to squeeze tight through Celliers-la-Thuile. Outside the hamlet that morning misty, moisty and dowly was the weather, and we met a woman gathering snails from a bank of nettles, her hair bound up in a clear plastic rain hat and the snails she had gathered packed in a clear polythene bag.

Along the skyline ahead, the mountain heights brood, like a stone-faced reception committee of Mafiosi bosses, a silent impassive board of examiners at a viva voce ready to pose the heavy stunner of a question on the hapless candidate. Trees crowd back at 14km, the road surface is uneven, on past a torrent (16.2km) and onto new tarmac. In Bonneval, a barn houses veal calves, suckled on milk to make their meat tender.

This northern approach, some 27km from La Rochette (374m) on the left bank of the Isère, is a more friendly, engaging ride, albeit there are, as with the southern side, long stretches of road with a blank side wall of hedge lower down. The gradients are similar, but there is a better supply of sinuous bends and flow.

# A TRANSITION

At the northern foot of the Madeleine, a side road swings south-east shadowing the dual carriageway into Moûtiers. From Moûtiers, the old capital of the Tarentaise, a side way to the climb of La Plagne leaves the N90 into Les Plaines and Notre-Dame-du-Pré, Our Lady of the Meadow, the Virgin herself in milkmaid's smock, straw hat and clogs, with a trug for hedgerow fruits. It's a delightful detour, climbing a series of tight hairpins out of Les Plaines at a steady 7 or 8%. Note the chapel, or hermitage, on a pinnacle high above Les Plaines, reminiscent of a curious form of asceticism best known from Simeon Stylites, a Syriac saint whose proclivity for exorbitant austerity prompted one monastery to ask him to leave. He spent thirty-nine years living on top of a column, praying, fasting and dispensing spiritual counsel to pilgrims gathered at the foot of his pillar.

This D88$^{\mathrm{E}}$ is a handy, anonymous climb, part shaded, skirting small patches of hillside meadow, full of merriment in its bend and chuckle. At La Fruitière, in Notre-Dame-du-Pré, 10km from the turn-off, you will find a cheery welcome, too, and a homely *menu du jour*. As the patronne enumerated the items on the day's card, I said that I had seen the *désert*. Her brow furrowed. She was puzzled.

> '*Le désert? Mais où?*' (The desert? But where?)
> '*A côté, la jeune fille.*' (The young woman sitting on
>     the next table.)
> Still puzzled. '*Ici?*' (Here?)
> I twigged. Ah, I understand, *le dessert*. My accent is of Paris.

She laughed and, with that French love of getting things straight, added:
'There is no sand here.'
From Longefoy 4km on, a technical descent of the same distance takes you to the foot of La Plagne.

# TOUR DE FRANCE 2010
## STAGE 9, MORZINE-AVORIAZ: *204.5KM,*

*66KM OF CLIMBING AND 4000M HEIGHT GAINED*

Another French attack early on in the stage and, at the finish in Saint-Jean-de-Maurienne, Sandy Casar, the third French stage winner that year. On the 27.5km of the Col de la Madeleine, Andy Schleck attacked Alberto Contador three times, and three times Contador held his wheel. This was the last day in the Alps, the Pyrenees to come. Had Schleck got clear, he would, surely, have driven his attack as hard as he could to distance Contador (now at 1m 1s) still further. But, the Spaniard would not cede. And so, bizarrely, they agreed a truce, expressly to not take unnecessary risks on a tricky descent,

From the foot of the col, Contador and Schleck chased in tandem along that road and very nearly caught the breakaways

having come to terms on the way up. The showdown would have to come in the Pyrenees. An odd way to contest a Tour, turning it into an agreed duel, time and date fixed ahead. Jens Voigt, the human engine, had relayed Schleck most of the way up the Madeleine, but was spent 1km short of the col. Had he been able to stay with his team mate, what work he might have done for him on the final straight flat approach along the valley to the finish.

From the foot of the col, Contador and Schleck chased in tandem along that road and very nearly caught the breakaways, among them the senior man of the peloton, Christophe Moreau, thirty-nine years old, who had just announced that he would retire at the end of the season. Casar, who knew the finish well, the sharp left-hand bend and the short dash for the line, attacked with smart timing. Schleck went into yellow and Anthony Charteau took over the polka dots from his compatriot Pineau.

Cadel Evans, who had started the day in yellow but was suffering from a badly injured arm, caved in on the Madeleine and collapsed in tears at the finish.

# COL DU GLANDON 1924M

*Northern approach from
Saint-Étienne-de-Cuines 483m*

LENGTH 19.9KM

HEIGHT GAINED 1441M

MAXIMUM GRADIENT 11%

From Saint-Étienne-de-Cuines a smoothly surfaced road loafs up the course of the River Glandon accompanied by gardens bedecked with an abundance of roses and vines. A gentle start at a regular 7–8% for 8.5km through hay fields, the broad byway rambling round mild bends, occasionally jinking into a sharp twist to make some height. A sign at 1.9km, *Bienvenue dans les Vallées des Villards*, welcomes the traveller to the valley of villages. Latin has an adjective *villaris* from *villa*, which is routinely translated as 'country house' and extended to mean a tenant's farmhouse or terrain with courtyard. Later it covered the fields pertaining to such a house and thence came to describe a small village or else a hamlet quite separate from larger habitation. Thus, *villaris* can apply to the inhabitant of a such a place, hence *villard*. Local dialect variants are numerous, including Vellerat, Vieillard (otherwise 'old man'), Vilaret, Vilars, Villair, Villaire, Villar…

A *virage dangéreux* (3.1km) is a very abrupt, and therefore dangerous, right hairpin, first of a series, interspersed with somewhat tauter bends giving give the gradient a taste of the mulish kick. Around 4.5km, a view up the valley opens as the road traverses a ledge. Soon,

a huge peak pops up above the line of trees far, far off to command a clear view when the trees lining the route allow it. This crag is one of a cluster of *cimes* (peaks): du Grand Sauvage (3169m), de la Valette (2838m) – between which two flows the Glacier de Saint-Sorlin – de la Cochette (2987m), and des Torches (2958m), lining the Champ de Tir, the massif along whose line meet the *départements* of Savoie, Hautes-Alpes and Isère.

Saint-Colomban-des-Villards (1100m, 9.5km), offers two hotels with bars – the Mur d'Escalade and the Hotel du Glandon – and hollyhocks adorn the narrow pavement at the foot of their walls. A placard indicates the ski stations, now named Sybelles, collectively for Le Corbier, Toussuire and Mollard, in summer home to VTT routes.

A long, flattish stretch through the extended village hits the second helping of tauter gradient which continues all the way to the col. Out into less obviously tended countryside where some vegetable plots have been cut into the marginal fields. A row of copper-capped street lamps, right posh for such a rustic setting, a visitation of new-town gentility, lines a side road off to the right leading into Valmaure, and there is an end to the houses which claim kinship with Saint-Colomban. The road has no further excuse to pass itself off as an urban boulevard and, mindful of its humbler, hayseed status, grows narrow into a longish straight and then a crooked, tree-shaded wiggler. It is, after all,

a minor feudal *chemin* in thrall to a mighty seigneur of alp. The massif of the Col du Chaput up to the left is home to the Toussuire ski station and cousin to the Le Grand Truc (2209m – the Big One).

A tarmac graffito '*EPO-BAR*' recalls an acerbic joke, first aired during the 1999 Tour, after the Festina debacle, alluding to the use of erythropoietin, which, developed as a treatment for anaemia by enhancing the proliferation of red corpuscles, has been used as an illicit performance-enhancing drug. A cynical wag set up a stall at the roadside from which he purveyed a cocktail known as a *mauresque* made with *eau* (water), pastis and orgeat, barley syrup flavoured with sweet and bitter almonds.

The gradient cranks up to around 10%, some sources giving as bad as 13%. L'Alpage de l'Échet (1456m, 14.5km), is no more than a sprinkling of huts and cabins in open, treeless country with a looming presence of mountains all round. Yet there is a local community at play here, as witness a football field to the right, cordoned off with a high net all the way round. Below the Alpage du Sapey (1570m, 16km), the Glandon River early in its course flows down to the right, fed by waters from the Lac Noir and the Lac de la Croix up on the frontier ridge to the west. From the upper of those lakes, a torrent rushes down a gully in the mountain wall. The Alpage Sous-le-Col (1634m, 17km, 'the high mountain pasture under the col'), in a renewed burst of 9–10%, has no dwellings; presumably it is a daytime resting place. The

gradient over the final 3km is very sharp, the road exceedingly narrow, trimmed by a skimpy verge to the right, as it picks its way over these inhospitable upper slopes. At 18km a tiny rectangular plaque of stainless steel is set into the parapet by the side of the road commemorating the death of a man on the Marmotte, that ride for amateur cyclists which crosses this mountain, from the south, then climbs the Télégraphe and Galibier to finish on l'Alpe d'Huez. A young Dutchman crashed on this descent during a *sportive* and was killed.

> *Vlieg over de Bergen*
> *Denk aan ons*
> *en Geniet*
> *Klaas-Jan Bakker*
> *12/10/1968 – 9/7/2005 la Marmotte*
> 'Fly over the mountains, think of us
>     and enjoy'

Just beyond this melancholy reminder of how perilous these roads can be, a more jocular graffito, though underlining in more wistful mood, perhaps, the perils of the game: pale yellow fading letters, 'MICKI MARTY NICO' next to a line sketch of a bike inside a circle with a diagonal drawn across and the legend 'NO CYCLING'.

These final loops, pinched as crochet hooks, continue up a very exposed, bleak upper reach to the col and the Chalet Hotel du Glandon below it at 1908m – tables al fresco, a jovial treat if you care to indulge.

*South-western approach from*
*Rochetaillée 711m*

LENGTH  29.2KM
HEIGHT GAINED  1213M
MAXIMUM GRADIENT  9%

The first 8km trot along past the Barrage
du Verney, an EDF (Electricité de France)
installation, a village called Oz – probably no
wizard, he (though who can tell?), but a Gallo-
Roman of a family Ossius – to Verney at the
lower end of the long Défile de Maupas eroded
by the Eau d'Olle. Maupas means 'dangerous or
difficult passage' (Old French *malpas*), but it's
for you to make up your own mind about the
Glandon. The 6km into Le Rivier-d'Allemond
(1275m, 13.8km) rise like an angler's rod under
the strain of a big fish, 6.5–10%: steeper and
steeper, scarcely a bend, shut in by trees.
A recommended cyclist-friendly *auberge*
in Allemond is La Douce Montagne.

Le-Rivier-d'Allemond proudly displays
a citation engraved in gold on a serpentine
marble plaque broadcasting its distinction as
the only village in France into which German
soldiers did not enter except as prisoners. The
village mayor cooperated with local Maquis
and FFI commanders to provide liaison,
information on enemy movements and, when
the time came, active involvement in the fight
with the Germans in July and August of 1944.
(As indication of how difficult it is, often, to
pin detail, the plaque spells the village with
a terminal 't' rather than 'd'.)

During the reigns of Louis XIII and XIV,
in the seventeenth century, the village was
the site of royal foundries built to deal with
minerals mined in the Chaîne de Belledonne,
principally silver, lead and copper. (Perhaps
this is the reason why they are called, locally
'Roches Bleues'.) The Romans had opened
anthracite quarries in the same area as well
as the first mines. The pits were swamped by
avalanche in 1952, and the old road running

# The 6km into Le Rivier-d'Allemond rise like an angler's rod under the strain of a big fish, 6.5–10%: steeper and steeper, scarcely a bend, shut in by trees.

along the flank of the massif was swept away. Its line is still visible as you plunge down the diversion, scattering hard-won metres of height to the unforgiving wind. The road at the bottom creases and goes up, back to the level you started at on the other side; it's like clambering out of a crater, 9%... 9%... 9%, so snarl and dig in.

Below the Montagne des Sept Laux, on the right side of the road, a memorial attests to the fighting here in the summer of 1944. The Maquis of Oisans held this strategic position and repulsed German attacks three times. By the end of August, Allied forces were outside Oisans, but several thousand Germans still occupied the valley. On 21 August, before daybreak, a huge column of Wehrmacht infantry and mules loaded with equipment left La Fonderie at Oz heading for Saint-Jean-de-Maurienne. They bypassed the Gorges de l'Eau d'Olle to avoid confrontation, making their way up to the dead end in Vaujany and on via the extremely treacherous sentier du Col du Sabot (2100m) south of the Défile de Maupas. On the col they spotted a resistance lookout post twenty-five maquisards of Grand'Maison together with five men of sector 1 of the FFI. (Grand'Maison also names the barrage that forms the lake below, from the dammed waters of the Olle, and refers to a specific place, possibly an alpage originally sited hereabouts. Small Maquis sections often took their names from villages and hamlets.) The Germans called in artillery to pin the maquisards down. After a

number of salvoes, a group of Germans climbed down and neutralized the resistants, three of whom were killed while the rest managed to scramble to safety. The dead are named, all Poles: Ceslaw Tutsanowski, Jean Siemet Korwski, Miczolan Litwin'czik.

A torrent sluices the rock wall to the left and way across, beyond the lake, what look like natural terraced ledges lunging at an angle down into the deep green-blue water are, in fact, the gouges made by the claws of cutting machines, the vacancies of quarried rock.

The country opens out beyond the Barrage and the road levels out for some 3km and then broaches the Combe d'Olle. The word *combe* is common to several European languages and means 'dale', 'dell', 'deep, narrow valley', although the French applies it more to a basin or bowl. Indeed, the terrain has the aspect of a crater, whose Greek original, *krater*, refers to a wide-rimmed drinking vessel. A big cascade tumbles down the rock face away to the east, with moorland to either side of the road. The final 2.5km are steep again and the col itself a tiny desolation in a wider wilderness, although an *alpage* with a collection of small cabins and byres for the summer pasturage speaks of kindlier presence.

The descent turns off left, the road continues, right, towards the Col de la Croix de Fer.

# COL DE LA CROIX DE FER 2067M

*From the Col du Glandon 1924m*

LENGTH  2.6KM
HEIGHT GAINED  143M

A swift climb up a rocky traverse. The filigree
wrought-iron cross is there near the col,
marking a pilgrims' route or simply to nod
reverently at God's ubiquitous presence.

## Northern approach from Saint-Jean-de-Maurienne 560m

The direct route up the D926 is 29.9km
long and the maximum gradient, on a road
of variable rhythm, nudges 10%. We give an
alternative longer approach on a quieter road
to the west.

Le Gavroche, a restaurant in the Place du
Marché, Saint-Jean-de-Maurienne, prides itself
on its home cooking. They 'peel, slice, scrape,
stir, taste and season fresh produce'. There
is a Musée de l'Opinel in town devoted to the
knife invented by Joseph Opinel, who made
the prototypes for friends and then, in the
1890s, began to sell them more widely.
The Opinel was the original penny knife:
traditionally a beechwood handle (latterly
sometimes oak, walnut, olive or hornbeam)
with a high-carbon blade, now stainless steel
(marked INOX – inoxidable).

The blade of the Opinel, favourite pocket
knife with gardeners and picnickers alike,
comes in various shapes – sharp or blunt-
tipped, billhook (its curve modelled on the
famous Turkish yatagan sword) – and bears
the stamp of a right hand, thumb outstretched,
index and middle finger pointing to a crown.
The image of the hand comes from the arms of
Saint-Jean-de-Maurienne, and represents the
relics of John the Baptist, three of whose finger-
bones were supposedly brought back from
Alexandria by Saint Thecla in the fifth century
and are now kept in the vestry of the eleventh-
to fifteenth-century cathedral dedicated to him.
The crown is that of the arms of Savoy.

Thecla, a young noblewoman who became
a follower of Saint Paul, first heard the man
banging on about the virtues of virginity – care
for the things of the Lord as against those
of the world – and thought 'That's for me'.
She survived various attempts to martyr her
– by bonfire, devouring by wild animal, and
violation – thanks to her armour of chastity.
No record of her existence survives. Perhaps
this is the place to point out that the bonfire
originally marked the midsummer festival,
24 June, usurped by the church in the name of
Saint John the Baptist, whose feast day it is. A
glorious blaze for the full radiance of the sun,
as recorded in *Festyvall* by Wynken de Worde in
1493: 'In worshyppe of saynte Johan the people
waked at home & made iij maner of fyres. One
was clene bones and noo [i.e no] woode, and
that is called a bone fyre.' Wynken de Worde,
originally Wynken of Woerth in Alsace (died
*c.* 1534), a publisher, popularized the use of
Caxton's printing press in England.

François-Emanuelle Fodéré (1764–1835), a native son of Saint-Jean-de-Maurienne, founded a system of *médecine légale* incorporating *droits du malade*, legal rights for the sick, at a time when many physicians were cavalier with both diagnosis and prescription.

Folklore had it that Maurienne was linked to the Moors (French *maures*) and that its inhabitants, therefore, had Moorish blood in their veins, which was not quite acceptable to country people. Those siding with this prejudice, the Tarentaises of the Isère valley, were once wont to say: 'Better ten moles in your garden than a Mauriennais for a neighbour.'

The D78D to Jarrier leaves the main road out of town at 650m. The view of Saint-Jean is not attractive to look down on: new square-block geometric buildings, ill-designed and blank of aspect, offset a tasteless industrial farrago beyond the town limits. Don't look back. Enjoy the wriggly, quieter road, through a succession of villages and hamlets at a pull of some 8% on your effort.

A wooden cross marked 'Mission 1948' at around 5km, 970m, a sixteenth-century church in Jarrier and a left turn towards Toussuire. After Les Bottières (8.7km, 1272m – a dialect word for 'wooded places'), and the Porte des Sybelles, the slope eases for nearly 4km, gathering energy for the final 8km of between 7 and 9%. The Camping du Col (1637m, 16.4km) sits by a junction for a 3km loop via Toussuire to the ski station (1705m). One

balcony nearby is ornamented with cut-out bikes, and yellow, white and green dots. The apartment towers of Le Corbier are in view off to the left. Toussuire was once *toche*, a Savoyard word for a parcel of forest sold at auction, the buyer being then held responsible to work it; it also meant an area of common land bestowed free or else for rent, for cultivation; another etymology, less convincing, is from *touches*, those poles protruding from snowdrifts to mark the paths.

The road swings down through Fontcouverte at 1170m (a polka-dot horse on a barn) a further 4.6km to rejoin the main D926 to the Croix de Fer. The village of La Bise (905m), a short way from the turn, gets its (Provençal) name from the chill north wind, not a kiss (*bise, bisou*).

Enjoy a downhill rest for 3km into Le Crêt and prepare for a quadruple smack of up to 9% before a succession of tunnels, the Combe Soudan (178m), lit, the Grand Tunnel (503m), lit, the Viaduc des Sallanches… and note the course of the old road through a gallery of what was a very tight piercing of the rock. Another 9km of mild climbing through various roadside attractions, more or less attractive, but provident to thirst or hunger, into Malcrozet, part of a sort of ski-set strip, three villages coalesced, where the gradient wakes up and cuts in with 7.5–10% for seven long kilometres into the uninhabited upper storey of this climb.

By the turn-off to Saint-Jean-d'Arves, in a side road, a polka-dot cow affixed to a telegraph

# COL DU MOLLARD 1638M

pole and a piebald horse a bit further on, relics of the last time the Tour passed this way, 2008.

Saint-Sorlin-d'Arves (1515m), 7.3km from the col, consists of a crowding of bars, hotels, restaurants, cafés, chalets, apartment blocks, residences, ski souvenir shops, all very commercial and straining for attention. The road narrows to squeeze the last bit of juice out of the place, barely two cars' width. About 4km on, a graffito, '*APERO GRATOS*' (i.e. gratis: free drink) with three arrows pointing to the left clings on, presumably from when the race went through, and '*LE TOURS* [sic] *TOUJOURS*'.

The skyline shows a jagged row of what might be broken and carious teeth, an old shark's worn crunchers. Another 2km and into a zone of rock, flattish but lumpy, like badly laid concrete, where, on a right-hand hairpin, perches a house (a refuge?) shuttered and closed, and a small pond down to the right with reed-fringed banks.

A Chalet du Col de la Croix de Fer stands near the iron cross, privy to a yawning view of the basin to the south, whose sides fall away steeply towards the Glandon.

The Latin *moles*, 'a mass or heap of matter', gives *môle*, 'a mountain round in shape' – think molehill on a grand scale – or massy structure, e.g. mole as breakwater, although the velvety mouldwarp has a different etymology.

The detour round the Mollard col offers another alternative to the main road up to the Croix de Fer. The D110 from the outskirts of Saint-Jean marches in parallel with the D926 to Gévoudaz (790m) from which there is a twisty road, 11.2km, to Albiez-Montrond at 9.7km, 1520m (another molehill simulacrum), and round to the col. From Albiez, there are *promenades au cheval* (horse rides) and some way on, in the old town Albiez-le-Vieux, a board relating this story: long ago, an old man of Mollard went down the mountain to the fair at Saint-Jean to buy a strong mule to replace his poor old beast of burden, exhausted by years of heavy loads – hay, wood and provisions. On the way back, just above Gévoudaz, the new mule suddenly halted and began to tremble violently. The man said: 'Ho, a fine mule like you, sick already? Come on, eat this bunch of sorrel and if you go well up to the Oratoire du Désert I'll make a thanks offering of 5 *sous* [pennies].' The mule picked up and on they went. When they reached the Oratory, the mule seemed to be full of beans, not sick after all. The man decided to press on without stopping or having to dip into his pockets to honour his promise. The road to Saint-Jean-au-Mollard is long. Reaching the col, the man paused, sat on a rock and said to the mule: 'You are a brave beast. I did well to buy

# COL DU TÉLÉGRAPHE 1566M

you. What's more, you've saved me five sous.'
The mule dropped dead on the spot. Touché.
Broken promise, broken mule.

At a bumpy rate of between 4.5 and 9%, the
road drops just less than 5km back to the main
road just above Pont de Belleville (1245m).
A graffito on a wall as you head for the Croix
(14km distant), in red, '*BRAVO A TOUS*', from
the Marmotte *sportive*, for sure. The annual
Marmotte *sportive*, for amateur riders, covers
174km, over three *hors catégorie* cols: Glandon,
Télégraphe and Galibier, l'Alpe d'Huez, 5180m
of ascent in toto. In a day.

*Northern approach from Saint-Michel-de-Maurienne, 718m*

LENGTH  12KM

HEIGHT GAINED  848M

MAXIMUM GRADIENT  8.5%

Take the D902 south off the big highway D1006
from Saint-Michel-de-Maurienne, part of the
industrial sprawl that oozes along the banks of
the Arc river hereabouts, through Saint-Martin
d'Arc, where the climb starts and is labelled
with new bornes giving altitude and distance
to the col every kilometre. The original name
of the town was Sanctus Martinus Ultra Arcum
– Saint-Martin beyond/on the far side of the
Arc (river).

The church bell was cast from the metal of
two bells stolen from the church in Valmeinier
during a battle on 1 October 1793 in which
900 French republican troops stationed in
Valloire to police the frontier faced soldiers
from Piedmont (home of the Duke of Savoy,
who claimed the territory), reinforced by local
inhabitants who, averse to any dictate from
Paris, wanted no truck with their Revolution.

A leafy lacework curtain of leaves to
either side of the road. In Les Petits Seignières
(930m), 9km to go, pronounced speed bumps.
Les Grandes Seignières is far smaller than its
lower neighbour, barely noticeable in transit,
but it does offer a fine view down the valley
of the Arc towards Modane. A naturalist's
establishment is housed in a small building

to the left, in its window a very pallid taxidermied stag.

The road appears to flatten for some distance, although 7km, 1095m, suggests otherwise. In fact, this stretch delivers a brief kick of the steepest gradient, around 8.5%, whereas the rest is around 7%. The deception of averages. Having broken clear of trees, the road now re-enters a tree-lined zone, dipping and rolling for 300m to gain energy and run free of shade once more. Be ready for a fierce right hairpin, a sudden sharp lift out of trees and a second hairpin near Lavizard d'en Bas (Lower Lavizard), comprising two or three houses only. More hairpins and 4km leads into Lavizard Dessus (Upper Lavizard), a grandiose place name apparently attached to but one dwelling. In an open stretch of road, a modestly sized memorial to an anonymous officer:

*Au Capitaine de France du 9ème Cuirassiers*
*15 juillet 1900 Sa veuve Son fils Sa famille*
*Les Officiers du Cadre et Ses Camarades de*
*l'Ecole Supérieure de Guerre*

To the Captain of France of the 9th Armoured Cavalry, 15 July 1900. His widow, his son, his family, his fellow officers and comrades of the War College.

Next to it, an irreverent graffito on a side wall derides the officer class: *MOUSTACHU BOUFFEUR DE CUL* (moustachioed bum bandit).

The junction of the road off to Valmeinier (now a ski station) at 3km, 1360m, is graced by a mixed gathering of *Acer monspessulanus* (the Montpellier maple, so called because it was first identified by a department of that city's university), *sorbier* (service tree), birch and various species of pine. At the end of a longish level stretch (1490m, 1km), the road narrows, shying away from a yawning space to the right into the shelter of a side wall, left. The Télégraphe is named for an adjacent fort that used the optical telegraph, invented by the engineer Claude Chappe while working for the French Revolutionary Army in 1792. This consisted of an upright post with two moveable arms set on top of a cylindrical stone tower, the signals being made by various positionings of the arms according to a pre-arranged code. Later versions of the telegraph employed moveable disks and shutters to emit flashes of light. These devices were later, and more commonly, known as semaphores (Greek for 'signal-carrying'), as in the system of messages sent by Boy Scouts, waving flags to spell out the letters of the alphabet.

The 4.8km descent into Valloire is, despite a rather ropy surface, fast and fairly straight, nothing much as an ascent.

## COL DU GALIBIER 2646M

Having broken clear of trees, the road now re-enters a tree-lined zone, dipping and rolling for 300m to gain energy and run free of shade once more.

*Northern approach from Valloire 1405m*

LENGTH  18KM
HEIGHT GAINED  1241M
MAXIMUM GRADIENT  9%

The Galibier's name may come from Provençal *galibié, garoubié,* meaning 'deep ravine'. The sign on the edge of town reads '17km' to the col, but this marks the distance to the tunnel originally cut through the uppermost boss of the mountain in the early twentieth century. The mountain's altitude was, accordingly, given as 2556m. When one of the tunnel's big supporting archways collapsed in 1976, it was closed and the road extended upwards over the shoulder of the massif, an added kilometre of around 10% to 2646m. (This figure comes from the Michelin map. Some descriptions give 2642m. The col sign itself indicates 2645m. At the end of such a long and arduous climb, who's counting anyway?) Lucien Van Impe was first over the new, super Galibier in the 1979 Tour de France. The tunnel was reopened in 2002.

Valloire, a sizeable town, is pleasant enough out of season although its principal purpose, nowadays, is as a ski resort. It also serves, year round, as the only source of outside social life for the squaddies of the Légion Etrangère's (Foreign Legion's) mountain training depot up the road. The legionaries learn to ski in the nearby Valloire-Valmeinier station, and the terrain hereabouts provides them with ample scope for all manner of rugged activity. They

*Snapshot*

# TOUR DE FRANCE 1911
## THE GALIBIER

On the eve of the Tour's first crossing of the Galibier in 1911, Gustave Garrigou led François Faber, the 1909 winner, by one point (in the old system of GC – General Classification) but it was Emile Georget, recovered from a nasty prang, who had the legendary honour of crossing the mighty Col du Galibier for the first time in the history of the Tour. (On the descent of the Ballon d'Alsace, Stage Three, Georget, a prospective winner, had collided head-on with a German motorcyclist roaring up from the opposite direction, but, miraculously, stayed in the race. History does not relate the state of the German motorcyclist.) Octave Lapize, the reigning champion, exhausted, crashed heavily into a ditch and could not continue.

Henri Desgrange, the Tour's founder, was up there, so too a large gathering of other officials and spectators. Suddenly, along the road towards them came Georget, on his own, hunched over his preferred cow-horn handlebars, goggles up on his brow, white neckerchief tucked into his cap to protect his neck. Although the sun was shining, it was bitterly cold at that gasping altitude. From the base of the climb, the road was scored and pitted, horribly uneven, no better than a cart track, a far worse trial to ride than the smooth surface of any of today's alpine roads. 'When Georget stopped and put his victorious foot to the ground on the head of this monster',

Although the sun was shining, it was bitterly cold at that gasping altitude. From the base of the climb, the road was scored and pitted, horribly uneven, no better than a cart track

wrote Desgrange, 'he was filthy dirty, his moustache clogged with snot and bits of the food he'd collected from the previous control, his jersey stained with mud from the last stream into which he'd pitched headlong. Looking a complete fright, but with the pallid face of a clown, he came across [there was a control] and snapped: "That's made you sit up."'

Georget gave his own wry take on the fearsome experience: 'The men who dug the tunnel at the top of the col might have driven it through at the bottom. It would have been a little bit longer, no doubt, but it would have spared us a martyrdom. Between the tunnel of the Métro and the summit of the Galibier, well, I still prefer the Métro.'

But Desgrange was cock-a-hoop. 'Does not this ascent of the Galibier on bicycles constitute the first triumph of mortal intelligence over the laws of gravity?' And of the mountain itself, his prose never stinting in hyperbole, he rhapsodized: 'O Sappey! O Laffrey! O Col de Bayard! O Tourmalet! I will not fail in my duty to declare that, by comparison with the grand cru of the Galibier, you are but wishy-washy, common or garden gnat's piss. Before this giant, one can but doff one's cap and bow very low.' (*Devant ce géant, il n'y a plus qu'á tirer son bonnet et saluer bien bas.*)

stroll into town on Saturdays in fastidiously ironed and creased green uniform and the distinctive white *képi* (high-sided cap). They are not talkative when approached by the inquisitive stranger but, should you wish to observe them discreetly at leisure, one of their favourite watering holes is the Hôtel Les Mélèzes. The patron is a big fan.

The vista from the edge of town, as you shed Valloire like clothes on the beach before the plunge, is striking: a grand tableau of massifs, to left, right and centre; the giant's family in stony, silent attendance. As if the road itself were cowed at the prospect of such an arduous journey in store, it shrinks into itself to squeeze through a narrowing profile like paste from a confining tube. Les Verneys (2.6km, 1558m) is an outcrop of ski chalets, a *village de vacances* (holiday village) – six-hole golf course, apartments, a tree-fringed slope to the left, pleated flanks of rock-studded grass to the right. The name comes from an Indo-European root meaning 'alder' or 'poplar', whence Old French *vergne* or *verne* referring to either the *Alnus glutinosa* or the more shrub-like *Alnus viridis*. There are numerous variants on the name given to villages and hamlets scattered across the Alps. The houses at this Verneys' far end crop the view of the mountains ahead on either side with amateurish lack of finesse.

Is this stretch really as flat as it seems to be? The bare statistics say 2.5%. Your legs, reluctantly submitting to the apprehension building in your head, may dispute this.

The mountains ahead rise clear of any intermediate interference of view – the jagged eagle's-beak peaks of the Galibier-Grandes-Rousses, Goléon, Aigle de l'Épaisseur and Aigles d'Arves to the west, the Sétaz Vieille and Sétaz des Prés to the east, Roche Olvera straight ahead to the south. The road, confronted by their frank menace, diminishes in size. The far-off crags are dusted with white frost and powdered snow. Nowhere is the intimidation of mountains better incarnated than on this long approach to the Galibier. This is the foyer of its majesty. You are, perforce, making obeisance.

As the slope hitches up to 5%, a couple of kilometres beyond Verneys, the road makes a big right-hand sweep past a forlorn outpost of huts called Bonnenuit, a refuge promising rest, you may hope, rather than a valedictory of doom.

A borne shows 12km to the col, 1645m. In the cleft of the river Valloirette down to the right, the crowding trees dwindle as the road enters open moorland and heath, sparse of vegetation. The stream now runs in a shallow course over iron-grey shingle, rocks and boulders in its flat bed, above it a slope covered with scree. Straight ahead, a chunky massif, the shape of egg whites beaten into a soft peak; to the right, a side entrant accommodating a stream flowing down a narrow furrow such as might be made by a trowel in loose earth, a trench for seed. The expanse of the country round about suppresses the visual assessment

of the slope, but in fact it nudges around 7–8.5%. These elements of the climb, the gallery of peaks across the entire horizon, the bare emptiness of the landscape on which they look down, are what make it so daunting. The Galibier is an ogre: slow to be provoked, but awful in its brooding power. Its very bulk seems to grunt 'You want some? *Really?*' to the mortal who dares its crossing.

Plan Lachat (1962m), the bare plateau at 8km from the col, is an upland sheep and goat summer station. There are a number of small cabins close by. One such stone hut with a wooden roof, Chez Pignotin, is possibly a café in season. *Lacha* is a local dialect word meaning 'stony high place, sparse of shrubs and grass'. A track snakes up the hillside to more cabins on the Camp des Rochilles below the escarpment of the Seuil des Rochilles. The cropped grass looks like moleskin. Off to the right, strung between pylons marching down the mountainside above the first ramp of the final part of the ascent, electricity cables sag and droop across the road. Here is the crunch moment, when the jaws of the climb close tighter on you: the cut of the road *looks* horribly steep and *is*, a consistent 9% now. It angles up and away from the receding view of the valley, the valley whose narrowing V abuts here in the adamantine stone. At the first bend of that ramp, the open ledge gives onto that view. Stretches of the road from here on seem to balance on scarcely any solid foundation, as if crossing a rope bridge.

When the Gauls sacked Rome in 387 BC, the elders of the Senate sat, each in his curule chair (*sella curulis* – the ivory throne of office), in the vestibule of his house, calm, immobile, mute, the embodiment of Stoic indifference to any danger or perturbation of the spirit. Their Olympian remoteness quite unsettled the enemy, who took them for gods. Just so might be this assembly of peaks gathered about the Galibier, the Capitol which held, while the city beneath its height fell. There is a marked difference, too, in the quality of the air, that sudden thinness which makes breathing so much more laboured, another factor compounding the peculiar ordeal of this climb.

Suddenly the road enters a landscape of broken stones strewn across it, as it were hacked corpses long since petrified on an ancient battlefield. An abandoned place, derelict and cast out of memory, the road edging through the desolation, like a traveller not wishing to know what happened here, what grief is enshrined. When Aeneas goes down into the underworld, he sees the harassed spirits of the dead, not yet taken across the rivers of Pain and Oblivion, how 'they stretched out their hands in desperate longing for the far bank and the repose it promised', *tendebantque manus ripae ulterioris amore*. Ahead, a ridge runs low across the direction of the road, pylons drag the cables further up and over the skyline. Five kilometres from the col, 2150m.

Les Granges du Galibier (2325m, 3.8km) is an alpage, with byres and cabins for the

summer grazing, and there is Fromage Beaufort *en vente direct* – local cheese over the counter. How small the cyclist is in this vast rockbound solitude of mountain. There is nothing of landmark or geographical finesse to encourage or reassure, only that this road leads to the col and you are on this road. Look up, there is the dip in the line of rock where the pass lies, but where does the road issue?

This is the view I wondered at that day in early September when I rode this mountain through the snow, the air misted with frost. Wondered at and succumbed to, because there is no place for anything but patient endurance in the long struggle with the Giant of the Alps. It takes its toll and you must pay every cent of that toll in accumulating instalments of steady and determined continuous effort. And, oh, the col itself, a mere hummock of tarmac of almost monastic austerity, stripped of any grandeur – that is all in the struggle up here to this lofty stop before the road tips away into the relief of the descent. And here, on the hard iron of this road, words of sweet encouragement: 'TO THE TOP DENIS'.

On another day, in late autumn, our photographer and I encountered Magnus Bäckstedt, towelling himself dry of sweat by a car in the turn-round near the tunnel.

MB: It's my most hated climb. I've done climbs maybe tougher, but there's just something that makes me hate it.

GF: Compared with Ventoux?

MB: Ventoux is a piece of piss by comparison. Okay, so it has a huge reputation, that's because it's a monument. Suddenly there's this massive chunk of rock. No, the Galibier is worse. It's the oxygen, too. Over 2,300 metres you really feel the oxygen depletion. The Pyrenees are different. They're generally not so long in distance, but they come often. You go down and you're straight back up. In the Alps, you sit a long time before the climbs.

GF: Do you take in the landscape as you ride?

MB: Oh, the landscape is still gorgeous even when you're racing, but the fact is you get up so high, your body starts to suffer and the bigger you are the harder it is.

GF: And the mental stress…

MB: The mental stress, right, no matter where you sit, at the front or in the back group, you all suffer as bad. The guys at the back even worse, maybe.

GF: Because they have that added anxiety of beating the time.

MB: Exactly.

I reflected. That added stress, the anxiety about beating the time limit, is something to which all non-climbers refer: the mind cannot free itself of that fear, whereas in those riders going for the win, the conscious tax of the mind can be suspended in the heat of competition, when the spirit is revved up, on fire, the willpower overriding normal responses. In effect, the

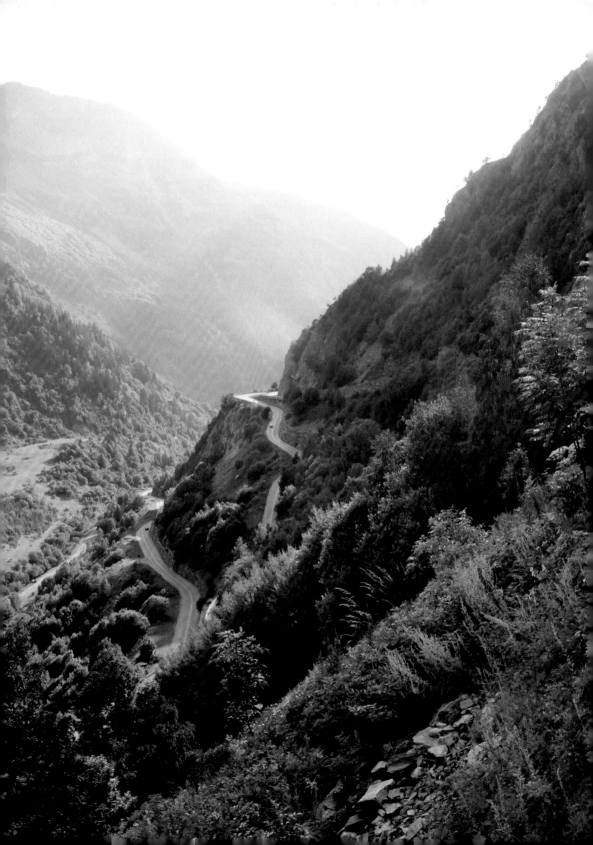

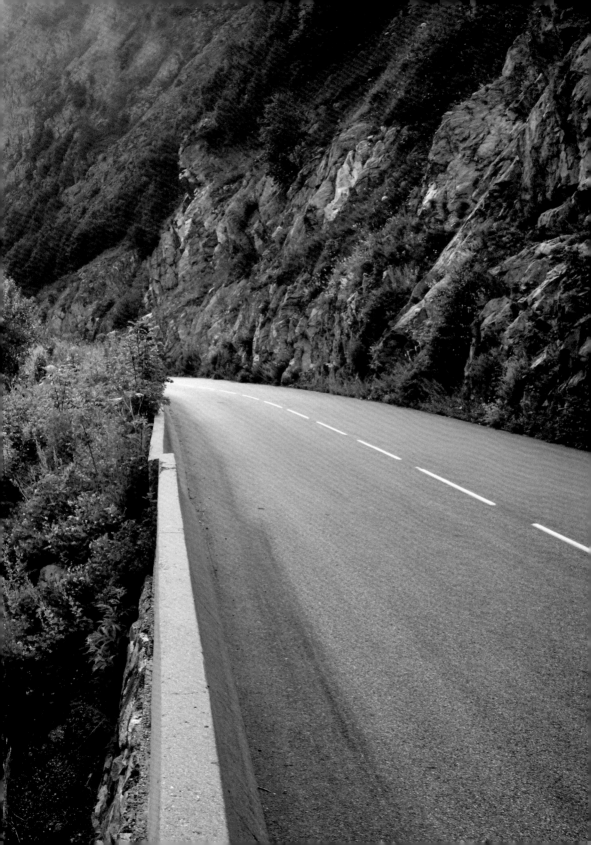

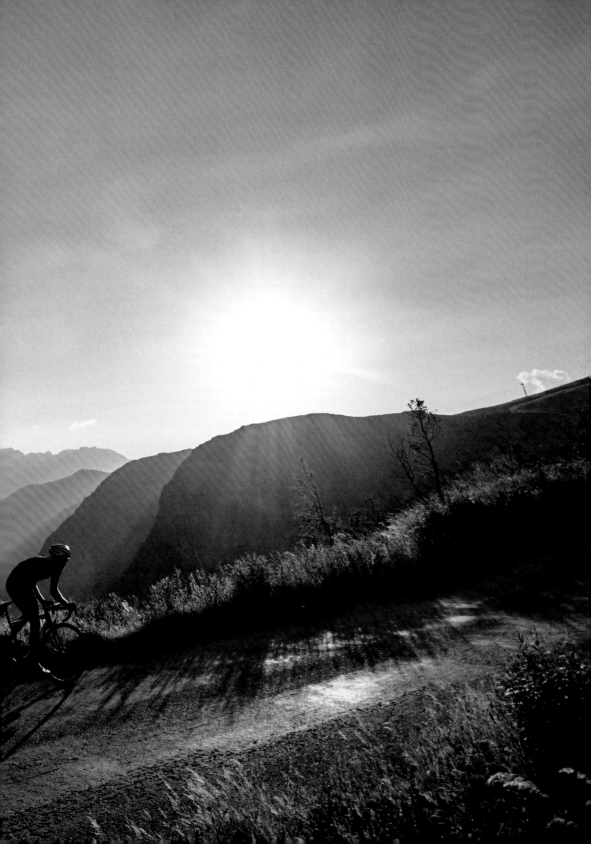

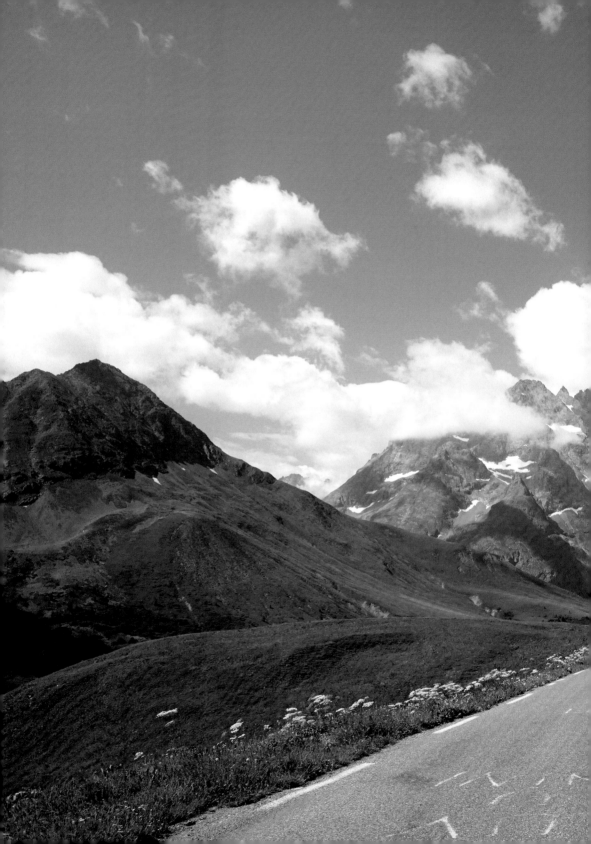

active influence of the brain is shut out to bypass awareness of the suffering, together with the consequences of giving in to it.

The café a short way below the summit on the south side is an Aladdin's cave, stuffed full of souvenirs of every imaginable quirk, racks and shelves of cold-weather clothing – gilets, sweaters, socks, mufflers, sheepskin gloves and slippers, hats and scarves – and books, booklets, postcards and posters. Close by the building stands the monument to Henri Desgrange, father of the Tour de France, whose craggy face once observed 'his' riders as they crossed the col and, in effigy now, greeted them again at the end of Stage 18 of the 2011 race.

The view from the summit is of that breadth and largeness which plants the absurd and fleeting idea that you could simply lean forward and take it in your arms. The edges of the road are lined with spindly tall sticks – hazel or ash – to mark the snowline, each spot of planting marked with a splash of lurid lime green paint.

Across the gulf into which plunges the descending road looms a massif with deep gullies gouged out of its flank, generally filled with snow, as if it were plaster. The riven sides, scored and lacerated, add to the sense that there is visible suffering in rock, the suffering of metamorphosis, the ripping, buckling, mangling, crushing of one shape into a new one. Consider the story of Niobe, in Greek myth, the princess of divine descent, punished for her hubris by Leto, mother of Apollo and

Diana, who ordered them to slay Niobe's children, six sons and six daughters, 'all [her] chicks at one fell swoop'. Niobe turned, in grief, to stone:

Even as she begged for the life of her last daughter, the girl whose life she implored died. The widowed, childless woman sank to her knees, rigid with grief, amid the corpses of her sons, her daughters, her husband. Her hair hung lifeless in the breeze, her face bloodless and without colour, her eyes staring in sorrow, not one sign of life in her.

Her tongue froze and stuck against her palate, the flow of blood stopped in her veins. Her neck, her arms, her legs locked, incapable of movement. Her entrails turned to stone. Yet still she wept, as the main force of a turbine of wind swept her away, back to the country where she'd been born. There, fixed to a mountain peak, she was left and, even still, her marble cheeks run wet with her tears.

Ovid, *Metamorphoses* VI, 301–12

The myth, as Montaigne puts it, in a reflection on the death of five daughters born to his wife – one survived – 'expresses that melancholic, dumb and deaf bewilderment which stuns all our faculties when oppressed with accidents greater than we can bear'.

In the late afternoon sun of mid-October, as autumn commandeers Nature's palette and

the trees glow with what Tennyson calls 'the mock sunshine of the faded woods', the thin mountain light playing on bare stone becomes imbued with pastel cyan, magenta, glass green, copper.

The road down is quite narrow, the turns often severe, and the view of the chasm into which this strip of tarmac might be the causeway path down can perturb. All round, the landscape has the look of having been beaten, pummelled, extruded into knolls, ridges, shapeless lumps by the savage force of expanding masses of ice or blasts of intense sub-stratum heat over countless millennia.

From the col, 7km at uneven gradient – 9% off the summit to 5% for 2km, another thump of 9% then tapering into a steady 6% down to the T-junction, the Chalet La Tourmente on the corner and the huge edifice of the Hôtel des Glaciers facing.

The view from the summit is of that breadth and largeness which plants the absurd and fleeting idea that you could simply lean forward and take it in your arms.

*Southern approach from the Col du Lautaret 2058m*

LENGTH 8.5KM

HEIGHT GAINED 588M

MAXIMUM GRADIENT 9%

The road over the Lautaret from Briançon and beyond towards Grenoble, completed in 1862, was the first surfaced highway to cross the Oisans region. Avalanches and erosion had already done some of the work before gangs of workers moved in with hand tools to hack a broader shelf out of the living rock.

A long haul of 28.5km up the valley from the European Union's highest city (1326m) in company with persistent heavy traffic in both directions makes a tiring slog on what slowly develops a stubborn 5% attitude. It does, though, make for a speedy, freewheeling descent.

In the 1911 Tour, Garrigou won and Georget came third. The following year, Garrigou had to walk up to the Galibier summit: pictures show the storm-swept roads in a truly shocking state, chewed and churned into deep mud granulated with stones, gouged, furrowed and near unrideable. Most of the riders crossed between snow walls on foot. Behind Garrigou, the Belgian ace, Odile Defraye, was in terrible straits. Knocked off his bike by a startled dog on the descent of the Aravis with some 250km still to ride, his knee was wrenched and he nearly abandoned but, in the absence of any vehicle

to give him a lift, kept going. His compatriot, Firmin Lambot, passed him on the Galibier, shot down the descent and, at the junction with the main road, turned left for Briançon instead of right to Grenoble. As he descended the Lautaret, a local, surprised to see a Tour rider go by, called out and told him he was heading the wrong way. So Lambot had to drag himself back up to the lesser col, where he met a very distressed Defraye. They were not in the same team, so he might have had no compunction about riding on regardless, but... the man was a fellow countryman. Lambot took pity and the two of them made it in tandem to Grenoble. Defraye went on to win the Tour. Lambot had his victories in 1919 and 1922.

Just before the short Tunnel des Valois over the main road, a turn-off, right, follows the Ancienne Route du Galibier, which joins the long-distance *randonnée* track for walkers, GR57, over the Col de la Ponsonnière. This is the way the early pedlars and hucksters went, from market to market, the drovers with their animals, the muleteers with their trains of beasts carrying loads of grain, cloth, salt and other commodities.

From the LAUTARET (2058m), we see the first ramps cut across the grassy mountain flank ahead and take in a big view back down the valley. This was originally a Roman road – stark evidence of the efficiency and energy of their road building. The word 'Lautaret' probably comes from a small Roman shrine, *altaretum*, on a high point in the vicinity. That early road

fell into disrepair and rendered up its stones to predatory local builders.

The imposing Hôtel des Glaciers standing back from the junction replaces a derelict building of the same name further back down the road.

Just past the turn, one day in July, we encountered a cheery individual picking the yellow heads of arnica flowers, which he was going to macerate in alcohol or oil. I quizzed him, at which he smiled, roguishly. '*Pour chocs, c'est extraordinaire. C'est interdit, mais, je m'en fous*' (For bruises and strains, it's remarkable. Picking is forbidden, but I couldn't care less).

Signs give gradient and distance, and such is the way the road curls on the open mountainside that the Lauteret is still in view 5.5km up, 2450m, at the end of a strenuous interval of around 9%.

Two kilometres from the col a memorial to a sergeant of the Rochilles unit of the Maquis alludes to the bitter summer when the French Forces of the Interior and the Resistance rose up against the German occupiers.

> *Ici est mort pour la France en service commandé le 11 août 1944 le Sergent Pierre Dequier maquisard des Rochilles.*

('*Service commandé*' refers to the general call to arms of the maquisards in June 1944.)

At 6.5km, a ruined building, an old refuge by the look of it, squats on a height ahead, beyond it the café then a stark view to the north-east of the Champ de Tir, the serrated, shark-tooth line of a 3000m ridge, which might be a lake of hardened lava, its waters chafed into small peaks.

The col hoves into clear view from about 500m and the road up to it is quite narrow, conscious of its humble place in the presence of legend. The archway into the tunnel may seem inviting, but why bother with that when you are this close?

*Snapshot*

# TOUR DE FRANCE 1930

Between 1911 and 2008, the Tour de France had crossed the Galibier fifty-five times. In 2011, centenary of the first passage, it crossed twice. The stories attached to this legendary ground are numerous. The Galibier hosted the final duel between Anquetil and Poulidor in 1966, tracked by the same gendarme who had followed them on the notorious elbow-to-elbow scrap up the Puy-de-Dôme in 1964. Ahead of them, Simpson, who had blown up trying to match the pace of Jimenez over the Télégraphe, grovelled over the Galibier, crashed heavily on the decent into Briançon and abandoned next day. Anquetil, having ensured the victory of his team mate Lucien Aimar over the man he always feared, Poulidor, climbed off his bike and out of the Tour for good three days later. On 11 July 1935 the Galibier claimed the first Tour fatality. The Spanish climber, Francisco Cepeda, son of a rich industrialist and himself a town magistrate, crashed on the descent towards the Lautaret. His front tyre peeled off, Cepeda pirouetted on the stripped wheel rim and he hurtled headfirst onto the road with dreadful force. He got up at once, the wound streaming blood, remounted and rode on a short way before pitching off again, inert. Surgeons at the hospital in Grenoble performed a trepanation to reduce the pressure of the bleeding but, three days later, Cepeda died.

When the 1930 Tour arrived in the Alps, Learco Guerra, the Mantuan Locomotive, took the stage into Grenoble and topped the Galibier two minutes ahead of the Frenchman André Leducq, in yellow. Descending at around 80km/h, Leducq lost control of his bike – he probably hit a stone – overshot a bend, somersaulted off the

machine and was briefly knocked unconscious. He was badly bruised, his knee gashed and pouring blood, hip severely grazed, his fingers lacerated. One pedal on the bike was bent out of true. Marcel Bidot rode up, and he and Pierre Magne got Leducq to his feet. Magne bent the pedal crank back into shape and they remounted. Leducq had held a lead of seventeen minutes on Guerra – but now?

They rode 100m, and one of Leducq's brakes failed. Another repair stop. 'They had to work very hard simply to get me going again,' Leducq said later. The three of them set off on the descent once more, but at much reduced speed – no better than 19km/h. Leducq's hands were so badly hurt he could hardly pull on the brakes. They rumbled into Valloire and onto the first slopes of the Télégraphe. Leducq, too shattered for any vocal complaint, was hard put to find any rhythm and, no more than a kilometre on, out of the saddle, desperate to keep up, his right foot shot away – the pedal had snapped off. Bidot at once offered Leducq his own bike – strictly forbidden in those days – but the bad luck was running out. A spectator gave them a crank and pedal from his bike, a French newspaper car provided an adjustable spanner and lo, like the cavalry appearing in the nick of time, up rode three other members of the French team, Charles Pélissier, Antonin Magne and Jules Merviel together with a *touriste-routier* (independent rider), Marius Guiramand, who undoubtedly pocketed some money for helping the French train which now set off in pursuit of the Italian, already some twenty minutes up on them and riding at express speed.

'I was totally dispirited,' said Leducq. 'The descent of the Télégraphe passed safely but we went cautiously. On the fast valley road of the Arc, we heard that Guerra's lead was down to fourteen minutes.' It was enough to restore the French ace's morale. His muscles gradually warmed through and soon the French team was driving on at 40km/h. By Albertville, Guerra's lead had been cut to a minute and a short way on, they caught him. There were still 140km to ride to the finish in Evian, but the entire French team, fired up by their astonishing ride, launched Leducq out in the sprint along the spa town's boulevard and he won the stage. They had ridden the 331km from Grenoble in 13h 39m 22s.

# COL DU GRANON 2413M

*From the main N91 west of Briançon,*
*turn north on the D234 just short of*
*Chantemerle, 1364m. The climb begins*
*at once.*

LENGTH 11.5KM

HEIGHT GAINED 1049M

MAXIMUM GRADIENT 11%

Before the Galibier in 2011, this was the highest ever summit finish, in 1986. Apart from a brief respite of 8.5% a third of the way up, the ascent does not drop below 9%.

On the morning of Friday 22 July 2011, I woke in the hotel room in Monetier-les-Bains at 4.15am. The night before, after a long wait, we'd finally got through the barriers and the line of stone-faced *gendarmes* blocking off the exit from Briançon – the Tour de France long gone – at 8pm and decided that the Col du Granon (for which I already had a certain pool of information) would have to be left unvisited. Because the roads between us and our escape to Geneva airport were due to be closed at noon the following day (Friday) they'd be clogged with traffic. It was a risk we couldn't afford.

In the shiftless dark of the night, I switched on the light and resumed my reading of *Ni d'Eve ni d'Adam* by Amélie Nothomb, the Belgian novelist whose work I revere. For two weeks my reading pabulum had been information boards, maps, the odd useful brochure, the open book of alpine terrain and roads and accumulated verbiage on the Tour de France in the French press, including the occasional forays into a sort of quasi-philosophical mandarin, beloved of those Gallic journalists who fancy themselves custodians of the purple-proseworthy arcana of bike racing, the sacred cult of *cyclisme*. I generally eschew them, but sometimes feel drawn, by professional curiosity, to trawl their bombast. I have no problem with the metaphysical aspect of the sport I love, none. It's the far-fetched allegory and the strained adjective which deter, and which, even herein, I occasionally satirize. It was with blessed relief, therefore, that I returned to Nothomb, a gift of intellectual manna, and, by sweet coincidence, to that part of the book in which she describes her walk, nay, her weightless bounding, up Mount Fuji.

'My body metamorphosed into pure energy,' her character says, and:

> In the time it took [for her companion]
> to ask where I was, my legs had carried me
> off so far that I had become invisible. Others
> have this attribute but I know of no one
> else in whom it is so unexpected, for, close
> to or at a distance, I do not look in the least
> like Zarathustra.
>
> But, that is who I became. A superhuman
> force took hold of me and I ascended in a
> straight line towards the sun. My head rang
> with hymns, not Olympic but Olympian.
> Hercules is my favourite sickly cousin. But
> there I am talking of the Greek side of the

family. We, the Mazdans, we are something quite other.

To be Zarathustra is to have, in place of feet, gods who devour the mountain and transform it into sky, it is to have in place of knees, catapults whose projectiles are the rest of the body. It is to have in place of a stomach, a war drum and, in place of a heart, the drum roll of triumph, it is to have a head inhabited with a joy so terrifying that it requires a superhuman strength to bear it, it is to possess all the powers of the world for the sole purpose that one has drawn them all together so to contain them in one's blood, it is to touch the earth no longer so as to have closer dialogue with the sun.

I read on for an hour or so and then decided it might be sensible to get a bit more sleep. Sensible, pah. I switched off the artificial light, lay down and contemplated, through the eclipse of the bedroom window, the pale wash of true light painting over the night's darkness and, like Xenophon galvanizing himself before he took over command of the March to the Sea, I thought: 'Why am I lying here?'

I got up, had a quick shower, dressed, stole to where Pete was sleeping and with deft fingers, lifted the car keys. He stirred. I whispered: 'I'm going up there.'

Reader, when you get the chance to approach the lonely summit that is the Col du Granon, do as I did: go at six o'clock on a summer morning, when the light in the valley is of silvered pewter, the peaks of the ranges to the south-west, the summits at the edge of the Massif des Écrins, are brushed with the dawn sun's white gold and the world is still.

The road is narrow and very steep. In the village of Le Villard-Laté, 10.5km from the col, at the foot of the climb, a sandstone portal bears the legend in lettering of Virginia tobacco orange-brown, *Café de l'Union Chez Candide*. Now, French *candide* means 'gullible', 'ingenuous', 'guileless'. Do not buckle. Steel your nerve. You will need it. I felt the intimidation picking at me like a hunger as I went slowly up the steep, steep road, away from the old buildings of the village into a long stretch of wood-lined corridor and then as it were to an open veranda, where lines of plush foliage tapestry in many variables of green alternate with large picture windows through which the line of peaks appeared, the sunlight melting further down their craggy pate, like a spread of thin treacle.

Beyond the village of Le Tronchet (or Les Tronchets: a subject for local wrangle, no doubt) the last 4km traverse a blasted heath. The road tippy-toes round the sloping ground as if uncertain of its footing, a nervous interloper, a tottering drunkard. Indeed, the name of this tiny settlement indicates that this is where trees have been cleared to make open ground for summer grazing (Suisse Romande dialect *tronc*, French for 'trunk', and *tronchet*, 'a billet used in the construction of barrels').

Daunted, I sensed another sting of alarm. Advancing down the narrow road, over the brow of a crest way ahead, rolled a military

convoy, a dozen assorted trucks and jeeps. This was time for discretion. I pulled over onto what passed for a verge of firm ground and waited as they drove through. As each motor passed, through the cab windscreen a salute, a wave, a gesture of thanks. When the last camouflaged vehicle went by, I looked up again: over the same crest and down the twisting slide proceeded a white car, a white van (an ambulance, in fact) followed by an excursion coach. Observing the same protocol, I waited like an usher and read, on the coach (full of men in military uniform), *ARMÉE DE TERRE* – French territorial army.

At the col, a clutch of stone barracks buildings – one a Refuge des Brigadiers – reinforces the sign which declares that this outpost is a Site d'Instruction, Centre d'Aguerrissement en Montagne – training camp for mountain warfare.

Now, awesome is a word much overused and devalued. How it can be decently applied (say) to a new line in trainers, a bust-enhancing bra, a circular pizza cutter or a cupcake, even a gourmet cupcake, is beyond me. Awe originally signified immediate and active dread, fear and, in its developed sense, dread mingled with veneration, reverential fear, as in the evocation of God's 'awful majesty'. On the Granon that morning on the exposed top, some way past the sign serving notice that this is a militarized zone and intrusion risks hot pursuit, but close by the wooden chalet of the Buvette du Granon which rather subverts the caution, on the windswept height where the road runs out into loose gravel, I felt awe. In the company of mountains – not the loftiest I've ever seen, but in their august presence all round – exultancy flooded me, heart and mind, and my spirit shivered with a glee that ought never to be regarded as the monopoly of children. And I was glad, so glad, to have stolen early time to go up there. In the working on such a book as this, there is much reading and eye-strain of looking at countryside flitting by amid frantic note-taking, puzzling at maps, then trying to fold the flapping things up in wind or car seat, endless close poring over detail, both factual and natural, and what amounts to no more than cursory glimpses at some of the most majestic scenery and landscape to which we are privileged to be given access, since there is on these occasions little enough time to stop and stare and absorb either the grandeur or the intimate loveliness of this portion of the world around which one has drawn a line for description and study. In those moments on the Granon, I recovered all that. I had felt dread going up there, a small dread, but elemental as all dread is. But I had found spliced into it the wonder, that impulse to praise which is the psalmist's exultancy. I had experienced awe.

The mountains saw me arrive. They saw me leave. They did not change.

Note: When I got home, I wrote to Amélie Nothomb to ask permission to quote from her novel. She wrote back, by return, agreeing: '*C'est un honneur.*'

# L'ALPE D'HUEZ 1850M

### The Alpe d'Huez rap

Three ways lead to l'Alpe d'Huez, in spite of
what the bike race says:

One from the back, the Sarenne track, one
    from the side of the Glandon and one –
The direct route up the ugly zigzag hacked
    from the rock to the ski-stop snow-crag

Twenty-one hairpins, at each a name,
kilometre, kilometre, fame thermometer:

Coppi, Kuiper, Zoetemelk Mayo, Schleck
    and Sastre, Hampsten, Bugno, Armstrong,
Winnen, Herrera, Hinault, Echave, Rooks
    and Aghostino, Theunisse, Breu, Pantani,
Conti, some of them twice, a double
    monte.

The roll of honour doesn't exclude the lesser
breed of climbing dude:

Wilbert… Freeze… Go… *où est…* ? *Deme*
    *Check die trek*… Stop Hop… Blade
Up… Hup Suc, Nog, Zut… *où est Jon?*…
    Moh!… on one foot:
*Allez François même sur 1 jambe tu es le + fort.*
(Go on Francois, even on one pin you're a
    kingpin.)

In view of such guts, his fortitude we cannot
but bow, two-kneed, before.

### 1. From Le Bourg-d'Oisans 719m

LENGTH  15.2KM
HEIGHT GAINED  1131M
MAXIMUM GRADIENT  12%

Across La Romanche on a bridge out of Le
Bourg, a huge right hairpin and the first ramp,
a brusque affront on the senses; one look and
you think, 'Fourteen kilometres of this?' Try
not to dwell on it. One look is never enough.
Settle in. The kilometre stones count down; it's
small comfort, but comfort to be sure. A sign
in French and English is on your side, you are
riding the big grey granite track to Tour history,
if that makes any difference, you and many
others of the shrine-going tribe: 'Motorists
beware please drive carefully a lot of cyclists
present on the road of Alpe d'Huez.' It's mostly
around 9 to 11% with a couple of dips, but
better not to dwell on modulation; it doesn't
much help.

    At 7.6km, 1210m, the top visible now, on
a left-hand bend stands the eleventh-century
Romanesque church in Saint-Ferréol d'Huez.
A war memorial honours eight men from the
village of Huez killed in the First World War.

    The alpages of these slopes were lost for
thirty years by indiscriminate clearance for
skiing, but re-established in 1980, to the benefit
of both animals and winter holidaymakers, by
restoring the marked pistes to pasture. As the
florid French of the information board puts
it: 'In summer, the flocks trample the fallow

ground and leave their droppings, precious as gold, to manure the ground, the ewes leave behind them a well-shorn grass which retains the first snows of the great white overcoat of the mountain. The flocks' cropping helps counter the waste land' – that is, the more they nibble the more the grass grows back. This stimulates resilience in growth and a juicy vegetation to nourish them, year by year.

The slopes are home to the royal eagle, *chocard à bec jaune* (*Pyrrhocorax graculus*, alpine chough), *grand corbeau* (raven), *buse variable* (*Buteo buteo*, buzzard), *sanglier* (wild boar), *chevreuil* (roe deer), *marmotte*, *renard* (fox), chamois.

At 10.3km, the Itinéraire Tour de France continues and a right turn takes an alternative shortcut to rejoin the main route. In the village of Huez (1460m, 10.5km), a road, left, leads down to Rochetaillée, and the gradient reaches its maximum for a kilometre or so. The nature of this climb, however, essentially a road chopped out of the mountainside without finesse or line, is not much marred by these breaks in rhythm, abrupt or not. There is, moreover, such a powerful draw of history in attendance that merely to ride this legendary ascent subjugates normal reaction. The final 2km flatten considerably and the citadel of the ski station is ever more visible and enticing, a quality that does not survive arrival thereat. The final hairpin is unnumbered, nor does it bear the name of a rider and, some 700m further on, the brief, flat run-in to the top

begins. About l'Alpe-d'Huez as an actual destination, the less said the better. About its mythic pull, your interpretation must succeed better than any interposition from me.

## 2. *From Rochetaillée 711m*

LENGTH  22.3KM
HEIGHT GAINED  1139M
MAXIMUM GRADIENT  12%

Hit the bottom of the Glandon and save yourself the detour into Le Bourg, if you wish. It's a gentle enough wriggly slope under the peak of La Grande Sure and a longish straight into Villard-Reculas, above the road to the left. From here, 1542m, the road drops at a sharper angle for the remaining 2km into Huez.

Saint Anne, the Virgin Mary's mother, is patron saint of l'Alpe d'Huez, as well as of joiners, carpenters, lacemakers and linen maids. Her festal day, 26 July, is celebrated here with costume parades, firemen in procession, a festal Mass, trout fishing and what the French are pleased to call 'human dancing'.

# COL DE SARENNE 1989M

*Via the Col de Sarenne, from
Le Freney-d'Oisans 930m*

LENGTH  24.5KM
HEIGHT GAINED  920M
MAXIMUM GRADIENT  11%

Since it is most unlikely that you will choose
the Sarenne as an alternative route up
to l'Alpe-d'Huez, the description gives you
the route down. There is a great deal to
be said for hurtling back the way you have
come up, of course, but the Sarenne is surely
worth exploring, on a second visit, say, as a
delightful backwater.

Head out east from the centre of town
towards the heliport to a roundabout, straight
ahead on the Avenue des Marmottes, straight
on at a crossroads (to the right rue du Rif
Briant), Chemin de font Morelle and Site
Archéologique de Brandes. An up-and-down
for 4km and a fairly hard lift of 3km more to
the col.

The road flips over the Sarenne stream
that rises under the Pic de l'Herpie (3012m),
overlooking both the Glacier de Sarennes and
l'Alpe, and flows down into the Romanche near
Bourg over a noted Cascade de Sarennes by
the bridge over the stream at the bottom of
the principal climb.

The route to the Sarenne crosses bleak,
open mountainside all the way from the
Alpe. Near the col, an archaeological site
has been marked out to unearth what is the
highest medieval village in Europe (twelfth
to fourteenth century). It was founded near
a silver mine and, as more workers arrived,
it expanded. Free admission, guided tours
(Wednesday 10am, Sunday 2.30pm), *objets*
collected in the town museum.

Climbers and abseilers (plunging down the
cliffs) set off from the Refuge de la Sarenne at
the col on the GR54.

The road was originally unsurfaced but is
now, by order of the Tour which crossed here in
2013, metalled. Not a particularly comfortable
descent at this upper level – 1km serves out a
very rough passage and 1.5km triggers one of a
number of paved troughs, the stones which take
the run of water off the slope not altogether
evenly laid – shallow but enough to give a car
in transit pause, so be careful.

There is a rugged beauty up here, the trees
are sparse and most are stunted, an image of
abandonment lending the road a lost air. It is
not much travelled, that's for sure. From Le
Perron, about 4km below the col, the road, now
tarmacked, is more jaunty as it joins company
with the course of the small river Ferrand.
Lower down, the Ferrand is fed from the east
by another twinkling stream, the Valette, and
their combined waters tip into the Romanche.
As the big river flows west towards Bourg, it
enters the Gorges de l'Infernet (Old French
*inferne*, infernal). Why this sinister appellation
I cannot be sure, save that perhaps the tight
throat of the gorge and the encroaching jaws of
pitted, riven stone evoked a forbidding image

of the entrance to the pit (*gouffre*) of Hell, the '*gouffres de misère, du néant, de l'oubli… qu'on appelle la nature humaine*' (the pits of misery, nothingness, oblivion… that we call human nature) as the novelist and short-story writer Jules-Amédée Barbey d'Aurevilly (1808–1889) put it. He was a man much interested in the evil under the surface, the sinister core beneath the respectable carapace of civility.

From 7km down, a human presence asserts. The trees grow thicker, the land is cultivated, there are potato patches, hayfields, barns, the road surface is good, round straw bales in rolls lie ready for collection into the winter stores. Outside Clavans-en-Haut-Oisans, at a left-hand bend, a sign for the Cimetière des Huguenots points off into thin woodland.

Clavans echoes French *claie*: a latticework, willow hurdle used in fencing off an enclosure. Thus, another place-name speaking of what must have been just one simple practice of the villagers in the conduct of survival.

These lower kilometres are sheer delight – quiet, shady, a backstairs ride to the grand acropolis of historic pomp which is l'Alpe-d'Huez.

There is a rugged beauty up here, the trees are sparse and most are stunted, an image of abandonment lending the road a lost air

BARCELONNETTE

# BARCELONNETTE

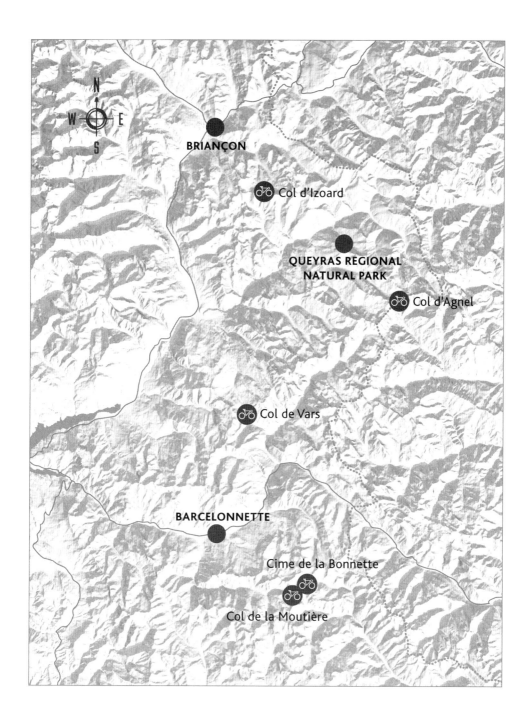

BRIANÇON

Col d'Izoard

QUEYRAS REGIONAL
NATURAL PARK

Col d'Agnel

Col de Vars

BARCELONNETTE

Cime de la Bonnette

Col de la Moutière

# INTRODUCTION

This small town in the valley of the river Ubaye, located at an important strategic crossroads close to the Italian border, was founded as Barcelone in 1231. (Provençal *uba*, from which Ubaye derives, means 'north, exposed to the north'.) The original name reflects the patronage of Ramon Berenguer IV, Count of Provence and Barcelona. He invested the place with prestigious market charters and sundry civic privileges as well as fortifications. The ancient French province had grown beyond the limits of the land colonized by the Romans as Provincia, a dull name, their flair for nomenclature being somewhat limited. Provence extended west from the Alps to the Rhône and the upper valley of the Durance rivers and south to the Mediterranean shore as far as the Pyrenees. Berenguer, a scion of the Catalan dynasty, became ruler of Provence east of the Rhone in 1220 and was the first Count of Provence to take up permanent residence in Provence and take its governance seriously. He embarked on a military campaign to impose his authority over the cities of Provence, to end the independence of Grasse and Tarascon, and to occupy Nice, which had tried to ally with the Genoa, a powerful independent city-state, along the coast. Barcelone was the obvious place for a stronghold: it straddled the main arterial road which ran eastwards from Gap and the heart of upper Provence and joined the main route across the Alps into Italy a few kilometres out of town. The frontier is a mere 33km away. That crossing, the Col de Larche, is now a busy highway. The town was once fortified and circumvallated, but only a fragment of the curtain walls survives.

François I, the French king, used the road over the Larche for his invasion of Italy with 21,000 men in 1515. Scouts must have reported their advance to the papal army drawn up across the foot of the mountain on the Italian side. But the French vanguard of cavalry moved at such speed that the papal army commander, General Colonna, whom they took prisoner, asked if they'd dropped from the clouds.

Another road, which continues south from Barcelonette over the Cime de la Bonnette, was classed as an imperial road, across France, linking Spain with Italy, on 8 August 1860 by the Emperor Napoleon III. The Cime de la Bonnette is one of a whole string of cols on what's known as the Route de Nice, leading all the way from Thonon-les-Bains on the Lake of Geneva to the Mediterranean coast.

Control of Barcelone swung back and forth between Provence and Savoy. When, finally, Savoy ceded the valley of the Ubaye to France, in 1713, the people of Barcelone, ardent Provençals, affronted and angered, insisted on being subject to the Parlement de Provence, not that of Paris, as citizens of the town they renamed as Barcelonnette, thus affirming the town as Barcelona's younger cousin.

Another town, just east of Barcelonnette, has still more exotic links with far-distant places. Jausiers has, since 1995, been twinned with Arnaudville in Louisiana. This might seem odd. However, the American town was named for the Brothers Arnaud, who donated money and land in the town to build a church open to both blacks and whites. In the segregated South that was a rare exception.

In 1805, Jacques Arnaud of Jausiers, then twenty-four years old, had set off for the French-American colony of Louisiana hoping to make money. There was no fortune to be made in the Ubaye valley. He married a Cajun woman, was joined by his brothers, founded the settlement later named after them, and went on to Mexico where he opened a clothes shop. His success with it stirred up local antagonisms – interloper collaring their trade – and he was murdered by a disgruntled competitor in 1821.

Their pathfinder's fate notwithstanding, other residents of Jausiers followed in his wake to seek their fortune in textiles and banking and came to be known as the altogether homely 'Barcelonnettes'. In the Place d'Arnauldville in Jausiers stands the ancient family home, Lou Filadour, the old silk mill where the Arnauld brothers were born. To

its wall is affixed a plaque commemorating their 'instigation of
the emigration to Mexico, source of the Ubaye valley's prosperity'.

Traces of the Mexican adventure persist in Barcelonnette,
too – a street is named for Porfirio Díaz, born in 1830 and, for thirty-
five years, off and on, president of Mexico, and the town boasts a
number of substantial villas, built with the money accumulated in
the textile business.

In the fifteenth century, Jausiers served as a refuge for the
Waldensians, a religious sect condemned by the Roman Catholic
church as heretics. They held that Purgatory, an important facet of
the Catholic scheme of final redemption, was the work of Antichrist,
that saints' relics were no more sacred than junk, pilgrimages a
pointless exercise, holy water no better than rain water, prayer in
a barn or outhouse quite as good as that in church. When, in 1685,
Louis XIV revoked the Edict of Nantes, the Waldensians of Jausiers
were forced to take to the road, probably to Germany.

## Fort de Tournoux

East of Barcelonnette, at 15.4km, the Fort de Tournoux, built at the
foot of the road, which crosses the frontier via the Col de Larche,
took some twenty years to build. Work began in 1843 on this latest
of a number of other military installations placed along this end
of the valley. A whole series of enclosed galleries, gun platforms,
batteries and lookout turrets linked by tunnels stretch some 1300m
from the barracks at the bottom to the highest emplacement at
around 2000m.

The road up which mules hauled double-ended carts loaded with
materials were so constructed that at each hairpin the muleteers
could park the cart, unhitch the animals, bring them round to
the rear of the cart and re-hitch them. This obviated the jolting
of a tight turn and the danger of losing the load. Between 1920

and 1930, as part of the extension south of France's major frontier fortifications, the Maginot Line (brainchild of the defence minister André Maginot), two ancillary forts were built on either side of the Larche close by Tournoux, at Roche-la-Croix to the south and Saint-Ours to the north. Looking back to the bluff on which the Tournoux perches and from which it hangs like a concrete landslide, one can see how its fearsome armaments dominated the approach.

The Tournoux barracks are now derelict, gutted, windowless and dilapidated: an example to the war buffs whose narrow perspective and violent disposition ought, by now, to be following suit.

The Col de Larche, which offers transit from this corner of the French Alps to the climbs of Western Piedmont, is generally very heavily invested with traffic, most unfriendly to bicycles, and is not, therefore, included in this section. Nor are any other crossings into Italy, save for the French road to what the French call the Col d'Agnel and the Italians on the other side know as the Colle d'Agnello. There are other crossings but, with some reluctance, we decided to ignore them: most of their interest lies on Italian soil and the confines of the book lie overwhelmingly in France.

# CIME DE LA BONNETTE 2802M

*Northern approach from Jausiers 1213m*

LENGTH 23.8KM

HEIGHT GAIN 1589M

MAXIMUM GRADIENT 9–10%

The D64 rambles gently out of Jausiers for a kilometre or so to the big toe of the mountain's foot, past houses and chalets. Sheep's cheese and honey for sale, *gîtes*, a walled cemetery in a field apart in Lans (1402m, 4km), the first of a number of named settlements over the first 13km. Signs for off-road mountain walks and, very likely, cyclists, both those of the touring genre laden with panniers, and others, slick as hair gel, on racing machines.

Gradually the valley closes in, hustling the road up onto the slopes. It may look reluctant as, indeed, you yourself may feel, but here is the bite of the climb and a sign admonishes you: *ROUTE DE HAUTE MONTAGNE… PRUDENCE RECOMMANDE.* Prudence, for sure. The gradient is a fairly steady 5–7% with a judder of 8–9% around La Chalannette at 6km, 1555m. The road is finding its hold in the inlet to the valley, the river below, a cascade supplying a full gush of water, a sign to a lake off to the right.

The gradient dips again, but from 8km it resumes at the steeper crank of 7–8% with a dollop of 9% here and there. These minor variations in gradient don't signify so much on the ground, however: there is a sort of accumulated pressure of climbing to which you adjust by the medium of patience and gradual inuring to toil.

Around 12km, 2000m, the road spills into the open plateau of the upper mountainside, steep grassy slopes to left and right, the banks of the river off to the right broadening, the moorland of the plateau made lumpy by outcrops of rock and boulder, poking up like giant petrified molehills.

This is a militarized zone used as a training area by the *Centre d'instruction du combat en montagne de Barcelonnette* and formerly home to the famous Chasseurs Alpins, the elite mountain infantry of the French army (literally 'alpine hunters'), also deployed as specialists in urban warfare. The terrain is similar to that encountered by Allied troops in Afghanistan and you are likely to see scary-looking individuals in flak jackets, with black-daubed face paint, toting bulky items of weaponry, looming out of the broken ground of the hillside. There will probably be armoured personnel vehicles in attendance and aloof types scanning the distance through binoculars.

Crags along the skyline, deep gullies in the mountain walls, a torrent passing under the road and the inkling of a high pass way up ahead where even clouds have to heave themselves with an effort over the dizzying altitude of the massif itself. The rocks form a circular rampart, reminiscent of a dam wall or the great Cirque de Gavarnie in the Pyrenees.

The mood of aggressive intent is not something you would immediately associate

with a rather less obtrusive resident of these bleak uplands, the marmot. When the 2008 Tour de France passed through this north-easterly corner of the large national Parc du Mercantour, strict orders went out to team cars and following vehicles not to use their klaxons, thus to preserve some ambient peace and quiet – invaders of the habitat were enjoined not to disturb its native fauna. The marmot, which can be induced to stop for photo calls by high-pitched short-burst whistling, seems to be a mild enough critter. Indeed, one sun-kissed afternoon on the Agnel, our photographer and I spent a happy quarter of an hour engaged in a delightful close exchange with one of the more laid-back brothers, his head cocked in curiosity, and I do swear he smiled – photographer clicking away, me sibilating most tunefully, like a Swanee whistle, to prolong the parley. The image is cosy but, sad to report, the marmot is known to engage in fights which, on occasion, can end fatally. Sex and power at the root, for sure. For the moment, let us leave the bellicosity to the human species in their Caserne (barracks) de Restefond, a bullet-head blockhouse with mean-eye loopholes at 19km, 2530m, looking very out of place in this natural, freestyle wildness.

Incidentally, some folk used to trap marmots and display them in their wicker cages to travellers and townsmen, for money – *montreurs* (showmen) of the same ilk as those who taught the chained Pyrenean bears to dance by anchoring them to heated iron plates or smouldering coals.

The gradient, round the large sweeping bends and the long straights in between, keeps to its preferred 7–8% but, at some 4km from the top, eases a little. Pray that you feel the slackening. It's bleak up here, and snow will cling on even in late June, banks of it lining the side wall. Just below the summit is a pill box at the side of the road, grim post for sharpshooters on guard for interlopers.

The full height of the massif, the Cime de la Bonnette (2860m), sits atop the crest up a loop of road sprouting from the col, the Restefond (2715m). Here the road flattens very briefly between two sizeable buttresses of rock, through what is called, baldly, 'La Porte' (the gate). This was once a military track between two fortified installations in a restricted zone. Here, a sign indicates 'NICE' towards the yawning abyss which is the southern approach and the gale blows strong. From this stony whithering height (Anglo-Saxon *whitha* is a squall or blast of wind) the far, far-off south holds promise of the blue waters of the Mediterranean, the sun-roasted beaches of the Côte d'Azur, journey's end for the Route des Grandes Alpes on which the Bonnette, the insurmountable roof of the Tour de France, lies. It is, indeed, a *porte*, gateway, to another glorious area for exploration, cycling, walking: Upper Provence, the Maritime Alps and the French Riviera, to the west, and, across the Italian border, to the east, Liguria and Piedmont.

In October 1961, ahead of the Tour's debut here the following year, the road from the Restefond was extended up to the Cime de la Bonnette, thus overtopping the previous lofts of cycle racing, the Col de l'Iseran (2770m) and two of the Giro's favoured climbs, the Stelvio (2757m) and the Agnel (2744m). From the Cime the panorama is unassailable: towering peaks and, on a clear day, the sea to the south and, to the west, Mont Aigoual, the high point of the Cévennes. A veritable rooftop. It begs a further kilometre of climbing and gradients of around 12 and 15%. In 1962, the Tour itinerary named the passage as Col de Restefond, an appellation preserved, whimsically, in the official guide for 2008, the Tour's fourth crossing, from the southerly direction.

*Southern approach from Saint-Etienne-de-Tinée 1144m*

LENGTH  23KM

HEIGHT GAIN  1658M

MAXIMUM GRADIENT  10%

Saint-Etienne is situated on the road which eventually winds on to the coast just east of Nice. On the side of the school in town, a sundial reads: *Bel soulélié soulélio l'ubac è l'adret* (A warm sun shines on north and south alike).

Into the gorge and some steep lifts heave you onto a ledge road, the River Tinée running below. At 8.2km, the riverbed is wide, stones and rocks form the banks and the valley morphs into a spacious, wide-throated gorge – a long sight of the road ahead creeping round the mountain's flank. At 10km, 1650m, Le Pra (the meadow), a shanty town of houses with tin roofs and a church. The surface is good, as all roads must be when the Tour issues its diktats on the prevailing state of asphalt, and it spins along a good open balcony towards the big knuckle of massif ahead. The general surroundings are attractive, the pastures are kempt, cattle-cropped and sheep-nibbled, another settlement of houses sits on the grassy slopes, trees stand erect. A stony fissure contains the downward flow of a torrent which is dammed at intervals to increase the pressure of the flow. At 13km, 1850m, where the gradient has stiffened to between 7.5% and 8%, Boussiéyas is a diminished outpost of

sociability – a derelict hotel/bar – and a view of the snaking road just travelled below. At 14km look up, right, to the crags, including the Col des Fourches looming over the ridge at 2261m. Moorland opens out, now, together with a mighty perspective of mountains all round. There are distance and altitude signs all the way.

At 16km, 2090m, a spasm of 8.5% as you near the crags which hang over the road, the lower skirts of the Cirque du Salso Moreno at 2250m overhead.

At 17km, 2345m, the abandoned Camp des Fourches, indicated some way below by a black marble monument standing up the hill from the road. This announces: *Camp des Fourches 15 Sept 1950* and *Boussiéyas 21 July 1950* in the form of a shield surmounted by a crested helmet, the latter similar to that warn by the ancient Spartans, and elaborate tracery enclosing a 7 (7th battalion, presumably). A short way along stand the ruined barracks of the camp. At the entrance to the line of hutments, a stone slab engraved with the Chasseurs Alpins' hunting horn motif (like that used by the Spanish Correos) enclosing '28 CAMP DES FOURCHES'. At the far end of the barracks a sign points to the '*Col de Pourriac frontière d'Italie*'.

The stone buildings were constructed in 1890 to house a battalion – 800 men – together with stables for mules. In winter, the garrison was reduced to forty men, all trained skiers, but what a miserable posting it must have been,

cut off by snow and cold, provisions hauled up in baskets by rope and pulley, cabin fever rife. Murals painted by stir-crazy troopers – exotic women, sunny scenery, palm trees – testimony to their hibernal hankerings. There also survives a graffito, 'Fuck the army', though presumably of later date and, perhaps, by a passing civilian rather than a squaddie risking martial punishment.

The soldiers were known as *diables bleus* (blue Devils), from their reputation for fearsome courage and, more prosaically, from the navy serge of their uniform (although it should be noted that from 1840 young recruits in the French army were called *bleu*, so too in the French Foreign Legion, for the blue blouse with which they were issued at the intake Legion barracks in Marseille). The Chasseurs' motto: *Jamais être pris vivant*, Never be taken alive.

Towards the summit on the northern side of the mountain, there are more signs of Chasseur interest hereabouts: a stone engraved with a horn and the number fifteen; further on, the same horn motif with *14ème et 6ème Cie 1905* (14th and 16th Company) painted on a rock in yellow on a green ground.

The Chasseurs are easily recognized by the wide beret they wear in parade dress, nicknamed a *tarte* (flan). The British army adopted the black beret in the 1920s, mimicking similar headgear sported by the 70th Chasseurs Alpins (since disbanded: only three battalions are in service now). The new

# COL DE LA MOUTIÈRE 2454M

uniform black beret, smaller than the French model, was first worn by the Tank Regiment because oil stains wouldn't show.

The road continues along a shelf cut out of the rock, and a short way up there is a memorial stone recording military manoeuvres in the summer of 1936. The fourteenth army corps was stationed on the south side and the fifth army deployed north, over the Col de Pourriac, to replicate incursion by Italian troops. One General Jacquenot was in overall command. On the morning the manoeuvres were due to begin, a local man called Martin read the sky and warned his immediate superiors that an electric storm was brewing. The general ignored the warning and walked up to the Camp des Fourches with an officer of ordnance to observe the day's action. The electric storm broke and both men were fatally struck by lightning. Never turn a deaf ear to local knowledge.

At the col stands a shrine to Her again, in another of her multifarious guises. Here she is *Notre Dame du Très Haut*, Our Lady of the Extremely High.

A side route to the top via the D63 which branches off the D2205, 4.2km out of Saint-Etienne, towards Saint-Dalmas-le-Selvage. It's very narrow, although the tarmac gives way at the col itself (17.3km) to a track, rideable, to the Restefond.

*Snapshot*

# TOUR DE FRANCE PIONEERS

There is kudos attached to crossing a summit for the first time, and Tour legend bestows some reverence on the names of the great pioneers: Octave Lapize, dominant in the Pyrenees, 1910, first inclusion of those mountains, led over the Ares, Aspin, Peyresourde, Tourmalet, Portet d'Aspet, Port and took the overall victory in Paris; Emile Georget (third overall 1907, 1911), the triple of Télégraphe, Galibier, Lautaret in 1911; Federico Bahamontes, the Restefond in 1962, and again in 1964. Raymond Poulidor said of the climb: 'I don't remember it being very hard but it was very long, it went on forever. And then, at that altitude, it was difficult to breathe. Also, it was very hot that day and we had to change wheels because the tar was melting and clogging between the rim and the brake blocks.'

Riding his first Tour in 1983, Robert Millar crossed the Restefond ahead of the field, an exploit that made him, as they say, one of the revelations of the Tour. It was an early marker of his extravagant talent: King of the Mountains and fourth overall the following year, third in the Points competition in 1985 ahead of Greg Lemond. Millar's climbing may be said to have reached its apogee that day on the Restefond in his debut Tour. Solo, in complete command, with the perfect eloquence of letting the bike speak for him, he matched

# Millar's climbing may be said to have reached its apogee that day on the Restefond in his debut Tour.

the brilliance of the great climbers who made the mountains their domain and stamped their exuberance and class on the history of the great race. He never had a nickname; he was, perhaps, too prickly to win that kind of affection, no Eagle, no Angel of the Mountains, no Pedaller of Charm – but up there with the best? For sure.

In only the fourth time of crossing the great massif of the Bonnette/Restefond in the 2008 Tour, another neophyte, the young South African John Lee Augustyn, riding for Barloworld, was first over, ahead of the entire field, and seemed in with a good chance of taking the win at the foot of the climb in Jausiers. He attacked over the last kilometre of the climb – and the last 2km are severe, upwards of 12% at the end of a 25km slog. Hurtling off onto the twisty descent, he overcooked a bend, flew off the road onto the verge between the tarmac and the ravine, and somersaulted off his bike. A spectator rushed over to help him up, but he was unhurt, not even scratched, so remounted and set off in pursuit. But his chance was gone and the fall – luckily, in the event, rather comic – detracted from that glorious moment when he rode across the roof of that Tour, the highest stretch of asphalted road in Europe, in the lead, on his own.

# COL DE VARS 2108M

*Southern approach from Fort de Tournoux 1308m*

LENGTH 14.7KM
HEIGHT GAIN 800M
MAXIMUM GRADIENT 11%

*Note: There are col signs, altitude and distance, on both sides, all the way up.*

A short way along the D902, branching from the D900 out of Barcelonnette, lies the Redoute de Berwick, the only survivor of seven forts built by Vauban. The fort is named after James Fitz-James, first Duke of Berwick, an illegitimate son of the Catholic King James II of England. He was born in France and returned there after the succession in 1688 of the Protestant Dutch king, William III, to the English throne. A brilliant soldier and general, he became a Marshal of France. After his crushing victory in the War of the Spanish Succession at Almanza, northern Spain, in 1707, he was created Duc de Fitz-James by Louis XIV. The battle of Almanza was remarkable in that a Catholic Englishman at the head of a Catholic Franco-Spanish army faced, and defeated, a Frenchman – Henri de Massue, Marquis de Ruvigny, Earl of Galway, a Protestant exile and mercenary captain – at the head of a Protestant Anglo-Portuguese-Dutch army.

This is a flat valley approach through verdant meadows and pasture, small farmsteads, somnolent cattle grazing, big bosses of rock lowering over the tree-lined banks of the River Ubaye. The Vars and the Larche both tend to lose their winter snow quite early and for that reason alone, this valley of the Ubaye was, for centuries, a favoured route for invasion and brigandage. Whichever flank melted first offered the prompt to a sally of arms and baggage trains for plunder.

At 3.5km a left-hand turn leads back round to the Fort de Tournoux and at 4.4km there is a tunnel with open embrasures looking out over the river and the sheer sides of the mountain, trickling streams of fresh water down their melancholy scored and furrowed stone face. And another tunnel, no windows but lit. The first 6km into Saint-Paul-sur-Ubaye (1450m) run at a leisurely pace, no stiffer than 4.5% with a bit of a kick up into town – hotel, *auberge*, chalets. The D25 to the right follows the upper course of the Ubaye and fades out into a footpath which treks to the source.

Now the climbing proper begins on a regime of 6–7%.

The *gendarmerie* (the national rural police force, military in organization; the word *gendarme* means 'armed man') has a barracks at 6.8km, 1480m, close by a sign indicating 'Col de Vars'. Off to the right, dominating the skyline, the great chain of the Chambeyron massif and, somewhere in amongst its jagged peaks, the Aiguille de Chambeyron at 3412m.

The road begins to levitate off the valley floor, bold ramparts of rock off to the left, a

long view ahead, and has a friendly, ambling feel to it, despite the statistics of gradient on what is one of the major climbs of these mountains. At 9.8km, 1660m, a small church below to the right in Les Prats (the leas) and the gaunt ridge of the Tête de Paneyron directly ahead. At a hairpin here, in June, the lilac is in abundant bloom and profuse of sweet scent. Across two small bridges and onto the serious final assault of the col: brace yourself for some nasty business, upwards of 11% and no relief for just over 4km.

The ground is open, hummocky, grassy, interspersed with blisters of exposed earth and rock, and the line of the col is in view, quite shallow with bare slopes of scree draped like a muffler round the wattled throat of the ridge. There is contentment and a spur to effort in the tantalizing sight of the pass, the goal, the destination.

At the col, a souvenir-covered stall – get your whistling stuffed toy marmot, here – and L'Igloo, a bar/restaurant/crêperie perhaps still run by a charming and obliging woman who will cook you an omelette to order and tempt you with various scrumptious fruit tarts, strawberry, apple, almond and pear... Do not resist, you owe yourself the treat.

A large commemorative stone by the road to the west records a brief history of salient moments in the bellicose shenanigans hereabouts.

1369 Vars sacked by a band of *routiers* (originally 'freebooters', later independent cycle racers; draw your own conclusion).

1383 The col is designated as part of the frontier between France and the state of Savoy.

1515 In July, an army led by king François I of France invades Italy over the col, heading for the Col de Larche.

1518 Ubaye becomes French once more.

1559 The col marks the new frontier.

1692 A battle on the col (26 July) between the Milices du Dauphin (heir to the French throne) and the army of the Duke of Savoy. French victory. Savoy returns to France on 21 September.

1713 Peace of Utrecht. Ubaye becomes definitively French sovereign soil.

1744 On 1 April a combined Franco-Spanish force under Louis François I, Prince of Conti, and Philip, heir to the Spanish throne, advances into Savoy over the Vars and on to Nice. On 21 April their combined expedition crushes the Piedmontese-Sardinian army at Villafranca (Villefranche-sur-Mer) on the Mediterranean coast east of Nice.

Another stone records the construction of the road by alpine troops and engineers of the French army and its opening in 1891.

*Northern approach from Guillestre 1000m*

LENGTH **19.7**KM

HEIGHT GAIN **1108**M

MAXIMUM GRADIENT **9%**

Guillestre, an old fortress town whose medieval fortifications have largely disappeared, is an agreeable place to stop. This was not a view shared, one assumes, by the captured English seamen and marines held prisoner here during the Napoleonic Wars. Many of the houses still show open granaries on the top floor with extending arms for the pulleys to winch up the sacks of grain. There are numerous sundials on walls, too, a particular feature of this region, sundials with moral injunctions to make the most of time, ever-passing time, localized variations, some in Latin or French, often in the Provençal dialect, all on the *tempus fugit* and *horas non numero nisi serenas* (I don't count the hours unless they are tranquil) theme, some bleak, some wry, all hortatory:

> *lou tems passo lacte* [i.e. *l'acte*] *resto*,
>     Time passes, get on and do
> *lou tems passo, passo lou ben*, Time passes,
>     pass it well
> *C'est l'heure de bien vivre*, Now is the
>     hour: live well (whether morally or
>     gastronomically)
> *utere praesenti, memor ultimatae*, Make
>     full use of the present hour, mindful
>     of your last

> *Le temps enchaîne la lumière guide*,
>     Prisoners of time, day's light our guide

And words issuing from the mouth of an angel:

> *Toi qui me regardes, écoute, accorde le
> rythme de ton coeur aux battements de mes
> instants, comprends-tu maintenant comme
> il est temps d'aimer*, Thou who look upon
> me, listen: attune the rhythm of your
> heart to my movements and understand,
> now, that it is time to love

> *O tempora currere talis torrens*,
>     O, the ever onrushing torrent of time.
>     (The Latin is cod.)

And others:

> *Mets la joie dans ta vie Aime travaille et
>     pri*, Instil your life with joy Love, work
>     and pray
> *La vie passe comme une ombre*, Life passes
>     like a shadow

One sundial warns:

> *Je passe et je reviens. Tu passes et ne reviens
> pas*, I pass and come back. You pass and
> do not come back.

The D902 sweeps broad and steep in wide bends out of town, some 8km of upwards of 8 and 9%. It does, if you allow the unsettling

327

thought to filter in, have the feel of a road built for skiers in coaches and cars. However, there is, to distract you, a strong presence of mountain, wide views, a number of small communities en route to catch your interest. The surface is good, the knowledge that there is an intervening flat step of 3km to come, perhaps a small encouragement, and the stiffish gradient is, at least, regular. Contrarily, there are long unflexed stretches, too, which can be tedious.

At 8.6km the slope flattens to a modest 4% or so, the road crossing three bridges in quick succession and then dropping into the first outcrop of the Vars consortium of hamlets, Saint-Marcellin-de-Vars (1635m, 10.4km), all of old foundation and now expanded to accommodate the seasonal tourist influx, although Saint-Marcellin exhibits no evident contamination. Sainte-Marie-de-Vars marks the last of this interim of easy riding with a snap of gradient, beginning 4km of up to 7.5% to the ski station of Vars itself. Idle ski lifts and their attendant commercial outlets, housing and apartmentalization do not do much for the limited attractions of the village, long since encrusted with all the appurtenances of the winter invasion, which is at least a peaceable invasion.

Pleasantly situated beside a lake fed by a stream (1960m, 17.4km), the Refuge Napoléon opened on 28 August 1856, one of six (eight were planned but funds ran out). They were constructed on the order of the Emperor Napoleon III from monies bequeathed by his uncle the Emperor Napoleon I (who died in 1821), in accordance with his posthumous wish to thank those three alpine *départements* of the Isère, the Drôme and the Hautes-Alpes, which welcomed him after his return from Elba. Napoleon III acted, he said, 'for durable and friendly institutions in the heart of the region to perpetuate the holy memory with which Napoleon I honoured them.' There are other refuges on the cols d'Izoard, de Lacroix, du Noyer, d'Agnel and de Manse.

The Vars refuge offers rooms and a restaurant as well as a range of facilities for those who wish to explore the area. The open moorland between it and the col is sweet relief at the top of the climb on a reduced slope of around 6%.

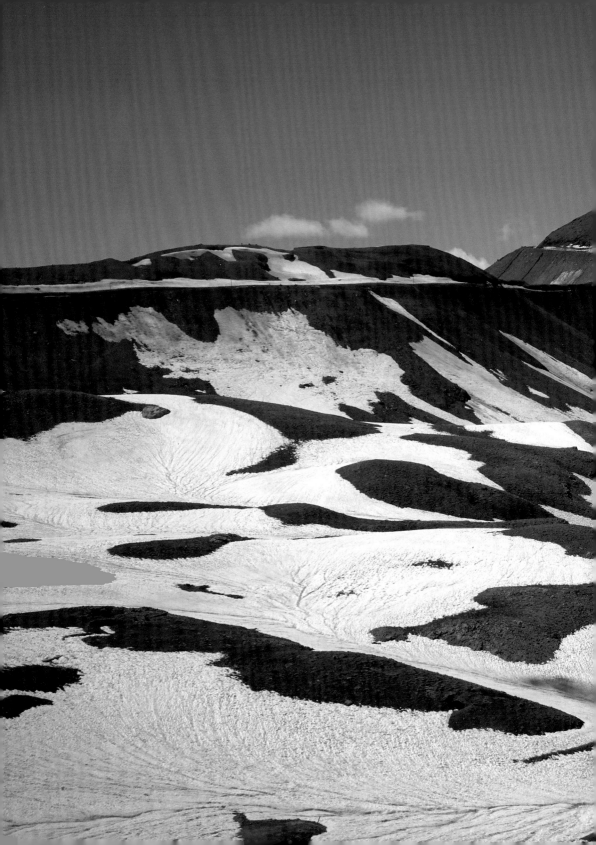

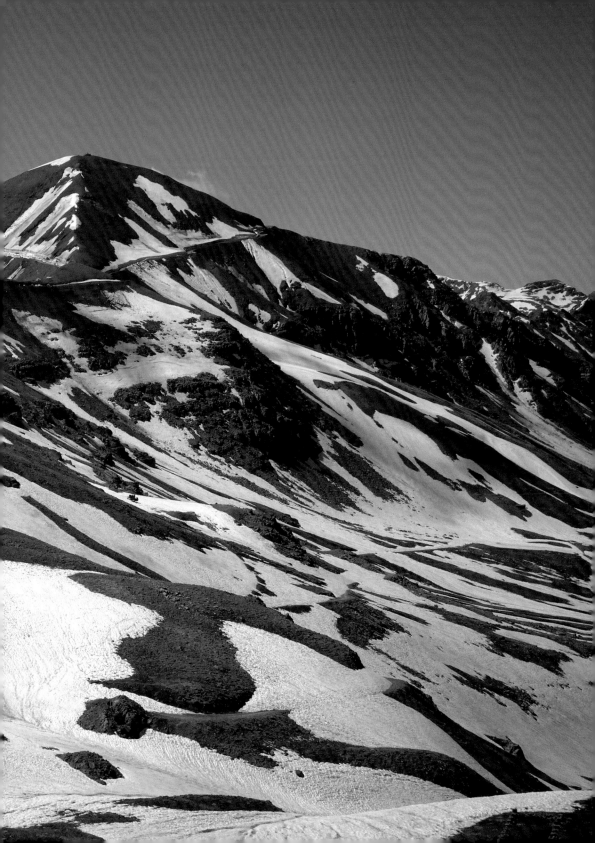

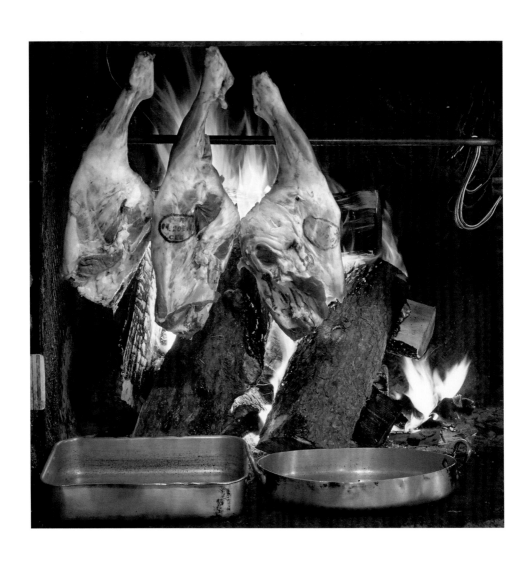

*Snapshot*

# TOUR DE FRANCE, COL DE VARS

The Col de Vars was first included in the Tour de France in 1922, often in tandem with the Col d'Izoard, also initiated that year. In 1933, the Frenchman Georges Speicher rode down the Vars heading for eventual victory in Paris with the aid of a new secret technological advance: a rear brake whose stirrups were fixed inside the rear stays instead of on the outside. This avoided snatching and delivered a smoother application of the blocks. In 1938, Speicher's Tour career came to an ignominious end, prefiguring that of his compatriot Jacky Durand in 2002: he was caught hanging onto a car door on a climb in the Pyrenees and disqualified.

In 1986, Bernard Hinault's Tour nearly ended on the Vars. Hinault was in excruciating pain from a pulled muscle in his knee. (He had, in the past, been badly afflicted with tendonitis – in 1980, he'd had to abandon.) It was, he said, the only time he ever cried on a bike. Although he had promised to work for his lieutenant Greg Lemond's victory, on the face of it he had been doing quite the opposite, attacking incessantly and shaking the American's trust. Indeed, Robert Millar, the specialist climber, said that they had never ridden the mountains so fast. (Hinault won the Mountains prize.) Dropped by Urs Zimmerman and Lemond, now in the hunt for

yellow, Hinault, in obvious distress, overheard a moto-cameraman say to his driver: 'Stay with him – he's going to pack.' Hinault was stung. He fought back, so far beyond any crowding thought of pain or discomfort that he limited his day's losses to four minutes on Lemond. He started the next day still in considerable pain, but if pride is no certain cure it can act as a powerful anaesthetic and, at the end of that celebrated eighteenth stage, Hinault drove himself and Lemond in a decisive lead, the pair of them alone, up to the finish at l'Alpe d'Huez.

Surely not referring to Speicher's super-duper component, Hinault once said: 'No technology can increase the willpower of a rider, nor can it lessen the doubts which sometimes overwhelm him.'

# COL D'IZOARD 2360M

*Southern approach from junction of D902 with D947 1355m*

LENGTH 14.5KM

HEIGHT GAIN 1005M

MAXIMUM GRADIENT 10+%

The D902 east from Guillestre passes through the narrow ravine of the Combe du Queyras, cut by the River Guil. At 17km from Guillestre, it meets a fork with the D947 off to the right. Continue on the D902. The great loom of the rock is up there, in full view, from the start. Apart from a sharp slope of around 7.5% into Le Pasquier (1530m, 4km), the approach is none too hard. The altitude signs are at odds with my altimeter reading, but that is a commonplace with atmospheric variability and nothing, O reader, *O mon frère, mon semblable* (fellow creature), to get in a swither about.

The string of small communities, once mindful of their own business – as ever, survival – have been inundated with a less pernicious influx than the destructive power of avalanche but one quite as momentous: skiing. La Chalp (1670m, 5.9km), overrun with squat chalets and ski lifts poking out of the encrustation, has been rendered an ugly, sprawling mess. As if the road itself expresses its own distaste, the slope hits 7 and then around 10% and, all at once warming to its anger, does not relent from here to the top.

After another outcrop of chaletdom at Brunissard (1755m, 7km), you may say that the climb proper is on. The road, until now a meandering ramble through the foothills, meadows pervaded by built-up areas, hits the first big right-hand bend out of Brunissard onto a succession of shorter hairpins and a snaky approach to the real meat of the ascent. It noses forward into the tightening grip of the Izoard, round steep hairpins and fairly short interlinks onto a longer terrace from around 10.5km, 2030m. Stony ridges appear on the open side and the bends do the switchback to crank up the height – twiddle-gear 9% and more – with a dramatic lash of the tarmac whip. A long straight leads up to a viewing platform (left) and a hard right-hand bend and there... the Casse Déserte.

Here, at 12.2km, 2210m, you see the famous lunar landscape, the teetering slopes of the mountain to the right, deep in scree, and the huge rock stacks towering out of the rubble. It looks smooth, like grey aggregate, pulverized shingle, a slide of lava turned to stone. Everyone who rides this colossus of a climb will retain an indelible memory of it. And, if the ghosts of the Tour gather routinely anywhere on the route, you feel it must be in the lonely canyon of the Casse Déserte, amid the ancient, ancestral menhirs, under the blazing furnace of the Dog Star. Those rock stacks might be the monolith embodiment of the implacable *juges de paix*, the arbiters of human frailty, who preside over the Tour, who punish the *jour sans* (off day) without pity, who oversee with a cold eye the shocking *défaillance* (loss of strength,

physical and mental) and the superhuman acts of bravery, endurance and tenacity alike.

The road sweeps down for half a kilometre into a curving dip on a snort of relief past the ghostly presence of the primeval stone pillars and then bites into the final hard slog of the climb, 1.8km of 10%.

Atop the col, in a large, unpaved parking area, stands an obelisk memorial to one Général Baron Berge and units of alpine infantry whose endeavours – with the cooperation of the *départements* involved – helped realize the Touring Club of France's dream of a Route des Alpes. By linking the cols d'Izoard, Vars and Cayolle they opened the way north–south to the Paris–Lyon–Mediterranean railway company.

A souvenir shop serves moral uplift on postcards of sundial mottoes in praise of the sun, the first two here in dialect, the last in Latin:

> *De tes rais raiou lou mel*, From your rays
>   comes honey
> *Lou sourey se levo per tutches,*
>   Your smile alights on all
> *Lumière est vie, vis dans la lumière,*
>   Light is life, live in the light
> *Nihil sine sole*, Nothing without the sun.

## Northern approach from Briançon 1210m

LENGTH  19.6KM

HEIGHT GAIN  1150M

MAXIMUM GRADIENT  9%

The D902 leaves Briançon at a steady 5% for around 4km. At 3.7km a by-road to the left leads up to the Fort du Goudran, part of the extensive fortifications of this key defensive position at the intersection of four valleys – Guisane, Durance, Cerveyrette and Clarée – and a mere 21km from the Italian border, north-west over the Montgenèvre pass. The old town, Ville Haute, circumvallated with a ring of forts, was laid out by Vauban, and its steep, narrow streets, home to souvenir shops and chic boutiques, are a great lure for tourists. The church of Notre Dame, in the shadow of Vauban's bastions, is girded with cypresses and dedicated to God rather than gunpowder, though carefully sited to double as a defensive salient if need be. Briançon, *petite ville et grand renom* (small town of great renown), held out for three months against a besieging Austrian army with a garrison of 300 in 1815. There are still barracks in the lower town and a military ski school for the Chasseurs Alpins, founded in 1904.

It is a long heave out of town along a narrow valley, some parts a bit of a highway, but the gradient has a fixed tempo and at around 4.3km, 1400m, it flattens and falls away for a while. Early in the climb such loss of height can

be taken in your stride. At 6km, in the company of wooded slopes, the climbing resumes, but for only a kilometre of 6–7% before a marked easing on the way up to Cervières (1615m, 9.6km) on a by-road to the left. The village was badly damaged during the final bitter fighting of the Second World War in this region, but the fifteenth-century church survived.

The road continues through broad meadowlands, a great cordon of trees far in the distance like a dense smokescreen shielding the flanks of the rock beyond. Two kilometres of the same 6–7% brings you to Le Laus (1750m, 12km), and a large, beetle-browed four-storey chalet, the Arpelin *auberge* and restaurant, a good place to stay – feather beds – and certainly to eat. Its speciality is open-hearth cooking, gigots hooked by their heels to a metal bar and roasted for some five hours over a fire of Scotch fir (*Pinus sylvestris*) and larch logs, assiduously basted by Monsieur le patron: a lovely sight. You may sample the incongruously named La Tourmente beer brewed from the pure *malte d'orge* (barley malt) of the region, which is very far from a torment.

When Pete, our photographer, and I stopped for lunch that time, it was apparent that the waitress was not French. Indeed, her accent had a distinctly English note. I said to Pete: 'She'll be from Leytonstone.' She was, in fact, from Walthamstow, next door.

The final 7km head into the woods and negotiate a series of hairpins. The scents of pine and mountain beguile and perhaps distract from the sharp twist and turn of these hairpins at what now sets to a constant hammering at your legs and lungs, and possibly your back, too, of 8–10%. At around 1km from the top, the trees finish and the Refuge Napoléon pops out to the left like a Siren to seduce you to stop for warm cake and coffee and all manner of things with which to regale your suffering stomach and spirits but, should you wish to ride this col all in one, the final steep ramps on the helter-skelter that is the last kilometre beckon like a good deed in a naughty world and, hey, you can always scoot back down for food. Moreover, those last racks of the climb *look* horribly severe but are not, in truth, horribly severe. For you have come this far, so what folly of indifference can suppress the adrenalin, the willpower, the sheer cussedness to go all the way in one?

*Snapshot*

# TOUR DE FRANCE, COL D'IZOARD

On the southern approach, just below that Shangri-La of the col where the roads dips away north, stands a memorial to two men who wrote their names into the history of the Izoard by crossing it alone: Fausto Coppi and Louison Bobet. Coppi rode over the Izoard in yellow, 1949, the year of his first Tour win. The year before, his great rival Bartali did the same on the way to his second win and, in 1953, when the road over the col was still no more than a rustic track, thick with dust, littered with flints, Coppi stood next to the French team's *directeur*, the former rider Marcel Bidot, at the side of the road, where the plaque is now, with a camera slung over his shoulder.

As Bobet rode by, in yellow, he gave the *campionissimo*, his hero, a friendly nod and Coppi remarked to Bidot: 'Beautiful.' Years later, Bobet told Bernard Thévenet that the mark of a real Tour champion was to lead the race from the front through the awesome wilderness, in yellow. And in 1975, Thévenet did just that. Merckx, the five-times winner and dominant champion of professional cycling, who had lost yellow to the Frenchman the day before, attacked him again and again but Thévenet didn't falter and finally pulled away. Nearing the top, he passed a young woman holding up a banner which read: 'Merckx, the Bastille has fallen.' It was 14 July.

Merckx in yellow claimed the Izoard in 1972, his fellow Belgian Van Impe took the Tour – and the Izoard, in yellow – in 1976.

The mountain entered the Tour in 1922. Its first conqueror was another Belgian, Philippe Thys, first triple winner, and in 1923, riding to overall victory, Henri Pélissier baptized the great col, as it were, with a mystic significance.

When I interviewed him for the first time, Thévenet used his ride up the Izoard that day as an example of how a rider must parcel out his effort: to expend every iota of his strength up to the col, saving only a bare fraction with which to jump-start recovery on the way down. He said the experience of the crowds cheering him deliriously up and over the Izoard as he reinforced his superiority over Merckx 'filled one of the great moments of my life. Ah, the last 3km, cutting through the crowd pressing right on my front wheel, even though there was a motorbike *gendarme* escorting me…' At the beginning of the stage, he held a lead of just under two minutes – 'no more than a speck of soot with someone like Merckx' he told me. By its close, in solo victory, he had doubled it.

# COL D'AGNEL 2744M

*Western approach from Ville-Vieille 1400m*

LENGTH 20.2KM
HEIGHT GAIN 1344M
MAXIMUM GRADIENT 10%

Take the D902 east of Guillestre along the ravine to Château-Queyras, another stark example of Vauban's work, dominating the Guil valley to the west of Ville-Vieille. Backing up this defence-work constructed by man, divine support issues from a rocky peak, L'Ange Gardien, just to the south. Ville-Vieille, a town situated at the start of the Agnel that existed long before this intervention of military engineers, is tranquil, and the Hôtel Gilazur offers fairly basic accommodation and a very friendly welcome. The Bar du Village, next door, serves excellent meals (although the Gilazur does have a restaurant) and I urge you to try *raclette* if you have not sampled it yet. From a dish of boiled new potatoes pluck one and onto it scoop cheese – the local cheeses are perfect for cooking – from a big slice which has melted under an overhead hot iron. Scrape off the goo, leave the harder layer underneath to melt in its turn. Eat with *cornichons* (gherkins) and, perhaps, thin slivers of blood-red, locally cured ham marbled with white fat. Delicious. Round off your supper with a slug of *génépi*.

The Agnel pass has seen a lot of action, one way and another, the details of which are listed on a large rock stele up the valley.

218 BC Hannibal, his army and his elephants heading for Italy. (There is some dispute about the pass they crossed. Montgenèvre, Mont-Cenis and Saint-Bernard some way to the north are all proffered, but the evidence seems to point most directly to the unpaved Col de Savine-Coche – generally known as the Petit Mont-Cenis, just south of its Grand cousin. The historian Livy, following the earlier writer Polybius, insists that Hannibal arrived in Italy in the territory occupied by the Taurini tribe, the environs of modern Turin. Polybius writes that Hannibal pointed to the great, fertile sweep of the plains in the Po valley and the well-ordered and prosperous communities of the Gauls who inhabited them and told his men – exhausted by the long trek – that life there would be good.)

51 BC Caesar's legions (from the reverse direction) for the conquering of Gaul.

1515 Chevalier Bayard, often considered the last of the true knights in shining armour, *le bon chevalier*, who busied himself much with his king's interests in these disputed territories.

1578 Duc de Lesdiguières, Constable of France, who secured the final submission to the crown of the then independent Dauphiné.

1579 Maréchal de Bellegarde, from a famous Savoy family. More interesting than

344

his belligerence is the fact that the king, Henri IV, poached his mistress, Gabrielle Estrée, a woman of high intelligence and feisty temperament. The king showered her with money, honours, titles, even offered her the throne just to keep her. She remained unswayed. She wrote:

> Strange thing to watch
>   a great king
> In thrall to women,
> Honour forgotten,
> Seeing an angel in a whore.

1712    Duc de Berwick (see Col de Vars)
1743    Philip V of Spain

A local heroine, Marguerite Eyméoud, is also celebrated here, though the date of her exploit is given as 1692 – other sources give 1792. I was at pains to find out who she was. The *patronne* of the Gilazur did not know, gave as her excuse that she is from the other end of Provence, but recommended a visit to the Maison de Presse in Aiguilles up the road as the owner was, it seems, a rare scholar. He hadn't a clue. I asked the garage man at Ville-Vieille, 'Do you know of a Marguerite Eyméoud?'

'Yes,' he replied, 'she's my cousin, she lives in Molines.'

Either I had stumbled on a miracle of longevity or she was a descendant. Sadly, the cousin knew no more than the others about the story and my search continued.

It transpires that the widow Eyméoud, Marguerite, of Molines-en-Queyras, hailed originally from Costeroux, a mountain hamlet above Fontgillarde, up the valley. Seven of its houses were swept away by an avalanche in 1708, another eleven were destroyed by avalanche in 1788, leaving only ten, until the village was finally abandoned shortly after 1824. The ever-present threat of destruction by snow and rock clearly put steel into Marguerite's will because, sick of the incessant depredations of brigands, she galvanized the inhabitants from round about to take a stand. Very *Magnificent Seven*. In a defile of the Aigue Agnelle (the river flowing down this valley), the villagers ambushed a wagon train of robbers, reclaimed the booty and saw the intruders off. Sadly, the bold Marguerite died in the affray.

In November 1944, her shade was once more invoked by six volunteers who 'fell for liberty and the defence of Queyras'.

At Ville-Vieille, leave the D902 which continues as the D947 and follow the D5, 4km of variable steepness, 6–8%, and on into Molines-en-Queyras (1765m, 5.5km) after a short flat stretch.

At about 4km, to your right you will see one of the celebrated *Demoiselles Coiffées*, 'Girls with Hair-dos'. These curious geological formations, peculiar to the region, consist of tall stacks of softish sedimentary rock which taper upwards to a flat capping of much harder

stone. They might be women in shapeless floor-length shifts wearing pancake berets or with flat-top, grunge haircuts. The technical term is hoodoo, a variant of voodoo – witchcraft. Since the French also call them 'fairy chimneys', the connection with spooking seems to brood there.

Out of Molines, take the left-hand fork, D205, onto a long balcony of a road at a brisk 8% or so to another more even stretch into Pierre-Grosse (1885m, 7.5km), a tiny mountain village with a very narrow street of bumpy texture, houses, many of them ramshackle, pressing in from both sides like eager fans. Imagine the Tour coming up through here as it did in 2008. Extra. A sundial on the outside wall of a *gîte* admonishes: *Tant que tu vis, vis* – Live life to the full.

There is a big presence of ski chalets in Pierre Grosse and Fontgillarde. Just outside Fontgillarde, across the hillside to the right, on the flat bank of the river, someone has spelled out '*STIEB*' (German: 'rise up') in stones next to a large C inside a double circle, also in stones. A plea, surely, to Christ?

Here you will see the big range which dominates the horizon, far, far ahead.

Beyond Pierre-Grosse, the land opens out into flower-spangled meadows, the river cutting its way over a scumble of boulders and large pebbles over to the right, the road snaking through like a causeway. Fontgillarde (1990m, 9.5km), low enough below Marguerite Eyméoud's vanished home hamlet not to be in imminent danger of avalanche, yet still alert to the threat of off-mountain jetsam, has transverse rain gutters set into its high street. A short lift out and into grassy meadow slopes, a flattish moorland, a scatter of chalets, the river below to the right and a bastion of rock pinning some history to the landscape, the Rocher d'Annibal.

Set back from the road to the left, near a bridge over the river, a small wooden cabin houses Chez Mem's, a *buvette* – French snackery.

The last 8km begin the true climb away from the riverine pastures and up into the bleak fastness of this border pass, slow to tighten but after 2km of warm-up, a steady smack, smack, smack of upwards of 9%. The mountain sides are more exposed too, loose scree for vegetation, the road hitting some sharp bends, the ridge often snow-streaked still in June and exhaling a chilly mist.

Here the climb feels wild, testing, the verdure of the lovely valley gone, the grass more scrubby and the marmot sentinels on the instant *qui vive* (look-out) for intruders. Perhaps their atavistic suspicion jumped the gene pool into that of the local humans.

The surface is good, the bends serious, the gradient hard and the tip of the road over the col most welcome. The Refuge Napoléon is now nought but a pile of ruins, although there is a large chalet-refuge off to the right below the pass and a visitor centre to the left.

A stone, placed here in 1823, marks the Franco-Italian frontier and the altitude. The view south into Italy is staggering, dramatic, handsome recompense for the long ride up.

# ESSENTIAL FRENCH VOCABULARY

| ENGLISH | FRENCH |
|---|---|
| adjustable spanner | clef (clé) anglaise |
| allen key | clef hexagonale or à six pans |
| bag | sacoche or musette |
| battery | pile |
| bike | vélo |
| brake | frein |
| brake block | patin de frein |
| brake cable | câble de frein |
| brake lever | poignée de frein |
| brake hood | cocotte |
| broken | cassé (-ée) |
| cap | casquette |
| cassette | roue-libre à cassette |
| chain | chaîne |
| chain rivet extractor | dérive-chaîne |
| chainwheel | plateau de pédalier |
| cleat | cale-chaussure |
| crossbar | tube horizontal |
| down tube | tube diagonal |
| forks | fourche |
| frame | cadre |
| front | avant |
| gear cable | câble de dérailleur |
| handlebar | guidon |
| handelbar tape | tresse pour guidon |
| headlamp | phare |
| headset | jeu de direction |
| head tube | tube de direction |
| helmet | casque |
| hub | moyeu |

| | |
|---|---|
| inner tube | cambre à air |
| jersey | maillot |
| nut | écrou |
| oil | huile |
| pedal | pédale |
| pump | pompe |
| pump up | gonfler |
| puncture | crevaison (verb: crever) |
| quick-release hub | moyeu à blocage rapide |
| rear | arrière |
| rear lamp | feu arrière |
| rim | jante |
| rim tape | fond de jante |
| saddle | selle |
| saddle post | tige de selle |
| screwdriver | tournevis |
| shoe | chaussure |
| shorts | cuissard |
| socks | chaussettes |
| spoke | rayon |
| sprocket | couronne |
| stem (of handlebar) | potence |
| tights (bib tights) | collant (collant à bretelles amovibles) |
| tyre | boyau / pneu |
| valve | valve |
| washer | rondelle |
| water bottle | bidon |
| wheel | roue |

# INDEX OF CLIMBS AND COLS

# ACKNOWLEDGMENTS AND BIOGRAPHIES

Our thanks to Lucas Dietrich for overseeing the publication of a book which, in a very different form, first appeared as a Rapha imprint, and to Fleur Jones for managing the editing process with such cool and friendly consideration. – Peter Drinkell and Graeme Fife

**GRAEME FIFE** is a writer and broadcaster who has written for BBC Radio and the World Service, as well as numerous books and articles for magazines and national newspapers.

**PETER DRINKELL** is a photographer and filmmaker based in London.

On the cover: L'Alpe d'Huez

First published in Great Britain in 2010 as *The Great Road Climbs of the Southern Alps* and in 2012 as *The Great Road Climbs of the Northern Alps* by Rapha Racing Limited, Imperial Works, Perren Street, London, NW5 3ED

This edition first published in the United Kingdom in 2019 by Thames & Hudson Ltd, 181A High Holborn, London WC1V 7QX

Maps by Peter Bull Art Studio

Designed by Sam Clark / bytheskydesign.com

British Library Cataloguing-in-Publication Data
A catalogue record for this book is available from the British Library

ISBN 978-0-500-022719

Printed and bound in China by C & C Offset Printing Co. Ltd

To find out about all our publications, please visit **www.thamesandhudson.com**. There you can subscribe to our e-newsletter, browse or download our current catalogue, and buy any titles that are in print.